Black & White
DIGITAL PHOTOGRAPHY
Made Easy!

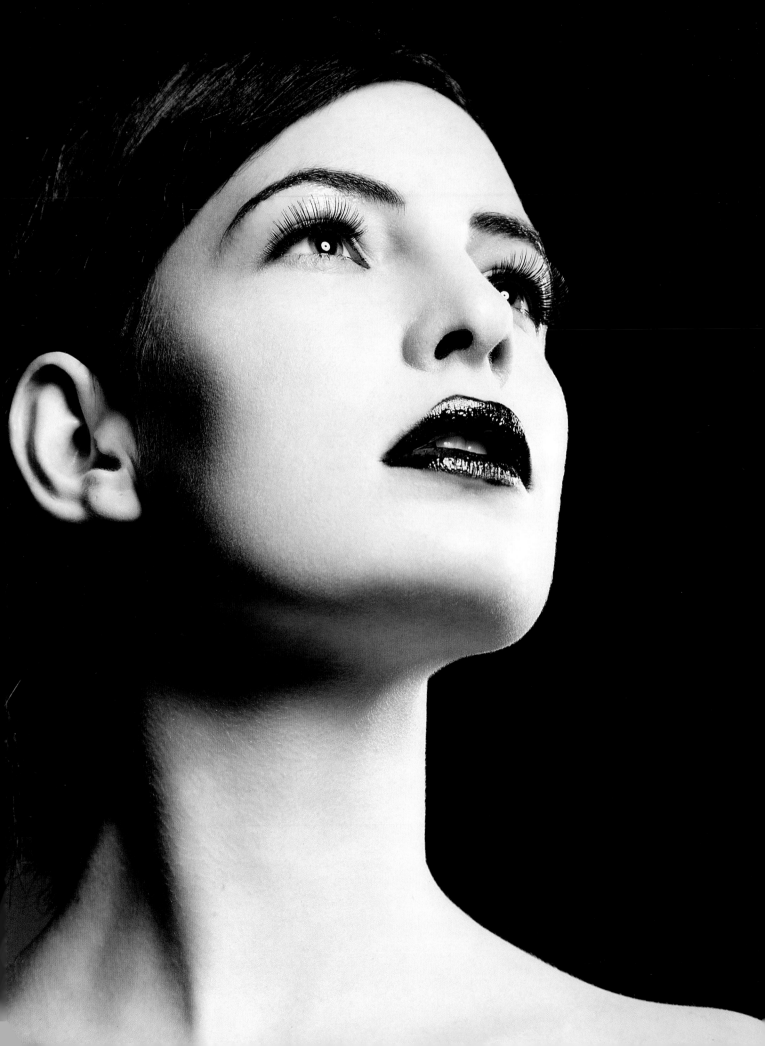

Black & White
DIGITAL PHOTOGRAPHY
Made Easy!

The All-In-One Guide to Taking Quality Photos and Editing Successfully Using Photoshop

BY EDITORS OF
PhotoPlus MAGAZINE

FOX CHAPEL
PUBLISHING

© 2012 by Fox Chapel Publishing Company, Inc., 1970 Broad Street, East Petersburg, PA 17520

Black & White Digital Photography Made Easy is an original work, first published in 2011 in the United Kingdom by Future Publishing Limited in magazine form under the title *Black & White Photography Made Easy*. This title printed and distributed in North America under license. All rights reserved.

ISBN 978-1-56523-718-6

To learn more about the other great books from Fox Chapel Publishing, or to find a retailer near you, call toll-free 800-457-9112 or visit us at *www.FoxChapelPublishing.com*.

Note to Authors: We are always looking for talented authors to write new books. Please send a brief letter describing your idea to Acquisition Editor, 1970 Broad Street, East Petersburg, PA 17520.

Printed in China

First printing

Black & White
DIGITAL PHOTOGRAPHY
Made Easy!

Imagine if you could only see the world in black and white. For some this might make them feel restricted and constrained, however, for photographers like us, seeing the world in monochrome opens up a whole new raft of exciting photographic possibilities. Without colour acting as a distraction, you can start to see the world as a beautiful range of tones instead.

In *Black & White Digital Photography Made Easy* we explore the world of black and white and look at exhilarating new ways to approach the mono medium. Whether you're a semi-pro photographer looking for inspiration or a total beginner unsure which D-SLR settings to use, in our essential guide we will help you improve as a photographer by broadening your horizons and opening your eyes to the potential of black-and-white photography.

From landscapes to city scenes, portraits to fine-art nudes, weddings to urban imagery, over the following pages there's something for everyone to learn how to approach shooting for black and white. Plus we have over 80 pages of Photoshop advice with the best ways to convert your colour shots to mono – from basic methods to more advanced image-editing techniques. All these tutorials are backed up with video guides you'll find on your free DVD-ROM!

CHECK THE DVD!
Turn to the back page for your jam-packed DVD-ROM!

Peter Travers, editor

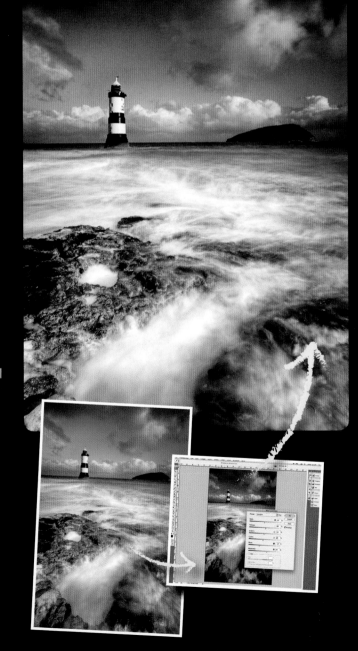

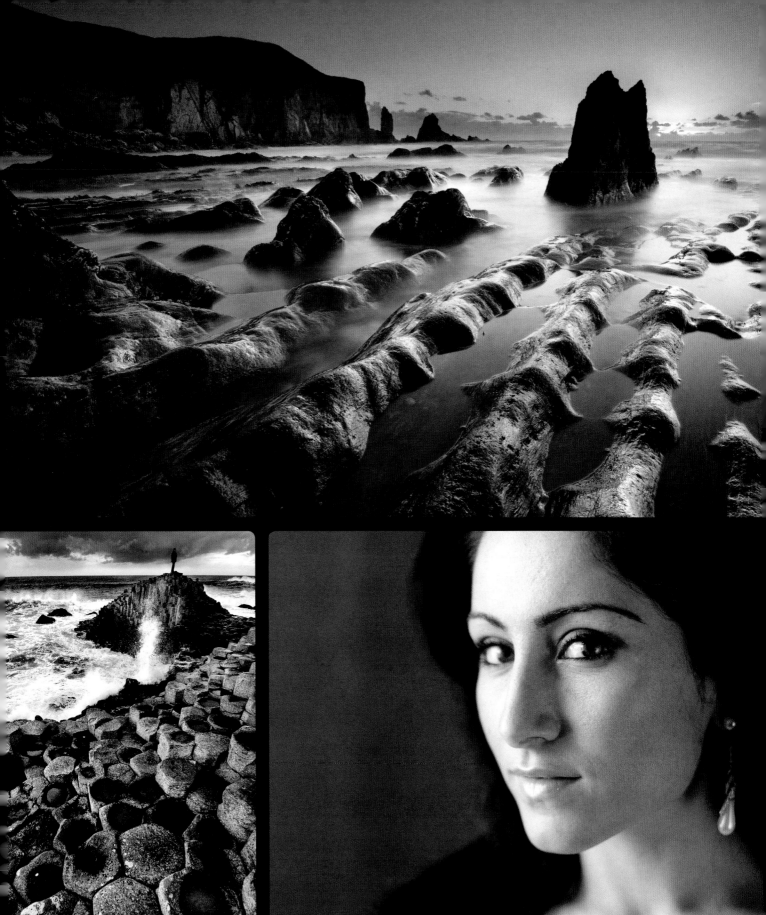

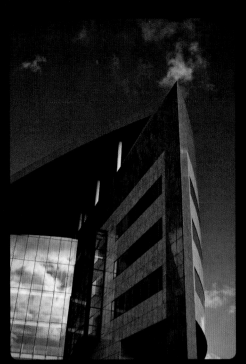
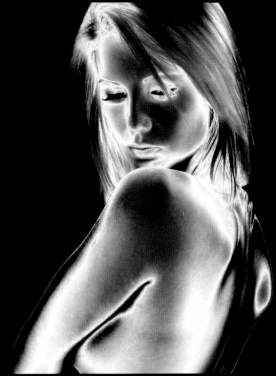

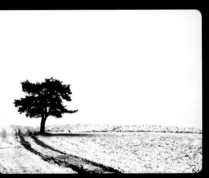

How to get the most
out of the disc that
comes supplied with
this book...

Camera skills

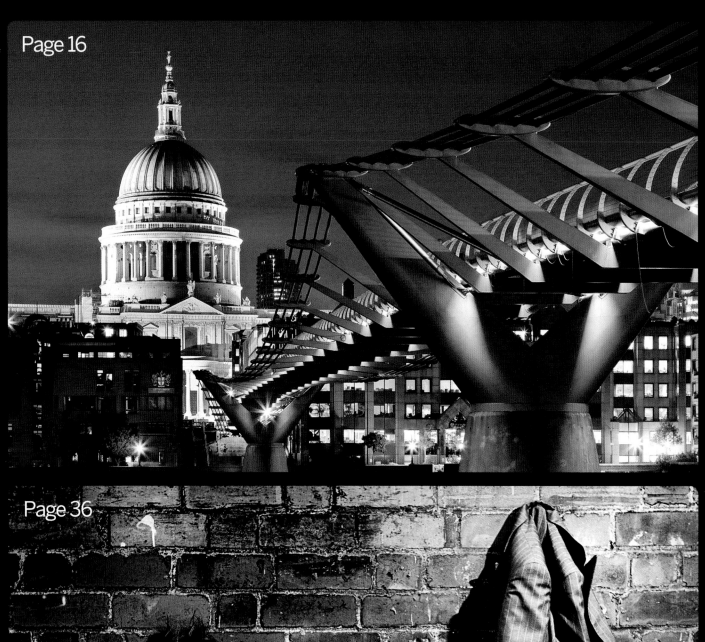

Page 16

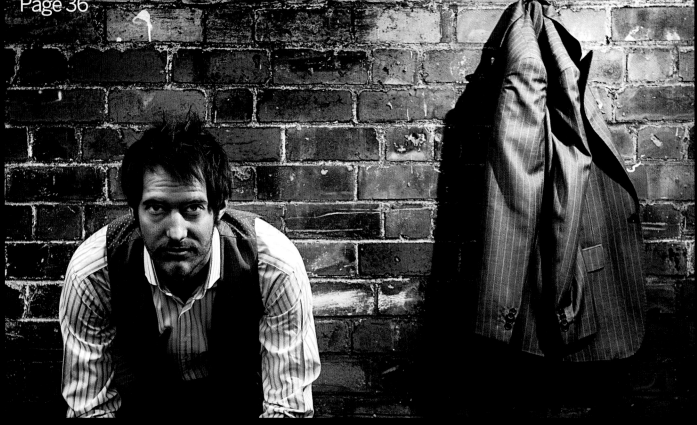

Page 36

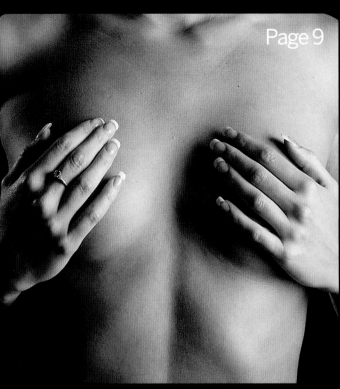

Page 9

Camera skills

1

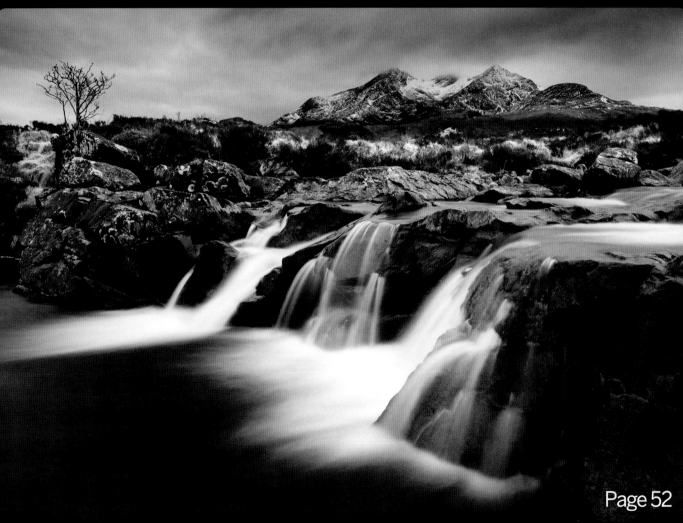

Page 52

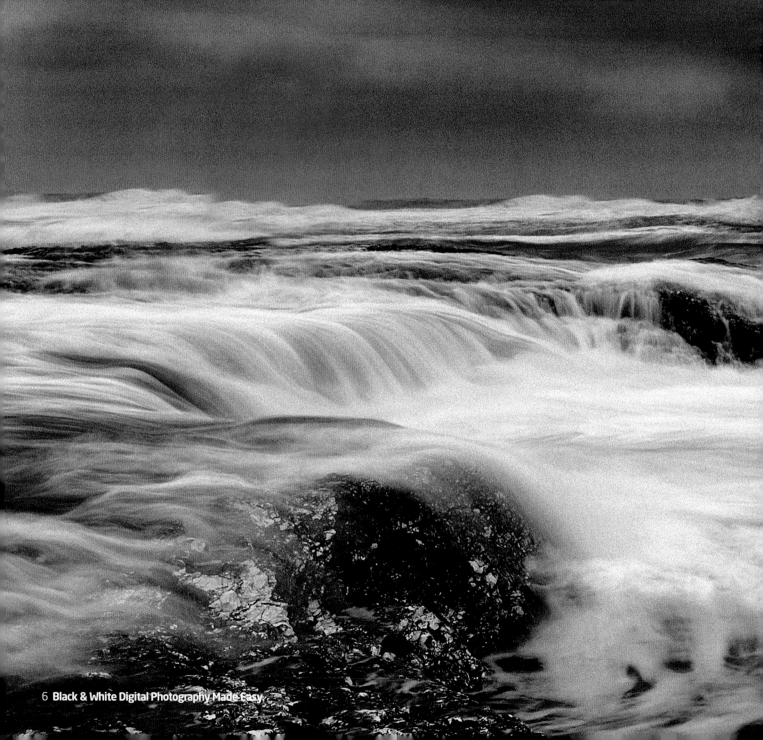

How to shoot for...

Black & White

Removing colour is one of the best ways to add drama to landscapes, and many other subjects. But it's vital you pick your subjects with care – and shoot with monochrome in mind. Here we reveal how to lose the colour and win!

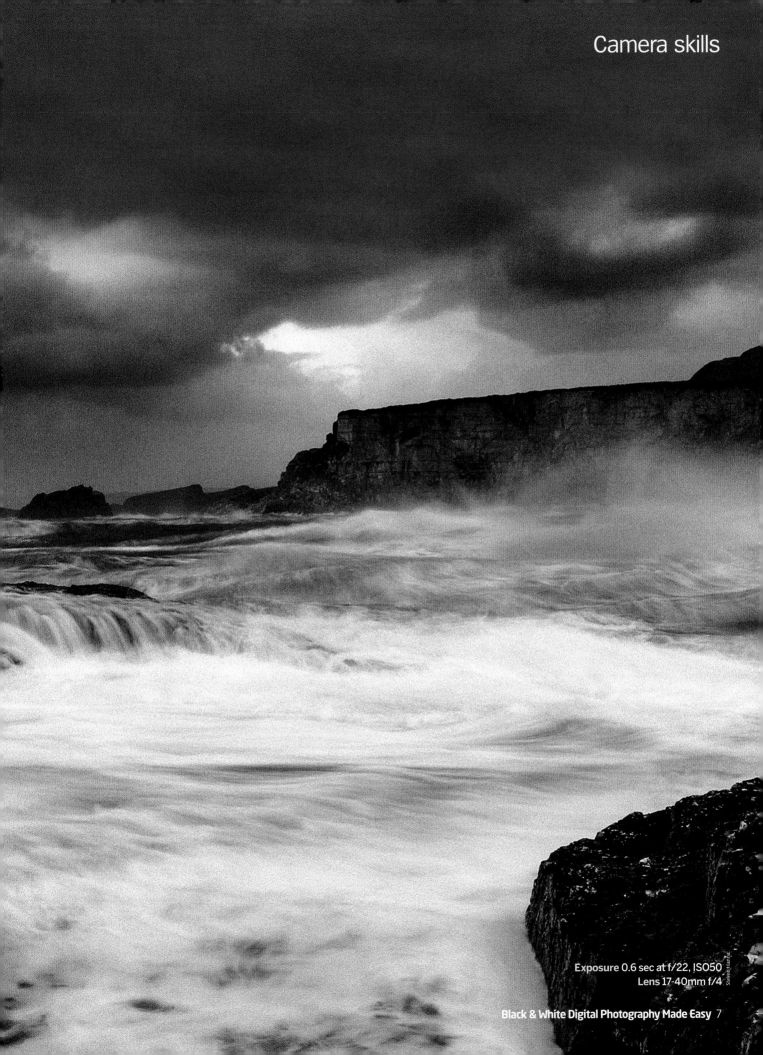

Exposure 0.6 sec at f/22, ISO50
Lens 17-40mm f/4

Steve Hanna

THE BASICS

Why shoot in black & white?

Going black and white for the sake of it makes no sense. Follow our guidelines instead...

You might think that black-and-white photography would be a thing of the past by now. After all, the Victorians shot in monochrome simply because colour film had not been invented. But its popularity lives on despite advances in technology over the past 150 years. There's still something special about black and white that entices the viewer and excites the serious photographer.

Because every digital SLR is more than capable of capturing the world in full colour, it may seem strange that so many photographers want to take shots that are made up of multiple shades of grey. But over the following pages we'll look in depth at what makes a successful monochromatic picture – and how to find and capture such shots.

The essence of monochrome's magic comes down to nothing more complicated than that colour can often be a distraction. Take it away and the photographer can show the world in a simple, more interesting way.

Black and white is a natural choice for portraits because removing colour makes the viewer concentrate on facial features. Clothes can complement a portrait – but their hues can also be a distraction. Skin pigmentation, blemishes and spots can also appear too prominently in pictures of people.

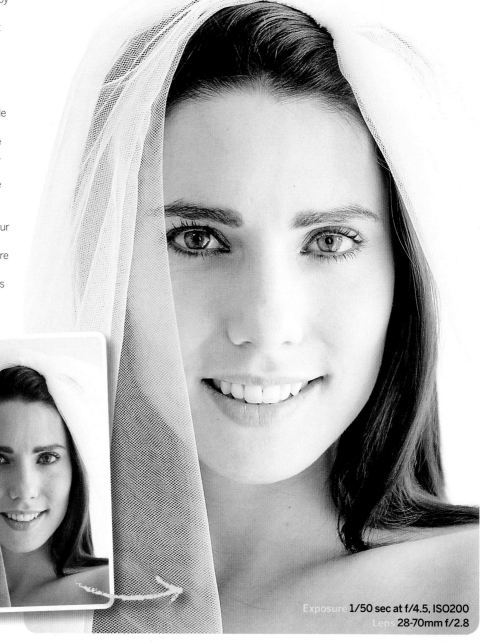

Exposure 1/50 sec at f/4.5, ISO200
Lens 28-70mm f/2.8

Chris George

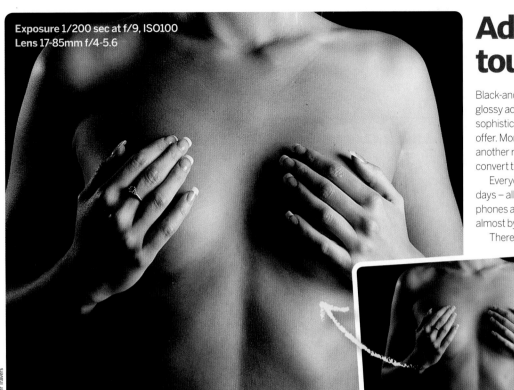

Exposure 1/200 sec at f/9, ISO100
Lens 17-85mm f/4-5.6

Peter Travers

Add an artistic touch to shots

Black-and-white photography is often used in glossy advertising campaigns to give an air of sophistication and refinement to the products on offer. Monochrome images are classy, which is another reason why photographers often choose to convert their shots.

Everyone can take colour photographs these days – all they have to do is take out their mobile phones and snap away. A black and white picture is, almost by definition, that little bit more professional. There's an important compositional point, too. Artistic photography is often about creating an abstract study, rather than a truly accurate representation of the real world, and you are already one step closer to an abstract shot if you shoot in black and white, rather than in full colour.

No more colour clashes

Converting to black and white also means you don't have to worry about colours that clash. The shade of black, grey or white that they become is your only concern. In this still life, for example, the plum-coloured cushion distracts from the colour of the pomegranate pips, but in mono the cushion becomes a dark-grey textured backdrop.

Going mono is also a lifesaver when you are shooting in mixed lighting, where there are two or more light sources of different colour temperatures that your camera's white balance system cannot correct for. In a home studio setup, for example, this means you can mix lighting from a desk lamp with that from a window, without the fear of nasty colour casts.

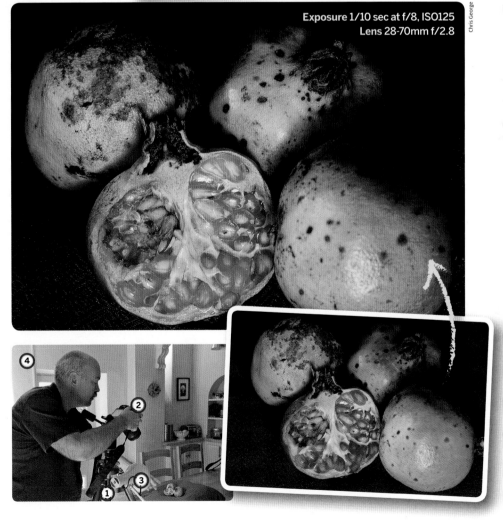

Exposure 1/10 sec at f/8, ISO125
Lens 28-70mm f/2.8

Chris George

Secrets of mono still lifes

1 A sturdy tripod will keep your camera still as you align your subject and help avoid camera shake.

2 Switching to Live View allows you to see the scene as the camera sees it as you perfect your composition.

3 An anglepoise lamp is used as the main light source.

4 Window light creates fill light. It doesn't matter that this is a different colour temperature to the desk lamp when you are shooting for black and white! ▶

SEEING THE PICTURE

Which shots work in black & white?

Converting to black and white doesn't mean you can forget about composition. Here are some golden rules for monochrome framing

To shoot successful black-and-white photographs you'll need to learn to see the world in a new light. But there is a trick used by artists that will help you to see the sorts of subjects that will work in monochrome.

The secret is to analyse subjects according to the key visual elements. These essential elements are shape, form, texture, pattern and colour. Everything we photograph contains some, if not all,

of these elements, but often the most successful shots are those that use composition and lighting to highlight just one of these elements alone. If you are shooting for black and white, you can obviously forget about the colour. But this does mean that the best subjects are those where you can accentuate the shape, form, pattern or texture in the scene.

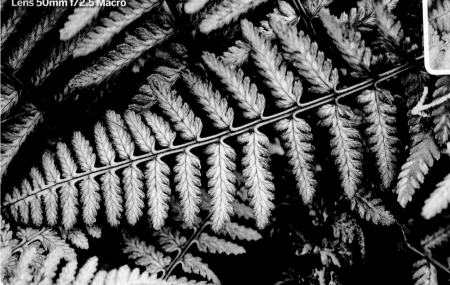

Exposure **1/125 sec at f/7.1, ISO400**
Lens **50mm f/2.5 Macro**

Chris George

Seeing in shapes

The shape is the outline of a subject, and the best way to emphasise this in a black-and-white photograph is to frame a dark subject against a bright background, or with a bright subject against a very dark background.

The obvious example of a subject where shape is the major (if not only) visual element in a picture is a silhouette. But with black and white, you don't have to go to that extreme. In the shot above, the outline of the painted Japanese fern is emphasised during the mono conversion, making the shadowy background really black, while turning the green a contrasting shade of grey. This then highlights the delicate shape of the fronds.

How to pick out pattern from a scene

Pattern is simply a repetition of shapes in a scene, and once you start looking with your camera you'll be amazed by how much there is around you. Nature abounds with pattern – from the hexagons of a honeycomb and the lines of a fence, to fallen leaves on a pathway. The secret to emphasising pattern in a shot is to get in close – with a macro lens or a long telephoto – so that you see the repeating shapes alone, and not its distracting surroundings.

Architecture is a good place to start. It's full of pattern, from simple brickwork to elaborate decoration.

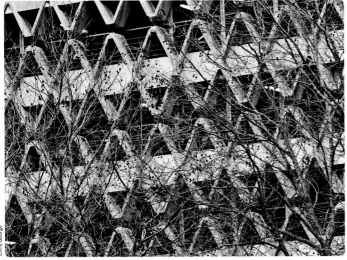

Shooting a patterned surface from a flat-on camera angle helps to reinforce the repetition and accentuate the effect

Convert with caution!

Some shots simply don't work in black and white – spectacular golden sunsets, for example, or other images where colour really is key.

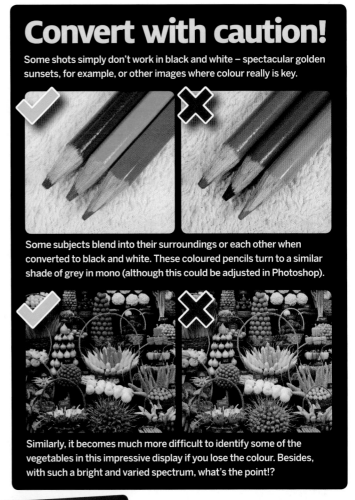

Some subjects blend into their surroundings or each other when converted to black and white. These coloured pencils turn to a similar shade of grey in mono (although this could be adjusted in Photoshop).

Similarly, it becomes much more difficult to identify some of the vegetables in this impressive display if you lose the colour. Besides, with such a bright and varied spectrum, what's the point!?

What is form?

Identifying shape, pattern and texture is relatively easy, but it can be tricky to spot form – the 3D shape of a subject. This is what tells us a football is not just a round shape, but a 3D sphere.

Form is important in photography, because your pictures are two-dimensional. Finding a way to photograph a subject to accentuate form allows us to reveal physical depth.

It is subtle variations in shading that give away a subject's form. The angle of the surface to the lighting affects how bright it appears, and its these changes in brightness that show us where the curves and corners are.

Form is best accentuated when the subject and camera is lit from the side. ▶

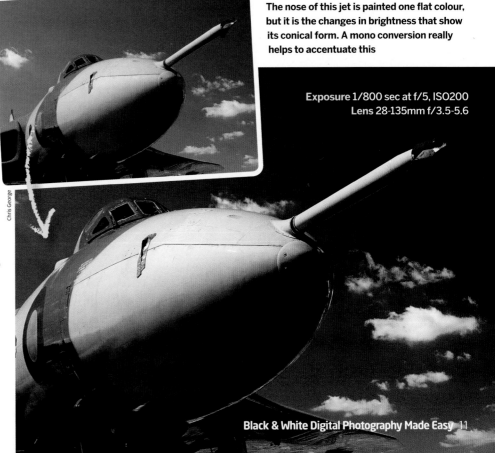

The nose of this jet is painted one flat colour, but it is the changes in brightness that show its conical form. A mono conversion really helps to accentuate this

Exposure 1/800 sec at f/5, ISO200
Lens 28-135mm f/3.5-5.6

LIGHTING AND EXPOSURE

What weather is best for mono shots?

As with colour landscapes, the weather plays a crucial role in great monochrome scenic shots

You can shoot in black and white whatever the weather, but there are days when it's more productive to concentrate on mono. Blue skies are great for colour-rich architectural shots and picturesque landscapes, but an azure sky can work just as well in black and white. The key is the colour; it is easy to make the sky any tonal shade you want, from ugly featureless white to dramatic deep black.

But black and white photography comes into its own on cloudy days. The cloud patterns can be accentuated to create a moody image. In fact, even on the greyest days, shooting for mono can be successful because it's possible to increase the contrast of the image to a much greater extent in black and white than would ever be possible in colour.

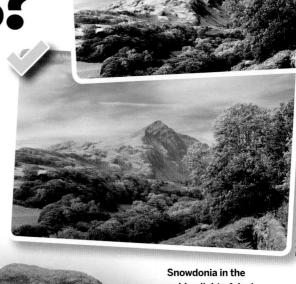

Snowdonia in the golden light of dusk. The mono version is okay, but there's little doubt that the scene looks better in colour

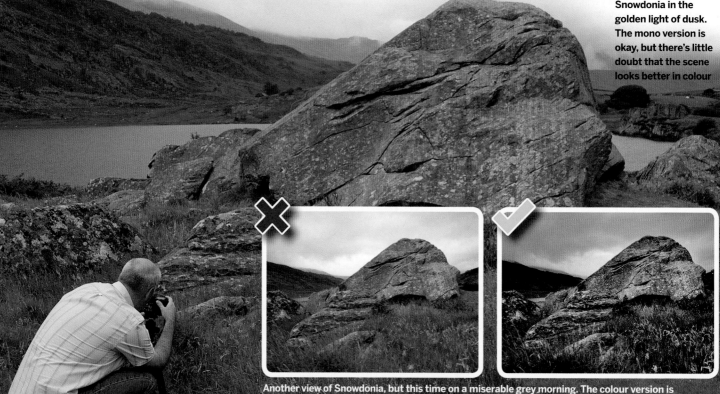

Another view of Snowdonia, but this time on a miserable grey morning. The colour version is lacklustre, but by converting to black and white the scene is really brought to life

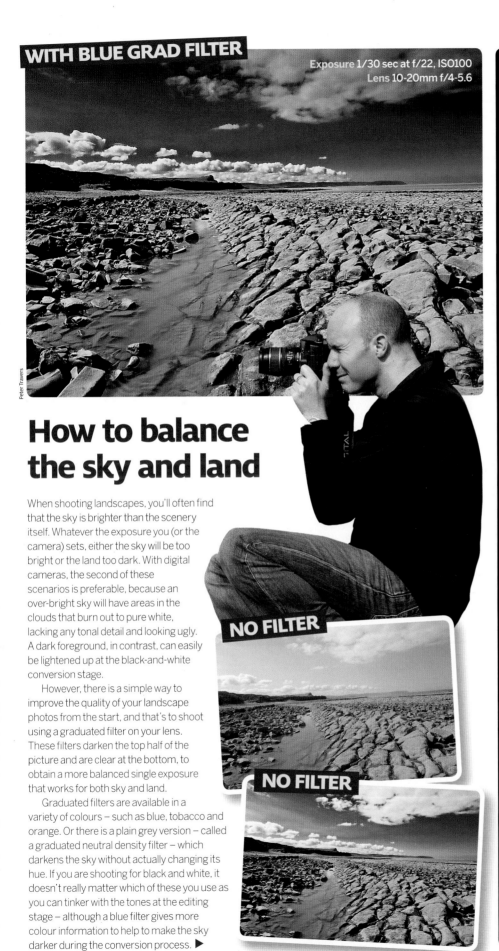

WITH BLUE GRAD FILTER

Exposure 1/30 sec at f/22, ISO100
Lens 10-20mm f/4-5.6

Peter Travers

How to balance the sky and land

When shooting landscapes, you'll often find that the sky is brighter than the scenery itself. Whatever the exposure you (or the camera) sets, either the sky will be too bright or the land too dark. With digital cameras, the second of these scenarios is preferable, because an over-bright sky will have areas in the clouds that burn out to pure white, lacking any tonal detail and looking ugly. A dark foreground, in contrast, can easily be lightened up at the black-and-white conversion stage.

However, there is a simple way to improve the quality of your landscape photos from the start, and that's to shoot using a graduated filter on your lens. These filters darken the top half of the picture and are clear at the bottom, to obtain a more balanced single exposure that works for both sky and land.

Graduated filters are available in a variety of colours – such as blue, tobacco and orange. Or there is a plain grey version – called a graduated neutral density filter – which darkens the sky without actually changing its hue. If you are shooting for black and white, it doesn't really matter which of these you use as you can tinker with the tones at the editing stage – although a blue filter gives more colour information to help to make the sky darker during the conversion process. ▶

NO FILTER

NO FILTER

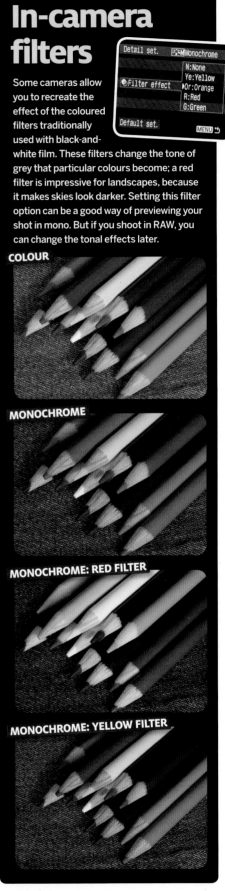

In-camera filters

Some cameras allow you to recreate the effect of the coloured filters traditionally used with black-and-white film. These filters change the tone of grey that particular colours become; a red filter is impressive for landscapes, because it makes skies look darker. Setting this filter option can be a good way of previewing your shot in mono. But if you shoot in RAW, you can change the tonal effects later.

Detail set. | Monochrome
Filter effect
N:None
Ye:Yellow
Or:Orange
R:Red
G:Green
Default set.
MENU

COLOUR

MONOCHROME

MONOCHROME: RED FILTER

MONOCHROME: YELLOW FILTER

Learn to photograph in...

MONO

Improve your desaturated shooting skills with our complete guide to black and white photography

Has your photographic vision remained firmly in glorious colour since buying your D-SLR? Then it's high time you toned down the saturation and dived into the subtractive world of black and white!

Monochrome is the medium that gave birth to photography, but the format arguably still has just as much a place in our modern lives as colour imagery. Rich, powerful and bold, black-and-white images can be much more captivating than their colourful counterparts. The trick is knowing what sorts of images respond well to the treatment.

You need to learn to avoid the magnetism of vibrant colours and begin to see world as a range of tones. With colours all around us catching our eye on a daily basis, the concept of removing them goes firmly against the grain.

And true, it's impossible to imagine the fabulously saturated month of May without that relieving burst of green, a bluebell or rapeseed field in sight. Yet the power of black and white can transport the mind elsewhere, like a visual side step, with an almost dreamlike effect. Remove colour and the mind is forced to make an artistic interpretation.

Although mono was once the only way of capturing and reproducing the busy world around us, it now remains in parallel with colour, rather than demoted to second best. Chic, classic, sensuous or timeless, whether it's landscapes, portraits, architecture or countless other subjects, over the following ten pages we reveal how black-and-white photography is capable of changing the way you appreciate and interpret your world. ▶

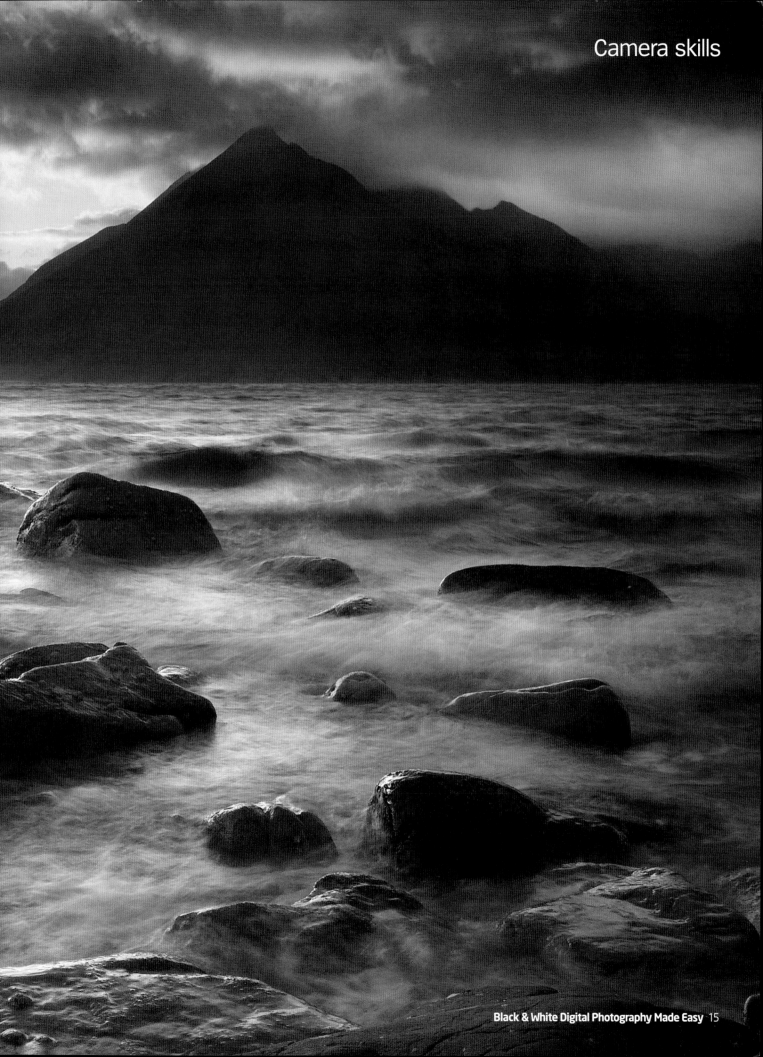

Why shoot black & white?

The best reason to convince yourself to make the positive step towards black and white is portfolio diversity. Good photographers are able to demonstrate their abilities at handling a variety of subject matters – and with different photographic mediums. Shooting successful black-and-white images will communicate your ability to diversify.

Although it can feel like an alien concept, saturated colours can actually become overwhelming. Mismatches in hues, whether its skies and clouds or skin and clothing, can conspire to pull the image downwards.

Although shooting certain subjects in black and white seems somewhat pointless, it is often surprising just how spectacular they can look.

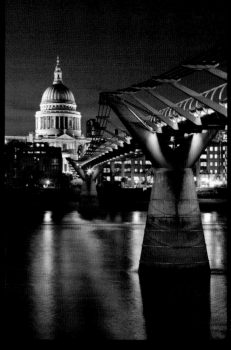

David Clapp

Convert from colour

Even with shots envisaged from the outset as being black and white, it's always best to shoot in colour and then convert to mono on your PC. Shooting in colour means that the image can be converted in a variety of ways, and as your Photoshop skills develop, you can revisit older images using new mono techniques – something you certainly cannot do if the original was shot using your camera's monochrome setting.

STEP BY STEP
Simple black-and-white conversion

How to use Photoshop's Black and White command to turn your colour shot into monochrome, and create a professional-looking conversion in the process

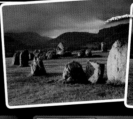

David Clapp

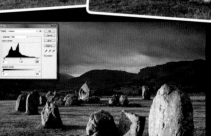

Convert to mono

1 Think about the colours that will respond well; the dawn light is made up of reds and yellows. Open the Black and White Filter (Image>Adjustments>BlackAndWhite) and hit the Auto button to see what the computer would make of it.

Tweak the sliders

2 Adjust the Yellow and Red sliders for an enhanced effect. As the slider value gets higher, so the brightness of these tones will increase. Make sure your slider play is not too excessive as this can introduce artefacts and excessive noise.

Ramp up the contrast

3 Once you are happy with the result, open up the Levels window (Image>Adjustments>Levels) and move the black and white points inwards to maximise contrast. This will add richness and depth to your black-and-white image.

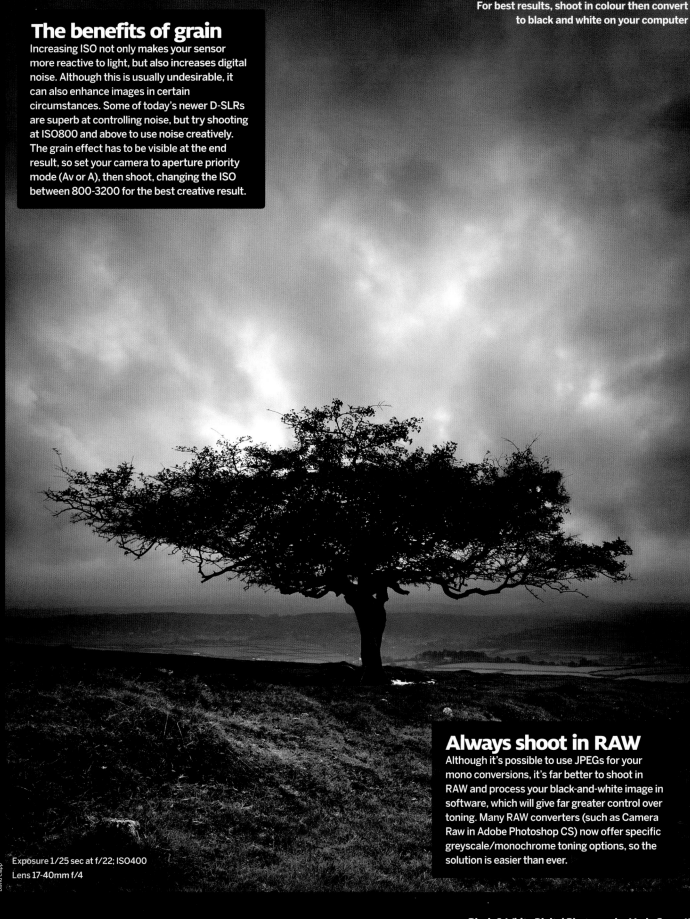

The benefits of grain

Increasing ISO not only makes your sensor
more reactive to light, but also increases digital
noise. Although this is usually undesirable, it
can also enhance images in certain
circumstances. Some of today's newer D-SLRs
are superb at controlling noise, but try shooting
at ISO800 and above to use noise creatively.
The grain effect has to be visible at the end
result, so set your camera to aperture priority
mode (Av or A), then shoot, changing the ISO
between 800-3200 for the best creative result.

Exposure 1/25 sec at f/22; ISO400
Lens 17-40mm f/4

David Clapp

Always shoot in RAW

Although it's possible to use JPEGs for your
mono conversions, it's far better to shoot in
RAW and process your black-and-white image in
software, which will give far greater control over
toning. Many RAW converters (such as Camera
Raw in Adobe Photoshop CS) now offer specific
greyscale/monochrome toning options, so the
solution is easier than ever.

Learn to see in mono

Exposure 1/2 sec at f/11; ISO100
Lens 24-105mm f/4

Developing an eye for black and white takes time. It is vital to look at the tonal range of the subject. Ideally, you want images with tones at the extreme ends of the contrast spectrum, such as frothy waves breaking against dark rocks, along with a range of midtones, such as those found in moody skies. Examine your pictures carefully to identify these sorts of attributes and this will give you a great head start.

Although some images, like waterfalls and rivers, contains brighter areas than their immediate surroundings, it is important to get some striking light into the scene for a boost in contrast. This seascape at Westcombe Bay in South Devon shows a very drab-looking colour palette, but with direct sunlight pushing the contrast, it creates all manner of feathery water textures and tones. Once converted to black and white, the effect is enhanced even further.

Shapes and texture

Look for shapes, textures and form alongside conventional contrast and tones. Composition and image content is a vital ingredient to the success of an image. Not all pictures have to contain intricate and complicated textures like this frenzy of lines inside this bank entrance, some can be very simple. Light falling on smooth surfaces, curves and bends can give subtle gradients that work magically. Look out for simplicity in architecture and shoot with a longer lens, like a 70-200mm telephoto zoom, to pick out details.

This flat-looking landscape shot is totally transformed with a mono conversion

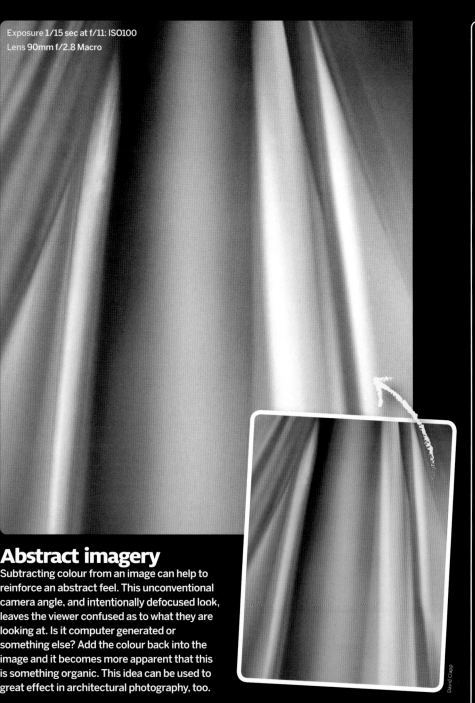

Exposure 1/15 sec at f/11: ISO100
Lens 90mm f/2.8 Macro

David Clapp

Abstract imagery

Subtracting colour from an image can help to reinforce an abstract feel. This unconventional camera angle, and intentionally defocused look, leaves the viewer confused as to what they are looking at. Is it computer generated or something else? Add the colour back into the image and it becomes more apparent that this is something organic. This idea can be used to great effect in architectural photography, too.

Beware of the shades of grey!

Colours, despite looking very different, can have the same tonal value in black and white. Look at this comparison for a good example. The green and brown squares look rather different in colour, but when desaturated to represent their tonal values, they are identical. Although this studio example does not represent the complexity of the world around us, it shows why some images do not convert well into mono.

Use Picture Styles to help

Some cameras have a monochrome Picture Style. Use this to get you into the black-and-white mindset, so that when you preview the image on your LCD you see the results in shades of grey. Take your shot in colour, though, as long as you're shooting in RAW, you'll still have the full-colour image to work with. Here's how to set it on a Canon EOS D-SLR...

Access Picture Styles

1 Engage your D-SLR's Picture Styles menu on the rear LCD by pressing the Info button. From here you will be able to see what Picture Style is being used.

Switch to Monochrome

2 Press the Picture Style button and then use the thumbwheel to navigate the cursor to the 'M' – for Monochrome – on the left-hand side.

Adjust the contrast

3 Play around with the parameters further, especially contrast slider, as this will give the image better tonal range and impact. ▶

Marvellous mono landscape shots

Landscapes provide limitless opportunities for black and white, simply because the subject can be so varied. From intricate details to the grand vista, it is surprising just how many choices there are in black and white. Again, seascapes are all about textures and tones, but with the coast providing many shooting situations that are devoid of seasonal change further inland, it's always rewarding to shoot mono in the great outdoors.

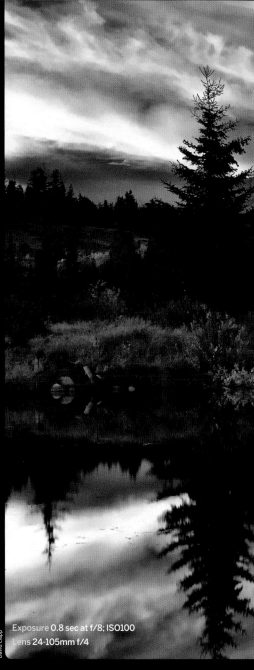

Exposure 0.8 sec at f/8; ISO100
Lens 24-105mm f/4

David Clapp

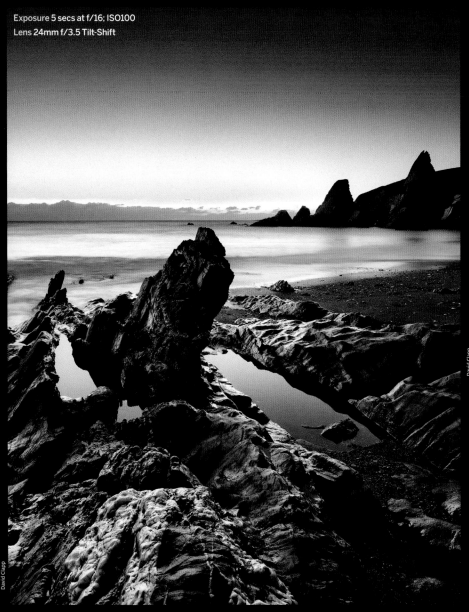

Exposure 5 secs at f/16; ISO100
Lens 24mm f/3.5 Tilt-Shift

David Clapp

Which subjects work best?

Coastal colours are often muted, so removing all of their colour isn't going to be a compromise. Look for rocky details, as the geology is often varied and full of surprises. Inland, a foggy morning can create all manner of opportunities in woodlands and moorland. In contrast, bold clouds over a summer wheat field can respond well, due to shapes and textures in abundance. Skies can be darkened by adjusting the blues, when converting your image, to provide a wonderful tonal range.

David Clapp

Which scenes don't work?

Saturated colours found in nature, like rapeseed fields and bluebell woodlands, don't respond well to black-and-white conversions. It seems like sacrilege to remove those glorious yellows and blues. Wildflowers do not respond well either; our minds are so used to associating them with colour, there is little point converting them.

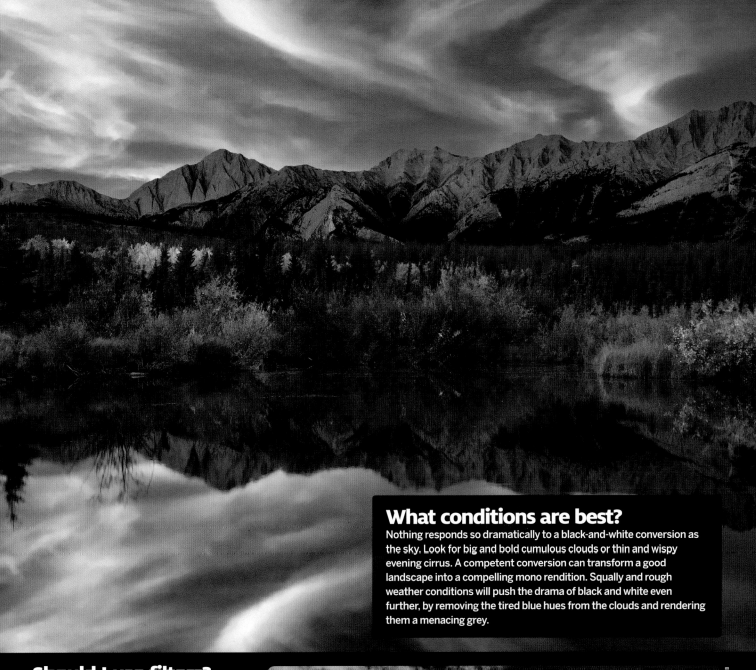

What conditions are best?

Nothing responds so dramatically to a black-and-white conversion as the sky. Look for big and bold cumulous clouds or thin and wispy evening cirrus. A competent conversion can transform a good landscape into a compelling mono rendition. Squally and rough weather conditions will push the drama of black and white even further, by removing the tired blue hues from the clouds and rendering them a menacing grey.

Should I use filters?

The great thing about shooting with modern D-SLRs is that there is no longer a need to carry coloured filters in your kit bag. With black-and-white film, coloured filters were used to boost and enhance tones and the contrast range between elements. In editing software, the sliders are your filters. Yet there is one very helpful tool that can help enrich your image: a polariser can really push the tonal range, but carefully does it, or the skies can go almost black and look unrealistic and unnatural.

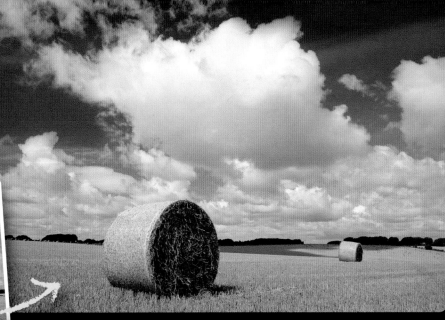

David Clapp

Go mono for punchy portraits

Peter Travers

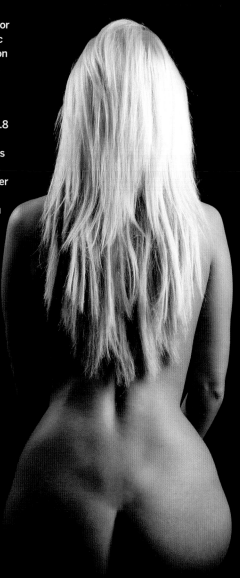

Although specialist portrait lenses can be expensive (an 85mm f/1.2 or f/1.4 lens is considered the classic for portraits) there are ways around this on a budget. If you are using a camera with a crop body, a 50mm standard lens has an effective focal length equivalent of 75-80mm, and is considerably cheaper.

Keep the apertures wide (between f/2.8 to f/5.6) to get a flattering out-of-focus background, but watch wider apertures as the focal plane is so thin that one eye can be in focus while the other is blurred. Wider apertures also mean that the shutter speeds are considerably higher, but if you are using natural lighting it's far better to mount the camera on a tripod.

Why do portraits work in mono?

Portraiture can be greatly enhanced with a competent mono conversion. Where clothing and hair colours can clash and distract from your subject's face, a black-and-white conversion can draw the eyes to their facial features instead. It's also a good way to smooth out facial skin tones. Nude photography is often shot in black and white too. Flesh tones can look pale and unappealing in colour, yet in mono the gradients and tones become far more sensuous as light falls across the body.

Peter Travers

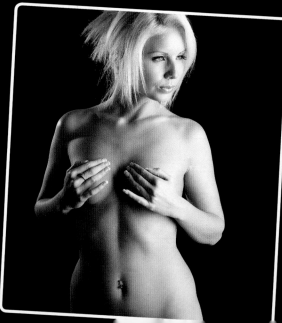

Backgrounds choice for mono

Portrait techniques called high-key and low-key use complimentary backgrounds to create specialist effects. High-key portraits offset the person against a white background, as though they are emerging from ethereal light, whereas low-key portraits use a black background, so the person steps out of the shadows, giving a moody and often powerful look – especially when used with fine art nude photography. Both can enhance the emotional content of a black-and-white image tenfold, and can emphasise something personable about the model's character.

Peter Travers

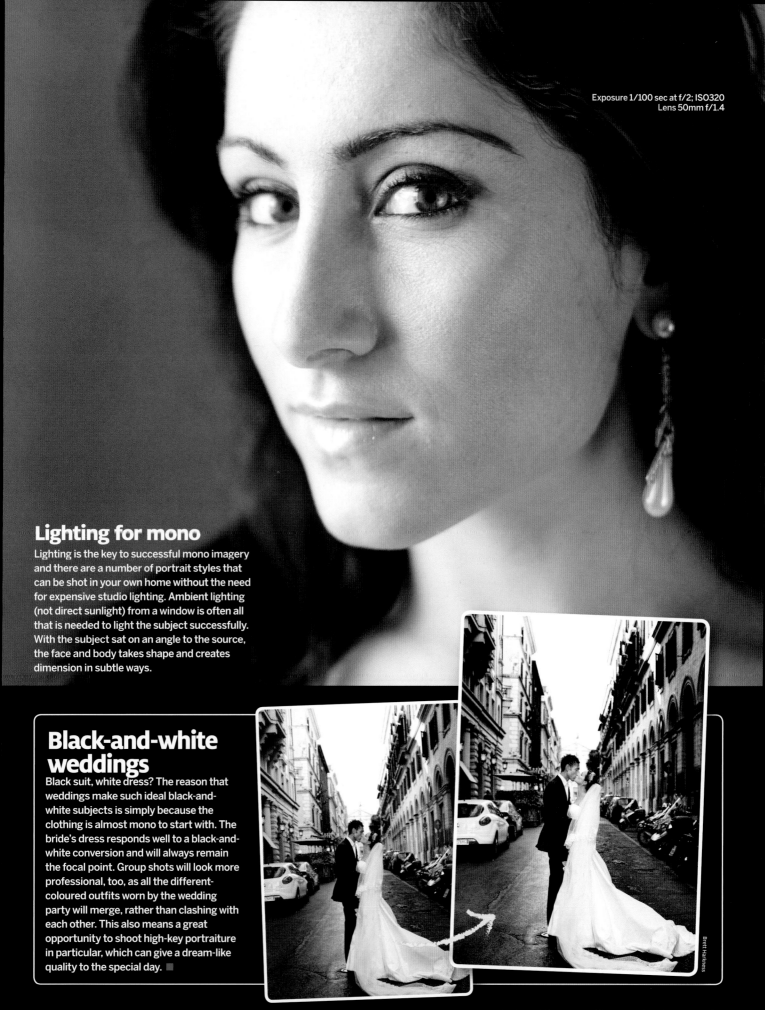

Exposure 1/100 sec at f/2; ISO320
Lens 50mm f/1.4

Lighting for mono

Lighting is the key to successful mono imagery and there are a number of portrait styles that can be shot in your own home without the need for expensive studio lighting. Ambient lighting (not direct sunlight) from a window is often all that is needed to light the subject successfully. With the subject sat on an angle to the source, the face and body takes shape and creates dimension in subtle ways.

Black-and-white weddings

Black suit, white dress? The reason that weddings make such ideal black-and-white subjects is simply because the clothing is almost mono to start with. The bride's dress responds well to a black-and-white conversion and will always remain the focal point. Group shots will look more professional, too, as all the different-coloured outfits worn by the wedding party will merge, rather than clashing with each other. This also means a great opportunity to shoot high-key portraiture in particular, which can give a dream-like quality to the special day. ■

Brett Harkness

Monochrome masterclass

From starting to see the world in monochrome through to the dark art of printing without colour, your comprehensive guide to black-and-white photography starts here

Without colour to hide behind, black-and-white photography has to rely on light, texture, tone, contrast and composition. For inspiration, start by looking at the work of masters like Ansel Adams and Henri Cartier-

Bresson – you'll find the drama comes from several simple elements that work together perfectly as a whole.

Black-and-white photography takes time to master, but everything you need is in this

guide. Follow it, and soon you'll be exploring new ways of seeing the world around you. And don't forget that if you take time to master the art of black and white, your colour pictures will benefit too...

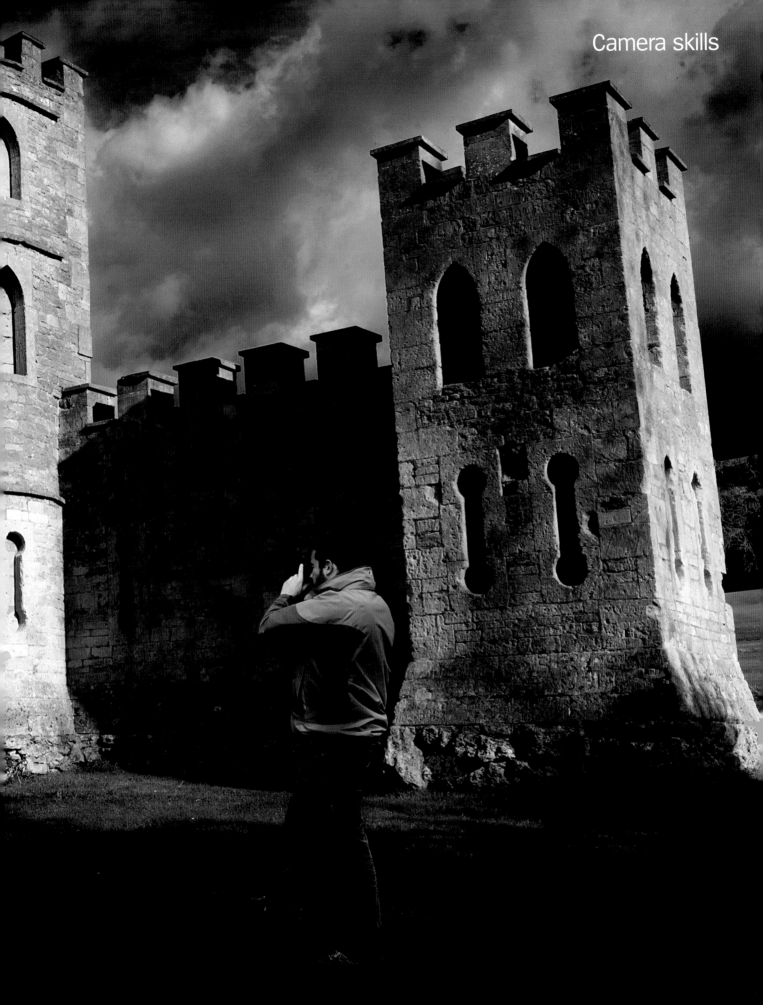

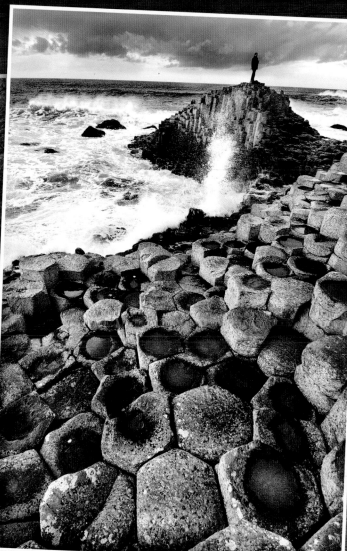

Andrea Thompson

Be inspired in black & white

Learn to see the world in a whole new light and unleash your creativity

Although relatively few people still shoot using traditional black-and-white film, black-and-white imaging still remains first choice among many digital photographers.

Part of the enduring appeal of monochrome is the timeless quality it produces. By removing the distraction of colour, black-and-white photographs communicate far more directly with the viewer, focusing attention and creating a visual intensity that's almost impossible to achieve in colour.

What's more, with turbo-charged image editors like Photoshop, you can exercise a degree of fine-control over the look of mono images that was virtually unheard of in the days of traditional darkroom development.

It's crucial to note that not every scene will translate well into black and white. The key is to learn how to see the world in blacks, whites and shades of grey. You can then start to enhance your compositions using secondary elements such as shape, texture, contrast, lighting and shadow – elements which you may have overlooked when shooting in colour.

Training your eye to interpret scenes successfully in terms of tone needs practice.

We think and see in colour and it's often the vibrancy and/or interplay between colours that first draws us to a subject. If you're not sure where to start, ask yourself whether your main subject would translate to a significantly different shade of grey to the background, or whether it's likely to blend in. Another good trick is to seek out subjects that are virtually mono already. You may also find it helpful to take a test shot using your camera's black-and-white mode, but, unless you're shooting RAW, always remember to switch back to full-colour mode before taking the real shot.

Give old pics a new lease of life

A great way to get a feel for the types of images that work best in mono is to have a go at converting some of your existing colour photos. In doing so you may be surprised to find that it's not always the liveliest-looking images with the punchiest colours that have the most potential to work as mono conversions. Remember, you're looking out for well-defined shapes, textures and grey tones rather than eye-popping colours.

So don't be too quick to dismiss some of the more mundane scenes in your collection that were perhaps shot on a rainy day, or that don't contain the most arresting subjects. Who knows – start work on that old shot of a graffiti-covered bus shelter, high-rise office block or bleak, overcast landscape and there may well be a mono masterpiece that's lurking inside...

Subjects that appear drab in colour can spring to life in black and white as shapes, patterns and textures are revealed

Andrea Thompson

Rescuing a shot

Occasionally a bungled colour shot that's headed for the trash can actually be rescued by converting it to black and white. For example, a badly overexposed shot might just work as an arty mono image that uses an extreme high-contrast effect to blend in the blown highlights. This technique might grate among photography purists who believe that using Photoshop tricks to disguise poor photographic technique is feeble and even deceptive. It's certainly not for everyone, but if you get a terrific creative result and you're up front about what you've done, why not? ▶

Ed Godden

Camera skills for mono

Give your photography the edge with our guide to setting your camera up for finest quality and finding the best mono subjects

Contrary to what some online photography 'gurus' might have you believe, shooting in black and white isn't as simple as switching your camera to Mono mode and then applying a few filters and effects in Photoshop. If you want killer black-and-white photos you need to set your camera up like a pro – and target the types of subjects and conditions that'll convert best to monochrome. Let's start with the right camera settings...

Camera settings

File format

1 For the best-quality mono conversions shoot in RAW. RAW files not only capture more data that JPEGs, but they can also withstand more fundamental mono image-editing techniques, such as dodging and burning. What's more, you get to fine-tune the sharpening, contrast, saturation and white balance in software instead of fixing these in-camera.

Black and white mode

2 If your camera has a black-and-white mode, switch it on while shooting RAW. This gives you a handy mono LCD preview, while keeping all your RAW colour data intact. If you shoot JPEG, avoid Mono mode because it limits your editing options.

ISO sensitivity

3 Unfortunately, the noise created by digital cameras at high ISOs doesn't quite have the same aesthetic quality as film grain, tending to muddy colours and degrade details rather than enhance images. It's better to keep your ISO down where possible – you can always add 'film grain' in software.

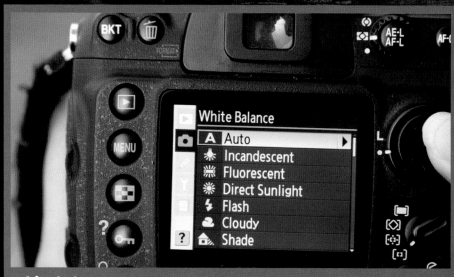

White balance

4 Colour casts affect mono conversions because they shift the grey tones onto which the colours are mapped. It's therefore important to ensure that your white balance is correct during shooting, although with RAW files you have the safety net of being able to correct white balance inaccuracies in your RAW software before converting to mono.

Exposure bracketing

5 The types of extreme lighting conditions that often make for great B&W shots are often the trickiest to meter for. To ensure you get at least one perfect exposure, bracket several exposures up to a stop either side of the metered exposure, either using exposure compensation or your camera's autobracketing feature.

Get it right in black and white

When you start out shooting black and white, consider the types of subject characteristics that will translate best

Pattern and shape

1 One of the simplest and most effective ways to add impact is to incorporate distinctive shapes and patterns. Between the hard, graphical shapes of the urban landscape, the sculptural contours of the human body and the remarkable patterns found in nature, you'll be spoilt for choice. Zoom in on details to create abstract images where shape and pattern reign supreme.

Texture

2 Surface textures that might otherwise be overlooked take on far greater significance, helping to convey all kinds of information about a subject. Think animal fur, wrinkled skin, weathered stone, rugged landscapes. Low-angled, direct lighting is best for accentuating surface textures: use it to heighten the three-dimensionality of subjects and give images a tactile quality.

High contrast

3 High-contrast scenes are popular with mono photographers because they instantly produce striking results. Use direct sidelighting or shoot subjects that are naturally light and dark. You can also mimic high-contrast conditions in Photoshop, though you risk blowing highlight detail. If blown highlights pose a problem during shooting, take a spot or partial meter reading directly from the highlights and bracket.

Low contrast

4 Although effective in many cases, high-contrast treatments won't suit every subject. For instance, you probably wouldn't want to give a young child a hard, high-contrast look. Instead, you may prefer to use softer, more delicate lighting and then reduce the contrast further in Photoshop. Similarly, a misty or foggy landscape might better suit a subtle, low-contrast treatment.

Mood

5 By restricting the tonal range of your composition to either the light end (high key) or dark end (low key) of the tonal spectrum you can influence the mood and message of your images. For example, you may choose predominantly light tones to give your shots a positive, airy, feminine feel; or mainly dark tones to create a harsh, foreboding, masculine mood.

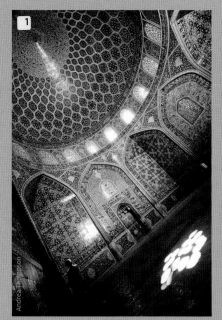

Andrea Thompson

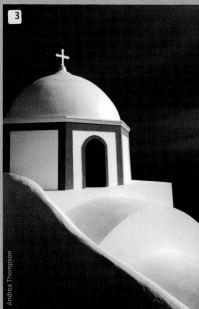

Andrea Thompson

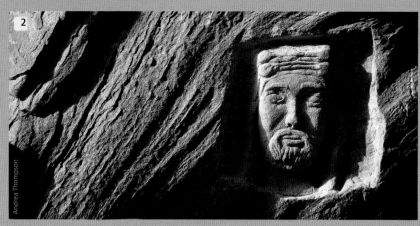

Andrea Thompson

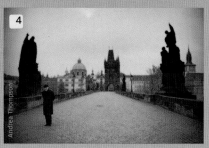

Andrea Thompson

Ed Godden

Filters for mono landscapes

You can replicate the tone-altering effects of traditional monochrome filters in Photoshop. It's impossible however, to truly replicate the effect of Graduated Neutral Density filters, so you'll still need to use these to balance scenes in which the sky is much lighter than the foreground. Polarisers are also useful for mono landscapes, helping to darken pale blue skies and make white clouds really stand out. ▶

How to go mono

Learn how to transform colour photos into powerful black and white images using our expert digital darkroom techniques...

Unless you're using your RAW converter to go B&W, to get the benefits you must first process your RAW images properly, optimising exposure, brightness and contrast and then saving as a colour TIFF. You can then perform your mono conversion in Photoshop using one of the options below. Sharpening can introduce artefacts and colour noise reduction can soften details, so these tweaks are best left until just before you save ready to print.

Photoshop's Black & White tool

There are several ways to convert to mono, but the Black & White tool, found in Photoshop CS3 and above, offers a simple, intuitive and flexible way of working. It works by letting you independently vary the luminance levels of eight individual colour ranges and thereby control their influence in the final conversion. It's best to use the Black & White tool in the form of a 'non-destructive' Adjustment Layer (Layer>NewAdjustmentLayer>Black&White) so that you can tweak the values later by double-clicking on the Adjustment Layer in the Layers palette.

WARNING!

Messing about with colour channels without restraint can quickly lead to serious image quality issues such as halos, blocking and noise. For this reason, it's vitally important to keep an eye on your image at 100 per cent magnification when you make changes.

Using the sliders

1 Dragging a colour slider makes its grey tones darker or brighter. The strip above the slider shows how light the tone will be.

Being more precise

2 Click within your image and drag to the right or the left to lighten or darken those tones. Click the Preset Options button to save your greyscale mix.

The Black & White conversion palette

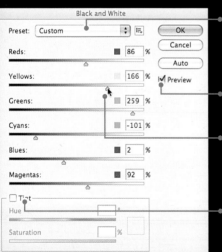

• Photoshop offers ten ready-made mono conversion recipes via the drop-down Preset menu.

• Uncheck the Preview box to reveal your image's original colouring.

• You can adjust the colour sliders manually or click-and-drag on the image to adjust the slider for a particular colour range.

• To add a pro-style tint click the Tint box, choose a colour via the Hue slider and set the intensity via the Saturation slider.

Elements' Black and White tool

To access Elements' Black and White tool, go to Enhance>ConvertToBlackAndWhite. Here you can select from a series of preset conversions, or try out the RGB sliders. ▶

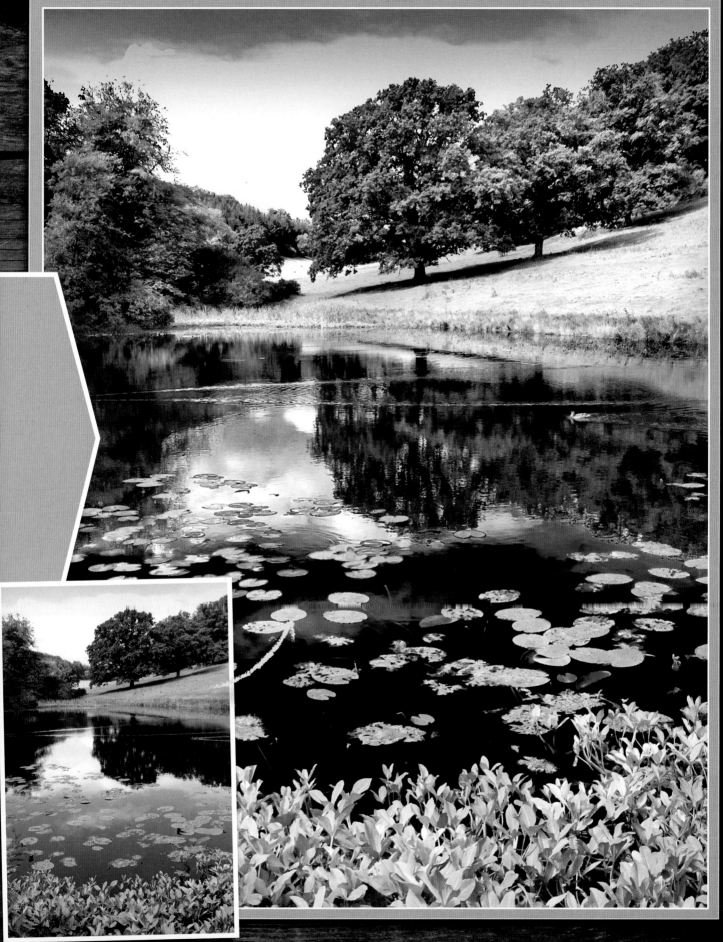

Alternative conversions
Which one suits you?

There are many ways to skin a cat in Photoshop, and converting to mono is no exception. Here we examine the eight popular methods

Greyscale

Simply changing the Mode of your image from colour to greyscale actually gives a pretty reasonable mono conversion. Click Image>Mode>Greyscale, then click OK when asked if you want to 'Discard colour information'. The problem is that you have zero control over the result. Switching to greyscale also blocks many adjustments and filters. If you're really pressed for time, though, this might be just the job.

✔ Reasonable results almost instantly
✘ No control over result

Lab Colour

Lab Colour is another quick and easy conversion technique. Again there's no control, but it does generate a particularly light, airy and smooth looking result that's well suited to delicate subjects and/or high-key or low-contrast treatments. Click Image>Mode>LabColour. Now click Window>Channels and click on the Lightness channel. To finish, choose Image>Mode>Greyscale and click OK.

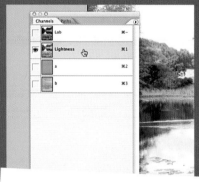

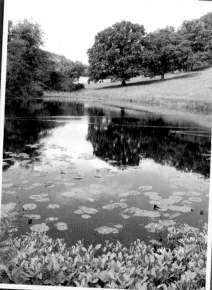

✔ Creates smooth, airy results quickly
✘ No control over result

Desaturation

Clicking Image>Adjustments>Desaturate is another quick way to convert to mono, but again you have zero control. Layer>NewAdjustmentLayer>Hue/Saturation provides much more control and more pleasing results. First drag the Saturation slider to -100, then use the drop-down Edit menu to selectively vary the Lightness of the Reds, Yellows, Greens, Cyans, Blues and Magentas to taste.

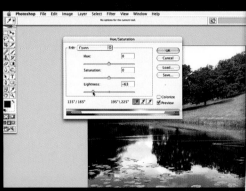

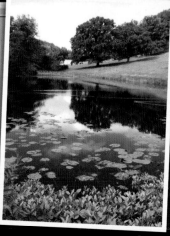

✔ Lightness control over individual channels
✘ Limited control compared with RAW

Calculations

Calculations (Image>Calculations) enables you blend two source channels to create a mono conversion. By default, the channels are set to Red and the Blending Mode to Multiply. For non-portrait shots, this set-up plus a reduction in Blending Mode Opacity will usually produce the best results.

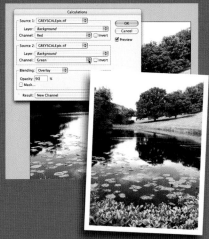

✔ Quickly creates dramatic results
✘ Limited conversion settings

Channel Mixer

The Channel Mixer is the most flexible way for earlier versions of Photoshop, allowing precise blending of the Red, Green and Blue channels to create a wide variety of mono effects. Choose Layer>NewAdjustmentLayer>Channel Mixer. Check the Monochrome box and vary the Source channels, keeping the overall percentage total to around 100.

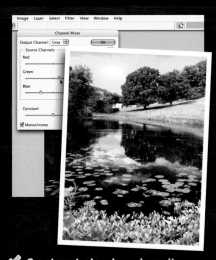

✔ Great control and good results
✘ Requires time and experimentation

Gradient Map

For harder, high-contrast results, try the Gradient Map tool. Click Layer>New AdjustmentLayer>GradientMap and click OK. Set your Foreground Colour in the Tools palette to Black, choose the Foreground to Background gradient and click OK. Refine the contrast by dragging the Colour Stop and Smoothness sliders.

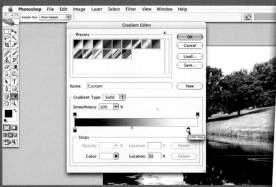
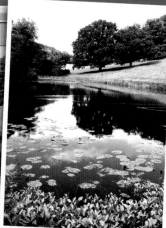

✔ Punchy results and fine-tuning available
✘ Best for mid to high contrast subjects only

Adobe Camera Raw: HSL/Greyscale

The Camera Raw HSL/Greyscale tab offers an effective method for converting RAW images to mono. Once you've primed your shot using the standard Camera Raw controls, click the HSL/Greyscale tab and choose Convert to Greyscale. You can then separate and enhance the individual tones using eight Greyscale Mix colour controls,

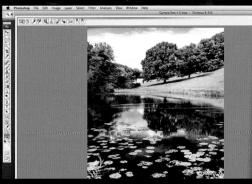
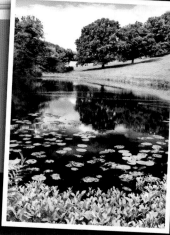

✔ Offers vast array of controls and effects
✘ Changes must be applied to entire image

Plug-ins

You can re-create in Photoshop virtually all of the effects offered by third-party plug-ins, such as 'Film Grain' by Power Retouche. For example, you could track down grainy traditional 35mm films, scan them in and turn them into mono grain filters. For those without the time or inclination to do this, dedicated plug-ins can be used. ▶

✔ Extensive new controls and effects
✘ Quality plug-ins don't come cheap

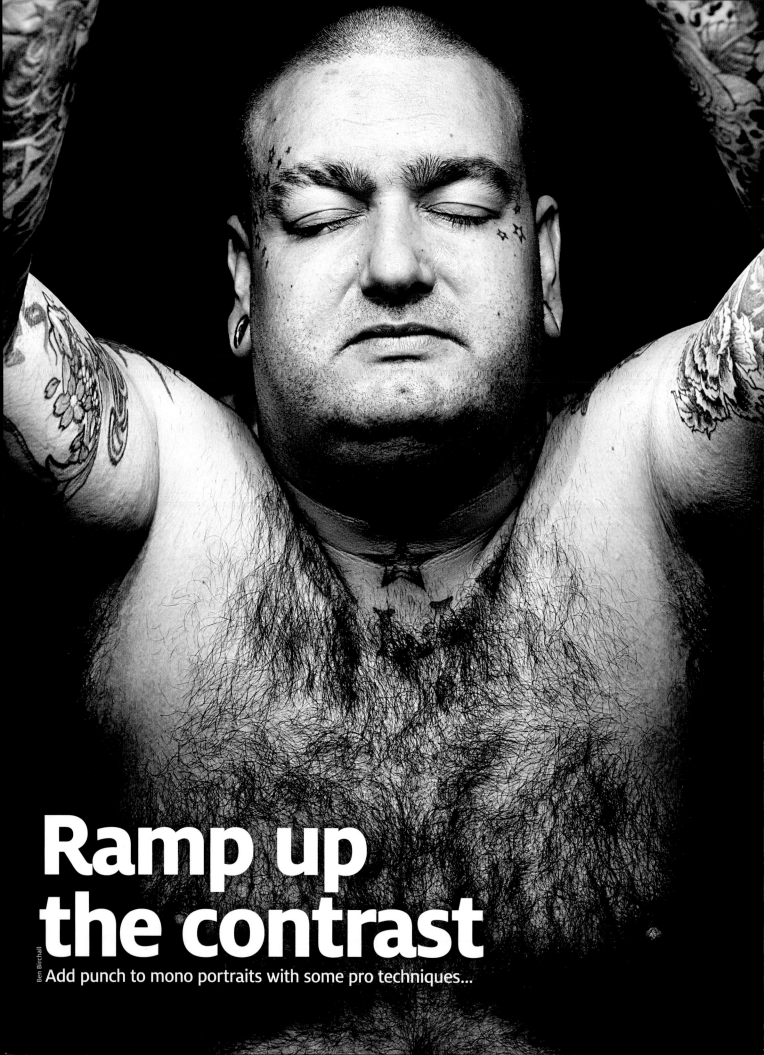

Ramp up the contrast

Ben Birchall

Add punch to mono portraits with some pro techniques...

When it comes to shooting black and white portraits you should approach it in the same technical way as when shooting in colour: eyes in sharp focus, good exposure of the skin and a clean, uncluttered backdrop.

It's the tonal range of your subject matter that you have to think more about. If there's not much contrast as you look through the viewfinder then don't expect much in the darkroom when you hit 'Greyscale', although, of course, careful processing can boost contrast between certain colours.

So what camera settings and gear will help? As always, shoot in RAW so you have a good 'negative' to work with in the digital darkroom. A standard to long focal length for 'normal' portraits, somewhere between 50mm and 200mm and a wide-angle for something a little 'funkier'. Wide apertures, such as f/2.8 to throw out backgrounds and accurate Spot or Centre-weighted metering with Aperture Priority exposure mode will see you get some killer shots.

Why it works

The symmetry, high-contrast lighting and fantastic subject matter of our model, Sumo, provides a great mono canvas.

Lighting
High-contrast lighting creates shadows that sculpt and pick out natural features, for impact without colour

Detail
Tattoos give the image detail around the whole frame as the black ink on white skin creates a striking contrast

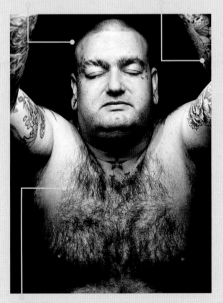

Texture
It may sound grizzly, but his body hair lends more texture to the shot, creating a sense of depth and detail to the overall shot

Outdoor portraits

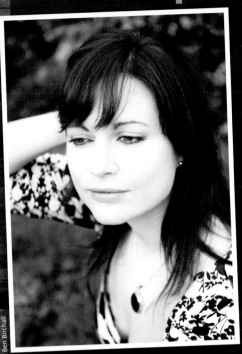

Ben Birchall

An uncluttered, but textured background and all the focus on the face, skin and eyes

Shooting black-and-white portraits outdoors with a reflector will produce very smooth skin tones. Your model will thank you, especially if you overexpose the skin slightly, for a fresh, youthful and wrinkle-free look.

For three-quarter portraits, get your model to hold the reflector and zoom into their face to meter, giving about half a stop overexposure to brighten the skin. Lock the exposure in Aperture Priority mode and use a wide aperture to ensure the background is thrown out of focus.

A dark, uncluttered background is the hardest part of outdoor mono. Finding a slightly textured dark background will give a great contrast to your brightly lit model and work much better on a print to make your subject spring out of the dark frame.

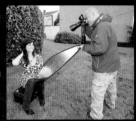

Get your model to hold the reflector and help them to get the most light on their face

Indoor portraits

Portraits shot indoors near a window will produce results that have plenty of mood. Depending on how strong the light is you can get effects ranging from super contrasty, with just one half of the face lit, through to a softer low-key style with plenty of shadows.

The technique is to get your subject near a window and switch to spot metering on your camera. Take a reading from a light part of their face, but not from the brightest highlight. Somewhere around the lower cheek or eyes is best. Select the widest aperture you have, as light levels can be low, and make sure the shutter speed is fast enough for hand-holding the lens – around 1/60 sec if you're shooting at 50mm.

Don't forget to switch off any ambient lighting to avoid colour casts and de-clutter the background. ▶

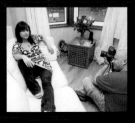

Move the sofa next to the window to get your model comfy and capture most light

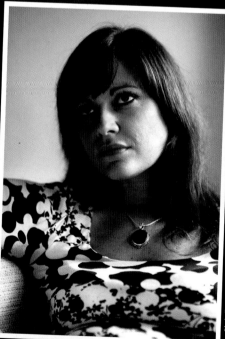

Ben Birchall

Natural light falling on your subject from one side creates a mysterious feel

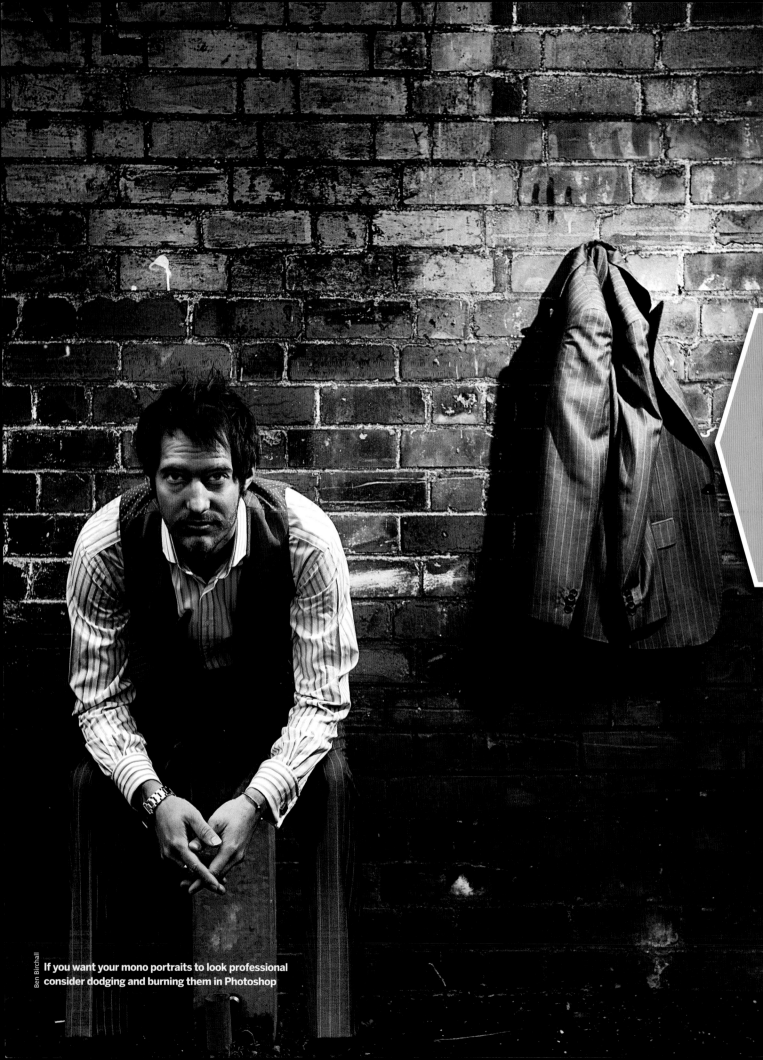

Ben Birchall

If you want your mono portraits to look professional consider dodging and burning them in Photoshop

Dodge & burn

Want to make your portraits stand out from the crowd? Dodging and burning is the answer

Good-quality dodging and burning of traditional black-and-white prints is the secret weapon of any master printer, and in this digital age why should things be any different? Always finish off your mono portraits with a touch of dodging and burning. Don't think of it as a rescue for poor exposure, but approach it with a view to enhancing lighting and adding extra impact.

Remember that your digital images will suffer from pixel degradation if you overdo the traditional dodge and burn tools so make sure you use Adjustment Layers to add your dodging and burning effects. There are plenty of methods out there, but for a non-destructive effect use our grey Fill Layer method, below...

Do it the right way with a grey Fill Layer

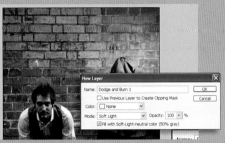

Create a grey Layer

1 Click Layer>New Layer. Choose Soft Light from the Mode menu and check Fill with Soft-Light-neutral colour (50% grey).

Select the Brush Tool

2 Select the grey Layer and choose an appropriate sized and feathery Brush (B) tool with 'normal' blending.

Start painting

3 Use black to burn and white to dodge. Switch brushes with X. Change Opacity for a weaker or stronger effect.

How we added impact

Midtones
This was shot to preserve midtones in the brickwork and clothing as the main contrast is provided by the face, shirt and jacket. The midtones in the bricks were deepened and the highlights brightened using the Dodge and Burn tools.

Highlights
A Curves Adjustment Layer was used to brighten the highlights across the whole image, then black was painted on the layer where the highlights were clipped.

Shadows
The natural shadows are mainly around the model, jacket and ground. True 100% black shadows were left alone and the shadows around the jacket, brickwork and floor were darkened using a grey Fill Layer.

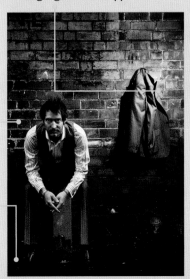

Alternative methods

Here are two other ways to dodge and burn images. Remember the golden rule of enhancing the existing lighting, so no dodging shadows to lighten them or burning in clipped highlights! ▶

Level Layers

1 Create two Levels Adjustment Layers: one for highlights and one for shadows. Adjust the Levels slider to darken the shadows on the shadow layer, then use a black brush to paint back in highlights. Repeat for the highlights layer.

✔ **Greater contrast control and organic looking**

✘ **Can be a convoluted process and easily overdone**

Colour Range

2 Click Select>ColourRange and choose Highlights from the Select drop-down menu. Hit OK and feather the selection before adjusting the Levels to brighten it. Repeat for the shadows, making them darker.

✔ **Fast and simple without any brushwork**

✘ **Can create harsh edges and is destructive**

Add a fine art feel

Transform your landscapes into minimalist monochrome masterpieces

Shooting in black and white and stripping back your pictures to just a few elements enables you to really focus on what's important in a shot. Without colour to help carry the shot, you have to rely on your 'eye' to make your pictures count; and keeping things pared down and simple can create a more abstract, much more intimate feel to your images.

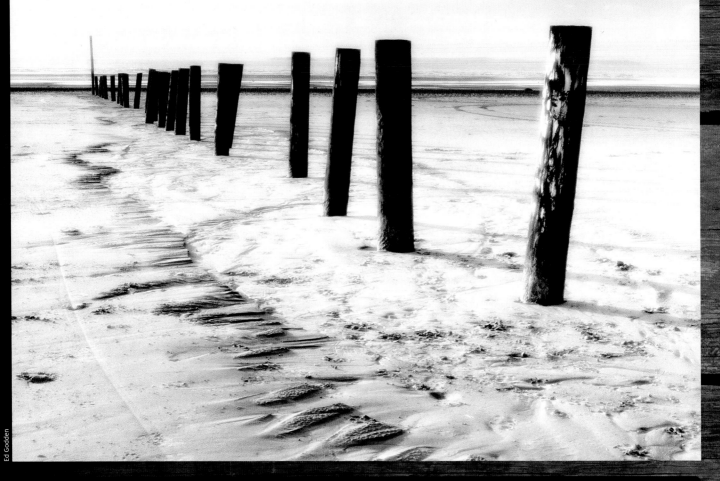

Ed Godden

What makes a good B&W minimalist landscape image?

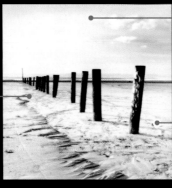

Composition
When you're dealing with minimalist landscape shots, look for a balance of elements – an odd number of points of interest tends to work better than an even number.

Artistic treatment
Shoot with a black and white conversion in mind for the best results. Enhance the mood of the shot by toning it and adding a border. An image can jump off a page with these finishing touches.

Square crop
Instant class! Square pictures have a simplicity and tranquillity that you should make the most of. The symmetry of the square also gives them a pleasing solidity.

How to spot your scene...

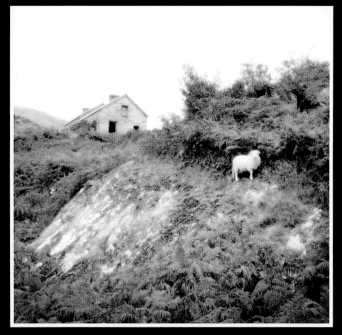

Create depth

By positioning the building in the far distance, the image's main point of interest is in the background. The eye is drawn through the image to the building, the derelict wall in the foreground giving a sense of depth.

Look for balance

This image has three main points of interest: the derelict cottage that provides shape and form on the horizon; the glimmers of white shining through from the hill; and the lone sheep. Three is the magic number!

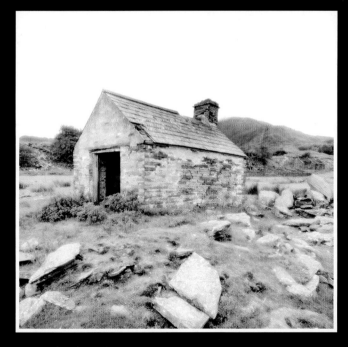

Ed Godden

Keep it simple

Sometimes it can be too easy to miss the perfect shot because of a scene's simplicity. But keeping it simple is often the best policy. In this shot, the building dominates the frame, but there's also plenty of foreground and background interest.

Use natural props

Finding rustic objects can really boost the impact of a mono image. They may not look that interesting when you first come across them, but try to imagine how they'll appear in black and white. Tones and textures can really make a shot. ▶

Training your eye...

Finding a shot within a scene

How to spot minimalist mono abstracts in the wider landscape

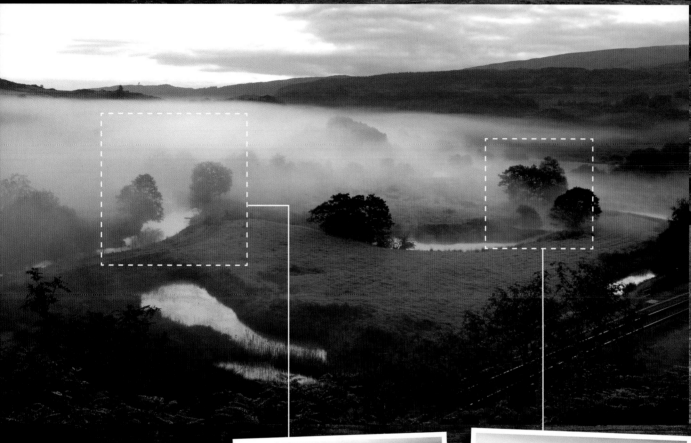

It can initially seem rather daunting trying to train your eye to see a landscape shot in black and white. It's important to look out for simple, balanced shapes that will sit well within an image. The trick is to give yourself plenty of time to just stand and look around. Don't set up your tripod too early as you may find yourself rooted to the spot; instead, fix a telephoto zoom to your camera and move around a location, zooming in to isolate elements that you find the most interesting.

We came across this scene in North Wales early one morning at 6.15am on a dawn shoot, only to discover that there were a number of possible minimal landscape opportunities within it. By positioning ourselves nice and high above the valley, we were able to get a good look around and enjoyed 15 minutes or so of shooting as the sun rose and the mist began to lift. We used a 70-200mm lens and shot away without a tripod – we had to move fast because the sun was coming up and the moody, misty atmosphere was disappearing rapidly.

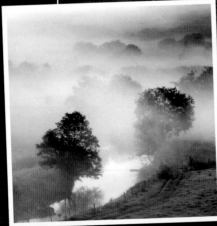

Balancing act

The first thing that stood out for us was the number of trees in the valley. As the mist lifted, the trees in the foreground appeared dark, contrasting well with the ones in the background that were still shrouded in mist and rendered much lighter.

Frame the scene

As the mist lifted further, the river sweeping through the valley suddenly became more prominent and we used the trees surrounding it as a natural frame. The ghostly reflections in the water and the trees poking through the mist in the distance add to the atmosphere.

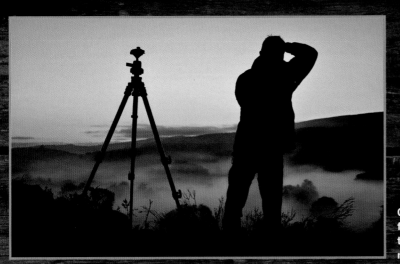

Go handheld from the tripod for more freedom

How to...
Work up the shot in Photoshop

Use quick selections to boost the impact of your monochrome minimal landscapes

Converting your images from colour to mono can sometimes leave your once-striking landscapes looking flat. This can be because colour and exposure in different areas of an image need different adjustments to boost their tone and detail. In this tutorial, find out how some quick tricks can add more impact to your shots...

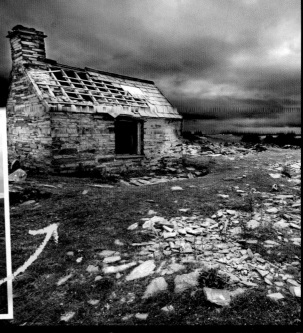

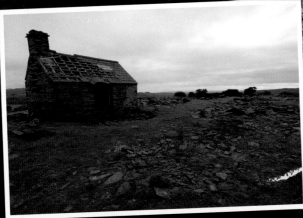

Convert to black and white

1 Crop the image square, create a Hue/Saturation Adjustment Layer and set Saturation to -100. Duplicate the 'Background' layer.

Select the sky

2 Use the Quick Selection Brush to select the sky. Create a Levels Adjustment Layer and duplicate it. Ctrl+click on Mask and Invert. Adjust Levels for both Layers.

Dodge and burn

3 Use B&W brushes on the Layer Masks to blend the Layers. Alt-click New Layer, select Soft Light and Fill 50% grey. Use this Layer to dodge and burn.

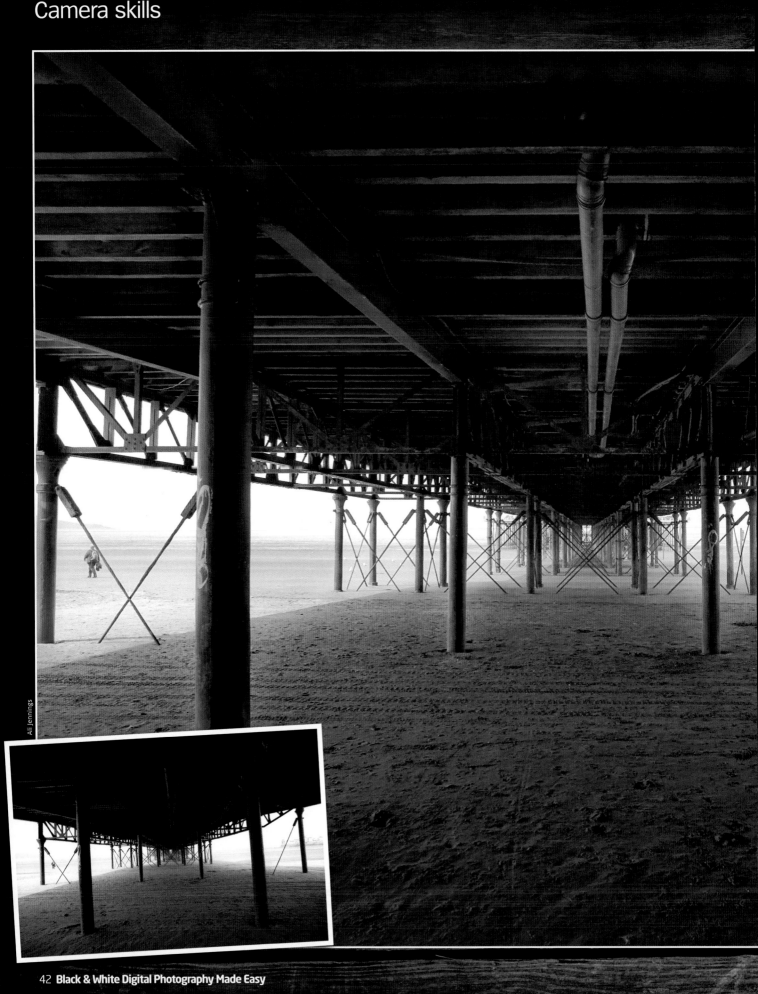

Ali Jennings

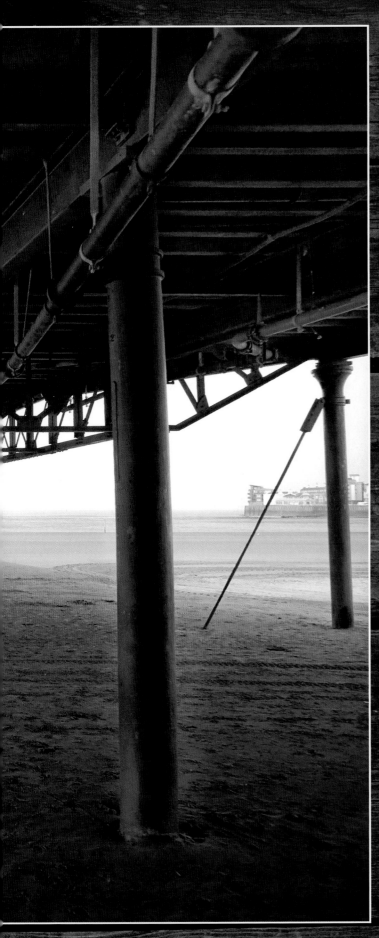

Create classic toning effects

Classic techniques to spice up mono shots

WHAT YOU'LL NEED Photoshop CS/Elements
WHAT YOU'LL LEARN How to use the Hue/Saturation command, use Solid Fill Layers for toning and Split Tone in Adobe Camera Raw
IT ONLY TAKES 45 minutes

Toning black and white images gives them more warmth and atmosphere, or even imbues them with an old-world charm. We're going to demonstrate three different ways to do this. These are split toning – where you apply one tint to the highlights and another to the shadows – and a couple of Elements techniques for reproducing the antique hues of old tintype images and the cool blue feel of cyanotypes. All of the processes achieve the same aim of adding a hint of colour to monochromes. Choose your start image carefully as these techniques suit photos that have a classic, timeless quality.

Quick and easy
Split toning

After converting your image to black and white in Camera Raw, click on the Split Toning tab. Increase the Highlights Saturation slider to around 30 and choose your Highlight colour with the Hue slider. Repeat this for the Shadows, choosing a darker colour. Adjust the saturation of each colour to taste. Use the Balance slider to make one colour more dominant than the other. ▶

How to...
Create a Cyanotype

Give your mono shots a cool blue tone by recreating this classic Cyanotype effect

To create your cyanotype image you first need to convert the photo to black and white. Next, within the Hue/Saturation dialog you can choose the appropriate blue tone and adjust its intensity. You can always return to the black and white 'Background' layer if you want to make further adjustments to the image.

Convert to Black and White

1 Go to Enhance>Convert to Black and White. Choose a preset or adjust the individual channels, before clicking OK. Add a slight vignette by going to Filter>CorrectCameraDistortion, drag the Vignette Amount slider to -100 and click OK.

Hue/Saturation Layer

2 Go to Layer>NewAdjustmentLayer>Hue/ Saturation. Check the Colourise box and drag the Hue slider to around 198 for a cool blue. Now adjust the Saturation slider to tweak the strength of the tint.

How to...
Create a Tintype

Turn back time and give your shots a rich, warm finish using a simple blending trick

Again, the key to this technique relies on first creating a black-and-white image. We'll use a Solid Fill Layer for the Tintype toning effect, setting its Blending Mode to Colour in the Layers palette. One of the advantages of this technique is that you can control the intensity of the tint by adjusting the Opacity of the Solid Fill Layer.

Solid Fill Layer

1 On the Background Layer, use Convert to Black and White to create a fairly high contrast monochrome image. Go to Layer>New FillLayer>SolidColour. Choose a deep sepia brown from the Colour Picker. In the Layers palette, set the Blending Mode to Colour.

Curves adjustment

2 Return to the 'Background' layer and go to Enhance>AdjustColour>Adjust ColourCurves. Darken the shadows by dragging the slider right. Reduce Midtone Brightness a little. Go to Filter>Correct CameraDistortion and add a vignette.

Add a classic border

The Canvas Size command is all you need for a super-fast way to create a classic frame

WHAT YOU'LL NEED Photoshop CS/Elements
WHAT YOU'LL LEARN How to use the Canvas Size dialog. How to add a key line and a classic border
IT ONLY TAKES 15 minutes

There are many ways to create classic plain borders and key lines in Photoshop Elements, but this has to be one of the quickest. Via the Canvas Size command, you can add both a key line and a surrounding border, and specify the width of these by either exact measurements or as a percentage of the existing image dimensions. Choosing colour for your lines and borders is as simple as choosing an option from the Canvas Extension Colour box.

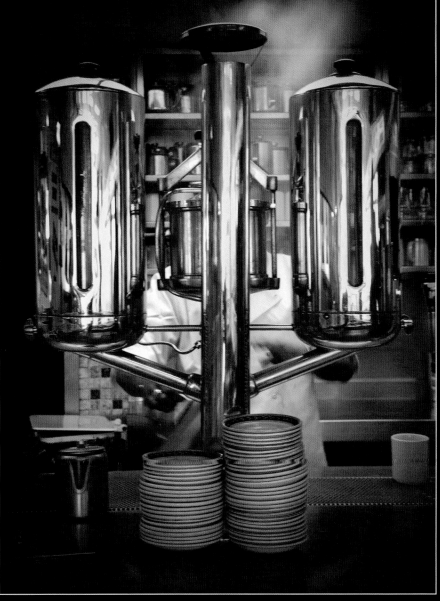

Lucy Sparrow

Measurement units

1 Go to Image>Resize>Canvas Size. Make sure you check the Relative box. Choose your desired measurement units to increase your canvas size by clicking one of the boxes next to either the height or width dimension.

Add a key line

2 We want the white key line. Enter 10 for both the height and the width. Click in the Canvas Extension Colour box and choose White. You could also use your current foreground colour for the line by choosing Foreground Colour.

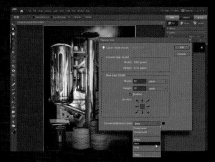

Adding the border

3 Return to Image>Resize>Canvas Size. Check the Relative box and choose Centre for the anchor. Choosing Pixels for units, enter a bigger value in the boxes and choose Black for Canvas Extension Colour.

Perfect mono prints

Less than pleased with your black and white prints? Follow our guide to master this dark art

Printing mono prints at home should be fun and creative, but it's all too easy to sit by your printer watching endless sheets of wasted paper and expensive ink spewing out. However, it's simple to get consistent and fantastic looking black-and-white results with the gear that's in front of you, rather than blowing your budget upgrading your printer and monitor.

Leaving aside the dots per inch quality of your home printer, problems usually arise due to a combination of monitor calibration, inks and paper. What you see on screen can't be replicated faithfully because the emitted light image on a monitor is capable of producing many more shades and tones than the reflected light from prints.

Another factor that affects the look of your mono prints is using colour ink to create black and white images. Colour inks produce the finest quality dots, but result in slightly green or magenta-washed photos. You can use the black cartridge only for a more faithful reproduction, but the trade-off is grainier prints.

If money is no object for you then there's a wealth of dedicated black and white printers, inks and papers on the market. However, in these cash-strapped times, getting the best results from the equipment you have isn't only prudent, it's deeply satisfying. Also, the level of experimentation that's involved means you'll be creating something original and unique to you.

Inks

You have two basic choices: manufacturer or third-party brands. Manufacturer inks tend to be more consistent print-by-print and better quality, but can be expensive. Third-party inks are often cheaper and can produce great results if you're prepared to experiment.

Paper

There are so many paper types, brands and shades of white on the market. Carrying out a test is key to finding a brand that suits you, but heavyweight papers generally produce better quality prints. Store your paper in a dark, clean and moisture-free environment, and load one sheet at a time when printing.

Ben Birchall

Working area

An often-overlooked aspect of printing is the dusty, coffee cup cluttered work area. Choose an airy, neutral coloured room that has adequate daylight for viewing prints, yet can also be shaded for editing work. Keep the area tidy, dust-free and avoid putting your monitor near bright windows.

Greyscale wedge

This is your ticket to superb black and white prints. A greyscale wedge will help you transpose the tones you see on your monitor to what is eventually printed on paper. You'll need one for every paper and ink combination you use. Follow our guide as we show you how to create and use wedges technically and creatively.

Quick and easy mono profiling

Often it's the shadow detail in mono prints that suffers the most, because when the ink output gets above 85% it all bleeds into a muggy mess. But that's easily taken care of by using a greyscale wedge to create an Adjustment Curve. This can then be applied before printing to provide the best ink coverage. It's not an all-out cure, but it should ensure better print consistency.

Print and scan

1 Open the 'Greyscale wedge' file on the disk and, using colour ink, print it onto photo paper using the Best Quality setting. Leave it overnight to dry, then scan the wedge at a resolution of roughly 600ppi.

Make adjustments

2 Open the scan in Photoshop and click Image>Mode>Greyscale. To enable even sampling, click Filter>Blur>Gaussian blur and set a Radius of 8 pixels. Select the Eyedropper tool and ensure the Info tab is visible.

Sample the wedge

3 Get the print out. Run the Eyedropper around each wedge centre and note a few values of the Actual Colour – the percentage next to K – in the Info tab, writing the averages in the Sample Value box. ▶

Camera skills

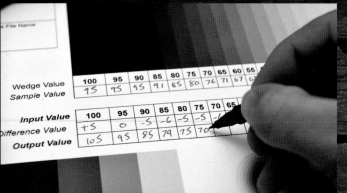

Adding up

4 The difference between the Wedge Value and the Sampled Value is found by subtracting the Sampled Value from the Wedge Value. Jot the results down in the Difference Value box, including a plus or minus symbol. Now subtract or add (depending on the symbol) the Input Value and the Difference Value to work out the Output Value for your Curve.

True black

5 Open the Curves box in Photoshop with Ctrl+M and click on the top right-hand point with an Input and Output Value of 100. You may find that your Output Value is above 100 and the Curves dialog won't let you enter this number. If this is the case either leave it at 100 or enter your Sample Value in the Input box to get a deeper black.

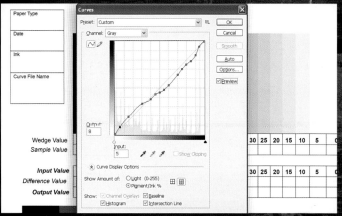

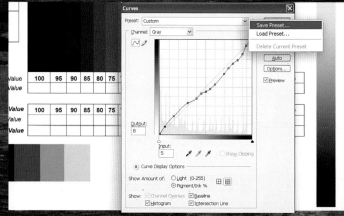

Curve adjustments

6 Work your way down the Curve from 95 to 30, altering the values as you go. When you hit 30 there won't be any more points available to adjust. The Curve is fairly accurate at this point, but if you need to make any further adjustments you can take away points that are close to each other on the Curve by dragging them off-screen.

Save profile

7 To save the Curve, click on the Options button next to the Curve Preset at the top of the box and select Save Preset. As this Curve only gives accurate results for the paper stock, ink manufacturer and printer settings used to print the greyscale wedge, name the saved Curve so that it can be identified and referenced to the printed wedge.

Test print

8 Close the scanned wedge file and make the original wedge active again. Apply your Curve by clicking Layer>NewAdjustmentLayer> Curves and select Load As from the Preset drop-down menu. Print the adjusted greyscale wedge and compare it to the unadjusted one. You'll see better separation between the sections and finer tonal gradation.

Tweak the Curve

9 For better results, let that print dry, scan it and try re-sampling any problem sections. You can even create another Curve for stubborn areas, such as deep shadows. You'll use lots of ink and paper, but tweaking the points on your Curve to get the best looking separation by eye is the best way to finish off this technique.

Your Greyscale wedge questions answered!

We provide simple solutions to demystify your wedge woes

Q I'm struggling to separate 100% true black from 95%. Are you sure that this can be done with my setup?

A This is a common problem and it can be solved by having one Curve for the overall image, then applying an Adjustment Curve for the deep shadow, but be aware that if you're printing with colour inks this can introduce a colour cast.

Q The image looks good on-screen, until I apply the Curve and then it looks awful! What's going on?

A You've changed the pixel values to what you want to see on paper, rather than printing the screen values, which your printer can't handle. Just trust your print.

Q How come I've scanned the corrected Greyscale wedge, but when I sample the values of each section they don't match up?

A It would be almost impossible to get a perfect wedge with a basic home setup. This method is designed to get you as close as possible to the best results. As long as the printed wedge and your test prints look good, even if some sections are 3 or 4% out, you've done the job correctly.

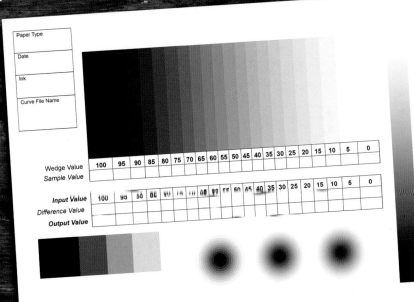

Has the dog eaten your disc?

Here's how to create your own greyscale wedge in Photoshop. It's can be done in other editing software too, but if you don't have a Posterize command just create 20 separate blocks, with ink values ranging from 5% to 100% in 5% increments.

Marquee
1 Create a greyscale image at around 300ppi and the size of an A4 sheet. Select the Marquee tool and draw a wide rectangle onto the blank document.

Gradient
2 Click the Gradient tool and select the black-to-white gradient. Drag it from one side of the box to the other while holding down the Shift key to keep the gradient level.

Posterize
3 To create the wedge, click Image> Adjustments>Posterize and enter 21 in the dialog box. This creates 20 even shades of grey, ranging from 5 to 100% black.

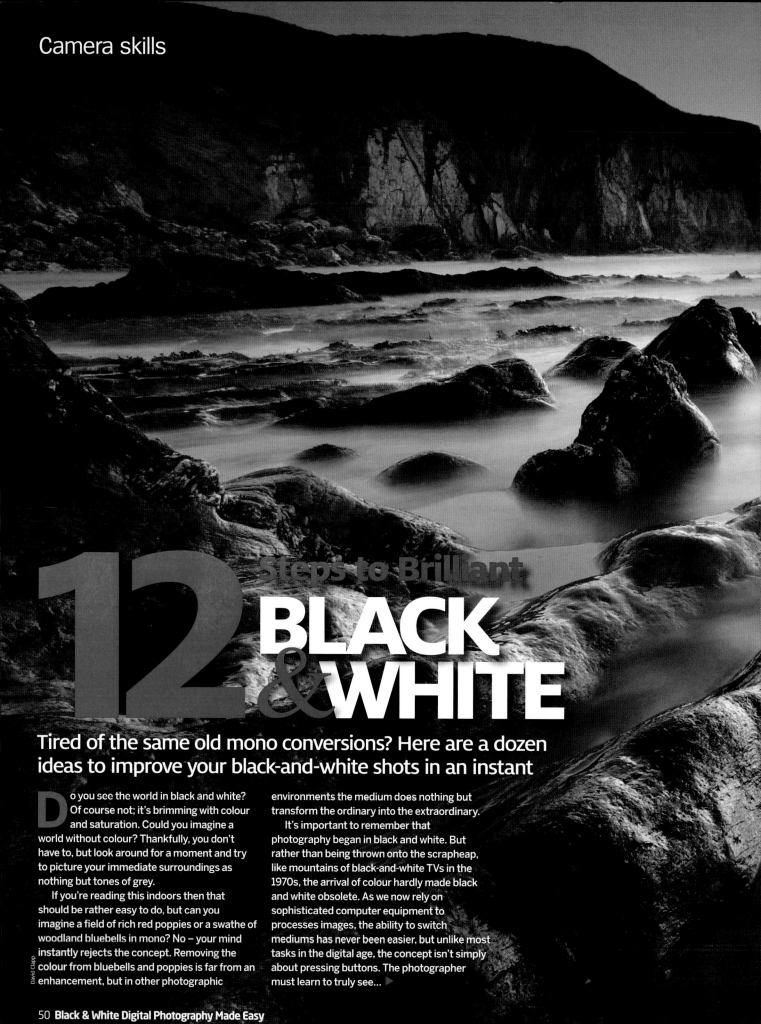

12 Steps to Brilliant BLACK & WHITE

Tired of the same old mono conversions? Here are a dozen ideas to improve your black-and-white shots in an instant

Do you see the world in black and white? Of course not; it's brimming with colour and saturation. Could you imagine a world without colour? Thankfully, you don't have to, but look around for a moment and try to picture your immediate surroundings as nothing but tones of grey.

If you're reading this indoors then that should be rather easy to do, but can you imagine a field of rich red poppies or a swathe of woodland bluebells in mono? No – your mind instantly rejects the concept. Removing the colour from bluebells and poppies is far from an enhancement, but in other photographic environments the medium does nothing but transform the ordinary into the extraordinary.

It's important to remember that photography began in black and white. But rather than being thrown onto the scrapheap, like mountains of black-and-white TVs in the 1970s, the arrival of colour hardly made black and white obsolete. As we now rely on sophisticated computer equipment to processes images, the ability to switch mediums has never been easier, but unlike most tasks in the digital age, the concept isn't simply about pressing buttons. The photographer must learn to truly see... ▶

David Clapp

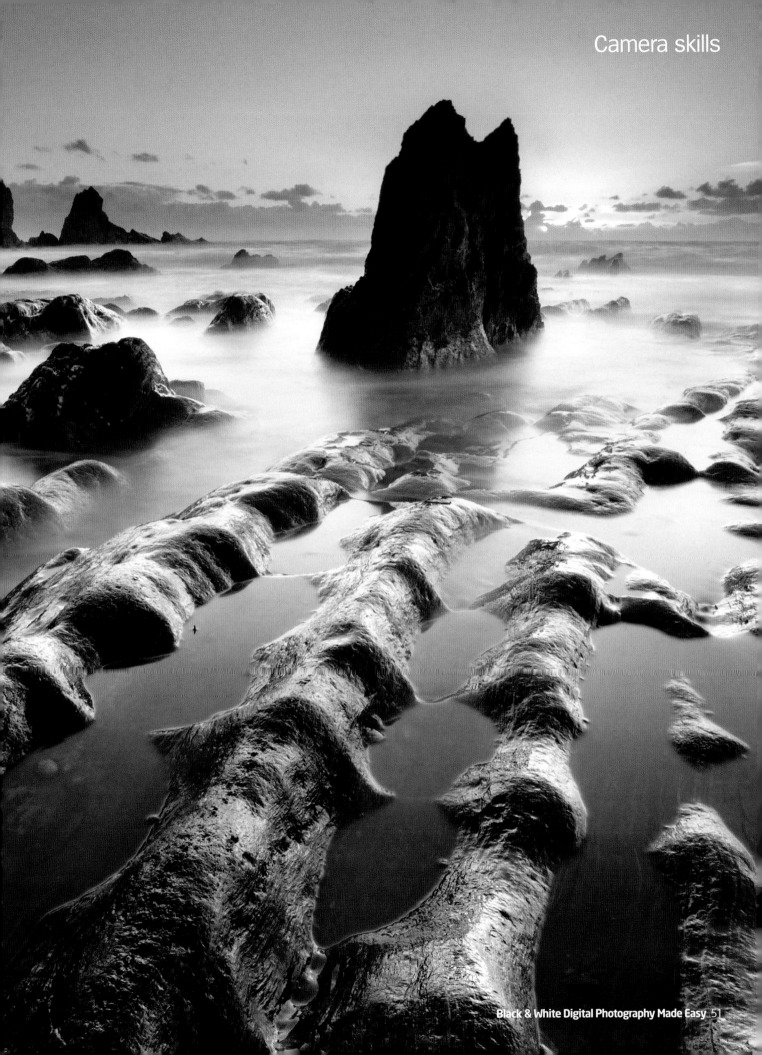

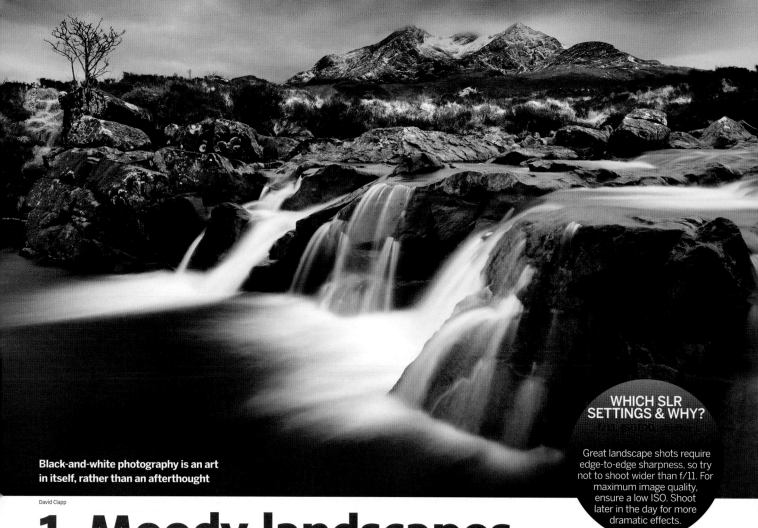

Black-and-white photography is an art in itself, rather than an afterthought

1. Moody landscapes

One of the most common misconceptions that photographers have when shooting landscapes is that black and white is a home for drab, uneventful imagery. It's not a compromise or a resting place for bland images. Without contrast, texture, form, and above all good light, the conversion won't work.

Learning to identify a black-and-white landscape is subtractive. Rather than being drawn to the obviousness of strong colour, it's a case of looking for textures, tones and the interplay of light in the field. Firstly, explore feelings and then imagine the content. Think abandonment, desolation and desecration, and its easy to conjure images of man's influence over the landscape. From industrial echoes to the urban landscape itself, all of these subjects can transcend colour to transform into an evocative portfolio.

Black-and-white landscapes rely on toning and enhancement. A straight desaturation can have little effect, but the toning work can start long before the flash cards reach the computer. Out in the field, graduated filters not only increase tonality to weak skies, but also add depth and balance to the land beneath. Black-and-white landscapes need mood and intensity to work well, so balance the image for greater artistic licence.

STEP BY STEP Get dramatic mono effects

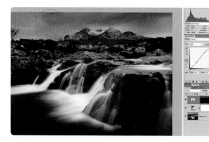

Use the sliders

1 Convert to black and white using a Black & White Adjustment Layer in Photoshop. You can now adjust the Red and Blue sliders to add the necessary depth to your image.

Add an S-curve

2 Add a Curves Adjustment Layer and create a slight S-curve. Set the layer Blending Mode to Multiply. Hit Ctrl+Backspace to fill the mask with the background colour.

Tweak the tones

3 Add tone to that murky sky using a soft brush set to 30%. Now simply make further adjustments to the Curves layer until you're satisfied with the overall image.

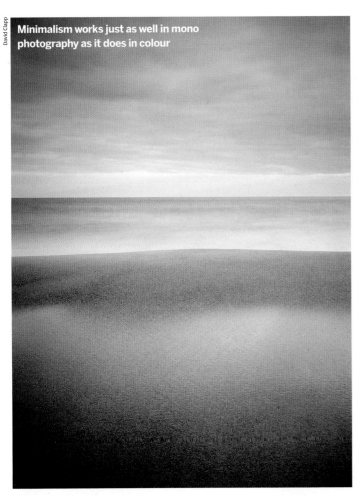

David Clapp

Minimalism works just as well in mono photography as it does in colour

2. Minimal landscapes

Black-and-white conversions work very well with minimalist landscapes or seascapes; sometimes, less really can mean more. A great exponent of this approach is Michael Kenna, whose approach to seascapes is entirely surreal. Using a square format, and often heavily vignetted, his work is particularly noted for creative use of long exposures. This turns otherwise obvious textures, such as clouds and waves, into soft suggestion by heavy filter usage or shooting in extremely low light. It's this exploitation of movement that creates his famed dreamlike effect.

Again, it's all about subject matter, sometimes with and without a focal point. Try using coastal features such as groins or posts, because these really help to strengthen an image. Yet sometimes the sheer lack of features can be just as compelling. It's important to look carefully at a potential subject and begin to visualise the end results before even taking your camera out of your bag.

Three-, six- and even ten-stop neutral density (ND) filters can give much greater control of shutter speed and should be top of the minimalist kit list. By allowing you to use much slower shutter speeds than is normally possible, they can tame raging seas into a milky blur. Try using them at different times of day for dynamic effects.

WHICH SLR SETTINGS & WHY?

Long exposures are key, so play with aperture, shutter speed and filters. Images become noisier when shutter speeds get longer, so stick to the base ISO.

3. Urban landscapes

One of the great things about photographing cities and urban areas is the diversity of black-and-white subject matter on offer. Whether it's sleek glass skyscrapers or back streets, the photographic possibilities can present themselves not just at either end of the day, but literally any time.

Shooting street-level architecture can benefit greatly from the opposites of the classic countryside landscape approach. Light reflecting from tower blocks and windows can make edges sharp and defined, and shapes can also benefit from the interplay of shadows that softer dusk lighting will subdue.

A choice of photographic lenses will help to provide a variety of options, but again, neutral density filters are useful. By using longer shutter speeds and a wider-angle lens, cloud drag can be accentuated to add something utterly unique – giving a sense that time is standing still. ▶

WHICH SLR SETTINGS & WHY?

Experimentation with ND filters can give an exciting take on city life, so try using a three-, six- or ten-stop filter when appropriate conditions are in place.

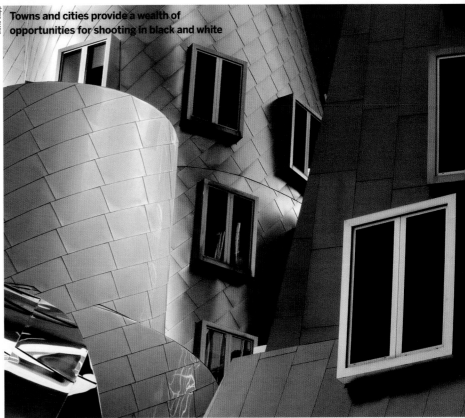

David Clapp

Towns and cities provide a wealth of opportunities for shooting in black and white

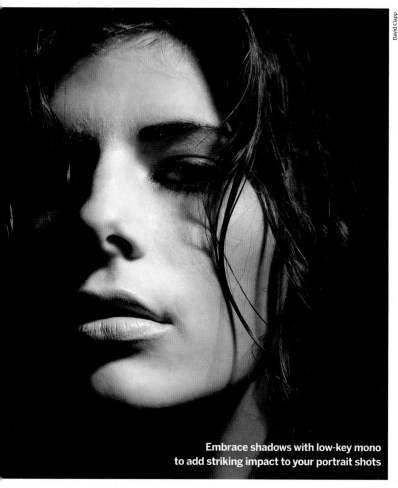

David Clapp

4. Low-key mono shots

If power, mystery or the exploration of a darker side is something you wish to convey, then low-key mono is the way forward. Although primarily a portraiture technique, this can also be very successful in landscapes, especially at last light, where shadow tones can help to reveal shapes in a more abstract way.

Low-key mono works in the opposite way to high-key portraiture (see below). Rather than the model emerging from a strong white, they step out of the shadows. This creates a more secretive, perhaps sinister, image that works extremely well in black and white.

One of the most popular low-key effects is a simple configuration, illuminating the face with a single light from one side. This enhances the contours and shapes of facial features and darkens one side of the profile. The effect can also work well with a half portrait or a full body, but take care to tidy areas that will attract attention (such as hands).

The key to a successful image is getting the exposure spot on, otherwise the effect becomes weakened. Overexpose the shot and the mystery is gone because the background lightens and reveals the model's surroundings. Underexpose and the model is subdued, feeling like they never fully engage with the scene. As the image will comprise of midtones and shadows, check the histogram to make sure these tones are correctly placed and your subject will look evocative and your image technically perfect.

Embrace shadows with low-key mono to add striking impact to your portrait shots

WHICH SLR SETTINGS & WHY?

ISO 200 ISO800 shutter speed between 1/500-1/125 sec

Try Spot metering mode and meter the skin tones in the middle of the histogram. Wide apertures will isolate the face and suggestively blur the surroundings.

5. High-key mono

High-key mono is a fabulous way of isolating and controlling the subject within portraiture, and even in the landscape. The principle bases itself around the use of a very bright or 'high-key' background, with a focal point that is a contrast to this tone. Overall, the image looks light, airy and heavenly, especially in portraits. Imagine a girl wearing a white blouse against a white screen. Her face and neck look like they're almost emerging from the background, which creates an intimate and sensuous mood.

The problem with high-key imagery is understanding where to place the light tones in the tonal range. Firstly, as in our example, the image will often contain little shadow information, so it'll only be made of midtones and highlights. The camera's metering system is easily fooled by these bright conditions and will try to underexpose the shot by positioning the whites as a midtone. This is because the in-camera metering system relies on measuring reflected light. It's very important to check the histogram and 'expose to the right' – in other words, correctly placing the tones in the upper part of the camera's tonal range, making sure the whites are white, not grey.

WHICH SLR SETTINGS & WHY?

ISO 100 ISO800 shutter speed 1/500-1/125 sec. Evaluative metering

If shooting in Av mode, you'll need to use +1.5 stops of exposure compensation. Wide aperture settings will isolate the face and blur the surroundings.

High-key mono can be challenging for your camera's metering system

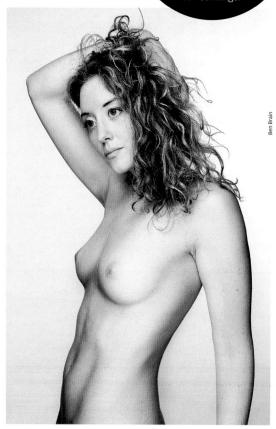

Ben Brain

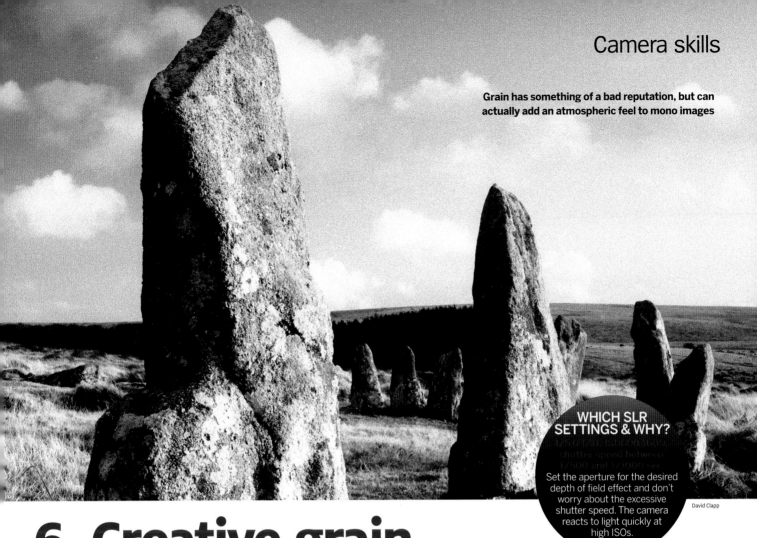

Grain has something of a bad reputation, but can actually add an atmospheric feel to mono images

WHICH SLR SETTINGS & WHY?

1/8th ISO500 ISO, shutter speed between 1/500 and 1/1000 sec. Set the aperture for the desired depth of field effect and don't worry about the excessive shutter speed. The camera reacts to light quickly at high ISOs.

David Clapp

6. Creative grain

Looking to add some old film magic to your digital shots? Then try using creative grain. Although unwanted grain and noise is the bane of the modern photographer's life, grain can also be used in powerfully creative ways, especially when it comes to black-and-white imagery. Perfect graduation of colour tones can often look somewhat sterile, leaving images looking far less engaging, so try adding grain to create moody landscapes and portraiture. The digital equivalent to grain is noise. The higher the ISO, the more noise texture occurs.

Most manufacturers pride themselves on creating cameras that produce cleaner images at higher ISOs, so what exactly are the options for adding noise and how can it be applied? Well, noise can be added at the moment of capture or by shooting at extremely high ISOs, or later on during post-processing. While the latter gives a better level of creative control, a high-ISO image captured in-camera can also look very effective.

One common photographic mistake is to leave the camera set at a high ISO after shooting in low light, then start shooting the next day without changing it back. But don't delete those files until you've checked them – the effect may look better then you think! ▶

STEP BY STEP Use grain to your advantage

Take our grain image and mix it with a digital black-and-white shot in Photoshop. Download our file at http://byscuits.com/grain-tm400.png

Size it up

1 Import the black-and-white grain layer mentioned above and resize it to the size of your main image using Image>ImageSize.

Set the Blending Mode

2 Next, Copy and Paste the grain layer onto your black-and-white image and change the layer Blending Mode to Overlay.

Alter the opacity

3 Now simply vary the opacity of the layer to your desired level using the slider at the top of the Layers palette.

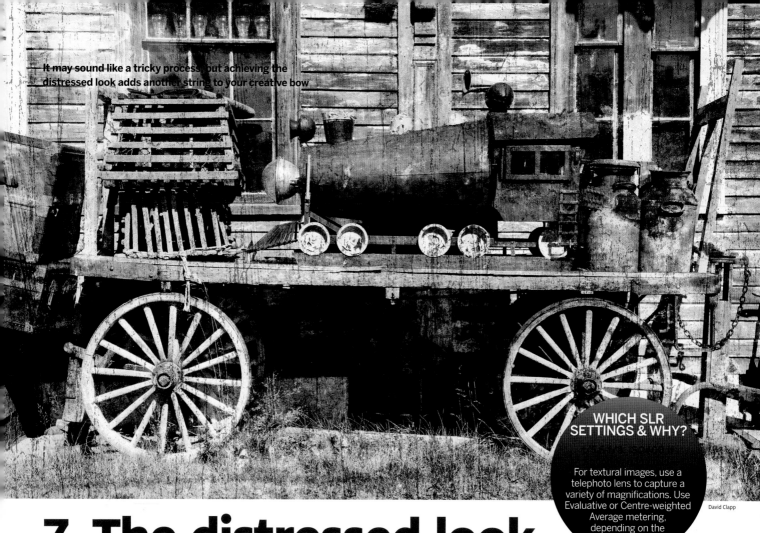

It may sound like a tricky process but achieving the distressed look adds another string to your creative bow

WHICH SLR SETTINGS & WHY?

For textural images, use a telephoto lens to capture a variety of magnifications. Use Evaluative or Centre-weighted Average metering, depending on the subject.

7. The distressed look

One of the great things about digital photography is the almost limitless ways a black-and-white image can be processed, and the distressed look is growing in popularity. This is achieved by making a composite image out of one main shot and a selection of photographs that comprise of textures. The images are then blended together.

First, look for an appropriate subject as the main image. Think dilapidation – old buildings,

farms, barns, ruins – or perhaps think the total opposite. The same effect can work extremely well in other genres such as portraiture. Distressing a face, or a full-body portrait, can have peculiar and time-altering effects when layered with textures, scratches and erosion.

The best starting point is to build yourself a texture library. There are plenty of textures to download online, but look out for textures you see around you and start shooting close-ups for your

own collection. Urban environments provide many opportunities. Shoot rust, crumbling masonry or layers of torn posters. Then, back on the computer, start with your initial image and use Photoshop to add these layers on top, changing the Blending Mode for some startling effects (try Multiply, Overlay and Vivid Light). Vary the effects by only converting some of the images to black and white, and the layers will not only distress but tint your montage too.

STEP BY STEP Try digital distressing

Make it mono

1 Open a photograph and add textural layers, but switched off. Then convert the image to mono using an Adjustment Layer.

Add a texture

2 Turn on the first textural layer. Change the Blending Mode to suit (Vivid Light worked well here) and then turn on the others.

Alter opacity

3 Finish the image by varying the opacity of each texture by playing around with the Opacity slider in the Layers palette.

8. Mono at night

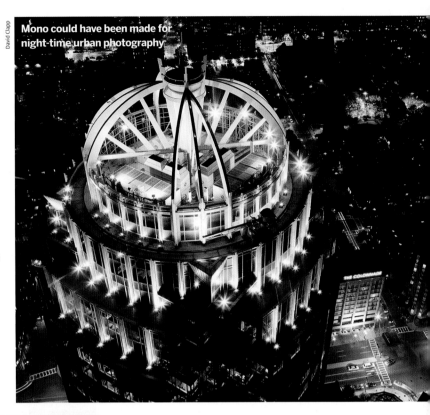

David Clapp

Mono could have been made for night-time urban photography

Shooting at night can create some really captivating and powerful imagery, but in black and white the same images can be even more compelling. Darkness has always been linked to strong emotions such as fear and awe, but after undergoing a monochrome conversion, your image can take on even stronger associations.

One of the biggest annoyances to photographers shooting cities is orange sodium lighting. So why not remove it altogether with a mono conversion? Now's the time to 'let go' of convention. One of the rules to break with mono night photography is to keep the shadows black. Travel photographers usually pack up when the night takes a grip, but this is where the magic can take hold. Just like low-key imagery, buildings will emerge from the night, hiding their entire form. Empty street scenes will evoke an element of tension, but in black and white they can transcend the sense of time.

WHICH SLR SETTINGS & WHY?

You'll need to increase your ISO setting if your shot contains movement. Try shutter speeds of between 1/30 sec and 30 secs, and make sure you carry a tripod.

David Clapp

9. Abstracts

Black and white makes a perfect medium for abstract imagery. For an abstract shot to truly work, the image needs to hit the viewer with questions. Which direction am I looking? What size is this? Take away relatable colours via mono conversion and the abstract becomes even harder to unravel as it gets pushed further out of context.

Shooting modern architecture is a great way to learn about abstract mono, because most of the work has been done by the architect. Using the correct focal length and camera angle, try and avoid framing all recognisable objects and concentrate on sensual and visual appeal. Convert the image to mono and try adjusting the tones of the image.

And it doesn't just need to be about buildings. Landscapes aren't the most obvious place for abstract imagery, but with the right combination of conditions and focal length, the effects can be astonishing. Lakes are a brilliant place for stunning abstracts, as inversions turn straightforward hillsides into bizarre patterns. Turn the image into black and white and the subtractive effect takes the image one stage further. ▶

Architects work hard to build in alluring shapes and patterns, so take advantage of these in your photography

WHICH SLR SETTINGS & WHY?

You'll need to increase your ISO setting if your shot contains movement. Try shutter speeds of between 1/30 sec and 30 secs

10. Solarisation

Solarisation can be quite an aggressive visual technique, but it works well with certain black-and-white images. The technique of solarisation began in the darkroom in the 1860s, and is the result of exposing an already-exposed negative film to light before or during processing. It was popularised by an American painter called Man Ray.

This quirky pop-art look does some strange things with the image highlights. The lighter they are in the correctly exposed image, the blacker they become when solarised. Bright lights are jet black and tones take an unlikely path, resulting in an oily, surreal interpretation.

It's surprisingly easy to make a solarised image. In fact, Photoshop and most other image-editing programs come with a filter preset that faithfully replicates this darkroom technique, but it's easy enough to make your own with a simple Curves adjustment if you'd rather do it yourself. The main technique is to push the blacks in the image the opposite way by creating a U-shaped curve, quite the opposite of a conventional image alteration.

STEP BY STEP Experiment with tones

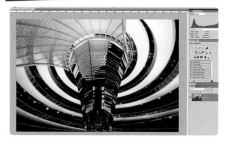 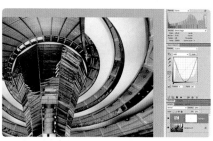 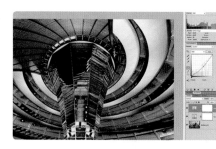

Use an Adjustment Layer
1 To start the solarisation process, first convert the image to black and white using a Black & White Adjustment Layer.

Add a control point
2 Once you've done that, open a Curves Adjustment Layer and insert a control point halfway along the line.

Around the U-bend
3 Now grab the black point slider in the bottom left and push it all the way to the top, making a U-shape.

David Clapp

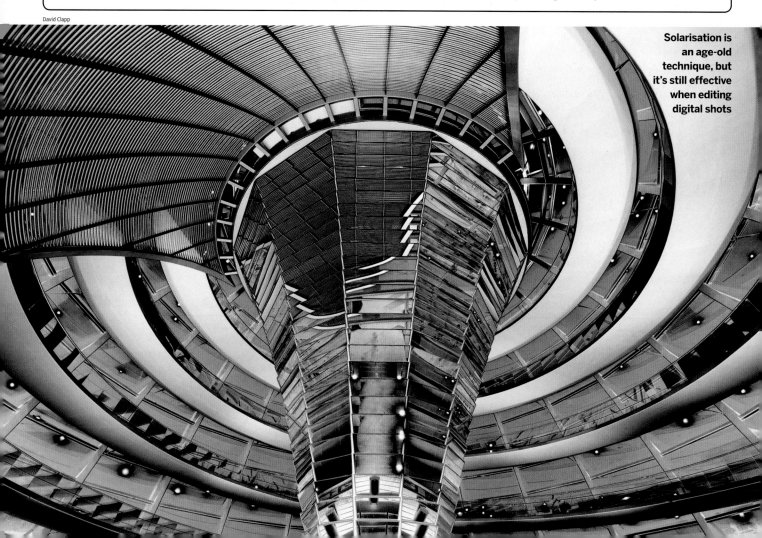

Solarisation is an age-old technique, but it's still effective when editing digital shots

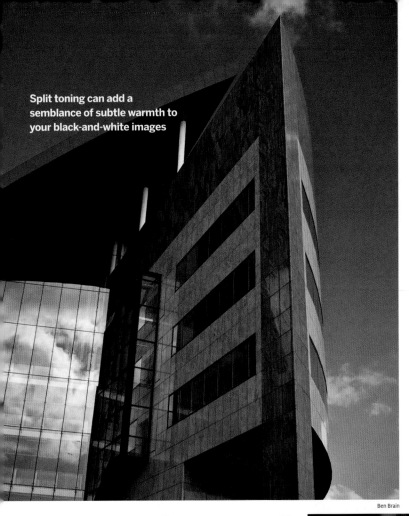

Split toning can add a semblance of subtle warmth to your black-and-white images

Ben Brain

11. Split tone

Split toning is a technique applied to black-and-white imagery to subtly add colour tints to what is essentially a mono image. The way this works is to add certain colours into tonal ranges, like the shadows, midtones or highlights. With its origins founded in the darkroom, split toning is a method of processing images using different chemicals, which can give a classy, unusual look, even in the digital age.

Split toning works particularly well when applied to portraits and landscapes, especially if the photographer happens to be searching for a classic sepia-style look with greater control than a preset can offer.

One of the main observations in digital black-and-white imagery is the amount of red that exists in the various midtones and shadows. By adding an element of blue or cyan into those shadows, the image can become 'inky' and much richer. Blacks start to look much blacker and the image has more depth without looking obviously toned.

Try converting the image to black and white and then using a Colour Balance Adjustment Layer in Photoshop to add different colours into the tonal ranges. Subtlety is the key here, so ensure that you switch the layer on and off to see split toning in effect as you work.

12. Infrared

Infrared photography is another extreme example of mono conversion, and one that can really transform your shots. But it's important to understand the principles of this striking, dream-like conversion.

Infrared photography was first discovered by Robert Wood in 1910, when he made an experimental film that side stepped the usual silver halide plates that were used at the time. Infrared produces a very strange effect by blocking out most of the visible spectrum. In trees, light reflecting off foliage is recorded as bright white, giving them a diffused and characteristic snow-like render. Clouds and skies also become radically altered, so choose the right subject and infrared is a powerful medium.

The first step is to check whether infrared photography is possible on your camera. The cheapest method is to use an infrared filter (which blocks most of the light outside the infrared wavelength), but there are problems that need addressing. For instance, it slows down your exposure and you can't see through the viewfinder. So you have to focus and compose before attaching the filter, making a tripod essential. Or you could permanently convert an old, no-longer-used camera body to infrared. Check out Advanced Camera Services (www. advancedcameraservices. co.uk) and other specialists. But be warned, the conversion process is not cheap. ∎

WHICH SLR SETTINGS & WHY?
f/5 @ f/11, ISO100-400, Shutter speed between 1/30 sec and 30 secs.
If using infrared, you should expect very long shutter speeds, even in daylight. So choose still days for shooting landscapes.

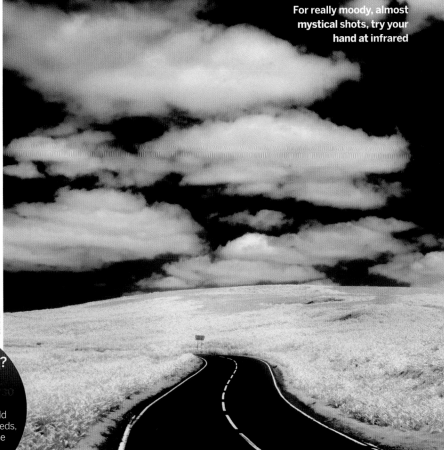

For really moody, almost mystical shots, try your hand at infrared

Ben Brain

Learn from the pros

Page 96

Page 72

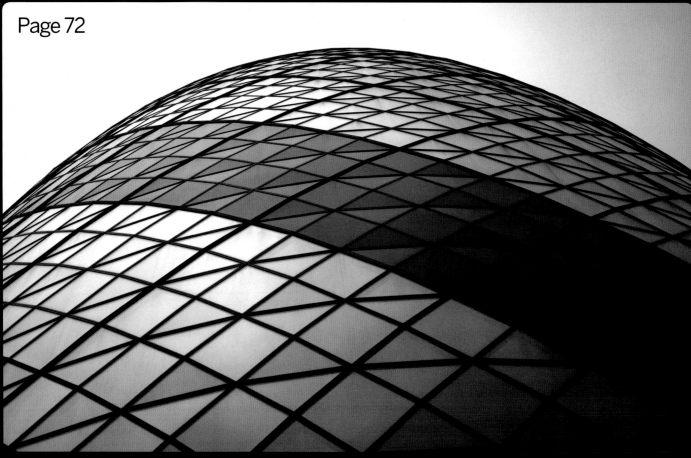

Learn how to shoot like a pro

2

Page 86

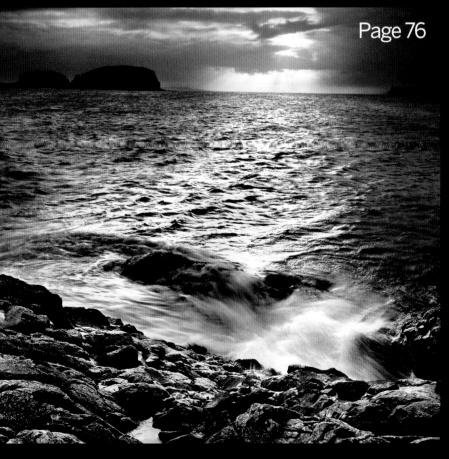

Page 76

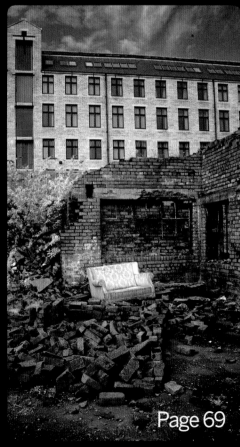

Page 69

Urban mono

We join Apprentice David Pighills in Bradford for a masterclass in urban mono and infrared photography

There's nothing more satisfying than black-and-white photography. Stripping out the colour from a photograph creates a whole new world of texture, detail and subject matter. Our decision to shoot urban scenes for a mono masterclass around David's hometown of Bradford, in Yorkshire, was an

easy one to make. The old manufacturing city is awash with historic factory buildings with Victorian brickwork.

Of course, there's more to a mono masterclass than rushing around with a camera, shooting in colour then desaturating the images on a computer. And to keep David

on his toes we decided to throw a little infrared photography into the mix! This creative branch of black-and-white photography not only gave us two bites of the artistic cherry when it came to capturing urban Bradford in monochrome, but some of the subtle effects can also really enrich an image, as you'll see... ▶

David Pighills

The natural frame made by the hole in the graffitied brick wall is a great device to use for bags of impact while out shooting

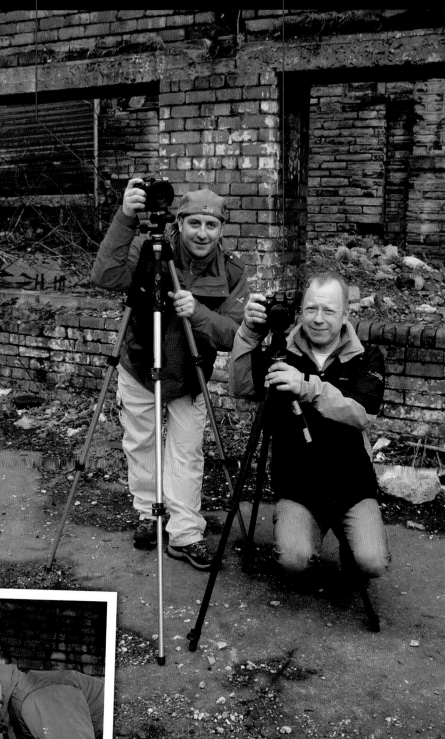

THE PRO...
Ben Birchall
Ben goes all gooey-eyed at the mere mention of mono, especially the chance to shoot some IR 'up north'. He's also dug out his flat cap and whippets for the trip.

THE APPRENTICE...
Dave Pighills
Dave, 45, from Bingley, West Yorkshire, loves shooting in black and white. He recently made the transition into digital photography after years shooting film.

Backstreet black and white

So what makes great mono? Well, subject matter can really make or break the image. The less photographed areas in Bradford, especially the residential backstreets, make perfect documentary material, with their complex structure, gritty detail and debris.

Unfortunately for David, we were shooting midweek, so the usual hive of people and activity that would usually have elevated our photos to fully fledged social documentary shots didn't transpire. David was keen to work the subject matter and shoot a variety of

angles, ranging from a standard 'record-type' shot to something with a little more impact using a wide-angle lens. The same compositional rules apply with black and white as with colour – foreground for impact, look for leading lines and play to the rule of thirds.

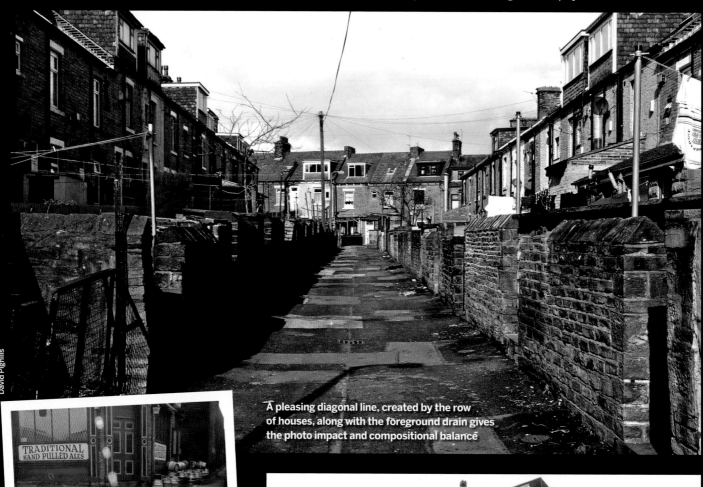

David Pighills

A pleasing diagonal line, created by the row of houses, along with the foreground drain gives the photo impact and compositional balance

TRADITIONAL HAND PULLED ALES

The Fighting Cock

TRADITIONAL HAND PULLED ALES

A low angle not only improves the composition of this fantastic-looking pub, it reduces the backlit effect of the sun directly behind it, eliminating flare and enabling David to compose and crop out the modern car on the right of the frame.

David Pighills

David Pighills

David Pighills

Okay, this is just another northern backstreet? Yes, but the added compositional element of the bright cement bag in the right-hand lower corner balances out the darker elements and provides a visual anchor for your eye to roam around. Try covering it with your thumb and see if it still has the same impact and aesthetic qualities.

Notice the child's red toy and other coloured clutter in the foreground. If the opposite image was in colour, the impact created by monochromatic balance and tone would be lost.

This has more of a 'record-style' feel, as it's taken from head-height and straight on, without a really wide-angle lens. Nevertheless, it's a strong image due to the compelling subject matter of an iconic, gritty northern backstreet. To further improve and transform this into a brilliant documentary, we needed people in the frame.

Why shoot infrared?

Although infrared (IR) is usually associated with summer landscapes and billowing deciduous trees, it can lend itself well to urban shots too. Small patches of foliage or weeds will come out white and provide better contrast, and coloured bricks, graffiti and signs can take on a whole new tonal range in IR.

What is IR photography?

Digital camera CCDs are not only sensitive to visible light, they also extend into the IR part of the light spectrum that we can't see. IR photography is recording this part of the spectrum instead of the visible light. This is achieved by fitting a filter that won't let any visible light pass through, but will allow IR wavelengths to become focused by the lens, and get recorded as an image on the sensor.

The reason foliage appears 'white' and hot surfaces 'glow' is because of the way infrared radiation is reflected/ absorbed (as happens with plants and foliage) or radiated from a source (as happens with tungsten lights or fires).

How David shot IR

Camera manufacturers work hard to make and fit filters, usually directly in front of the CCD, to block the IR part of the spectrum so it doesn't interfere with the visible light and ruin your photographs. Without this filter, your images would have a reddish hue and appear washed out.

David used the Sigma SD14 D-SLR because the IR-blocking filter on it is fitted before the mirror assembly and is therefore removable. We took this filter out permanently so the camera was able to record infrared.

David composed, focused and used Manual mode to expose the scene, as he would with regular photography, before fitting a black-and-white IR filter to avoid recording the visible part of the spectrum.

The lens was switched to Manual focus and David fired the shutter, bracketing his exposures for around five shots. We found on the day that 1- or 2-stops over-exposure from the metered reading without the IR filter worked best.

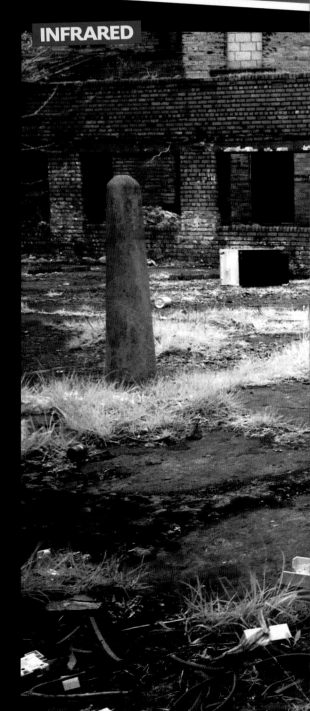

INFRARED

In the digital darkroom

As the IR images are still RGB files, they have a red wash over them. Taking this out is a simple matter of tweaking the Levels and converting the files to greyscale. We used our version of Photoshop CS, but any editing program that can convert to black and white and allow Levels adjustments will work just as well.

Render image

1 After opening the image we used Auto Levels (Ctrl+Shift+L) then rendered the image mono by converting the mode to Greyscale.

Make mono

2 To make the foliage white we opened up the Levels box (Ctrl+L), selected the white Eyedropper Tool on the right and clicked it on the grass.

Increase contrast

3 For increased contrast in the overall image, we opened the Curves box (Ctrl+M) and made a slight 'S' curve before applying a little Unsharp Mask. ▶

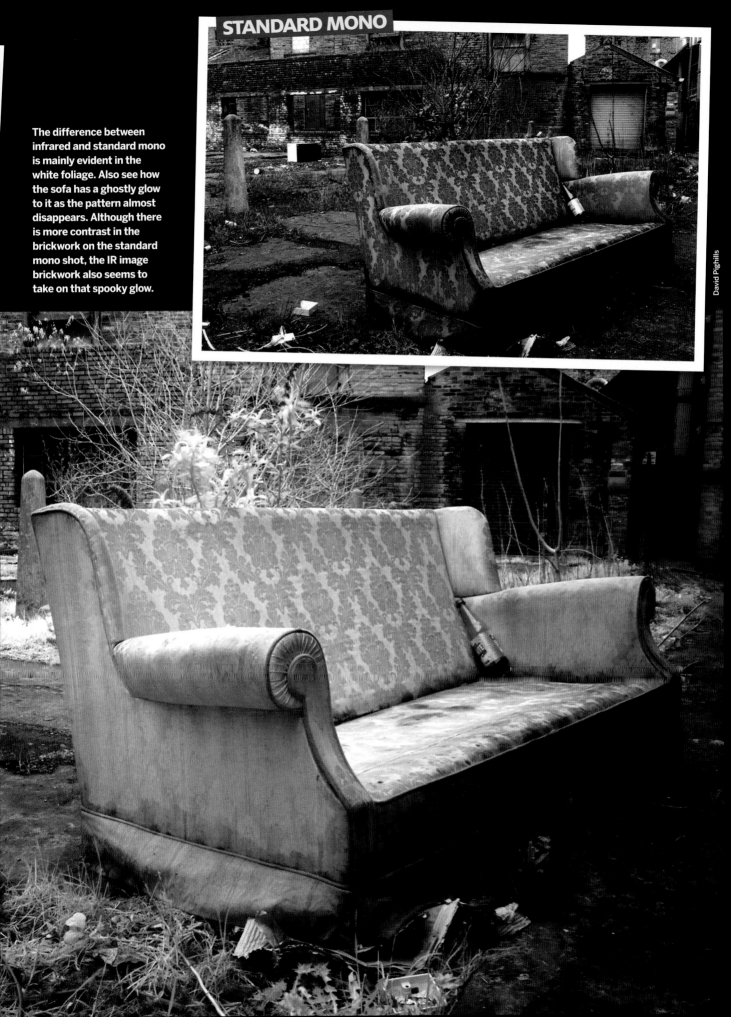

The difference between infrared and standard mono is mainly evident in the white foliage. Also see how the sofa has a ghostly glow to it as the pattern almost disappears. Although there is more contrast in the brickwork on the standard mono shot, the IR image brickwork also seems to take on that spooky glow.

David Pighills

Digital darkroom mono

The digital darkroom enables you to have total control over the monochrome photography process. For that classic 'urban gritty' feel we planned to have maximum contrast and tons of detail still visible throughout the whole frame. Simple plain adjustments with lots of good old-fashion contrast are all the steps we covered to get our desired mono effect from the day. Of course, it helps to be shooting in slightly more contrasty light, such as direct sunlight. We feel this creates a more classic documentary look than a modern HDR or exposure-blended shot. After all, the aim of David's urban mono is to show backstreet life and urban decay as it is.

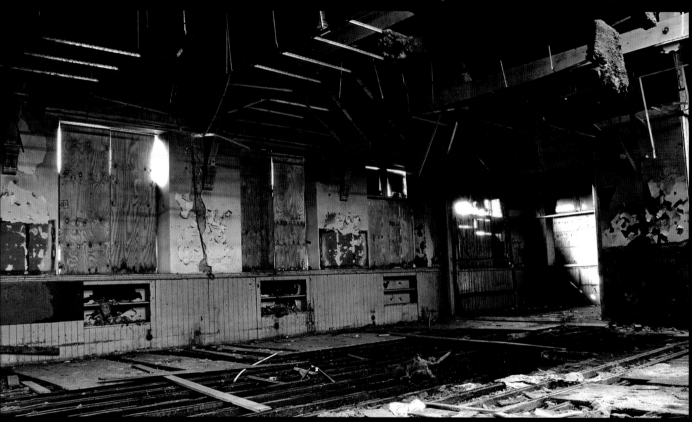

David Pighills

Simple mono adjustments

Avoiding over-complication and using basic adjustments for simple black and white is the order of the day. However, rather than just desaturating or switching to Greyscale mode, use the Channel Mixer in Adobe Photoshop or the Convert to Black and White feature in Adobe Photoshop Elements to produce more creative results. Both of the software features allow the individual colour channels to be manipulated ensuring maximum mono creativity. Most other photo editing software allows a similar level of control.

Mix it up
1 Go to Image>Adjustments>ChannelMixer. Check the Monochrome box to render the image mono. To bring out maximum detail, up the Blue channel to +200, take the Green down to –100 and leave the Red at +100.

Level head
2 Although there are patches of clipped pixels, we felt the image needed more contrast. We adjusted the Levels by dragging the Shadow (left slider) and Highlight (right slider) towards the centre of the histogram.

S-Curve
3 To further improve contrast we used the Curve adjustment (press Ctrl+M) and made a slight 'S' curve. To finish the image and prepare it for print we added a sharpening filter using the Unsharp Mask command.

Shoot urban decay

David was keen to shoot urban mono on his home turf and it paid off. His local knowledge was essential to accessing places. Why not have a go yourself? There must be plenty of subject matter in your own town. Look for the often forgotten parts of the city. Old industrial estates or run-down side streets make great mono shots. You seek out the subject matter and we'll give you the technique. Take a look on this page for five of our top tips.

Sign language

Signs not only give orders or inform us, they can be iconic and define areas of times gone by. Look for old, faded advertising signage on red brick walls or hand-painted signs, like this one, that have buckets of character and won't be around forever. Try shooting long and thin signs at an angle so they slice the frame at a diagonal to add energy to the picture.

From front to back

This image uses an old broken window frame and light fitting to tell the story of neglect and decay as it marks the visual path towards the background. Compose low and wide to take in plenty of ingredients and use a small aperture, such as f/18 or f/22, for front-to-back sharpness.

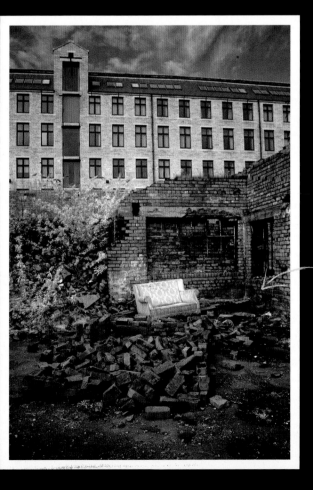

Don't worry, be happy

Relax your exposure worries and technical concerns. Shoot in Aperture or Shutter Priority mode. Select a low ISO, take the tripod, shoot in RAW and bracket your exposures. It's better to keep your photographic eye peeled for exciting locations and work the compositions than get bogged down with camera handling all day.

Something old, something new

There's no better way to reinforce dilapidation in your urban mono shots than to juxtapose the modern equivalent. Here we see the backdrop of a well looked after building against the foreground of a ruin with a grubby sofa in the middle of a frame. For this style you'll need to shoot the wider picture. Use a wide angle, around 17mm, and take in as much detail as you can.

Get picky

There may be a crumbling factory standing right before your eyes, but sometimes the story can be told better by picking off the details that truly define an area or building. Shooting detail means zooming in a whole lot more to give impact without distraction. A superzoom, between 18-200mm focal length is the perfect urban decay photographer's tool.

Old architecture
mixed with the new:
The Gherkin building,
towering high

Iconic city structures

We join Apprentice Sophie Burns on a dark
and dreary day in London to shoot some
fresh views of very familiar landmarks... ▶

THE PRO...
Ed Godden
A big fan of capturing original shots, Ed was more than happy to trek around the capital for a day.

THE APPRENTICE...
Sophie Burns
Sophie lives just a stone's throw from the London Eye. She guided us round her favourite iconic locations.

Essential
gear
Don't fill your bag with kit that won't see the light of day.

Digital SLR
Sophie uses a Nikon D60 and loves the clear tones and crisp resolution she gets from it.

Lenses
To get the most from our day we shot with just two lenses, a wide zoom and a telephoto, enabling us to be creative from a distance and close up.

Our challenge

Sophie Burns has lived in the centre of London for more than 10 years. She was keen to start capturing photographs of some of the iconic buildings and structures that sit on her doorstep, turning them into arty prints she'd be happy to hang on her wall. Visiting landmarks as diverse as the London Eye and Big Ben, we were able to cover everything from new structures to historic buildings.

Our challenge was to create shots that were unique and different. Not an easy task when you have to brave horrible British weather and dodge the occasional shower. Not deterred by this, we packed our camera bags with as little equipment as we could get away with, and headed off in search of some stunning shots.

Backpack
Because of all the trekking around town with our kit, we opted for backpacks, such as the Lowepro Flipside 400 AW. We only took two lenses in the bag, which meant there was still had plenty of room for a waterproof raincoat!

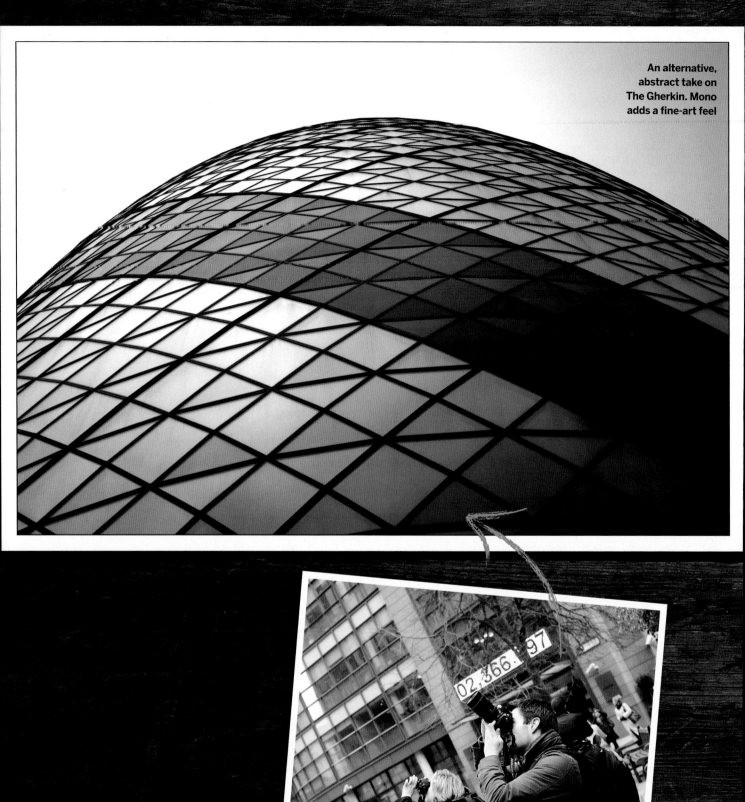

An alternative, abstract take on The Gherkin. Mono adds a fine-art feel

1 London Eye

We started our day at the London Eye. A relatively new structure in the capital, it has already been shot to death. So how to do you come up with something fresh?

Sophie captured this effective abstract shot of The Eye using her 55-200mm lens. Because it was such a dreary day, she opened the aperture to f/6.3 to get a shutter speed of 1/200 sec and ensure sharp shots. By shooting at a slight angle she was able to create an interesting shape while still keeping the effect of the height of the structure. Although the sky was bland, a conversion to mono and the addition of a black border has given the shot a fine-art feel.

Alternative angles

Take time to work a subject and try the extremes of your zoom. Here we've created two very different shots of the same subject. By shooting from a distance with the telephoto and framing a quarter of the wheel against the pure white sky, a graphic shot is created (top). Then, by switching to a wide-angle and getting underneath The Eye a greater sense of height is created (bottom).

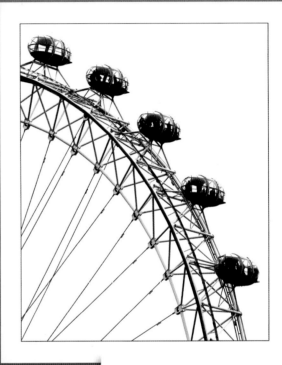

Move around and experiment – you'll find the perfect shot for your iconic structure images to take shape!

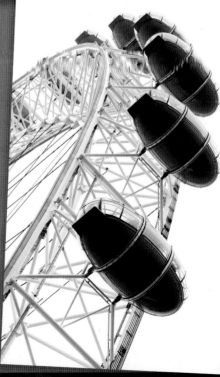

2 Canary Wharf

The Canary Wharf Tower dominates the London Docklands. It's visible (and has been photographed) from most of the capital's major tourist attractions.

Canary Wharf is full of photo opportunities – whether it's shots of commuters making their way to work in the rush hour, or shooting the tower from an interesting angle. Being such a tall structure, we knew we could create a shot with impact by getting underneath our subject and shooting upwards.

3 Tower Bridge

The suspension bridge that crosses the Thames near the North Bank area of London is a much-loved attraction for visitors to the capital.

To create an original image of an iconic structure that has been shot from every angle is no easy task. You need to aim for something unique, special and creative. Even when you're taking the shot, consider final presentation, such as how a mono conversion could enhance the image.

RIGHT Sophie spotted this shot as soon as we came out from the underground station. Standing back and selectively cropping in-camera using a telephoto avoids distorting the vertical lines of the building.

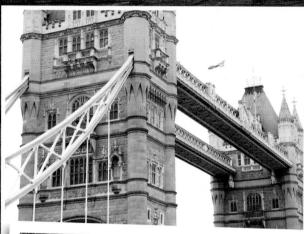

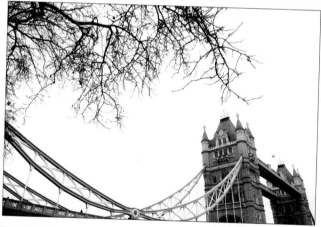

ABOVE By using the wide-angle lens at its 17mm setting and filling the huge expanse of white sky with some over-hanging branches, a run-of-the-mill shot is avoided and a creative mono print is produced. The bridge appears to be emerging from the bottom of the frame and the sweeping iron structure from the left-hand side helps to lead the eye into the focal point of the shot – the bridge itself.

Digital darkroom tips

Don't use bad weather as an excuse – you can still capture images to be proud of. Images that are full of detail or feature large areas of white space are ideal for dramatic mono conversion.

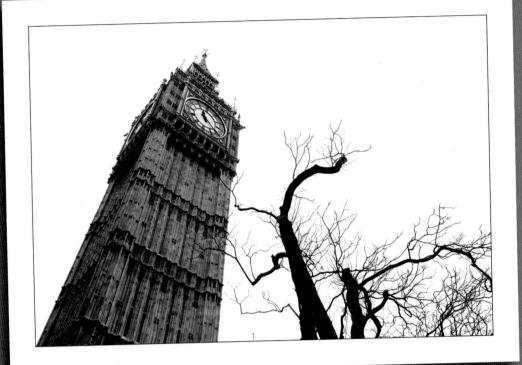

Keep it real or go for impact?

When the weather isn't on your side you sometimes have to consider how you might enhance the shot in post-processing. This shot of a historic building is a prime example. With its bright, white sky as the background and the dark brick work in the foreground, a decision has to made about what effect you want to create. For impact, bleach out the detail in the sky.

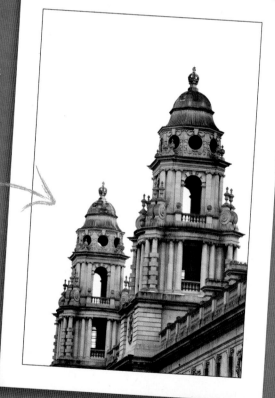

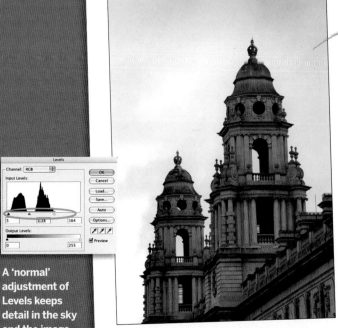

A 'normal' adjustment of Levels keeps detail in the sky and the image looking natural.

Dragging the Highlights slider to the right burns out the information in the sky.

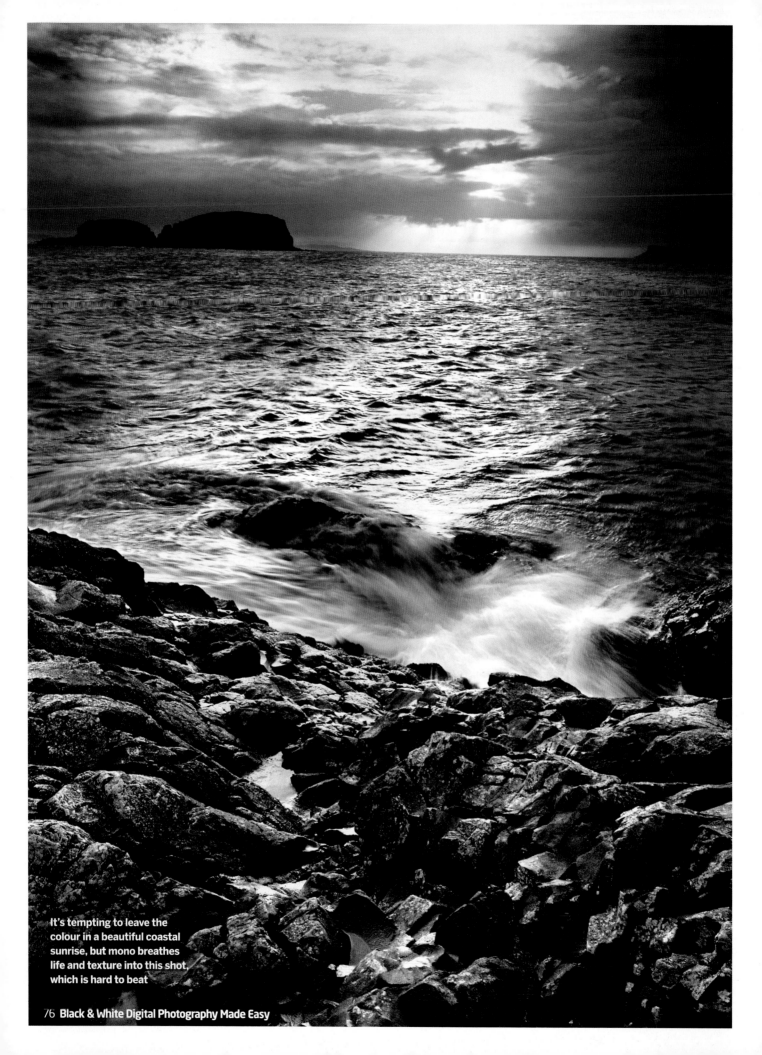

It's tempting to leave the colour in a beautiful coastal sunrise, but mono breathes life and texture into this shot, which is hard to beat

Coastal mono shooting skills

We go to Northern Ireland's dramatic coast for a masterclass in monochrome coastal shots

When you're out shooting coastal shots, black and white can sometimes take a back seat. But our Apprentice, Mark Fearon, loves the combination of the coast and black and white, and he often travels the coastline of Northern Ireland in search of stunning black-and-white seascapes to photograph.

To help Mark master his coastal mono technique, we went to the Giant's Causeway. And although the weather was pretty foul, we were determined to come away with some stunning coastal shots. Turn the page to find out if Mark managed to master the art of mono and whether he learned the D-SLR techniques for success. ▶

THE PRO...

Ben Birchall
This is Ben's first visit to Northern Ireland's coastline. And if it wasn't for the gales and rain, he'd be looking much happier!

THE APPRENTICE...

Mark Fearon
Mark is 43 and from Donegal, Ireland. He's a self-taught photographer and he even dabbles in aerial photography using kites.

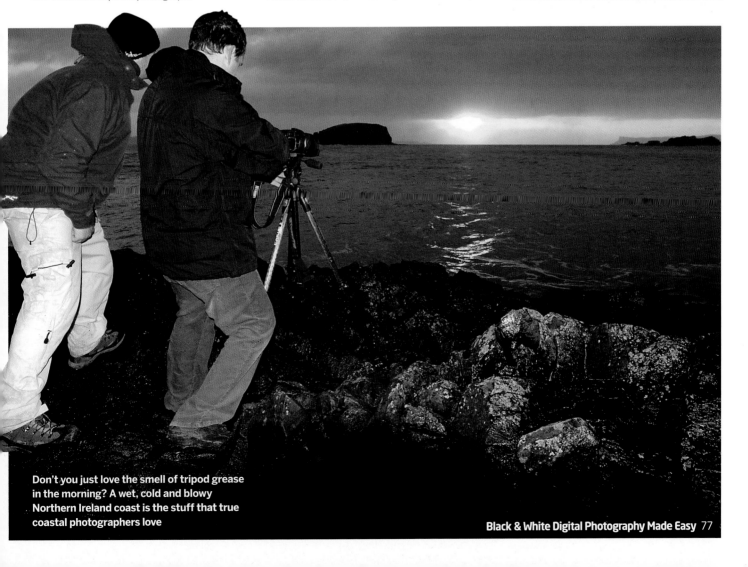

Don't you just love the smell of tripod grease in the morning? A wet, cold and blowy Northern Ireland coast is the stuff that true coastal photographers love

Why black and white?

The answer is simple: black and white has bags of atmosphere, mood and drama. When images are reduced to shades of grey, the amount of textural information is a visual feast for anyone who appreciates artistic photography. The lack of colour leaves little room for compositional error or bland subject matter, so you'll have to be spot-on when it comes to field techniques.

Some people might worry about wasting the atmosphere and beauty of the morning colour in a mono shot, when the sky and landscape is at its best, but that's the beauty of digital – you can have the best of both.

We shot in colour on the day, using RAW file format, and converted to black and white in the digital darkroom. It's the quality of light and colour that can help the conversion process to boost the drama. Remember that low, raking light on rocks and water surfaces can enhance texture and detail when you're rendering in black and white.

Mono is so much easier to work with in the digital darkroom. Dodging and burning can blast an average mono shot into orbit. At the right location – with good composition, interesting subject matter, moody drama and intricate texture – ditching colour can often be the best choice to make...

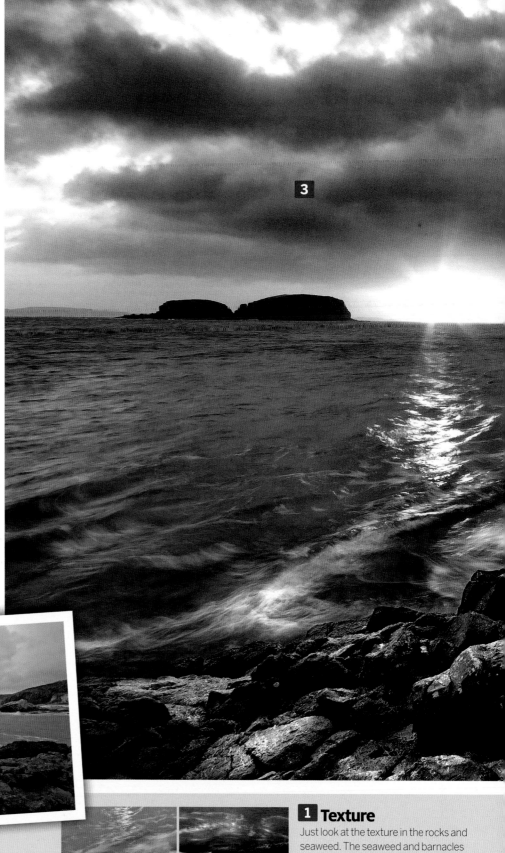

Colour vs mono

An early-morning shot can have great colours but don't be seduced by them. Think how mono can work to your advantage with dodging and burning to emphasise features.

1 Texture

Just look at the texture in the rocks and seaweed. The seaweed and barnacles become really separated from brown rocks with a good mono conversion. It's evident all over the image, too, not just when viewed at 100%, and delivers so much more for the eye to soak up.

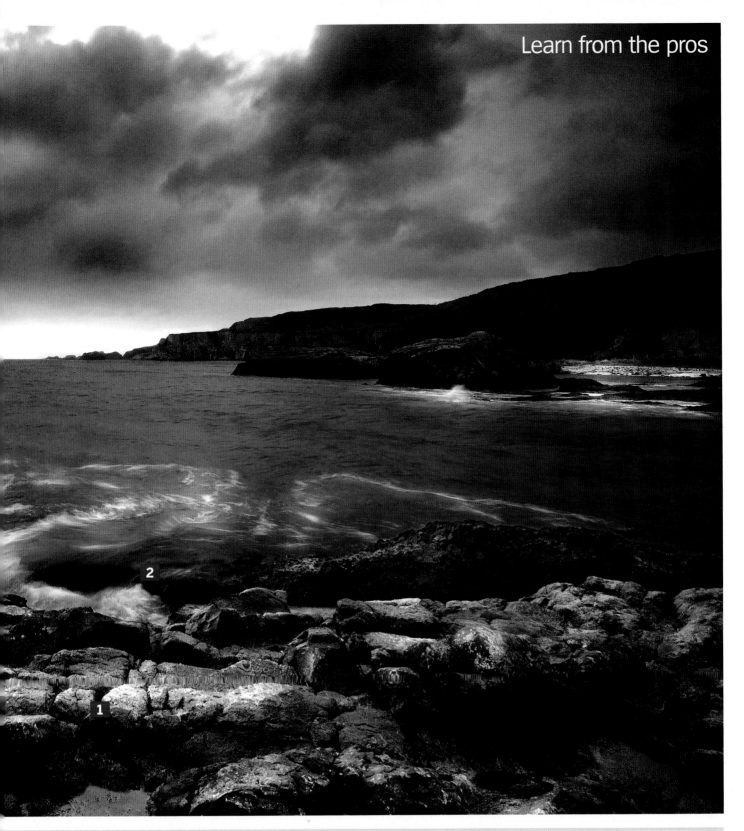

2 Detail

Ditching the colour from your photos can help pull out areas of similar colour that suffer flat, dull tones. The swishes of moving water hitting rocks don't stand up in the colour shot. Over-processing colour will result in over-saturated, cartoon-style colours.

3 Impact

Clouds and sky can really benefit from the black-and-white treatment. Darker clouds can go surprisingly black and that can create an enormous amount of impact as they contrast the brighter areas, which you can leave to bleach out. ▶

Coastal landscape gear

On our day out at the coast we packed just the important gear – we didn't get bogged down with excessive amounts of kit. Mark owns 10-20mm, 18-50mm and 70-300mm lenses. His ultra wide-angle 10-20mm model is essential – it's the perfect coastal lens and his first choice to keep fitted to his camera. He also decided to take the 70-300mm in case of any unexpected events but left his 18-50mm behind.

Mark's own tripod wasn't up to the job for the day, so we used a Manfrotto 190MF3 Magfiber carbon fibre tripod, with a sturdy three-way head. Mark used his own remote-release cable for remotely firing the shutter. He also used graduated Neutral Density filters to help him capture any sky detail that was floating around.

As the weather was so foul we wore plenty of warm, waterproof clothing and some sturdy boots. It was also a relief to ditch our kit bags in favour of pocketing our longer lens and filters at some locations while leaving the rest of the gear in the car boot.

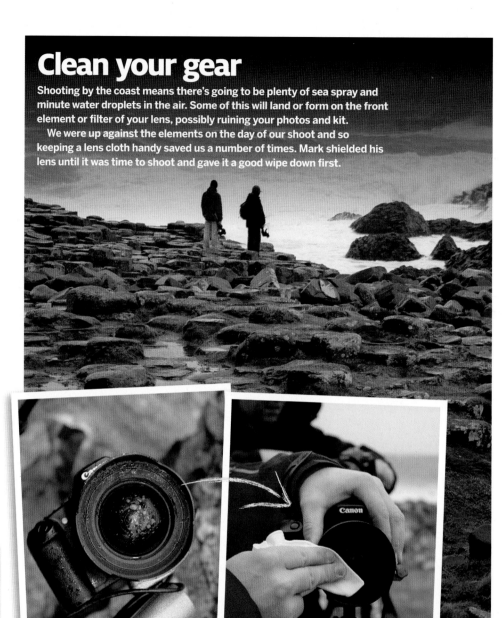

Clean your gear

Shooting by the coast means there's going to be plenty of sea spray and minute water droplets in the air. Some of this will land or form on the front element or filter of your lens, possibly ruining your photos and kit.

We were up against the elements on the day of our shoot and so keeping a lens cloth handy saved us a number of times. Mark shielded his lens until it was time to shoot and gave it a good wipe down first.

Coastal locations present a hostile environment for delicate digital gear

Sharper images

There's no way you're going to rescue a coastal shot, especially in low light, if it suffers camera shake or blur. Using small apertures, for front-to-back sharpness, will force the shutter speed from fractions of seconds down into lengthy exposures.

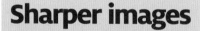

A solid tripod is essential for keeping the camera steady. Placing your feet on solid ground or rock helps, too. Give your tripod a good shake before placing your camera on top to make sure it's solid. Use it with a remote release cable, or your camera's self-timer and mirror lock-up function for confidently sharp images.

Camera settings

Having the correct settings and functions preset before heading out to the coastline will help you concentrate on composition and drama. Follow our guide to the best possible set-up.

METERING Overall metering that takes information from the whole frame for balanced exposures.

EXPOSURE MODE Aperture Priority works best for control over depth of field for maximum sharpness overall.

FOCUS MODE Use AF to focus a third of the way into the foreground, then switch to Manual and shoot away.

FILE FORMAT RAW for the best possible quality and the widest latitude for mono conversion and editing.

WHITE BALANCE Select the White Balance to match the conditions for consistent and naturally lit shots.

MIRROR LOCK-UP If your camera has this function, switch it on for the sharpest shots possible.

NOISE REDUCTION Auto is the best setting, as it will only kick in if or when you're shooting at very slow shutter speeds.

Better skies

A graduated neutral density (ND grad) filter will help reduce the contrast between the land and the sky. ND grads are great for creating skies with impact and resolving detail in the clouds. Mark uses Cokin filters, which come in three strengths: ND2, ND4 and ND8. An ND2 reduces the light by one stop; an ND4 by two stops; and an ND8 by three. You can also retain detail in the sky by taking several shots and blending them in editing software.

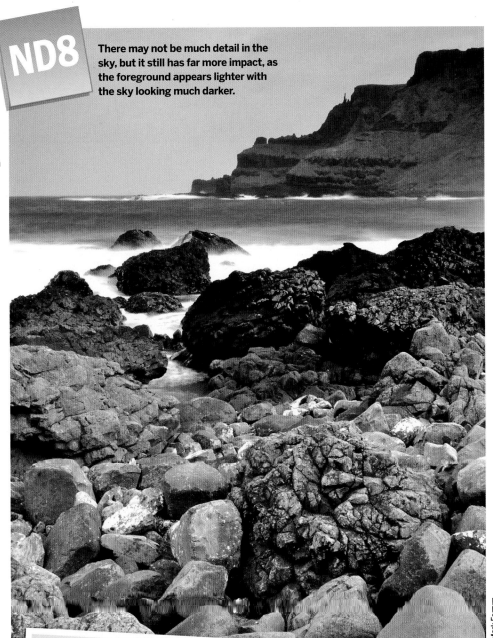

ND8

There may not be much detail in the sky, but it still has far more impact, as the foreground appears lighter with the sky looking much darker.

Mark Fee

ND2

The ND2 filter has reduced the light by one stop in the sky, but the effect isn't strong enough to balance the scene.

NO GRAD

Shooting without an ND filter has not only bleached out the sky completely, but affected the distant rocks, too. ▶

Cokin filters mount onto the front of the lens and can be slid up and down to be correctly positioned, according to the horizon

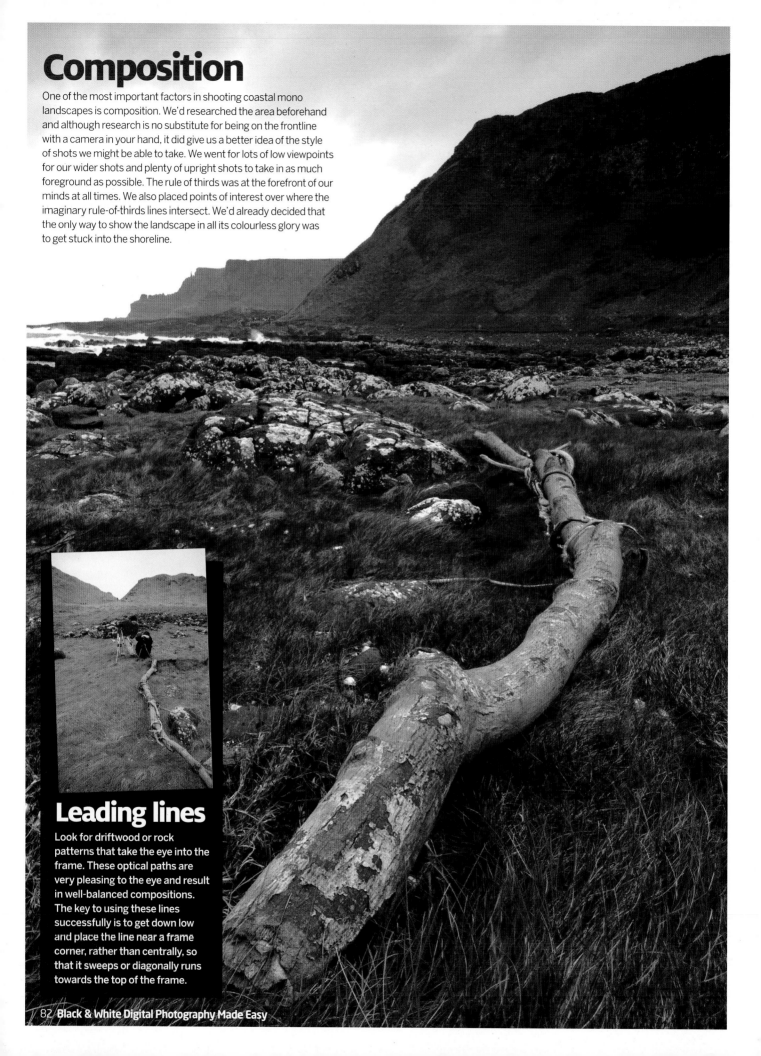

Composition

One of the most important factors in shooting coastal mono landscapes is composition. We'd researched the area beforehand and although research is no substitute for being on the frontline with a camera in your hand, it did give us a better idea of the style of shots we might be able to take. We went for lots of low viewpoints for our wider shots and plenty of upright shots to take in as much foreground as possible. The rule of thirds was at the forefront of our minds at all times. We also placed points of interest over where the imaginary rule-of-thirds lines intersect. We'd already decided that the only way to show the landscape in all its colourless glory was to get stuck into the shoreline.

Leading lines

Look for driftwood or rock patterns that take the eye into the frame. These optical paths are very pleasing to the eye and result in well-balanced compositions. The key to using these lines successfully is to get down low and place the line near a frame corner, rather than centrally, so that it sweeps or diagonally runs towards the top of the frame.

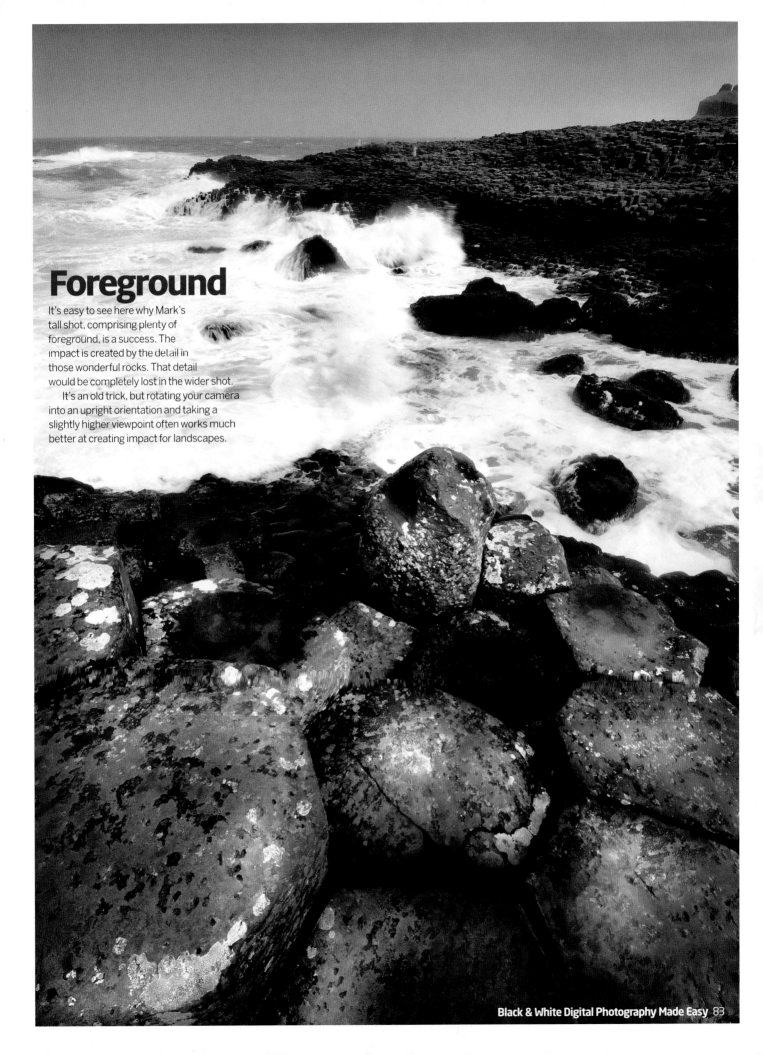

Foreground

It's easy to see here why Mark's tall shot, comprising plenty of foreground, is a success. The impact is created by the detail in those wonderful rocks. That detail would be completely lost in the wider shot.

It's an old trick, but rotating your camera into an upright orientation and taking a slightly higher viewpoint often works much better at creating impact for landscapes.

Get in there!

It's advice we often give for our action, street and people shots, but getting right into the thick of it will always pay dividends. Okay, so it can be fairly treacherous clambering over wet seaweed-strewn rocks with expensive camera gear, but the viewpoints can really pay off. If you stand back and shoot from afar, your photographs are at risk of turning into mere snapshots. Fortunately, Mark is fearless when it comes to balancing on slippery shorelines when he has one eye fixed to a viewfinder eyecup.

Go longer

Don't discount taking and shooting on a longer lens when you're out in the field. Mark's stark black and white capture of a wave breaking has energy, action and drama that can only be captured when you're zoomed right into the subject.

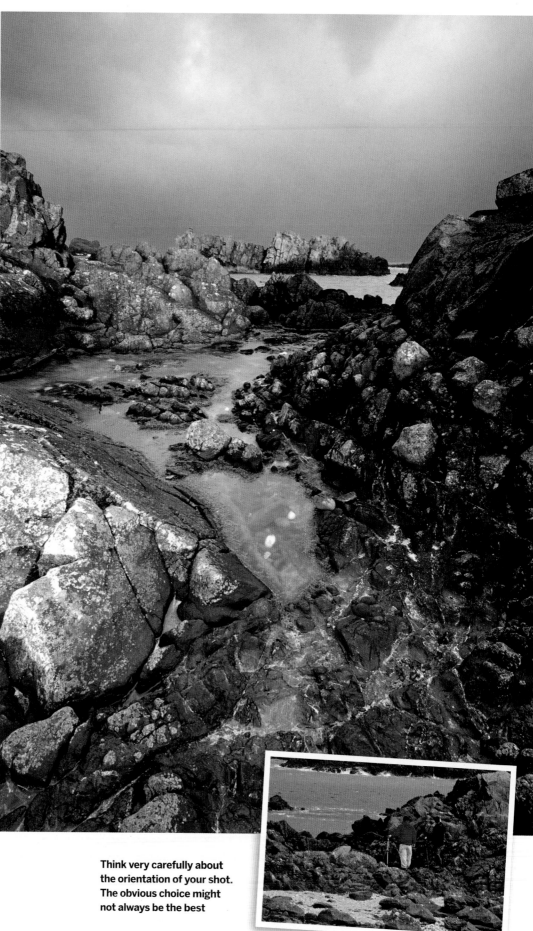

Think very carefully about the orientation of your shot. The obvious choice might not always be the best

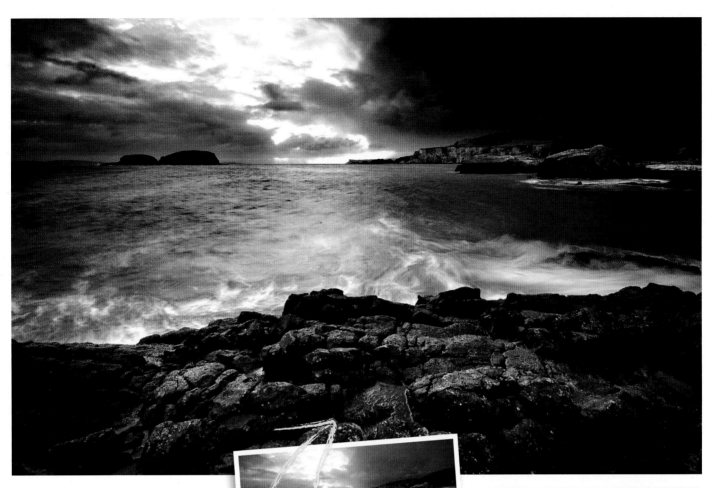

Digital darkroom tips

There are dozens of ways to transform your images in the digital darkroom. We used Adobe Photoshop CS to show Mark a simple, quick and effective way to create a mono masterpiece.

There are four essential steps to this process, but it's the dodging and burning phase that really puts the plum in the pudding. Dodging the highlight areas of the image draws attention to those spots and creates plenty of contrast to enhance the impact. Likewise, burning in the shadows and darkening them can take emphasis away from those parts of the frame. An overall subtle vignetting effect is also a great optical darkroom trick that can keep the viewer's eyes transfixed in the middle of the frame and hold their attention. Follow our three-step guide for mastering mono.

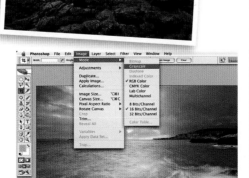

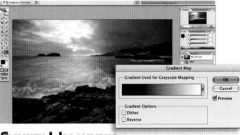

Convert to mono

1 One of our favourite ways is to convert to mono is to use the Gradient Map tool. Click Image>Adjustments>GradientMap. Leave it on the default gradient and click OK.

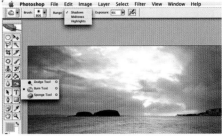

Greyscale

2 Now the image must be converted to a greyscale. Click Image>Mode>Greyscale. In the Options box, click OK to discard the colour information, as you won't need it.

Dodge and burn

3 Select the Dodge and Burn tool by pressing O. Dodge the shadows and burn the highlights. Set exposure around 6% and use a large, feathery brush to avoid streaky edges. ■

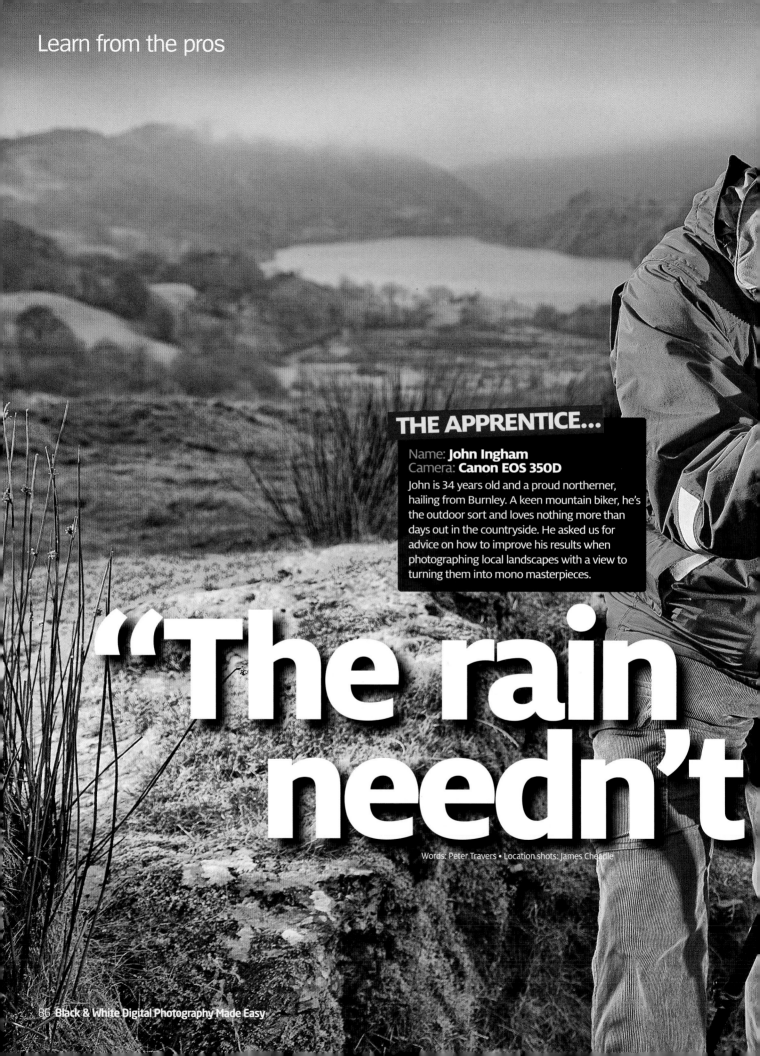

THE APPRENTICE...

Name: **John Ingham**
Camera: **Canon EOS 350D**

John is 34 years old and a proud northerner, hailing from Burnley. A keen mountain biker, he's the outdoor sort and loves nothing more than days out in the countryside. He asked us for advice on how to improve his results when photographing local landscapes with a view to turning them into mono masterpieces.

"The rain needn't

Words: Peter Travers • Location shots: James Cheadle

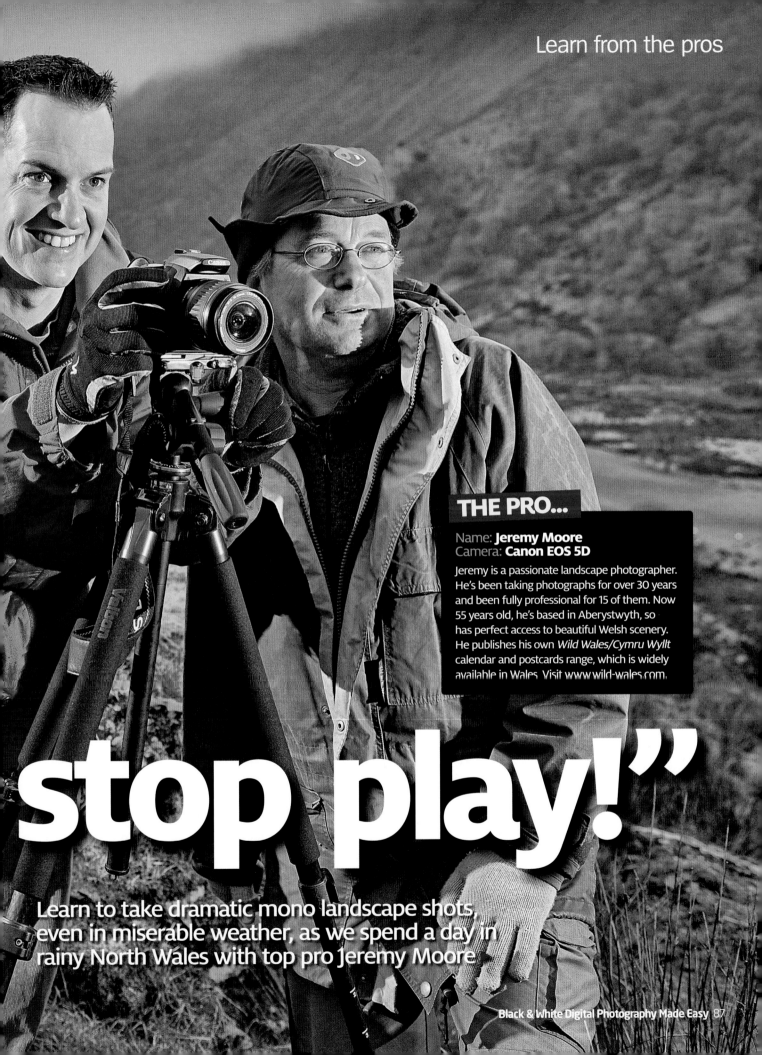

THE PRO...

Name: **Jeremy Moore**
Camera: **Canon EOS 5D**

Jeremy is a passionate landscape photographer.
He's been taking photographs for over 30 years
and been fully professional for 15 of them. Now
55 years old, he's based in Aberystwyth, so
has perfect access to beautiful Welsh scenery.
He publishes his own *Wild Wales/Cymru Wyllt*
calendar and postcards range, which is widely
available in Wales. Visit www.wild-wales.com.

stop play!"

Learn to take dramatic mono landscape shots, even in miserable weather, as we spend a day in rainy North Wales with top pro Jeremy Moore

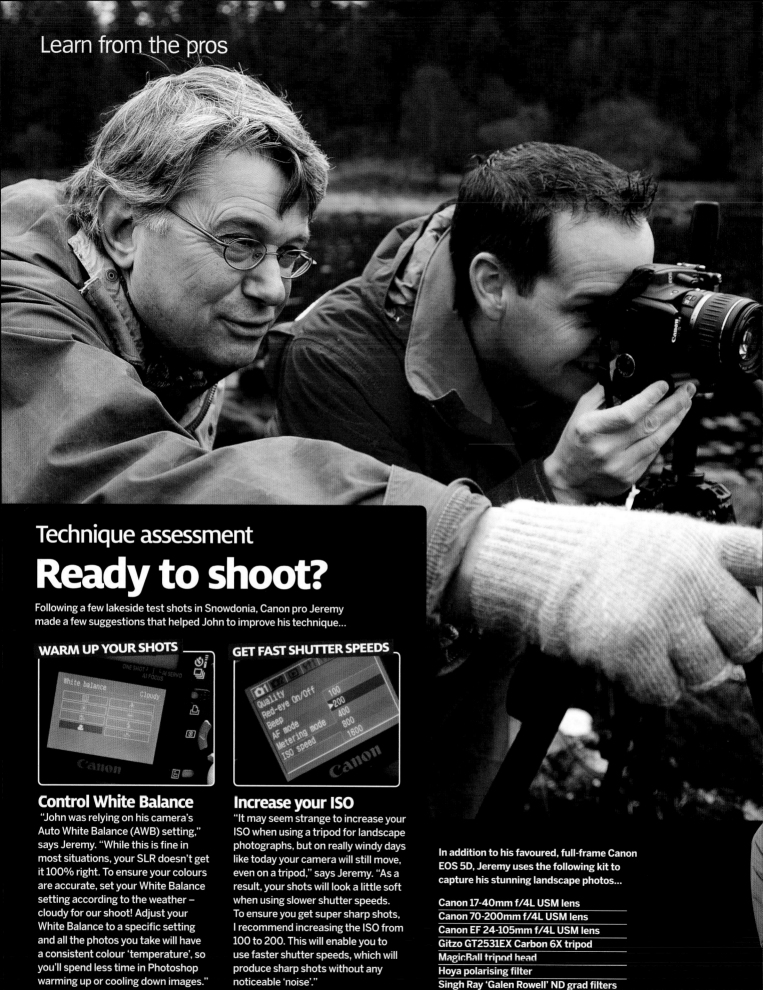

Learn from the pros

Technique assessment
Ready to shoot?

Following a few lakeside test shots in Snowdonia, Canon pro Jeremy
made a few suggestions that helped John to improve his technique...

WARM UP YOUR SHOTS

GET FAST SHUTTER SPEEDS

Control White Balance

"John was relying on his camera's
Auto White Balance (AWB) setting,"
says Jeremy. "While this is fine in
most situations, your SLR doesn't get
it 100% right. To ensure your colours
are accurate, set your White Balance
setting according to the weather –
cloudy for our shoot! Adjust your
White Balance to a specific setting
and all the photos you take will have
a consistent colour 'temperature', so
you'll spend less time in Photoshop
warming up or cooling down images."

Increase your ISO

"It may seem strange to increase your
ISO when using a tripod for landscape
photographs, but on really windy days
like today your camera will still move,
even on a tripod," says Jeremy. "As a
result, your shots will look a little soft
when using slower shutter speeds.
To ensure you get super sharp shots,
I recommend increasing the ISO from
100 to 200. This will enable you to
use faster shutter speeds, which will
produce sharp shots without any
noticeable 'noise'."

In addition to his favoured, full-frame Canon
EOS 5D, Jeremy uses the following kit to
capture his stunning landscape photos...

Canon 17-40mm f/4L USM lens
Canon 70-200mm f/4L USM lens
Canon EF 24-105mm f/4L USM lens
Gitzo GT2531EX Carbon 6X tripod
MagicBall tripod head
Hoya polarising filter
Singh Ray 'Galen Rowell' ND grad filters

HOT SHOT #1

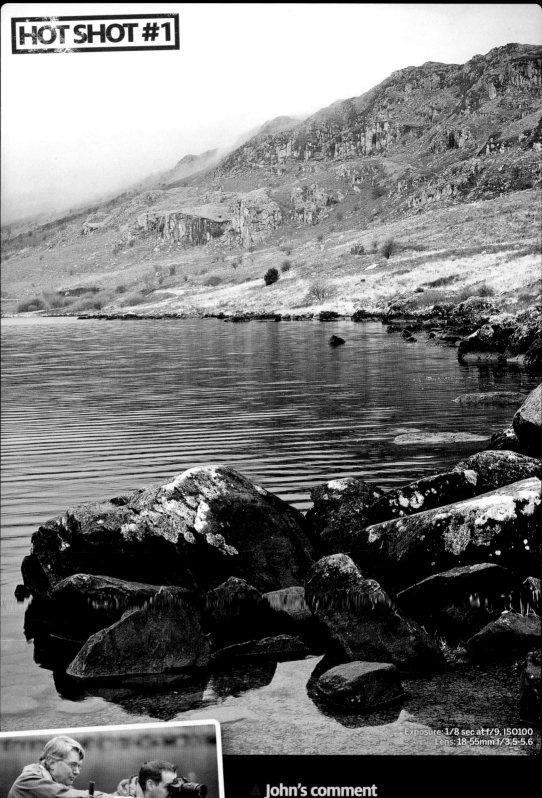

KILLER KIT OF THE PROS #1
OS maps

Like all good professional landscape photographers, Jeremy never leaves home without an Ordnance Survey (OS) map. "I'll study an OS map the day before a shoot to get a feel for the landscapes," he says. "As well as working out how to get to spots via roads or on foot using bridleways or footpaths, I work out good vantage points for photos and where the peaks and valleys are in relation to the rising and setting sun."

Exposure: 1/8 sec at f/9, ISO100
Lens: 18-55mm f/3.5-5.6

John's comment

"Not bad for my first attempt! Because the wind hadn't picked up the lake was flat, providing a glassy, subtle texture. Following Jeremy's advice, I positioned the rocks in the foreground to add some interest. He also encouraged me to try a vertical composition, which I prefer to the horizontal shots I'd taken before. The cloud and light levels were low, which made my original image look a little flat, so I used Photoshop to convert to black and white and to boost contrast to add some impact."

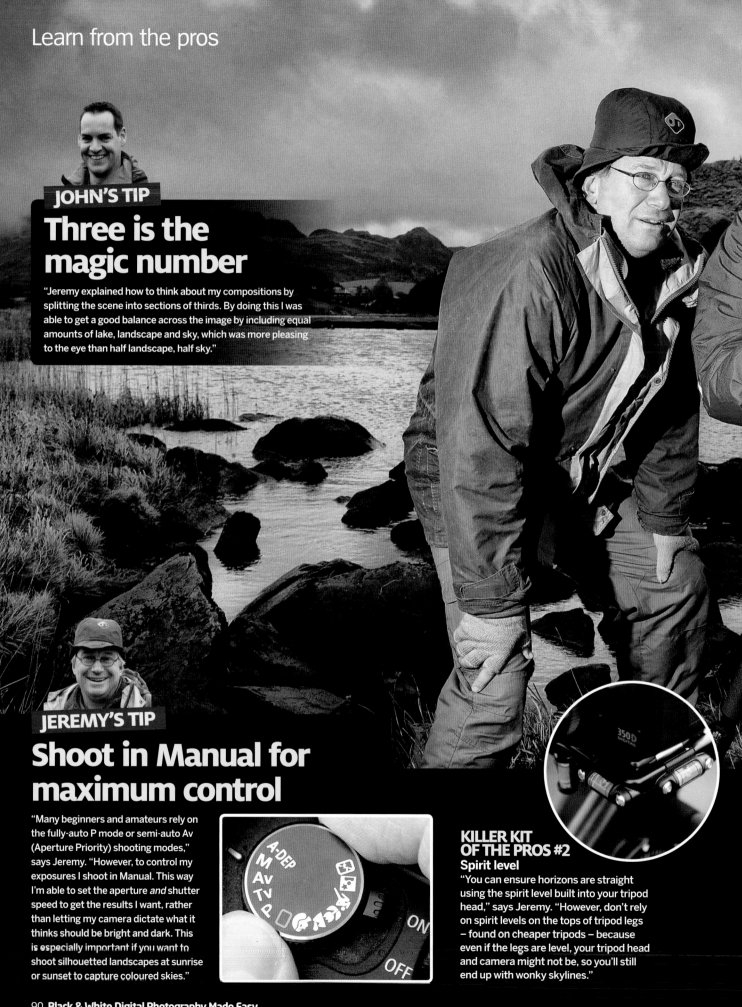

JOHN'S TIP

Three is the magic number

"Jeremy explained how to think about my compositions by splitting the scene into sections of thirds. By doing this I was able to get a good balance across the image by including equal amounts of lake, landscape and sky, which was more pleasing to the eye than half landscape, half sky."

JEREMY'S TIP

Shoot in Manual for maximum control

"Many beginners and amateurs rely on the fully-auto P mode or semi-auto Av (Aperture Priority) shooting modes," says Jeremy. "However, to control my exposures I shoot in Manual. This way I'm able to set the aperture *and* shutter speed to get the results I want, rather than letting my camera dictate what it thinks should be bright and dark. This is especially important if you want to shoot silhouetted landscapes at sunrise or sunset to capture coloured skies."

KILLER KIT OF THE PROS #2
Spirit level

"You can ensure horizons are straight using the spirit level built into your tripod head," says Jeremy. "However, don't rely on spirit levels on the tops of tripod legs – found on cheaper tripods – because even if the legs are level, your tripod head and camera might not be, so you'll still end up with wonky skylines."

KILLER KIT OF THE PROS #3
MagicBall tripod head

A tripod is only as good as its head, particularly when photographing landscapes, because you'll regularly set up on uneven ground and need to adjust your head to get your SLR perfectly level. "I love this MagicBall head," says Jeremy. "It's very quick and manoeuvrable, making it very simple to position, so I never miss a shot when the weather conditions are constantly changing."

▼ John's comment

"The wind had picked up at this point so, following Jeremy's advice, I increased the ISO to 200 for a slightly faster shutter speed that helped to minimise blur," says John. "Using my tripod, I aimed my camera downwards to reduce the amount of bland sky that would be in shot. This meant I could use the mossy rocks and tall grass to lead the eye down into the valley towards the lake and mountains I had positioned in the top third. Again, I used Photoshop to convert to mono and to increase the contrast and enhance the rocks in the foreground." ▶

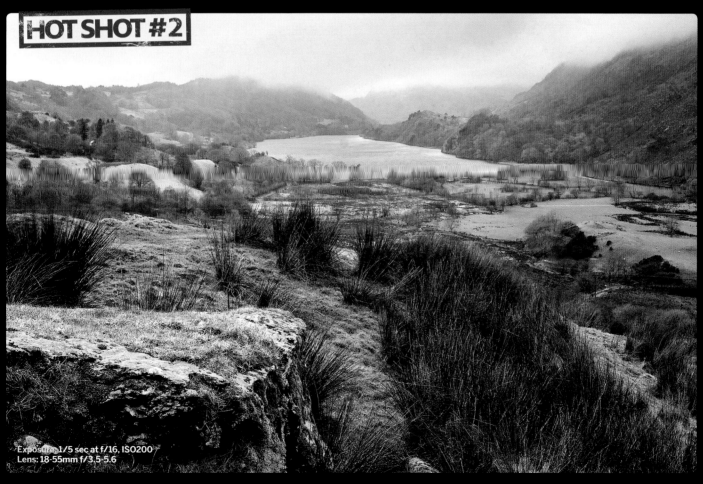

HOT SHOT #2

Exposure: 1/5 sec at f/16, ISO200
Lens: 18-55mm f/3.5-5.6

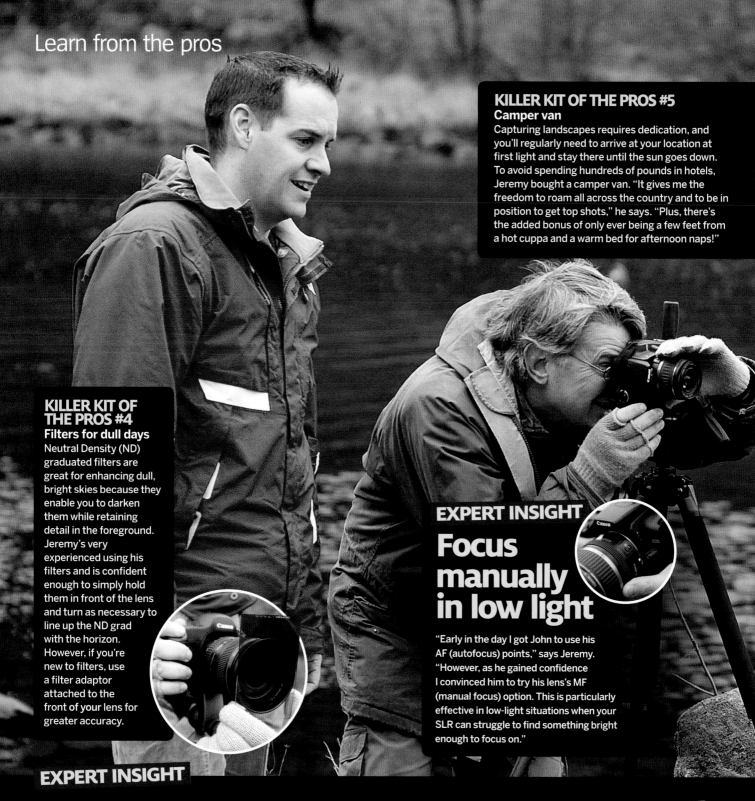

KILLER KIT OF THE PROS #5
Camper van
Capturing landscapes requires dedication, and you'll regularly need to arrive at your location at first light and stay there until the sun goes down. To avoid spending hundreds of pounds in hotels, Jeremy bought a camper van. "It gives me the freedom to roam all across the country and to be in position to get top shots," he says. "Plus, there's the added bonus of only ever being a few feet from a hot cuppa and a warm bed for afternoon naps!"

KILLER KIT OF THE PROS #4
Filters for dull days
Neutral Density (ND) graduated filters are great for enhancing dull, bright skies because they enable you to darken them while retaining detail in the foreground. Jeremy's very experienced using his filters and is confident enough to simply hold them in front of the lens and turn as necessary to line up the ND grad with the horizon. However, if you're new to filters, use a filter adaptor attached to the front of your lens for greater accuracy.

EXPERT INSIGHT

Focus manually in low light

"Early in the day I got John to use his AF (autofocus) points," says Jeremy. "However, as he gained confidence I convinced him to try his lens's MF (manual focus) option. This is particularly effective in low-light situations when your SLR can struggle to find something bright enough to focus on."

EXPERT INSIGHT

Use Depth of Field Preview

For successful landscape shots you need to make sure you're set up to capture the maximum depth of field (DoF) – how much of your image is acceptably in focus from front to back. "To check how much of your scene will be in focus use the DoF Preview button on your camera, if it has one," says Jeremy. "As you're looking through the viewfinder, press the DoF Preview button to 'stop down' to your current aperture setting.

You'll notice at narrower apertures (f/16, for example) most of the scene goes dark. Don't worry, your shots won't come out like that. Learn to look past the darkness and you'll be able to see which elements in your background will appear sharp. To see the difference, choose a wide aperture (f/5.6, for example) and press the button again. Your viewfinder won't go as dark and the background will now appear out of focus."

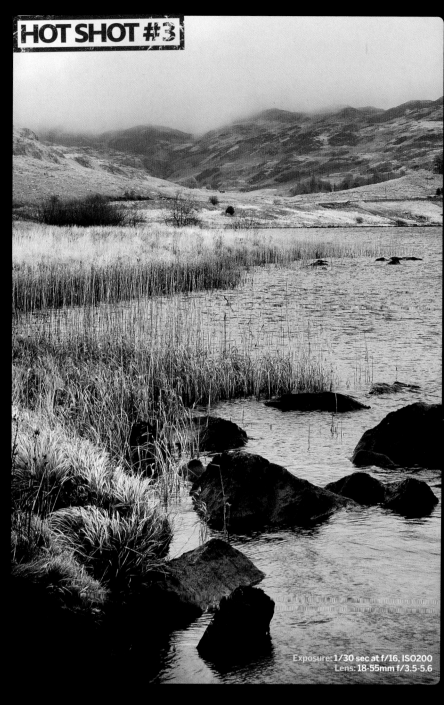

HOT SHOT #3

Exposure: 1/30 sec at f/16, ISO200
Lens: 18-55mm f/3.5-5.6

John's comment

"Jeremy told me that, when the sun's out and it's not too windy, you can get some stunning reflections of the mountains in this lake, but it was too overcast and cloudy when we were there! So instead, I decided to compose my shot vertically and used the rocks and long grass as foreground interest, with the grass in the central section leading you into the scene and towards the backdrop of mountains, which disappeared into the cloudy heavens. I cropped the image in Photoshop to lose some distracting rocks at the bottom, used the Clone tool to tidy up the edges, and then converted it to mono."

EXPERT INSIGHT

Remove colour to add impact

It's quick and easy to use Photoshop to convert images to black and white, which gives scenic shots a timeless feel – plus it's a great way of 'saving' those bland colour landscapes taken on dull days, which might otherwise be wasted.

Start with colour image

1 Before converting to mono, first boost contrast using the Brightness/Contrast window and Saturation with the Hue/Saturation tool. Set both to around +20.

Convert to black and white

2 Use Photoshop's built-in black and white conversion tool. We found the Green Filter preset worked best to bring out the vivid greens in this landscape.

Add a tint for a pro finish

3 Still in the Black and White window, click on Tint and set Hue to 233 and Saturation to 13% for a classy cool-blue tint. Boost the contrast one last time.

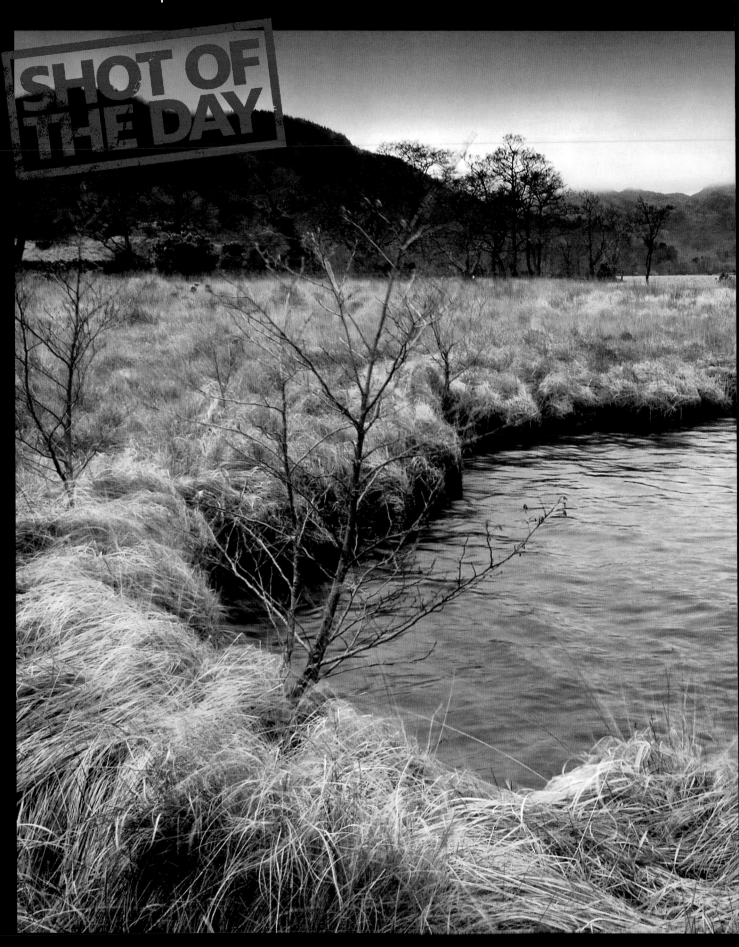

SHOT OF THE DAY

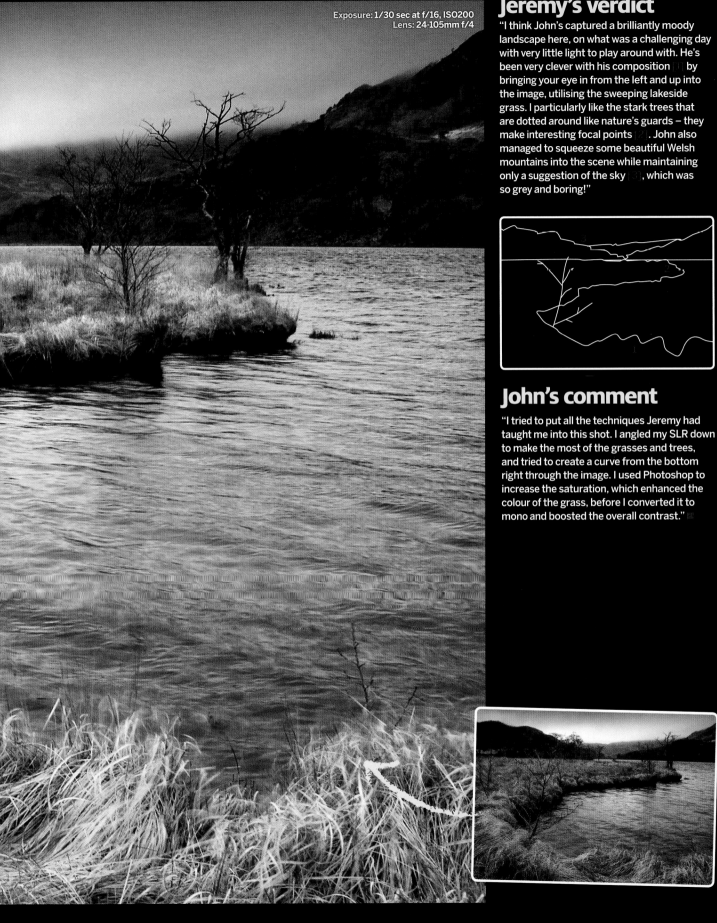

Exposure: 1/30 sec at f/16, ISO200
Lens: 24-105mm f/4

Jeremy's verdict

"I think John's captured a brilliantly moody landscape here, on what was a challenging day with very little light to play around with. He's been very clever with his composition [1] by bringing your eye in from the left and up into the image, utilising the sweeping lakeside grass. I particularly like the stark trees that are dotted around like nature's guards – they make interesting focal points [2]. John also managed to squeeze some beautiful Welsh mountains into the scene while maintaining only a suggestion of the sky [3], which was so grey and boring!"

John's comment

"I tried to put all the techniques Jeremy had taught me into this shot. I angled my SLR down to make the most of the grasses and trees, and tried to create a curve from the bottom right through the image. I used Photoshop to increase the saturation, which enhanced the colour of the grass, before I converted it to mono and boosted the overall contrast."

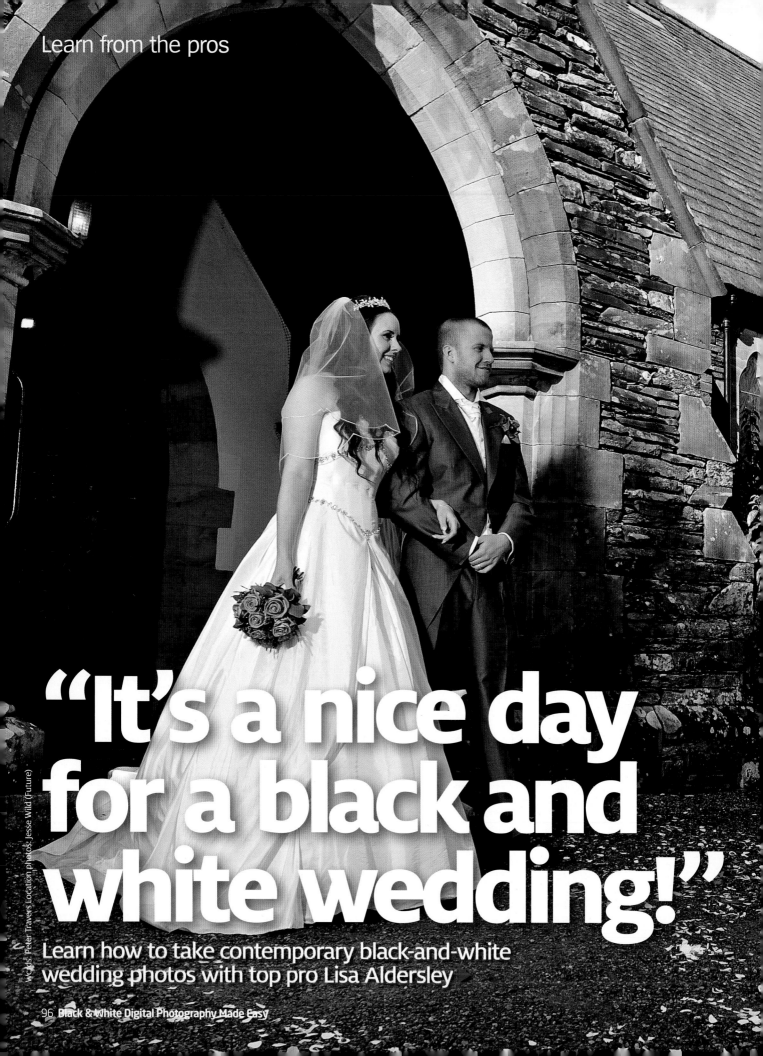

"It's a nice day for a black and white wedding!"

Learn how to take contemporary black-and-white wedding photos with top pro Lisa Aldersley

THE PRO...

Name: **Lisa Aldersley**
Camera: **Canon EOS 5D Mk II**

Bolton-based photographer Lisa, 42, has been shooting weddings professionally for seven years, and full-time for five. Lisa also works as a trainer with the Aspire Photography Training studio (www. aspirephotographytraining.co.uk) and has lots of experience of teaching amateurs the ways of reportage wedding photography. More info on Lisa and her gallery at www.la-photography.co.uk.

THE APPRENTICE...

Name: **Dr Howard Gould**
Camera: **Canon EOS 50D**

Howard, 53, has a doctorate in physics and over 30 years experience as a teacher. Howard's been a keen amateur photographer since the early '80s, and has photographed six weddings to date. He wanted help improve his wedding photography as he says, "My shots look like snaps, and too posed."

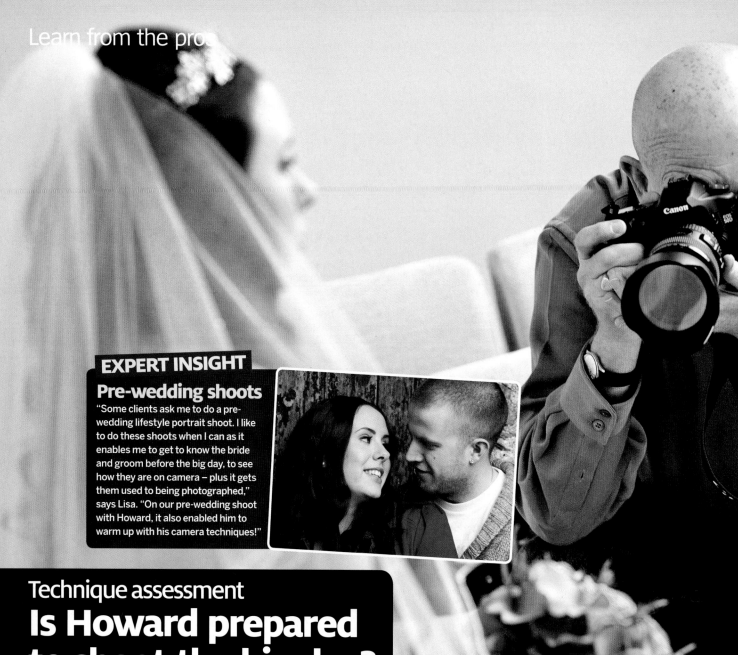

Pre-wedding shoots

"Some clients ask me to do a pre-wedding lifestyle portrait shoot. I like to do these shoots when I can as it enables me to get to know the bride and groom before the big day, to see how they are on camera – plus it gets them used to being photographed," says Lisa. "On our pre-wedding shoot with Howard, it also enabled him to warm up with his camera techniques!"

Technique assessment

Is Howard prepared to shoot the big day?

After the pre-wedding shoot with bride and groom, Janine and James, Lisa reviewed Howard's camera settings and suggested few tweaks to help him improve his results

METERING MODE

Metering mode
Center-weighted average

White balance
Auto

CENTRAL AF POINT

AF point selection
Manual selection

Canon

Accurate exposures

"I suggested Howard switched from the Evaluative metering mode to Centre-weighted Average metering," says Lisa, "This is because the people he photographs at the wedding will generally be central in his frame, which means his D-SLR will be able to expose them more accurately for more consistent results. This will speed up any post-processing work after the big day as well."

Keep focussed

"I encouraged Howard to manually select the central AF (autofocus) point as it's quicker to focus, hold the shutter button down as he recomposes, and then take the shot – rather than cycling through different AF points," explains Lisa. "This also works well with Centre-weighted Average metering as you can focus on your subjects in the centre of your frame to fix your focusing *and* metering."

Lisa uses two full-frame Canon EOS 5D Mk II D-SLRs for big, top-quality images, and because they're lighter (and cheaper) than two EOS-1Ds cameras. She also uses the following pro Canon lenses and kit:

Canon EF 35mm f/1.4L USM
Canon EF 50mm f/1.2L USM
Canon EF 100mm f/2.8 USM Macro
Canon EF 24-70mm f/2.8L USM
Canon EF 70-200mm f/2.8L IS USM
Canon 580EX II Speedlite flashgun
Apple MacBook Pro laptop

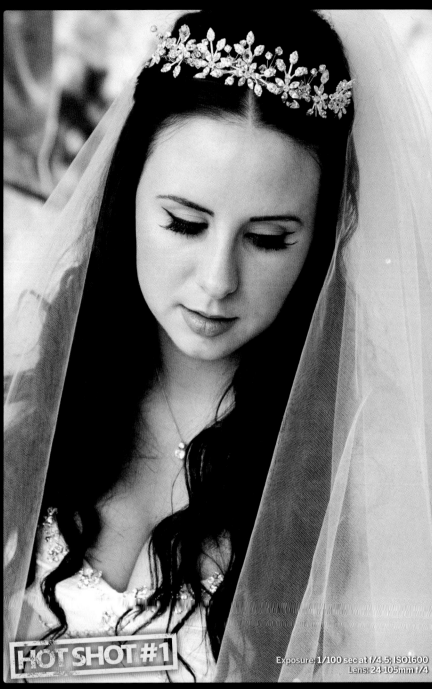

HOT SHOT #1

Exposure: **1/100 sec at f/4.5**; **ISO1600**
Lens: **24-105mm f/4**

▶ Howard's comment

"I managed to get this intimate portrait of the bride, Janine, while she was having her make-up and hair done in the morning at the hotel. I used a wide ▮▮▮▮▮▮▮▮ f/4.5 and focused on her eyes. I asked her to look down to make her look more thoughtful. This was shot using natural window light on her face, with an ISO of 1600. I converted it to black and white in Photoshop for added impact and emotion."

Get connected

"Howard's a scientist, and unfortunately kept getting bogged down by the science and technical aspects of wedding photography," smiles Lisa, "I explained that he needs to stop worrying about the knobs and buttons on his camera, and start concentrating on bonding with his bride and groom – and their family and friends – who he's photographing. If you can't connect with them, it will show in their facial expressions, and your results will lack that essential spark." ▶

KILLER KIT OF THE PROS #1
70-200mm f/2.8 telephoto zoom

A 70-200mm lens with a fast constant aperture of f/2.8 is ideal for reportage wedding shooting as you can stand back but still fill the frame, while the wide aperture enables you to shoot in low light and to really blur backgrounds so your subjects stand out in shot. "I swear by the pro L-series Canon EF 70-200mm f/2.8L IS USM lens, it's so reliable, fast to focus, has Image Stabilization for sharper shots, and is well balanced on my 5D Mk II bodies."

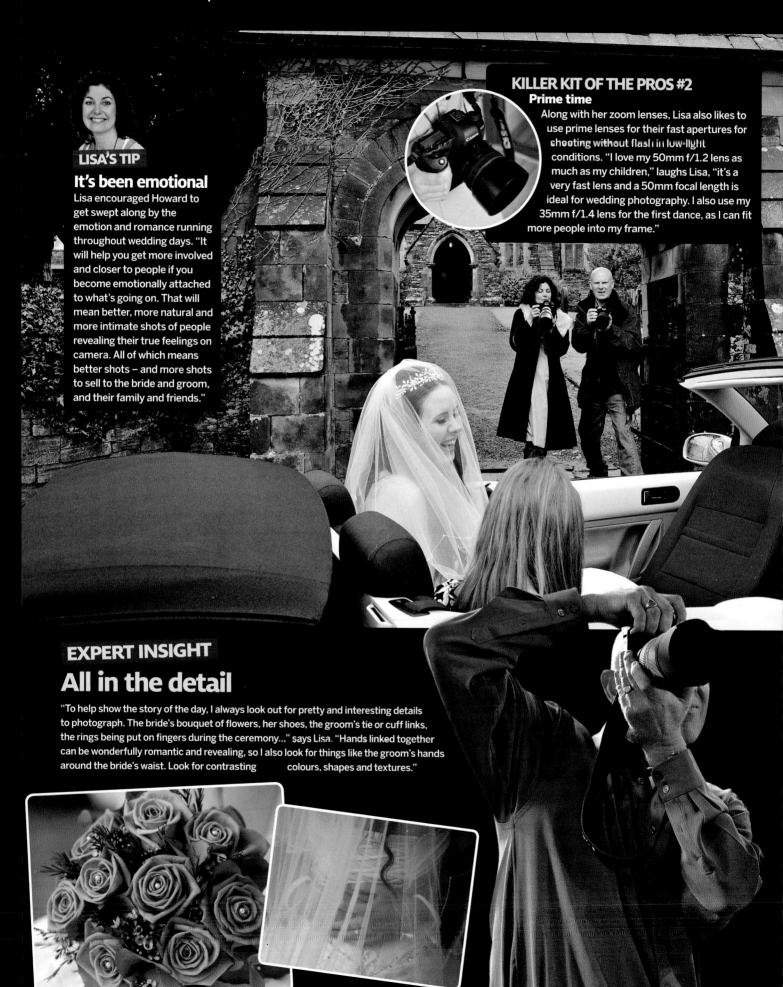

LISA'S TIP

It's been emotional

Lisa encouraged Howard to get swept along by the emotion and romance running throughout wedding days. "It will help you get more involved and closer to people if you become emotionally attached to what's going on. That will mean better, more natural and more intimate shots of people revealing their true feelings on camera. All of which means better shots – and more shots to sell to the bride and groom, and their family and friends."

KILLER KIT OF THE PROS #2
Prime time

Along with her zoom lenses, Lisa also likes to use prime lenses for their fast apertures for shooting without flash in low-light conditions. "I love my 50mm f/1.2 lens as much as my children," laughs Lisa, "it's a very fast lens and a 50mm focal length is ideal for wedding photography. I also use my 35mm f/1.4 lens for the first dance, as I can fit more people into my frame."

EXPERT INSIGHT

All in the detail

"To help show the story of the day, I always look out for pretty and interesting details to photograph. The bride's bouquet of flowers, her shoes, the groom's tie or cuff links, the rings being put on fingers during the ceremony..." says Lisa. "Hands linked together can be wonderfully romantic and revealing, so I also look for things like the groom's hands around the bride's waist. Look for contrasting colours, shapes and textures."

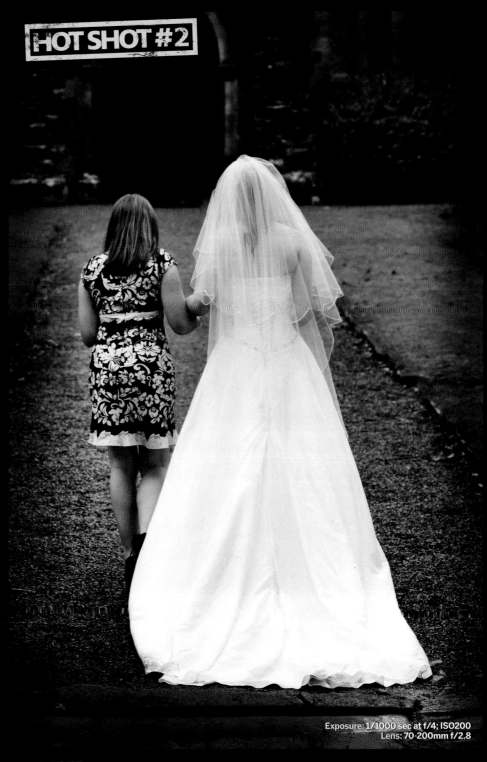

Exposure: 1/1000 sec at f/4; ISO200
Lens: 70-200mm f/2.8

HOWARD'S TIP

Controlling depth of field

"I learned from Lisa to shoot in the Av mode (Aperture Priority), setting my camera to f/2.8 and f/4, to capture a shallow depth of field to lift my subjects out of their surroundings. This helped my shots look less like snaps and more pro! I also tried to use longer focal lengths to enhance the shallow depth of field – my 24-105mm f/4 lens at the long end, and Sigma 70-200mm f/2.8."

LISA'S TIP

Image quality settings

"I encouraged Howard to shoot in RAW as it's the highest image quality setting and gives him more control when editing his images – which is helpful when you've had to expose correctly for white wedding dresses and black wedding suits," says Lisa. "Yet I reminded him you still need to capture the emotion and soul, as you can't add that in later in Photoshop!"

Howard's comment

"It was a wet day, but fortunately stopped raining as the bride arrived at the church. I'd been listening to Lisa's advice, and tried to capture a tender, romantic shot of the bride on her way to get married; shooting from behind rather than in front. Using a Sigma 70-200mm f/2.8 lens enabled me to focus tightly on the bride and her maid-of-honour, with the path leading up to the church doorway. Again, I converted it to black and white to suit the mood of the shot."

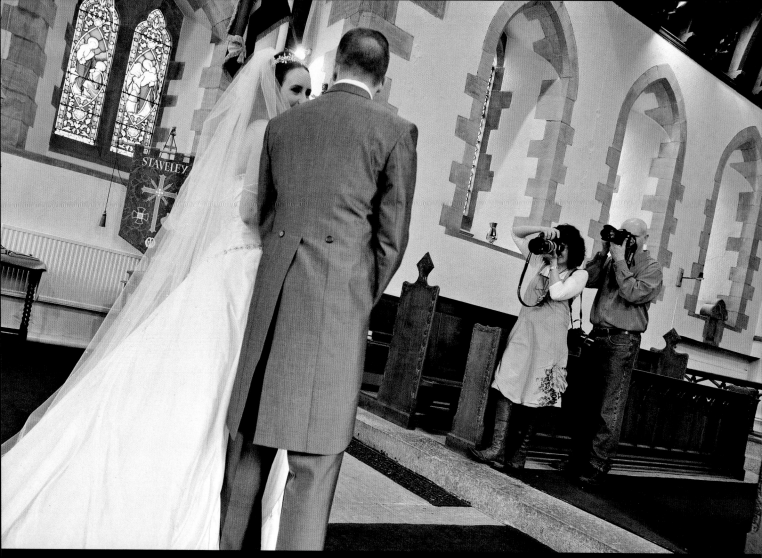

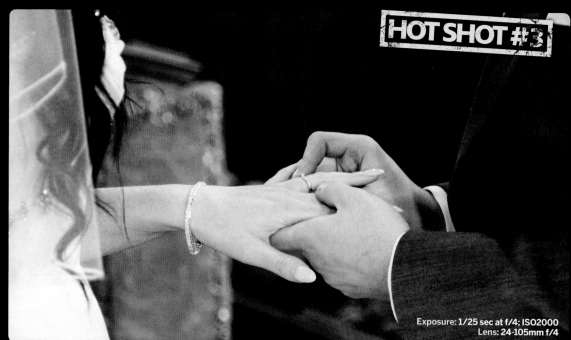

LISA'S TIP

No flashing, please!

When shooting weddings in churches, it's rare that you'll be able to use flash. Flashguns can also take a while to recycle, and you won't get a second chance to shoot those key moments on the day! "Flashes also draw attention to you, which won't help if you're trying to blend into the background to capture natural, reportage-style shots," says Lisa, "These are all more reasons why I shoot using natural light and just increase my ISO as necessary."

Exposure: 1/25 sec at f/4; ISO2000
Lens: 24-105mm f/4

Howard's comment

"We'd got all the traditional wider shots of the bride and groom at the altar, but I preferred this tighter composition, focusing on the exchanging of the rings. It was very dark inside the church, so I was really pushing my camera, shooting at ISO2000, and thanks to the image stabilisation on my lens, my shot was still sharp, even though I was shooting with a slow shutter speed of 1/25 sec and at a focal length of 105mm."

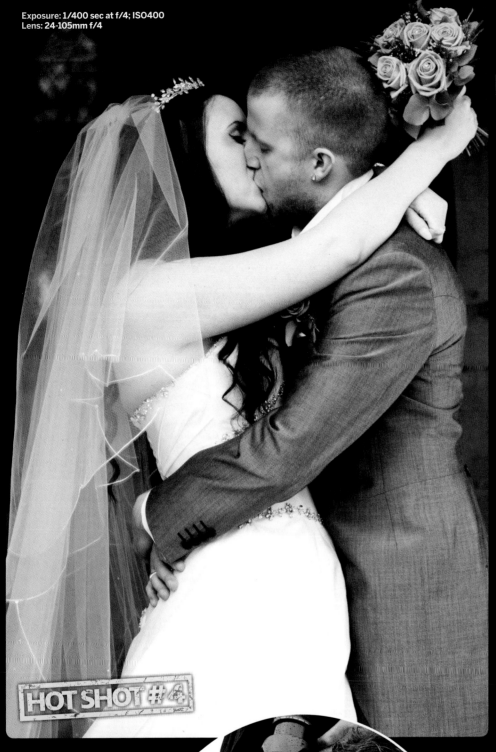

Exposure: 1/400 sec at f/4; ISO400
Lens: 24-105mm f/4

EXPERT INSIGHT

High-ISO action

"Many amateurs are surprised when I tell them I very rarely shoot using flash. As a reportage wedding photographer, it's essential for me to be able work quickly, and to capture people in (literally) natural light for natural-looking results. Flash light would mean unnatural shots," reveals Lisa. "Instead I use available light and increase my ISO as required to achieve fast enough shutter speeds to shoot handheld Trust in your camera's high-ISO performance. I'm confident shooting as high as ISO3200 on my 5D Mk II D-SLRs, and we worked out Howard's 50D was fine up to about ISO2500, which was more than enough when we were shooting in low light inside the church."

◀ Howard's comment

"A wedding album wouldn't be complete without a shot of the bride and groom embracing after the marriage vows. The couple stood in the church doorway so we could make use of the available light, while we made sure they were in shadow to avoid squinting and sunlight on their faces. I love the unabashed clinch and that the bride's still holding on to her bouquet. I then converted it to black and white to keep the romantic feel and for consistency."

HOT SHOT #4

KILLER KIT OF THE PROS #3
Lens hoods

"Not only do lens hoods reduce unwanted light and flare reaching your lenses to spoil your shots, they're also great for keeping rain off the end of your lenses when shooting in wet weather," says Lisa. "Some Canon lenses don't come with hoods, but I always buy them and keep them on my lenses."

HOWARD'S TIP

Beeping 'eck!

"Turn the beep off on your camera so it's not going off every time you focus on people, it annoys the congregation and vicar in the church, as well as drawing unwanted attention when you're trying to subtly take photos and go unnoticed in the background."

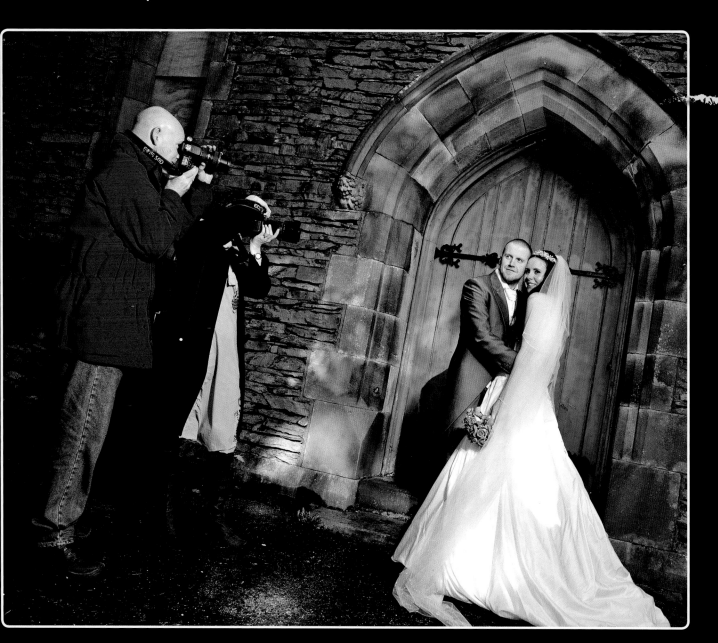

SHOT OF THE DAY

Lisa's verdict

"Howard did very well on the big day and, although he found shooting non-posed photos quite hard, he rose to the challenge admirably. In this shot his composition is strong and well balanced, using the shape of the doorway to frame the couple [1]. Using this old doorway gives this image a great contemporary feel [2]. By building up good rapport with the couple he was able to capture a very personal pose [3] and one that they will surely choose for their wedding album."

Howard's comment

"After the ceremony we walked the bride and groom to an old doorway around the corner from the church. Using my 24-105mm lens at 45mm enabled me to get more of the surrounding doorway in shot – I love its shape and the way it frames the couple – and I intentionally left space around them. As the doorway was shaded by some big trees, it meant there aren't any distracting shadows on the couple."

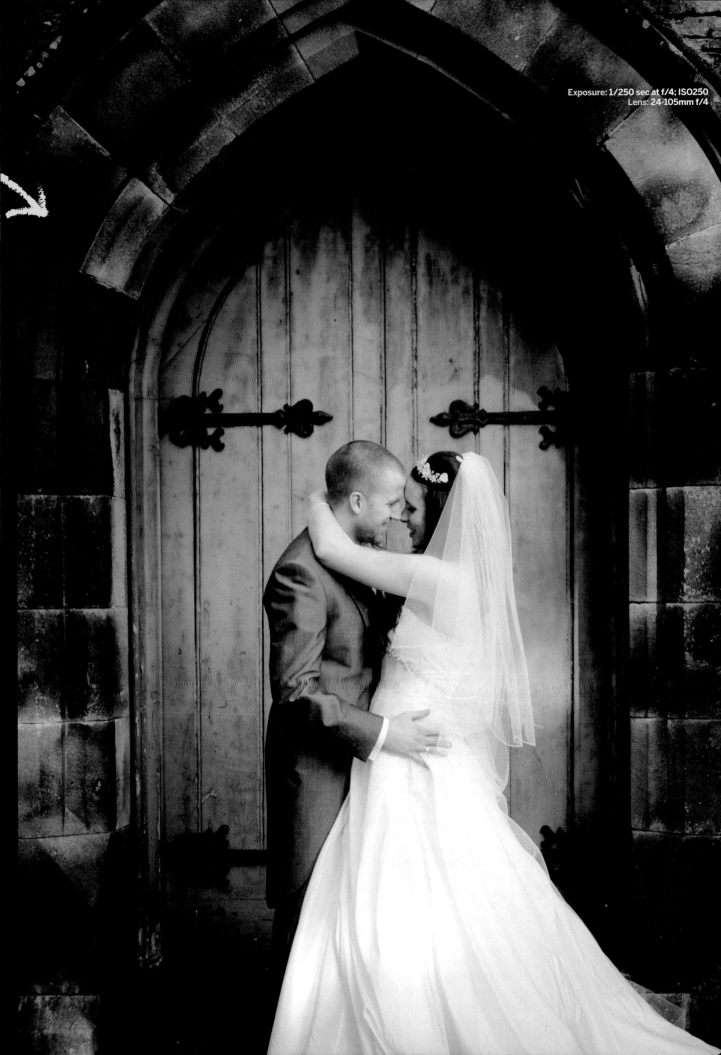

Exposure: 1/250 sec at f/4; ISO250
Lens: 24-105mm f/4

Learn from the pros

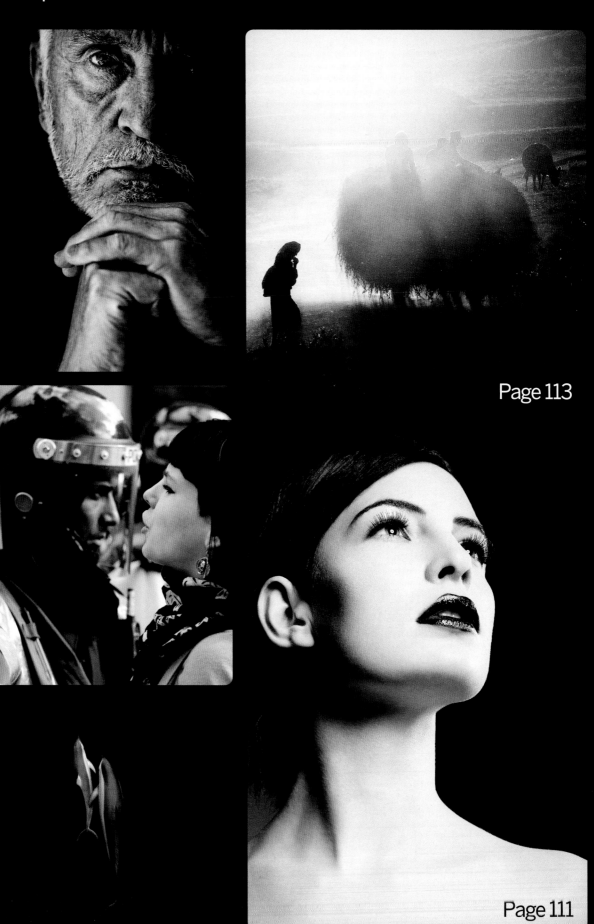

Page 132

Page 113

Page 129

Page 136

Page 111

Page 122

Hotshots 3

30 pages packed with a wide range of stunning black-and-white images by talented photographers from all across the globe

Page 120

Page 118

Hotshots

Roker Pier

Jeff Vyse

UK

"This was taken as the sun was setting using a 10-stop ND filter for a long exposure. The viewpoint was chosen to accentuate the curve. I converted to mono using Silver Efex Pro to achieve a good balance of tones, and also cloned out some people to clean it up a bit."

Nikon D90 with AF-S DX Nikkor 18-105mm VR at 90mm; ISO100; 221 secs at f/20

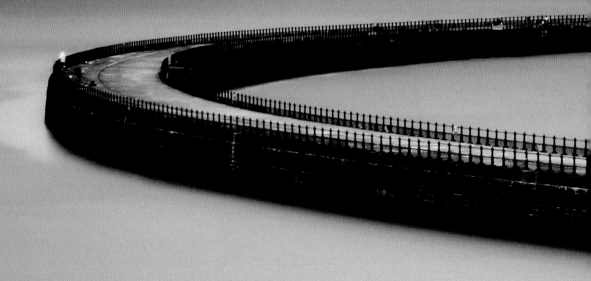

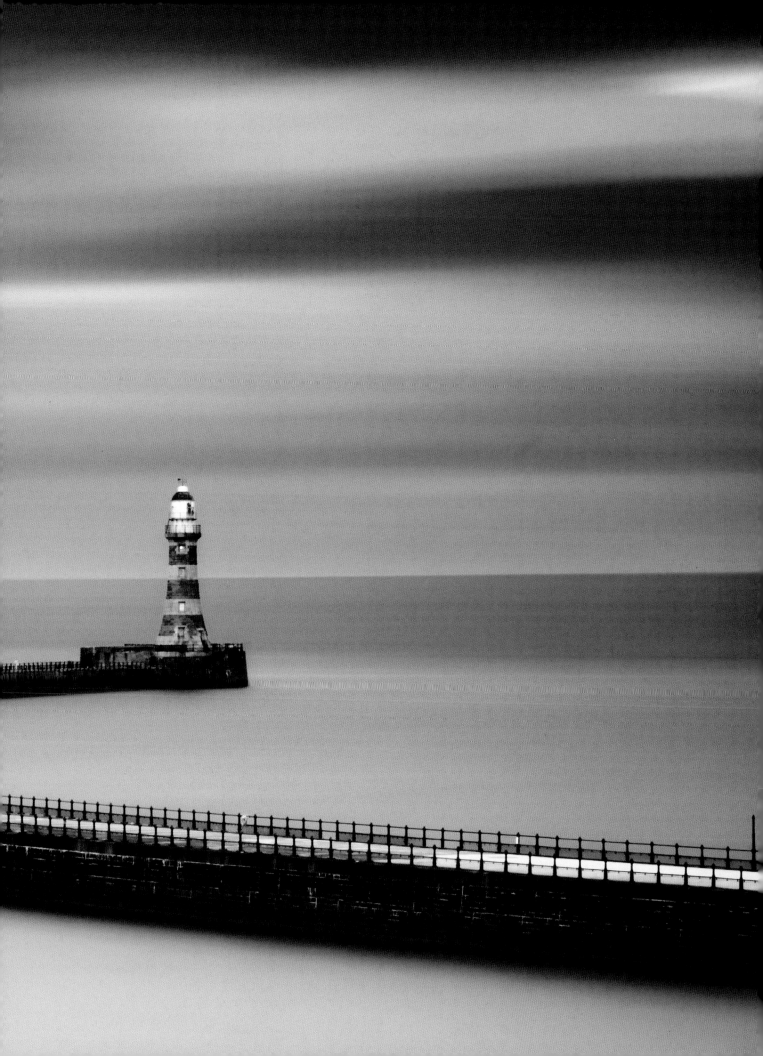

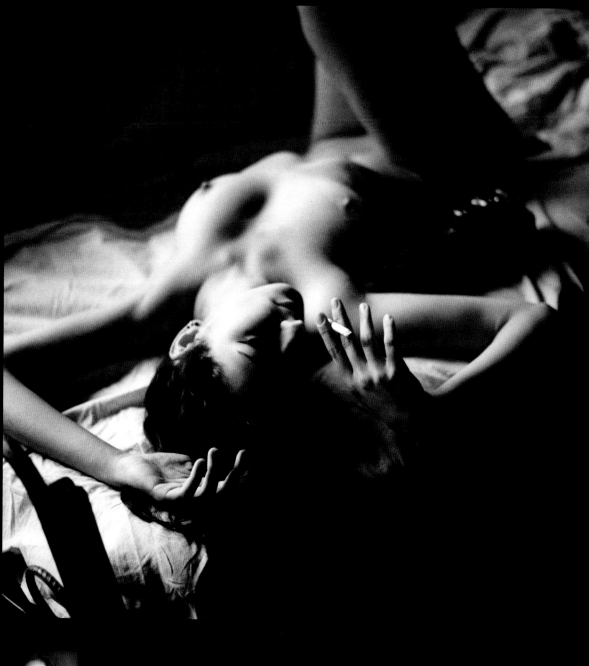

The Ballad
of the Absent

Ana Cernoschi
ROMANIA

"The image was made as part of a
photography workshop organised
by my photo club, and is part of a
bigger series."

**Hasselblad H3 with Planar 50mm 1/2.8; ISO100;
1/125 sec at f/5.6**

Kayt

Brian Rolfe
UK

"This shot of Kayt is an example of how simple lighting can produce
great results. I had a single Bowens 500R head with a gridded silver
beauty dish above and right of camera. I converted to black and
white in Capture One Pro then retouched in Adobe Photoshop."

Canon EOS 5D Mk II with EF 24-105mm f/4L IS USM at 100mm; ISO100; 1/125 sec at f/9

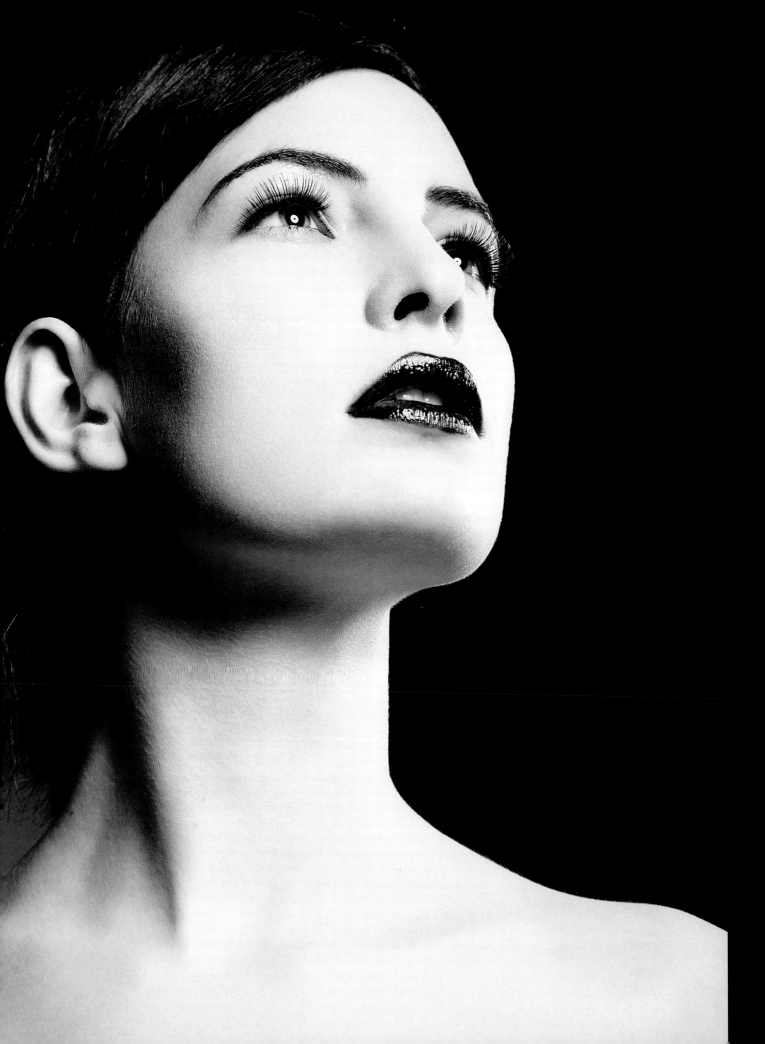

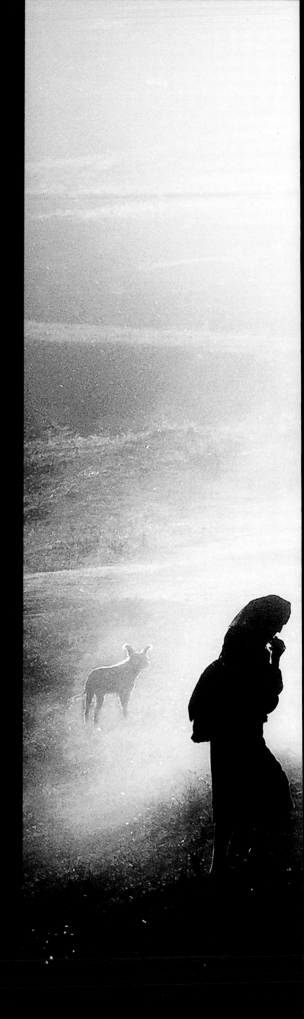

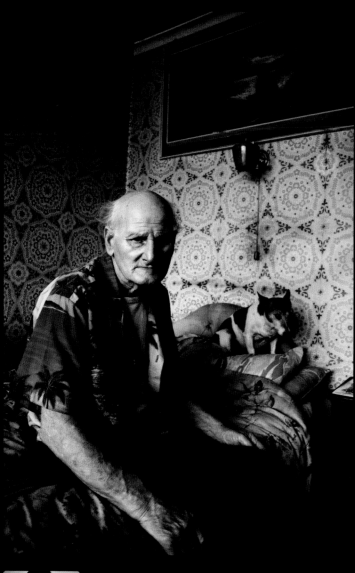

Jimmy and the Jacks

Jim Mortram

UK

"Jimmy was and is a local legend. He'd hold audience with anyone that stopped to listen, rolling out tales in a thick Irish brogue. Little by little our street talks blossomed into long conversations back at Jimmy's home. Tales of life in Ireland as a boy and young man, a father that absconded leaving 13 children, hard times. Tales of life in London during the 1960s, 'no blacks, no dogs, no Irish' in pub windows. Hard times."

Nikon D200, 18-70mm f/3.5-4.5G DX IF-ED at 18mm; ISO250; 1/60 sec at f2.5

Countryside in Romania

Bogdan Panait

ROMANIA

"A typical country scene at the end of a day near a small village in Romania showing local people returning to their homes after a full day's work in the field."

Nikon D200 with Nikkor 70-300mm f/4 5-5.6 at 300mm; ISO100; 1/500 sec at f/11

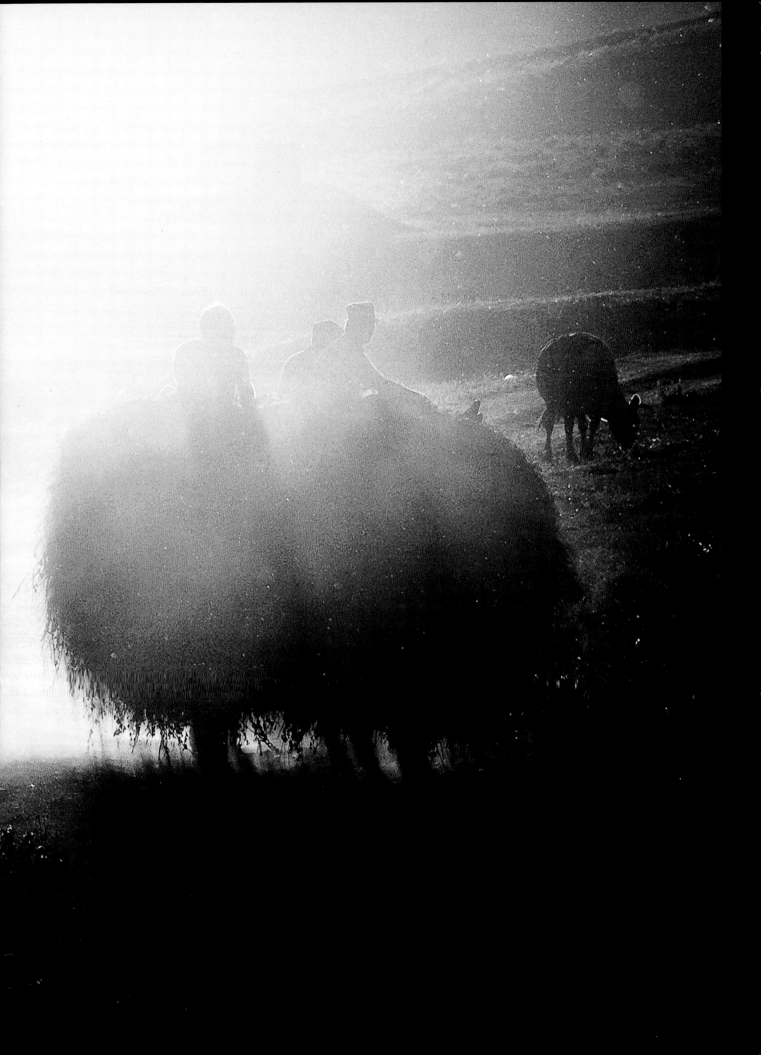

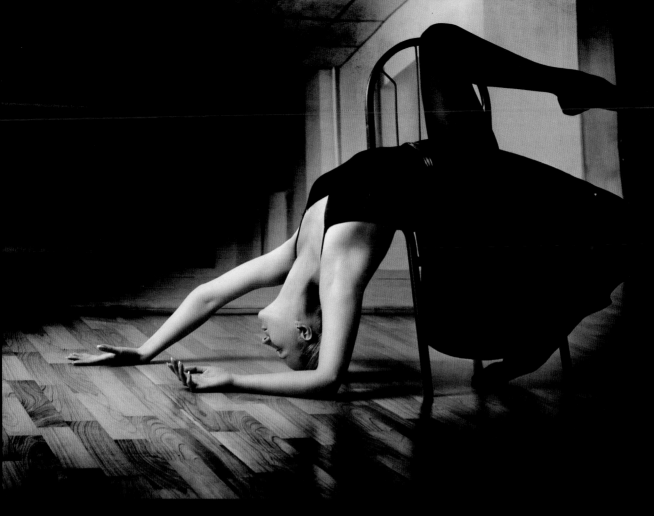

Lady on
the Chair

Almaz Junukeyev

REPUBLIC OF KAZAKHSTAN

"This photo was commissioned for
a ballet dancer. This photo is my
favourite of many taken during the
shoot. I posed the dancer and used
the light to help me capture the grace
of her body."

**Nikon D70s with Nikor 17-55mm f/2.8 at 50mm;
ISO100; 1/100 sec at f/5.6**

Face Off

Ashim Dey

INDIA

"As the model's dress was made of
black-and-white fabric, I decided to
photograph her inside, using studio
lighting. To complement the mono
design I went for a high-key effect."

**Nikon D80 with Nikkor 18-70mm ED DX at 31mm;
ISO100; 1/160 sec at f/10**

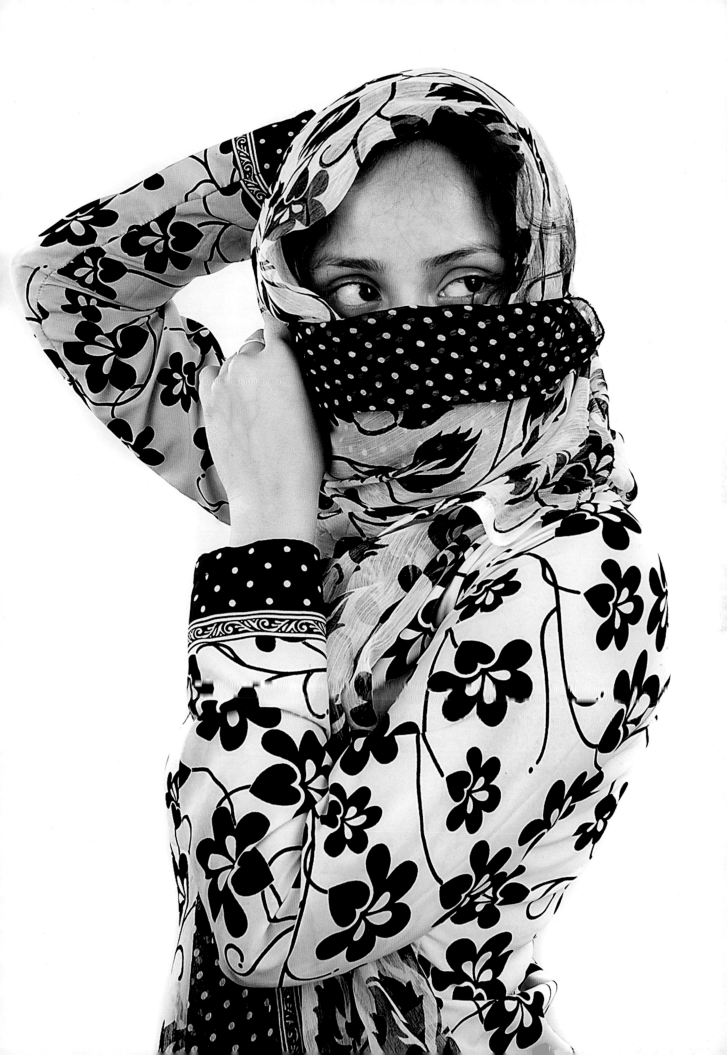

Hotshots

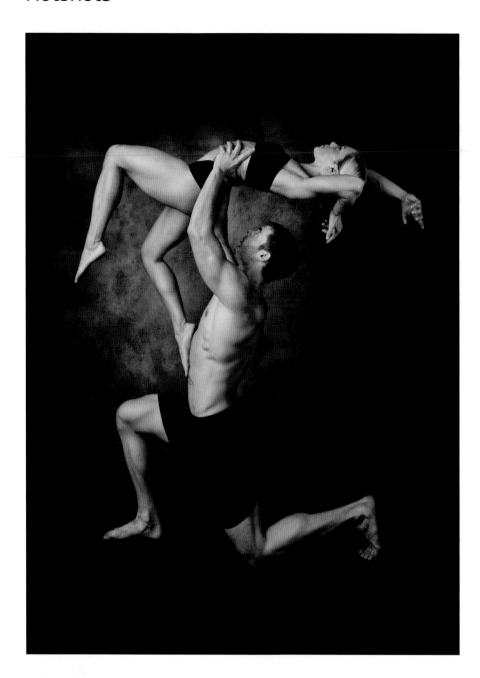

Balance
Marc Aviles

USA

"Michelle and Marcel both work in the
fitness industry and used this photo
for their portfolio. I took this in a studio
using two lights, one as the main light,
to give a sense of direction, and the
other as a fill light."

Canon EOS 5D Mk II with Canon EF 24-105mm f/4L
IS USM at 28mm; ISO125; 1/160 sec at f/9

The Butterfly Effect
Abdul Kadir Audah

UK

"The original photo was taken in a butterfly
garden, it was of a boy playing with butterflies.
I eliminated the background by adjusting the
light and contrast in Photoshop CS5, blended it
with a worn leather texture layer, then toned the
image to sepia and added a frame."

Nikon D200 with Nikkor 105mm and SB-800 flash; ISO200;
1/160 sec at f/9

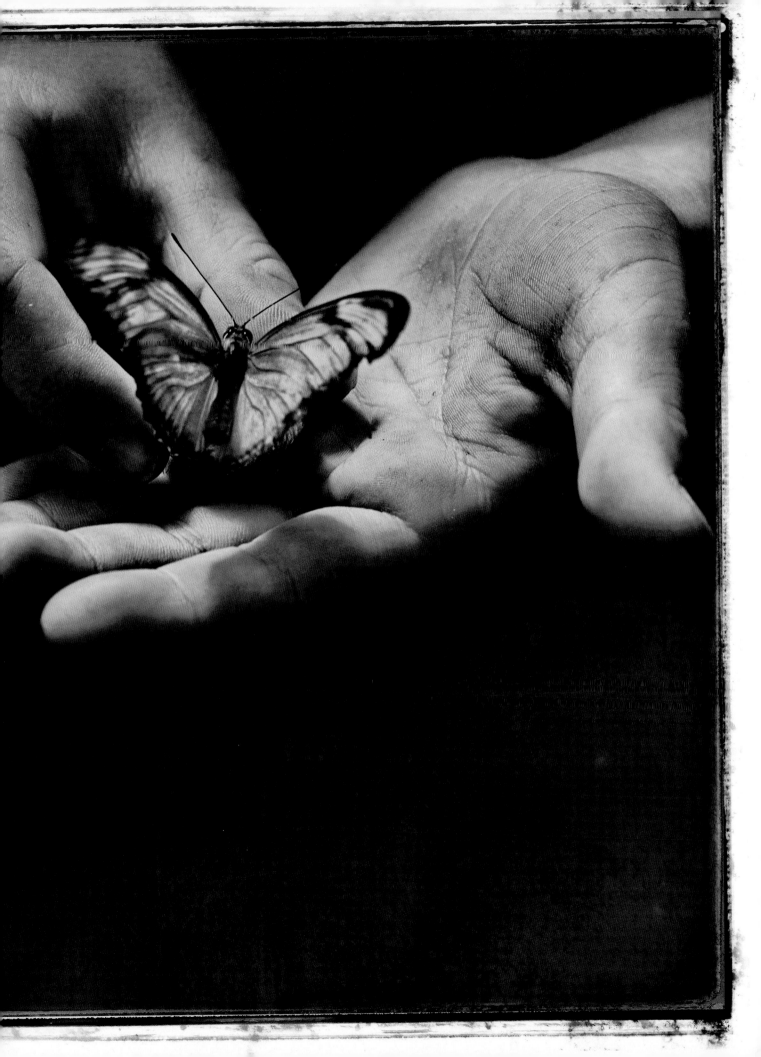

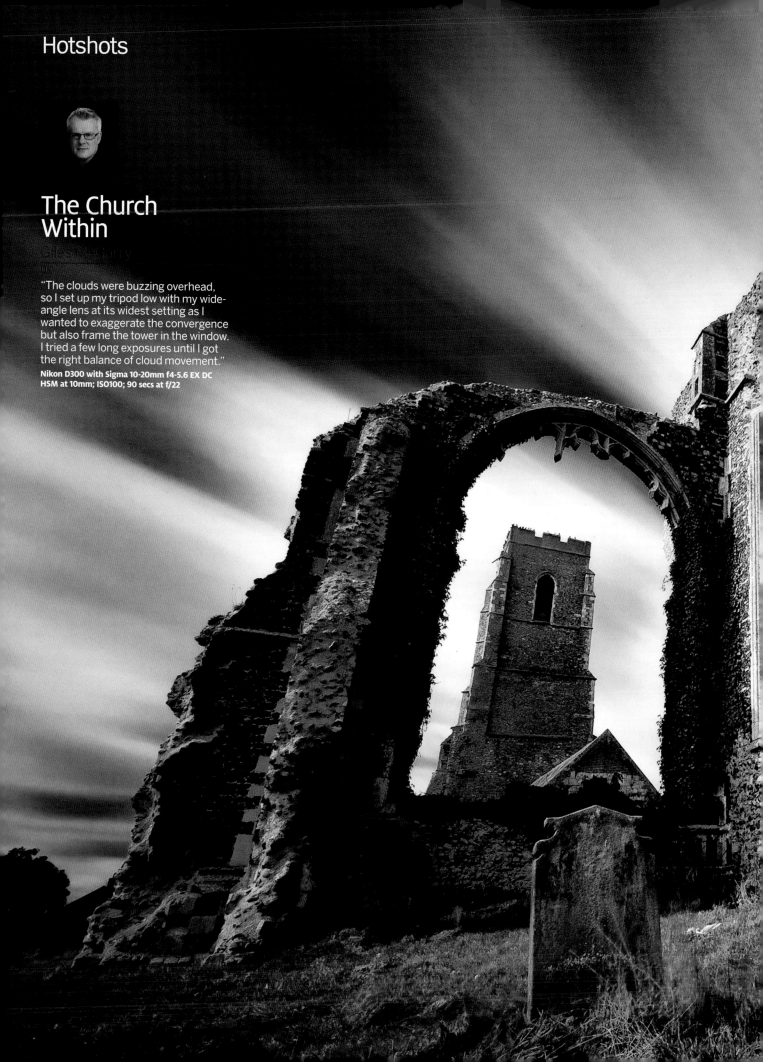

The Church Within

Giles McGarry
UK

"The clouds were buzzing overhead, so I set up my tripod low with my wide-angle lens at its widest setting as I wanted to exaggerate the convergence but also frame the tower in the window. I tried a few long exposures until I got the right balance of cloud movement."

Nikon D300 with Sigma 10-20mm f4-5.6 EX DC HSM at 10mm; ISO100; 90 secs at f/22

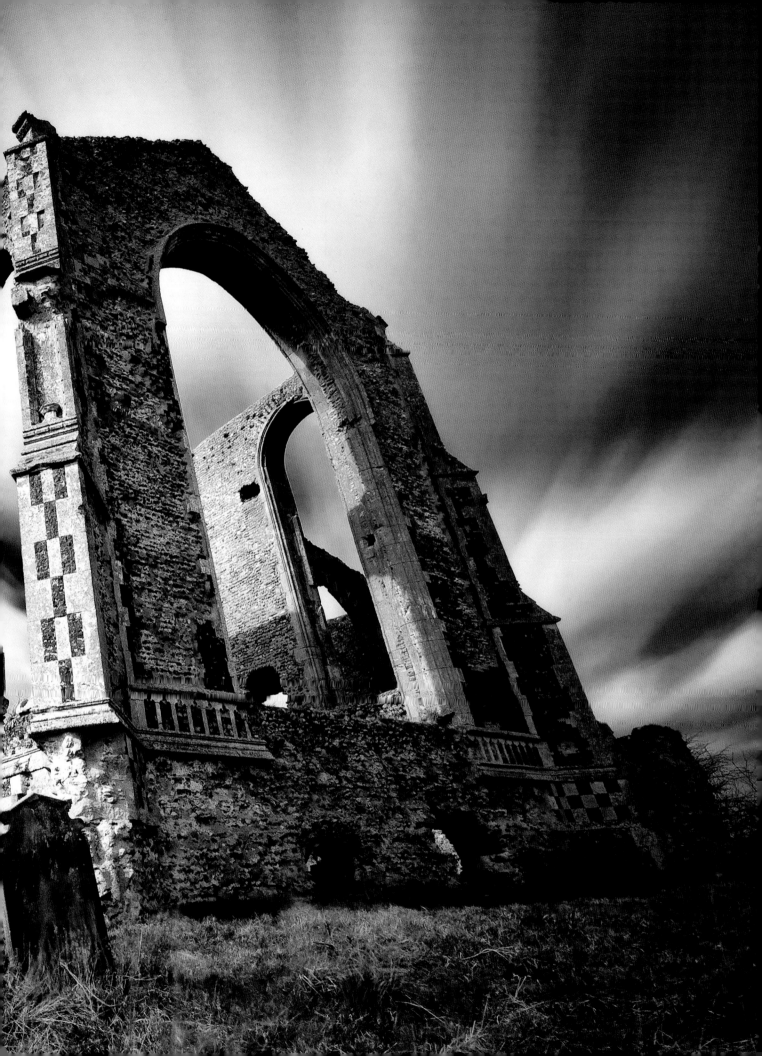

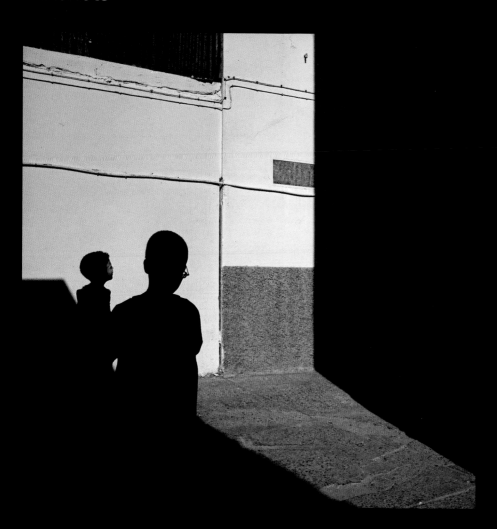

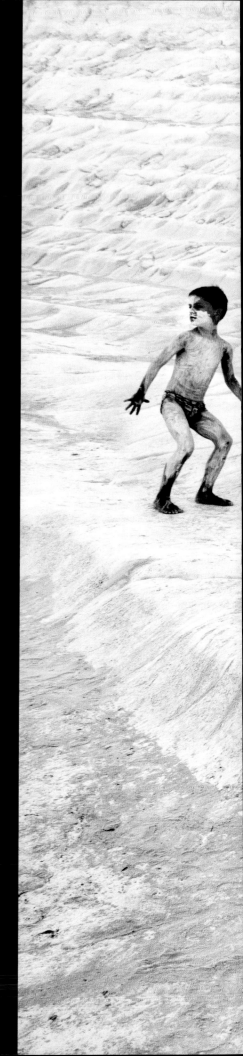

Before the Game

Pawel Miszewski

POLAND

"Rather than shoot the bright colours of Morocco, I decided to pre-visualise my shots with a view to converting to mono in the digital darkroom. I added a heavy grain during processing as a contrast to the strong sun rays."

Sigma DP1 with 28mm fixed focal lens; ISO100; 1/200 sec at f/8

Trinacria

Rosario Leotta

SICILY

"This was shot in a bay in Sicily – the children are not posed, they were playing with mud."

Canon EOS 400D with Sigma 18-50mm EX DC f/2.8 at 18mm; ISO100; 1/320 sec at f/5.6

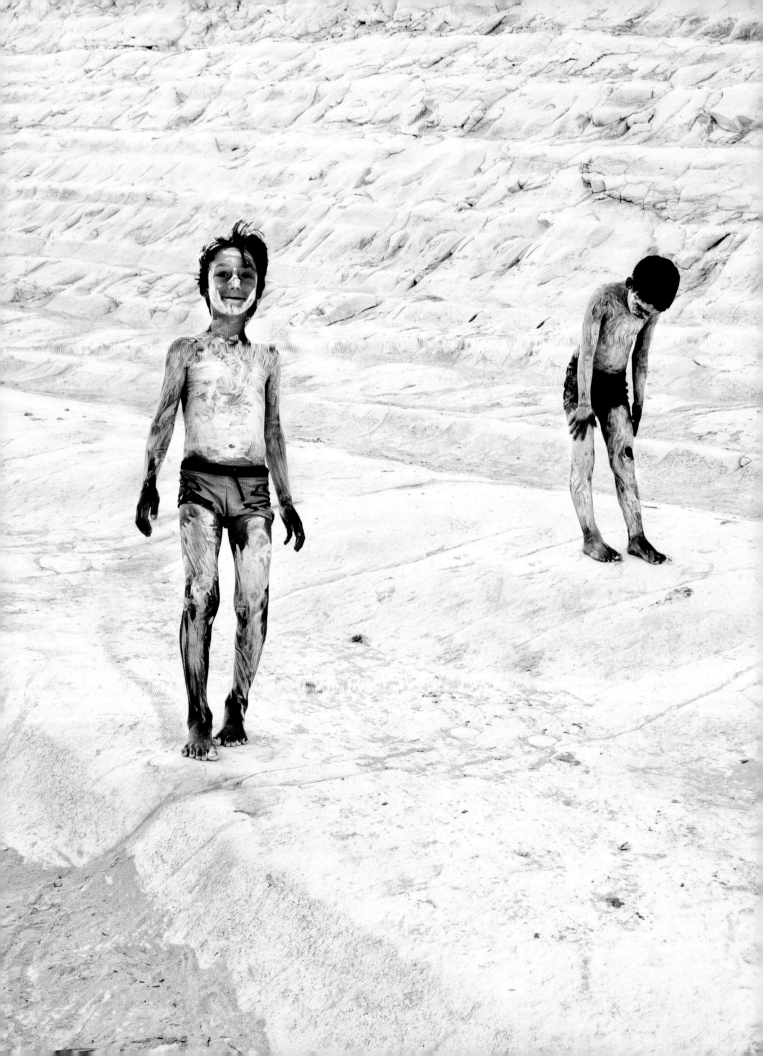

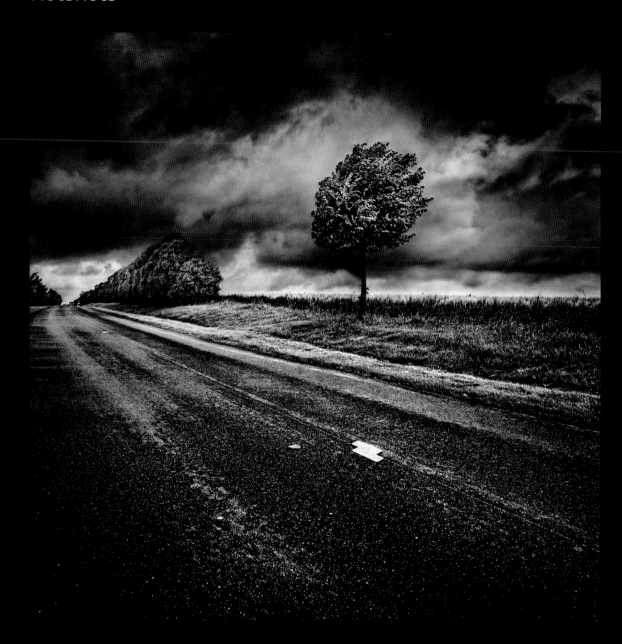

Storm

Lionel Huc

FRANCE

"This image was taken at the Vendée.
I took the photograph one day when
there was a big storm with heavy
winds blowing this tree."

**Nikon D700 with Nikkor 24-70mm f/2.8 at 35mm;
ISO200; 1/200 sec at f/11**

Greg Red Collection

Anna Bednar

POLAND

"This was made to promote a collection
by fashion designer Grzegorz Skwara. I
used simple light, with an octabox softbox
above the model and barn doors for the
background. I used an apartment undergoing
renovation for the location, with paint cans
and so on to get the appropriate effect."

**FujiFilm Finepix S5 Pro with Nikkor DX 18-70mm
f/3.5-4.5mm at 34mm; ISO100; 1/60 sec at f/6.3**

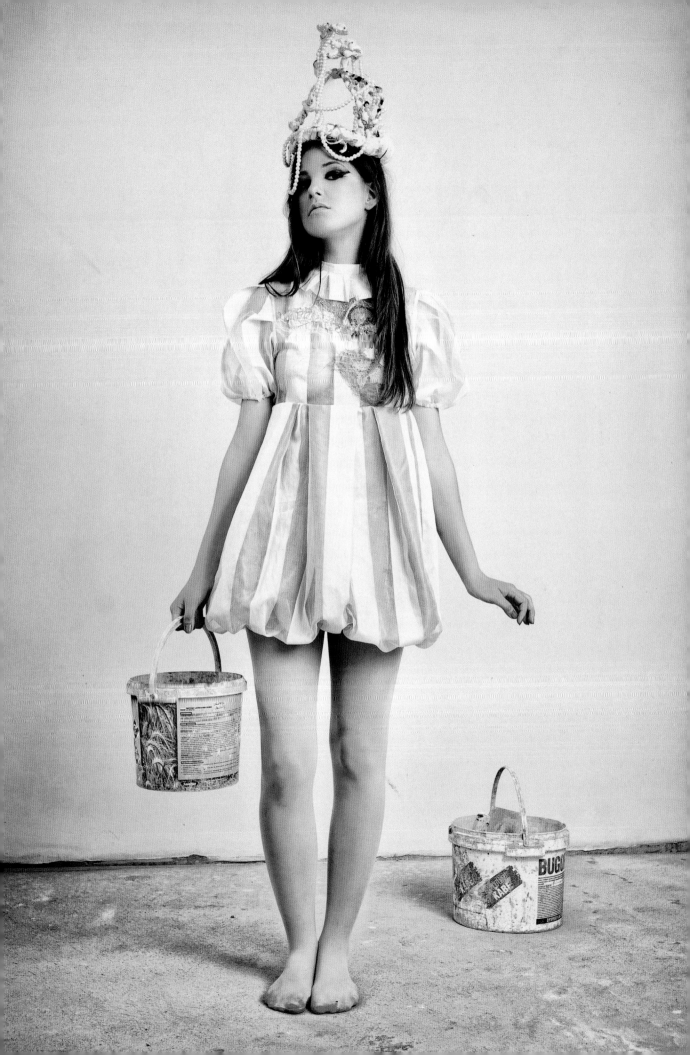

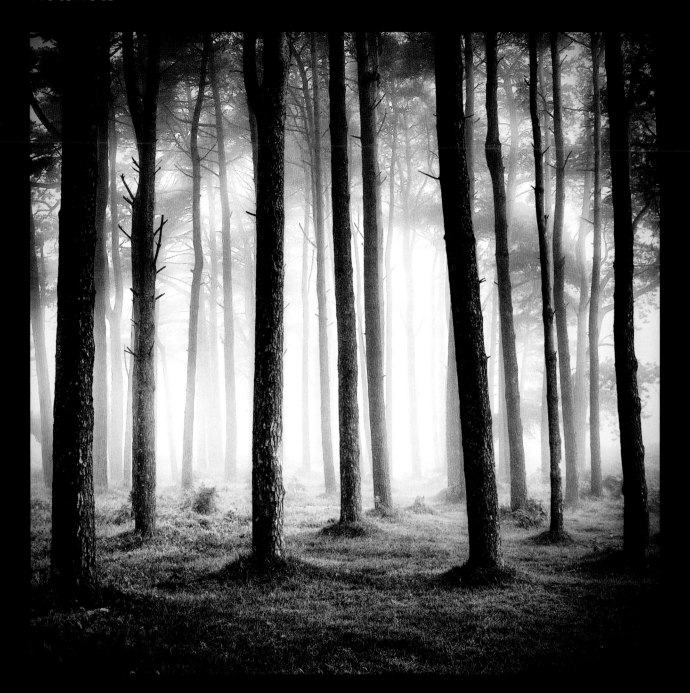

Black and Light

Keith Aggett

UK

"This was taken with a wide aperture to help the trees blend in with the mist. I waited for the right time as the sun burned through to produce a strong a side light."

Nikon D300 with Sigma 17-70mm f/2.8-4.5 at 24mm; ISO200; 1/160 sec at f/5

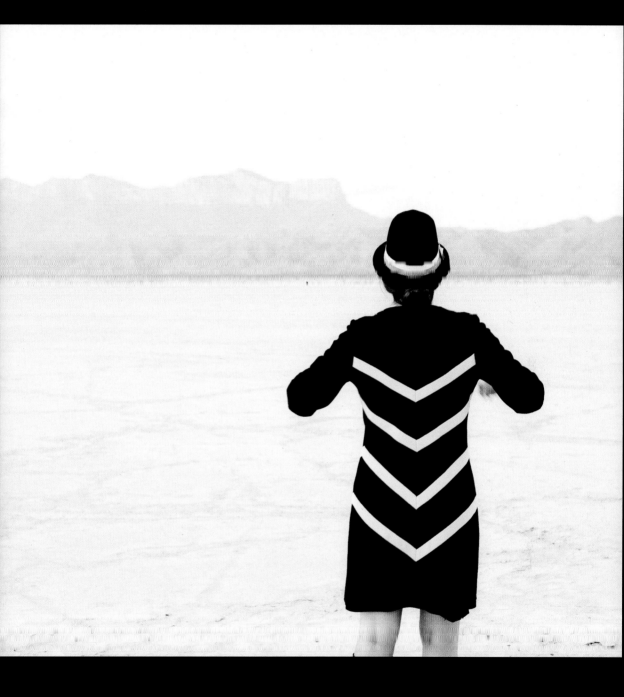

Arrow

Hotshots

Building Blocks

Shaun Parrin

UK

"This was shot in a studio using glasses against a background using mirror reflections and light sources through paper to reduce glare."

FujiFilm FinePix S7000; ISO200; 1/160 sec at f/2.8

Under the Boat Shadow

POLAND

"I was shooting life in Morocco during a few sunny days in late March. I was especially attracted by lazy hours between midday and sunset, so I meandered around the labyrinth of narrow streets and corners few hours a day."

Sigma DP1 with 28mm fixed focal lens; ISO100; 1/200 sec at f/8

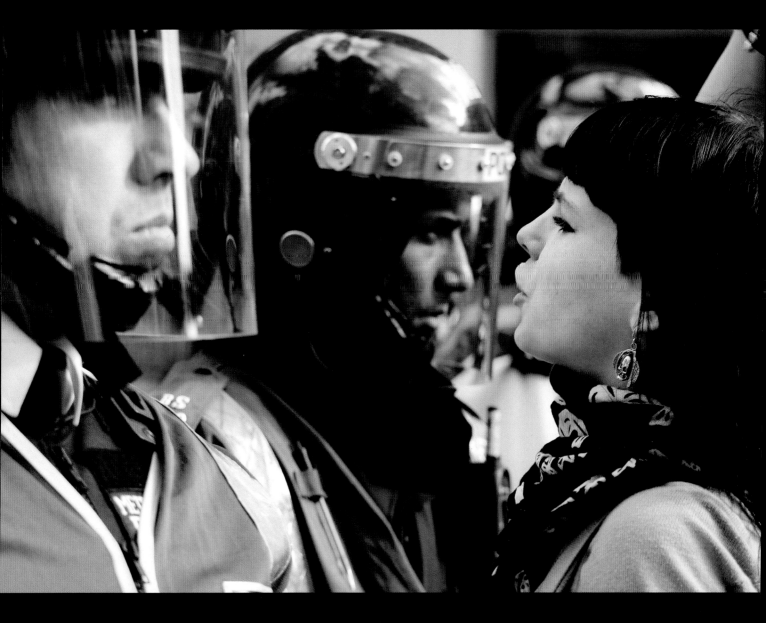

A Natural Landscape

Jim Mortram

UK

"I took this photograph at the end of a shoot. It was captured at sunset and I used off-camera flash set to manual at 1/16th power to light the foreground – which is actually a horse."

Nikon D200 with Nikkor 18-70mm f/3.5-4.5G DX IF-ED at 18mm; ISO100; 1/60 sec at f/22

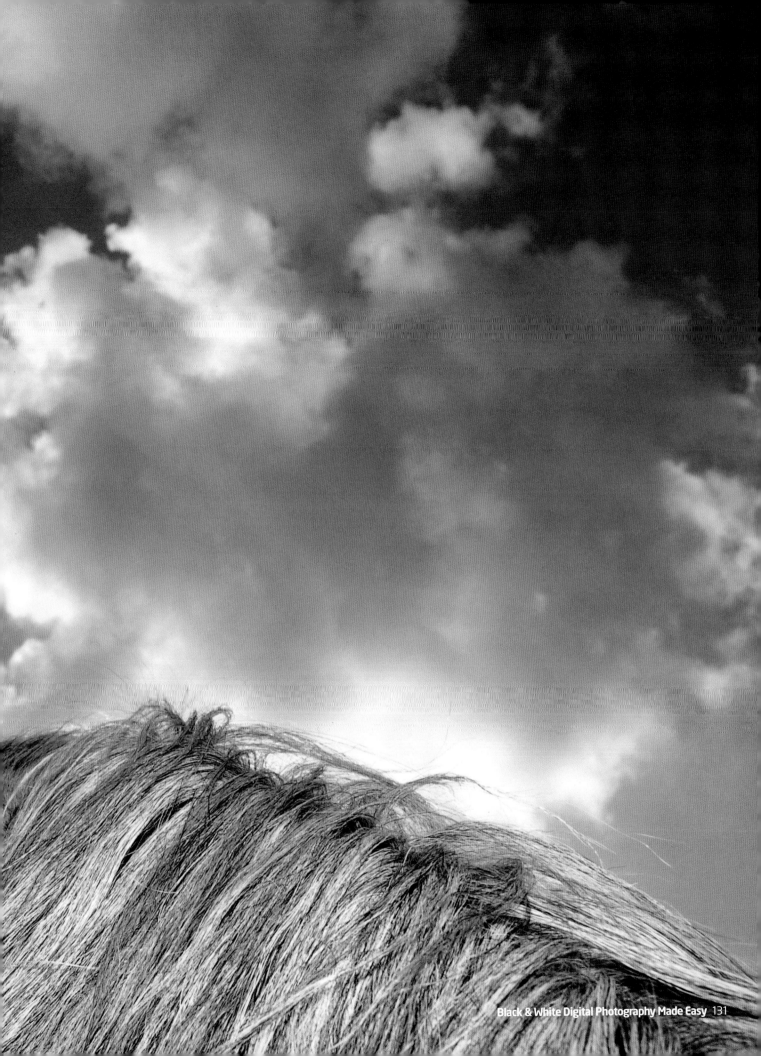

Hotshots

Terence Stamp

Robert La Plante

"This portrait of the actor was taken at my home in Ojai, California. I used available light from a large bay window in my living room, and sat Terence in an armchair a few feet away from it against a black background."

Nikon D300 with Nikkor 50mm f/1.4D; ISO100; 1/125 sec at f/2.2

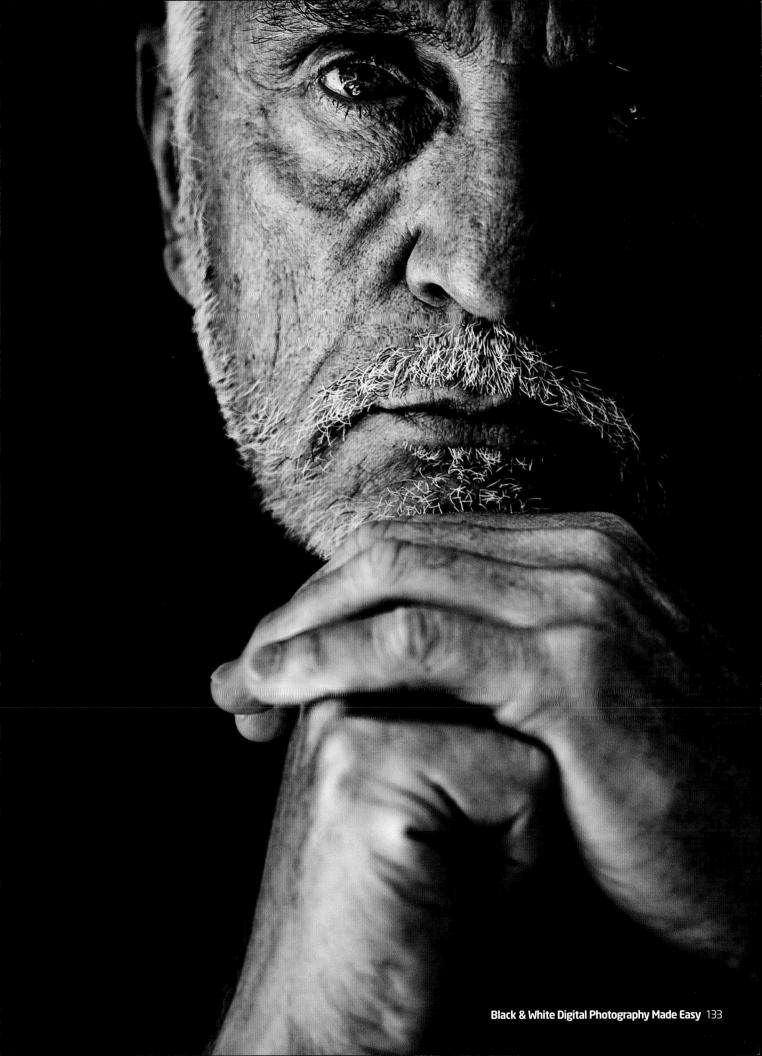

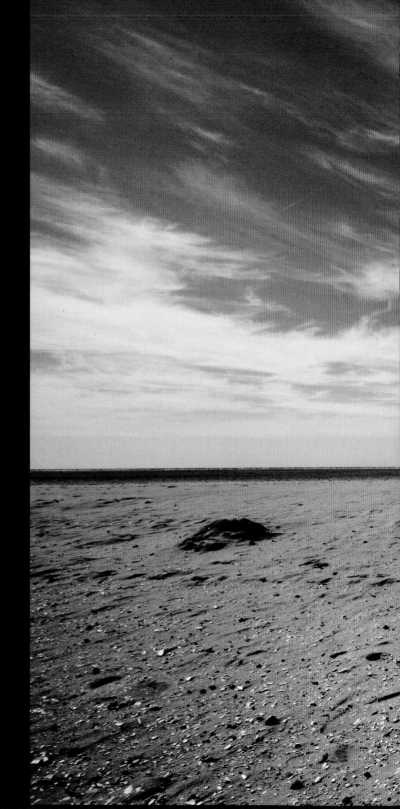

Posing on
the Beach

UK

"This was taken during a lifestyle shoot
on the beach. I shot from a low angle
using an Elinchrom Ranger pack and a
70cm softbox, using the sun from one
side and the flash from the other."

**Canon EOS-1Ds Mk III with EF 16-35mm f/2.8L II
USM at 16mm; ISO320; 1/250 sec at f/20**

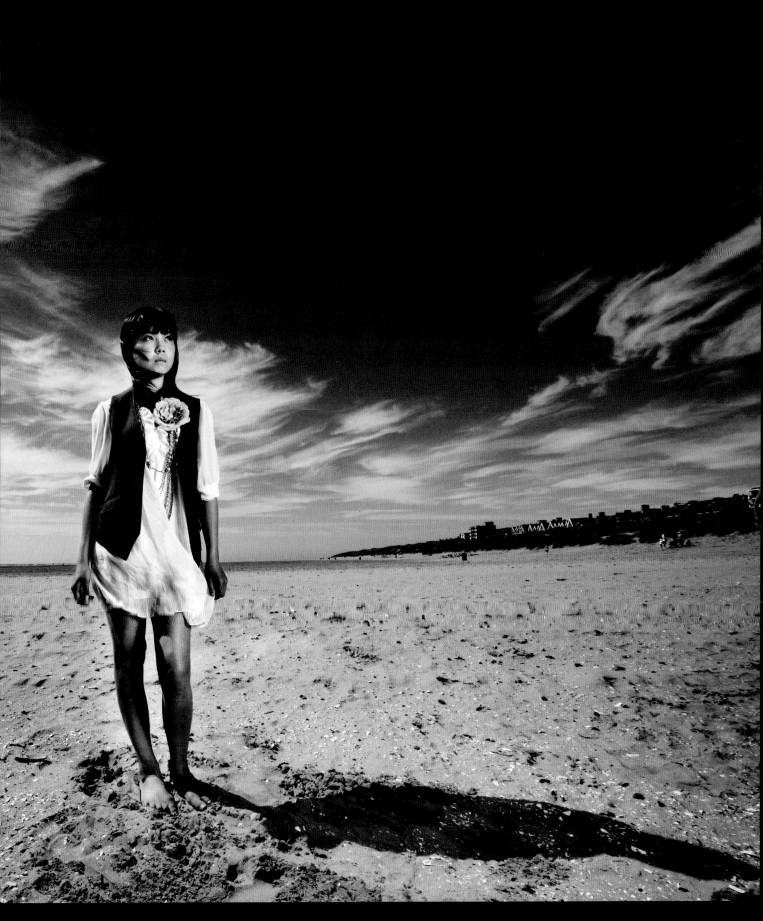

Ryan Hellard

Marc Aviles

CANADA

"Two wild spinner dolphins swimming together through the deep blue water of the south Pacific. I took the photo while snorkelling off the coast of Hawaii, near the city of Kona."

Canon EOS 5D with Canon EF 35mm f/2; ISO400; 1/320 sec at f/2; Ikelite underwater housing

Surveillance

"My inspiration for this picture came from the artist Alberto Giacometti. I tried to recreate his images of long, skinny figures it in my photos. It was taken in the subway when I noticed a third person. I imagined a scene in which a detective was spying on the couple."

Nikon D300 with Nikkor AF-S 17-55mm DX at 55mm; ISO400; 1/50 sec at f/2.8

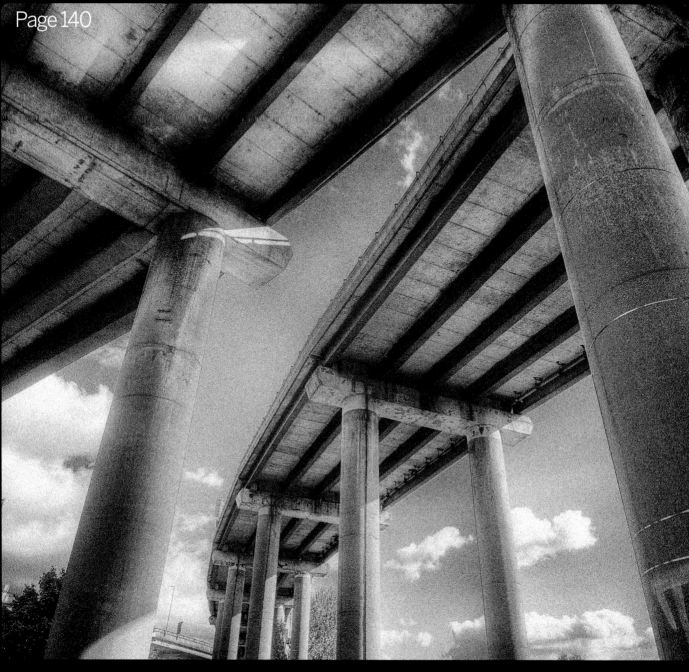

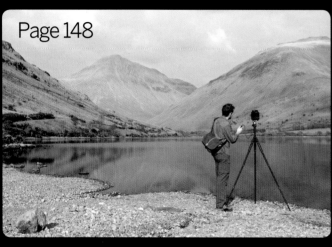

Page 148

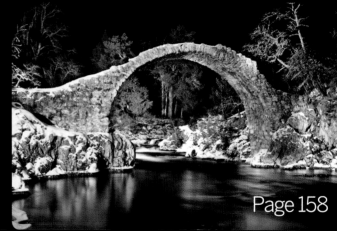

Page 158

Page 152

Masterclass 4

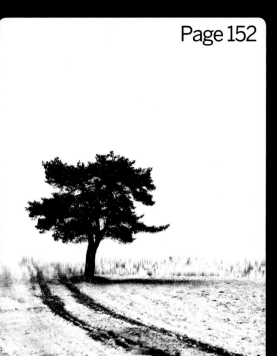

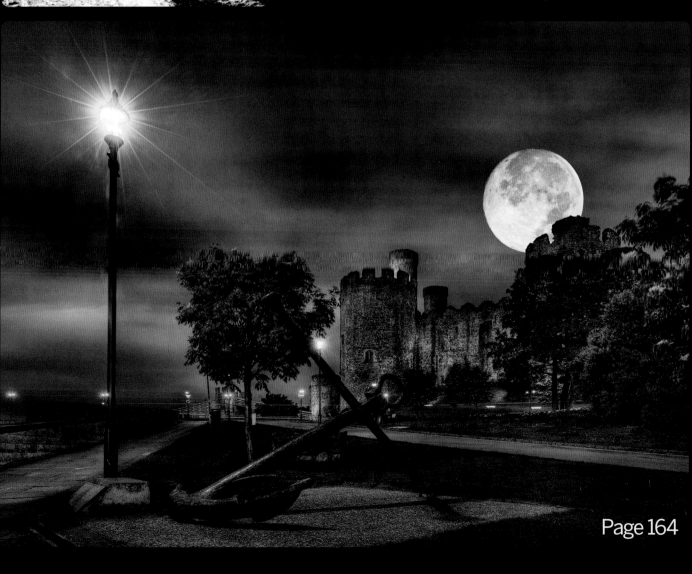

Page 164

Create gritty HDR urban landscapes

Give your black-and-white urban scenes a modern twist by searching the streets for unusual angles, rough textures and geometric shapes

On the disc
Start image and video on your free DVD

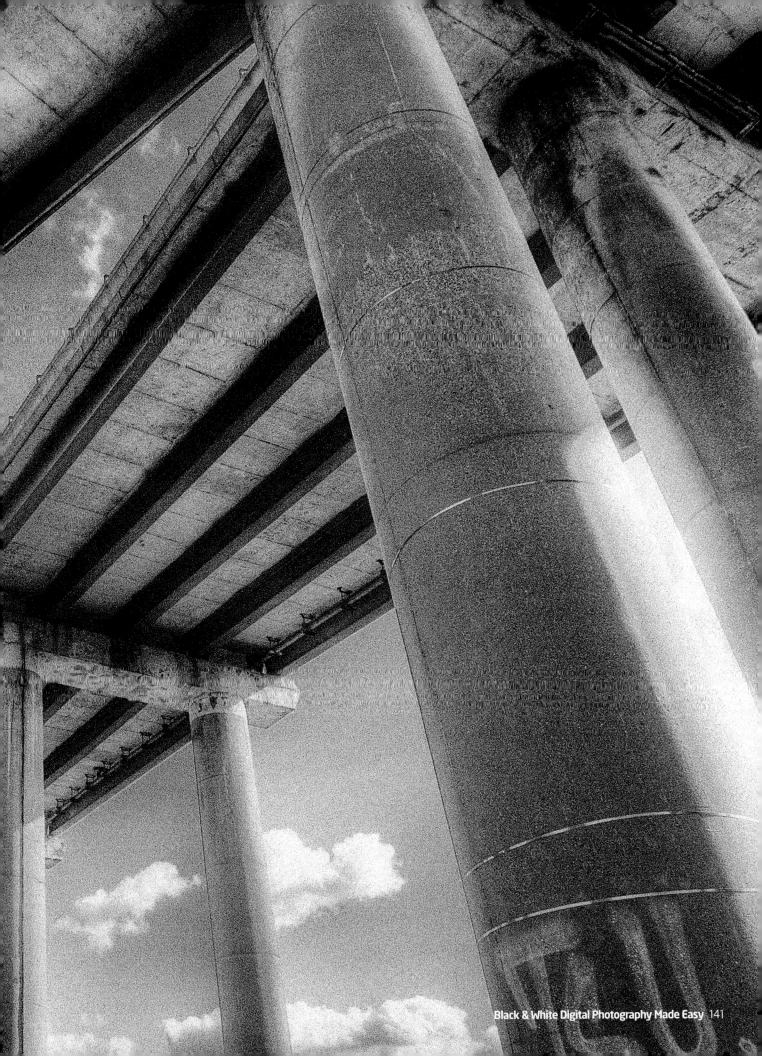

Masterclass

How to capture and edit urban landscapes

You don't always have to travel to the far reaches of the countryside to capture stunning landscapes. In fact, more often than not there are great photo opportunities right on your doorstep. If you stop and take a look at the world around you with fresh eyes you'll be surprised by how many potential shots there are – even in the unlikeliest of places. Anything from a multi-storey car park to a graffiti-ridden underpass can offer great prospects for the creative photographer.

For this Masterclass we went to the swirling mass of converging motorways in Birmingham affectionately known as Spaghetti Junction. It's probably not top of the list of Britain's most photogenic locations, but we like a challenge. We wanted to take a gritty urban image that captured the essence of the structure. After doing a little background research, thanks to the internet, we found a suitable shooting location – plus a good place to park – and proceeded with our photographic adventure.

We decided to use a variety of methods to create our image. First, we took multiple shots so we could use a high dynamic range (HDR) technique to combine several exposures and capture detail in both the shadow and highlight areas. We then made a black and white conversion using Nik Software's Silver Efex Pro plug-in, before giving it a slight bluish tint in Photoshop CS3. Finally, we added some noise to create a gritty, grainy look.

Shooting techniques

Follow our tips and tricks to get the most from your urban location

Plan your shoot

1 First, choose your location and do some research on the area. The internet offers invaluable tools for the photographer, and we used Google Maps (http://maps.google.co.uk) to plan our trip. Before we set off for Spaghetti Junction we used satellite images to find a safe place to park our car and scout out paths and potential shooting spots. We could also get a good idea of the direction of the light at different times of the day. Finally, we checked the forecast for the day using the BBC's weather service (www.bbc.co.uk/weather).

Go wide

2 A wide-angle lens was the best choice for this particular location – that way, we could squeeze as much of the scene as possible into the frame for maximum impact. We used a Tokina 12-24mm f/4 IF DX at the wide end. At 12mm it had an equivalent focal length of just over 19mm on our Canon EOS 40D, with its 1.6x crop factor. The wide-angle approach created some converging verticals, but for this image we felt that they added to the drama of the shot.

Shoot in Av

3 We used an aperture of f/11 to maintain a deep depth of field and keep as much of the image as possible sharp. To make the depth of field consistent throughout the three exposures we set our camera to Av mode. This effectively instructed the camera to change shutter speed rather than aperture when we used the Auto Exposure Bracketing (AEB) mode to make three consecutive exposures.

Bracket your shots

4 To create an HDR image you'll need three or more shots taken at different exposures. We set our camera to Auto Exposure Bracketing (AEB) mode so that it took three shots at different exposures, setting the parameters to between -2 and +2 stops. This provided one shot that was under-exposed by two stops (to ensure we captured detail in the highlights), a 'standard' exposure and a third shot that was over-exposed by two stops (to capture detail in the shadows). When combined, these images ensured a final picture with a full range of tones.

Keep it steady

5 When you're shooting multiple pictures with a view to combining them into a high dynamic range (HDR) image you'll need to ensure that they're all in exact registration with each other. The best way to avoid movement is to mount your SLR on a sturdy tripod and ensure you don't knock the camera between shots. Ideally, use a cable release to fire the shutter so you don't have to touch the camera at all.

Use a lens hood

6 Because of the angle of the sun in the sky we found that direct light was hitting the front of our lens, creating lens flare. A lens hood will prevent this, but if you don't have one you can easily use a piece of card, or even your hand, to shield the lens from the light.

STEP BY STEP 2 Create a striking urban mono landscape

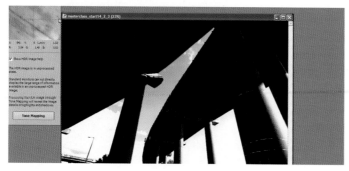

Generate an HDR image

1 First, open Photomatix Pro (download a free trial version from www. hdrsoft.com). Click Generate HDR and use the browser to select the 'masterclassspaghetti_start.zip' from the Video DVD, which contains the three spaghetti_start1.jpg, spaghetti_start2.jpg and spaghetti_start3.jpg start files. Once selected, click OK and the software will automatically start combining the images. This process may take a minute or two.

Download Silver Efex Pro

4 Go to www.niksoftware.com and download Silver Efex Pro 2 – you can use a free, fully functional trial version for 15 days. It should install into Photoshop's Plug-In folder. To access the Silver Efex Pro interface, go to Filter >NikSoftware>SilverEfexPro. Your image will now appear in a new window with a Before and After pane, so you can see the extent of your actions.

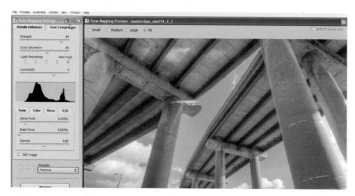

Convert to 16-bit

2 The image that appears will look a little odd because it's a true high dynamic range image that's displayed in 32-bit mode. Most PC monitors aren't capable of displaying 32-bit images, so you'll need to convert the image to a 16- or 8-bit image. Do this by clicking on the Tone Mapping button on the left. Using the sliders, set the Strength to about 85, Colour Saturation to about 50 and Light Smoothing to Very High.

Black and white settings

5 Take a few moments to familiarise yourself with the new interface and play with some of the sliders provided. However, for this tutorial we're only going to make basic adjustments. Set the Brightness slider to 40%, Contrast to 25% and Structure to about 45%. Now use the Colour Filter palette to select a Yellow filter.

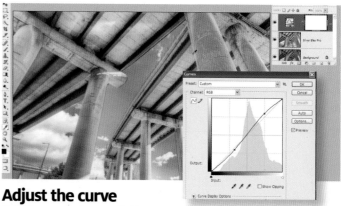

Save your shot

3 Experiment with the other sliders and see how they affect your image – we were happy with the adjustments we made in Step 2. Click on Process and your tone-mapped image will appear in the Photomatix interface. Go to File>SaveAs, choose TIFF 16-bit from Save as Type, and save the image to your desktop. Open the image in Photoshop CS3 (or above) and change your view to Full Screen Mode With Menu Bar (press F).

Adjust the curve

6 Once you're happy with the way your image looks in the After window, click OK. The software will process the black-and-white conversion automatically, creating the effect on a new layer back in Photoshop's Layers palette. Go to Layer>NewAdjustmentLayer>Curves and make subtle tweaks to the contrast and tones. Create a gentle 'S' curve by pulling and pushing the curve into shape until you get the result you want.

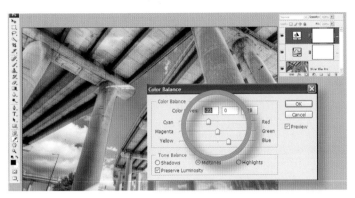

A hint of tint

7 To emphasise the urban quality of the scene we're going to add a subtle blue tint – just enough to give the image a cold feel. To do this, create another Adjustment Layer – this time for Colour Balance. Move the Cyan slider to -25 and the Blue slider to +25. If you want to increase the effect or try different colours, experiment with the other sliders. For our image, we decided on a subtle effect with just a hint of a tint.

Gentle glow

9 To give the image a subtle but effective glow, press Shift+Ctrl+Alt+E to merge all of the visible layers into a new layer on the top of the stack. Now, go to Filter>Blur>GaussianBlur, add an Amount of about 70 pixels and click OK. Change the Blending Mode to Soft Light using the drop-down menu at the top of the Layers palette. You can use the Opacity slider to reduce the effect of the change to a gentle glow.

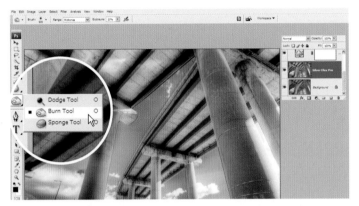

Dodge and Burn

8 Return to the black-and-white Silver Efex Pro layer in the Layers palette and select the Burn tool. Select a large, soft brush, set Range to Midtones, Exposure to 50% and use the brush to darken the corners and edges of the image to give it more depth. This will help to draw the viewer's eye into the scene.

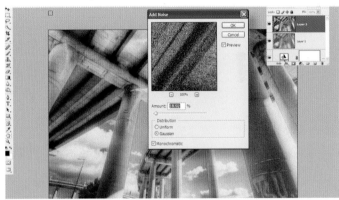

Get some grain

10 Make a layer at the top of the stack by merging the visible layers (Shift+Ctrl+Alt+E). To give the image a gritty, grainy feel, go to Filter>Noise>AddNoise and enter an Amount of about 15. Set Distribution to Gaussian, tick Monochromatic and move the Amount slider to increase or decrease the effect. Click OK.

How we created our urban landscape
Transform three colour images into a mono masterpiece in simple steps...

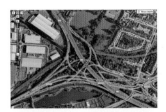

Scout out a location

1 After deciding on a suitable subject, we used the satellite view on Google Maps to find a place where we could safely set up our tripod and photograph our scene.

Shoot for HDR

2 To create our HDR image, we shot our scene at three different exposures to capture the highlights, midtones and shadows. We used a tripod to keep the shots registered.

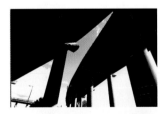

Make an HDR image

3 Using specialist HDR software Photomatix Pro, we combined our three shots to create an HDR image, which we then tone-mapped so that we had a full range of tones.

Convert to mono

4 Using Photoshop and a plug-in called Silver Efex Pro, we converted our image to mono, then added a blue tint and a little noise to give our shot a gritty, urban feel. ■

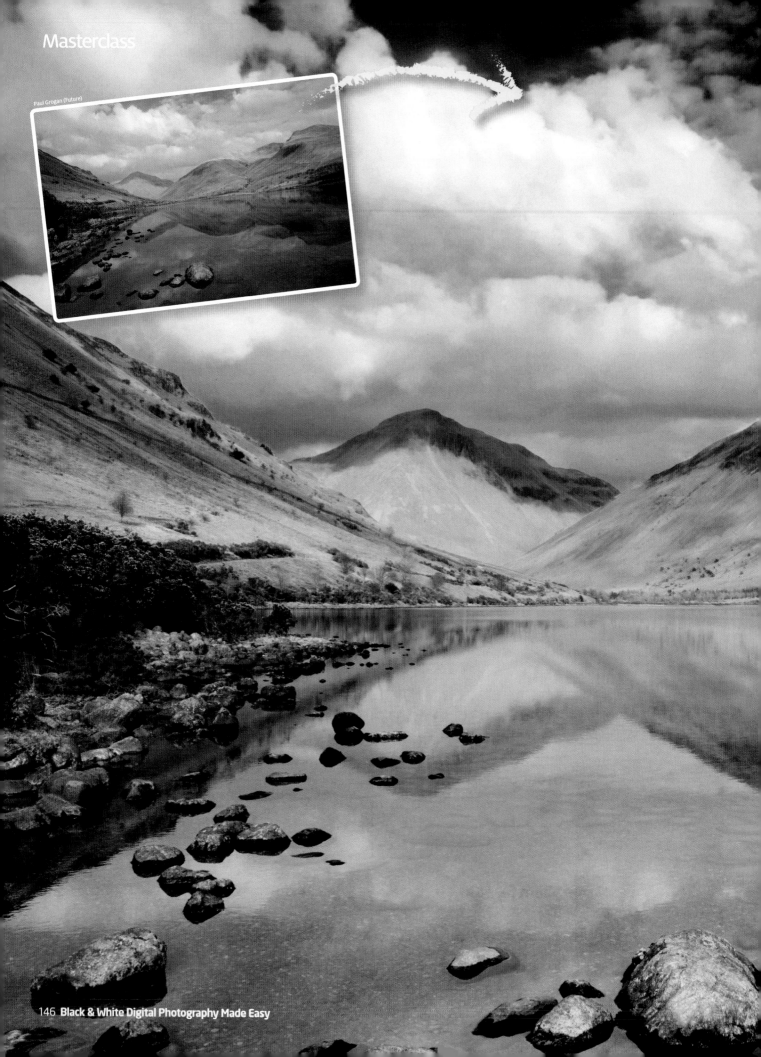

Paul Grogan (Future)

Create dramatic mono landscapes

On the disc
Start image and video on your free DVD

Converting to black and white can add interest and drama to landscapes and by combining different conversions in Photoshop you can get great results

The great thing about converting colour landscapes to black and white is that you don't have to wait for good weather to get great shots: all you need is a dramatic sky and plenty of contrast to really make your images pop.

The widely acknowledged master of black-and-white landscape photography is Ansel Adams (www.anseladams.com). Adams is perhaps best

known for his images of Yosemite Valley in California, so we travelled up to Britain's very own Yosemite Valley (aka Wasdale Head in the Lake District) to try and recreate his dramatic signature look.

Over the next few pages we'll show you how to make the most of any landscape shoot, and our step-by-step Photoshop guide will reveal

how to create the sort of high-contrast mono conversion that a master printer would be proud of. We'll show you a number of ways to convert a colour shot to black and white and demonstrate how to use layers and masks to combine three different conversions. Finally, we'll reveal how to add some subtle toning to your image using Colour Channels to really make it sing...

STEP BY STEP 1
Capturing the scene
Use these tips and tricks to make the most of any landscape shoot

Pack a map and compass

1 A good map is essential when you're shooting somewhere like the Lakes, where a wrong turn can set you back hours. Ordnance Survey's Landranger series (1:50,000) is fine for general walking, but the more detailed Explorer maps (1:25,000) are better if you're heading onto the fells. A compass is also handy, partly so you can work out where you are and partly so you know where the sun will be throughout the day.

Invest in filters

2 If you're serious about landscapes, consider investing in a set of filters. A circular polariser will boost contrast in blue skies and a set of ND Grads will help you avoid burnt-out clouds. If money is tight, just buy two filters (a one-stop and a two-stop) and combine them to create a three-stop. You'll wonder how you managed without them.

Take a long lens

3 Many photographers make the mistake of assuming that you can't shoot landscapes with a long lens and stick to wide-angle lenses instead. However, a good zoom – with a range of 70-200mm or 100-300mm, for example – can be extremely useful for picking out distant details, particularly when you're shooting somewhere as expansive as the Lakes.

Try a screen loupe

4 LCD screens can be hard to see in harsh sunlight, so a screen loupe can be a good investment. This gadget magnifies the screen and shades it, making it much easier to review your images on location. Hoodman (www.hoodmanusa.com) makes a loupe for screens up to 2.5 inches wide. A cheaper solution in bright light is to put a jumper over your camera and head!

Weigh down your tripod

6 If it's windy, it's a good idea to hang something heavy from your tripod's central column to hold it firmly in place. A small nylon bag with a drawstring is ideal – it packs down small, weighs next to nothing and can be filled with stones as needed. If you're shooting on gravel or grass, drive your tripod's legs firmly into the ground. If you don't, the tripod may sink a little during long exposures, resulting in blurred shots. ▶

Use a cable release

5 A cable release is essential for pin-sharp shots. Even on a bright sunny day, if you're shooting at ISO100 and f/16 to maximise depth of field, you'll need a shutter speed of around 1/60 sec – slow enough to result in less-than-perfect shots if you jog the camera slightly.

Masterclass

STEP BY STEP 2 Get the Ansel Adams look

Convert to mono

1 Download the file named ansel_start.jpg from the *Black & White Digital Photography Made Easy* DVD and open it in Photoshop CS. If the Layers palette isn't visible, go to Window>Layers, then select the Background layer. Go to Layer>DuplicateLayer and select the new layer, then go to Image> Adjustments>Desaturate to create a quick mono conversion.

Duplicate the desaturated layer

2 Go to Layer>DuplicateLayer to copy your newly desaturated layer, then double-click on the label 'Background copy' and rename the duplicate 'Bushes'. You'll use this layer to provide the tonal information for the bushes at the bottom left-hand corner of the image later in this lesson.

View the Channels

3 Click on the Create New Layer icon, then click the eye icons next to the 'Bushes' and 'Desaturated' layers to make the colour Background layer visible. Select this Background layer, then click on the Channels tab at the top of the palette. Click the eye icons on and off to see each channel separately and decide which is most suitable for a mono conversion.

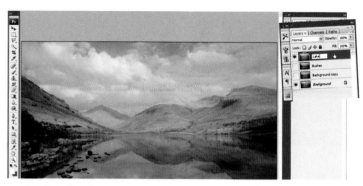

Use the Green channel

4 The lake's a bit flat in the Blue channel and a little harsh in the Red channel, so we're going to use the Green channel to provide the tonal info for the water. Select this channel, then press Ctrl+A to select it and Ctrl+C to copy it. Click on the Layers tab, select Layer 1, then press Ctrl+V to paste the Green channel into this layer. Rename the layer 'Lake'.

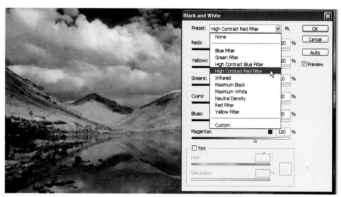

Boost the contrast

5 Click on the eye icon next to the 'Lake' layer to hide it and then select the colour Background layer again. Go to Layer>DuplicateLayer, click OK, then go to Image>Adjustments>Black&White. Use the drop-down menu to try out the various different presets. Select High-Contrast Red Filter for a moody, dramatic sky. Click OK, rename the layer 'Sky' and then drag it above the Background copy layer in the stack.

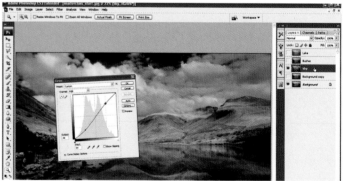

Work with Curves

6 With the 'Sky' layer selected, click the Create New Adjustment Layer icon and select Curves from the menu. Click-and-drag on the diagonal line to create a gentle 'S' curve. This will brighten the highlights and deepen the blacks in the sky. Click OK. Next, hover the cursor between this Curves Adjustment Layer and the 'Sky' layer, hold down Alt, and click to link them.

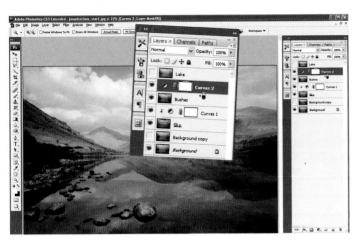

Enhance the detail

7 Select the 'Bushes' layer in the Layers palette and click on its eye icon to make it visible. As in Step 6, create a Curves Adjustment Layer and apply a subtle 'S' curve to deepen the blacks of the bushes and boost the highlights along the shore. Click OK and link this layer to the 'Bushes' layer as in the previous step. Repeat with the 'Lake' layer to reveal detail in the water.

Improve the lake

9 With the 'Lake' layer still selected, grab the Brush tool and select a large, soft-edged brush from the drop-down menu (we chose a diameter of 666 and a hardness of 0%). Set Opacity to 100%, Flow to 80 and ensure the foreground colour is white (by pressing X). Click on the layer's mask thumbnail and paint over the lake area to bring out the detail in the water.

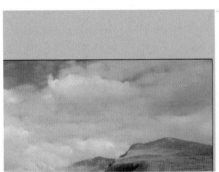

Add a Layer Mask

8 The top three layers should be visible and each one should be linked to a Curves Adjustment Layer. Make sure that the Background copy layer is visible. Select the 'Sky' layer and click on the Add Layer Mask icon. Ensure that the foreground is black, then press Alt+Delete to turn the mask black. Repeat with the 'Bushes' layer and the 'Lake' layer.

Work on the bushes and sky

10 Select the 'Bushes' layer and change the brush size to 400 pixels. Click on the layer's mask thumbnail and carefully paint over the bushes to reveal this part of the 'Bushes' layer. Next, select the 'Sky' layer, change the brush size back to 666, click on this layer's mask thumbnail and paint in the sky. To finish, save your file as a TIFF or PSD to retain your layers.

Try adding a split-tone effect
Inject a hint of colour to give your landscape added impact

In a traditional darkroom, split-toning involves partially toning an image, or applying a mixture of toners to selected areas to give the final image a moodier feel. The same effect can be achieved in the digital darkroom by selectively tweaking one or more of the colour channels in the shadows and highlights, while leaving the midtones unaltered.

The tweaks outlined here are simply suggestions; it's worth playing around with the various channels in the Curves

Adjustment Layer to see what works. Keep it subtle – as with many of Photoshop's more powerful tools, less is more.

To create a split-tone effect, select the top layer then create a new Curves Adjustment Layer by clicking on the icon at the bottom of the Layers palette. Select Blue from the Channels drop-down menu, and then apply a gentle 'S' curve to the diagonal line. Do the same with the Red channel, this time applying a gentle inverted 'S'. ■

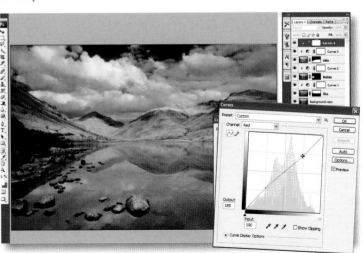

Shoot landscapes good enough to sell

On the disc
Start image and video on your free DVD

Fancy making more of your wintry landscapes? We reveal a failsafe way to capture and edit a shot that can be transformed into a beautiful fine-art black-and-white print

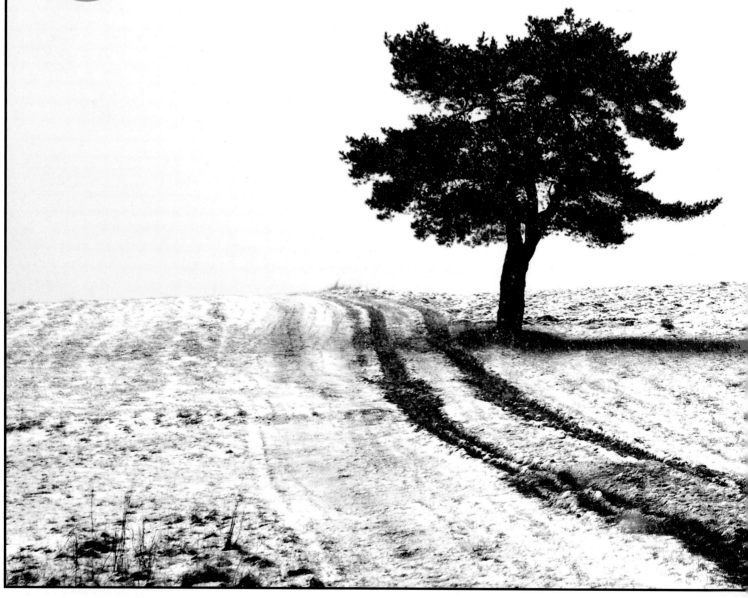

Just because it's cold outside there's no need to hang up your D-SLR until it warms up again. Admittedly it's hard to be enthusiastic about heading out to take photos when the temperature dips below zero, especially when you know you're going to be standing still for long periods of time, but the visual delights of beautiful frost-covered landscapes are sure to make your efforts worthwhile – in fact, you might find that you're inspired to take your best shots yet.

You may have to work harder to nail a great shot when the weather is bad, but the opportunities are there if you look hard enough. We spied this shot while driving though a snowstorm on a trip to Poland. We noticed the lone tree and track marks set against the blanket of white snow and knew we had all the ingredients for a great-looking fine-art print.

We 'pre-visualised' this scene as a black-and-white image and set about realising that vision. The minimal elements in the composition – the lone tree, the muddy track and the horizon line – worked well together, adding to the artistic look.

Over the next few pages we'll show you how to capture images that will look great as a print ready to go on your wall or to make a fantastic gift. We'll also show you how to add a black border and a digital signature so that your image looks professional and is ready for framing. So let's get started… ▶

Ben Brain

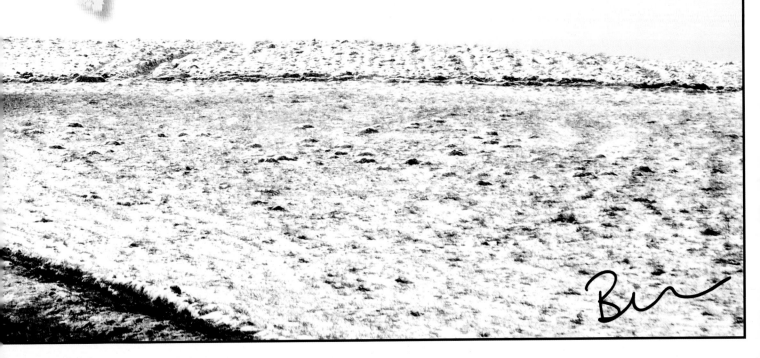

STEP BY STEP 1
Capturing the scene

Preparation, patience and planning will lead to the perfect print

Be prepared

1 It might sound obvious, but wrap up warm. Scarf, fleece, heavy-duty coat, suitable footwear and thermal underwear are all essential items for intrepid winter photographers. Plan the shot before leaving the warm comfort of your car. You can't afford to walk around in bad weather – your gear might get damaged and you'll soon get cold.

Shoot in RAW

2 Shoot in RAW, especially in challenging situations such as snow where exposure and white balance can be tricky. While it's good to get your shot spot-on first time, RAW processing can be useful when making adjustments post-shoot.

Plan your shot

3 Even when the odds seem stacked against you there are always shots to be found, although you might have to look a little harder for them. When we noticed this scene while driving through the Polish countryside, we visualised how the final image would look and then set about making it happen.

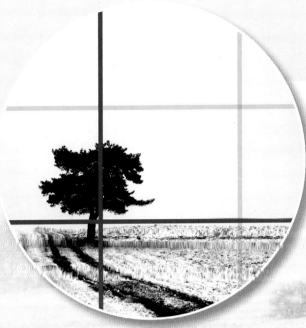

Frame carefully

4 There are very few elements in this scene. The lone tree is the main and only subject. As a result the framing is critical. We positioned the tree to the lower left-hand side of the frame – one third in from the left-hand side and intersecting with the horizon, which we positioned one third up from the bottom edge.

Use Exposure Compensation

5 To get a good white tone when taking pictures in the snow you'll need to adjust your camera's Exposure Compensation. Left to its own devices your D-SLR will make the snow appear a midtone grey. We effectively increased exposure to maintain detail in the snow.

Use the histogram

6 The histogram graph offers a great way to assess the tones of your image. However, don't be surprised if the graph looks clumped to the right. This is caused by the white snow and Exposure Compensation increase. There's a fine line between making the snow just white enough and losing detail in the light areas, so be careful not to over-expose beyond the point where the white 'clips' off the edge of the graph. ▶

Masterclass

Process in Adobe Camera Raw

1 Open the image masterclassprint_start.dng from the DVD. Using Camera Raw, move the Exposure slider to +.75 and the Shadow slider to +25. Make sure the Depth is set to 8 Bits/Channel and then click Open.

Crop your shot

2 In Photoshop Elements, select the Crop tool and in the menu bar type in the dimensions of the print: width (16 inches), height (12 inches) and pixels per inch (300). Make a crop that eliminates the lens vignetting and removes the trees on the right-hand side.

Clone the snowflakes

3 Zoom into the tree. The snowflakes in the foreground look like out-of-focus blobs. Select the Clone Stamp from the Tools palette, sample from a similar area and then clone out the offending flakes.

Convert to mono

4 Go to Enhance>ConvertToBlackAndWhite. In the window you'll see several options, but the Levels adjustment is best for ultimate control. This will help make the snow white, without losing essential detail.

Lighten up

5 Select Enhance>AdjustLighting>Levels. Pull the white slider slightly to the left to make the light grey even whiter, but be careful not to go over the top. Hold down the Ctrl key while moving the slider and the clipping indicator will help you to avoid any clangers.

Add an artistic effect

6 Go to Layer>DuplicateLayer and then Filter>Blur>GaussianBlur and type in 40. Change the Layer Blending Mode to Soft Light. Move the Opacity slider until you like the effect, then go to Layer>FlattenImage.

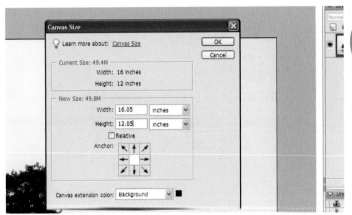

Now for the border

7 To add a border, first ensure that the background colour is set to black using the icon at the bottom of the Tools palette. Now go to Image> Resize>Canvas. In the window that appears, add .05 inches to the image dimensions. Click OK and a thin black border will appear around your image.

Your autograph, please

9 To add your signature, write it by hand onto paper and then scan it onto your computer. In Photoshop, make the signature black and white, ensuring there are no midtones, and then Copy and Paste it into your image. Change your signature's shape by grabbing the corners and reducing its size.

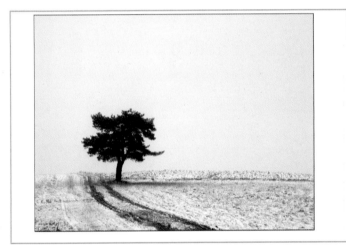

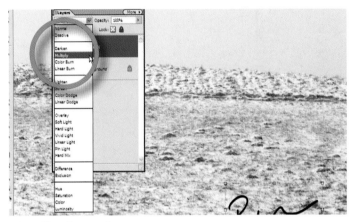

Frame your shot

8 Next it's time to make your image 'float' within a white border to add a professional finish. Simply repeat Step 7, but ensure that the background colour is changed to white. Use the 'X' key as a shortcut to swap the foreground and background colours.

The final touch

10 Place the signature in the bottom-right-hand corner and change the Layer Blending Mode to Multiply to remove the white background. Finally, flatten your image (Layer>FlattenImage) and make any final tweaks to the tones using the Levels window.

How we created our fine-art print
Your four-step review on making a classy winter landscape shot

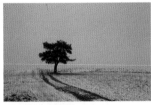

Finding a scene
1 We didn't worry about the unsociable weather. Even in adverse weather conditions such as these we found a great photo opportunity, and made the most of it.

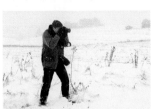

Planning
2 We 'pre-visualised' our final mono image, taking care that we were going to include all the necessary elements for a great fine-art print, before even attempting to take the shot.

Capturing the shot
3 Once the weather had taken a turn for the worse and become a snowstorm, we worked quickly so our equipment didn't get damaged and we didn't get too cold.

Post-shoot editing
4 We tweaked the Levels, converted to mono and removed unwanted areas. We added Gaussian Blur and a Soft Light Blending Mode and then added a border and signature. ■

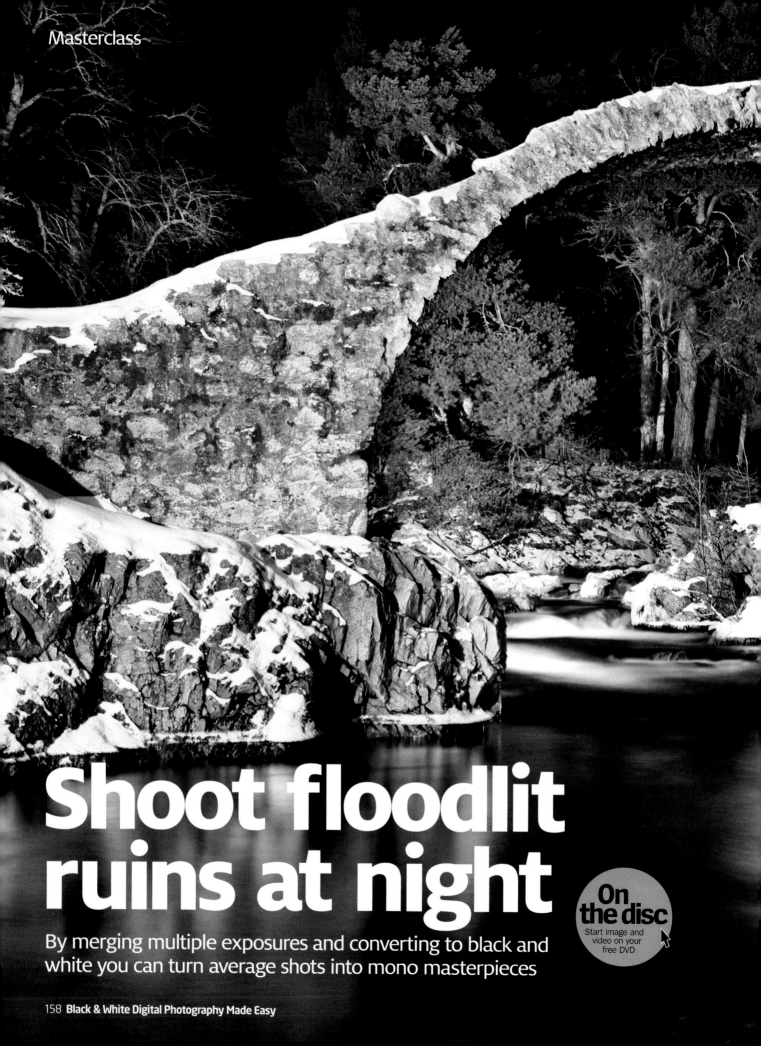

Shoot floodlit ruins at night

By merging multiple exposures and converting to black and white you can turn average shots into mono masterpieces

On the disc
Start image and video on your free DVD

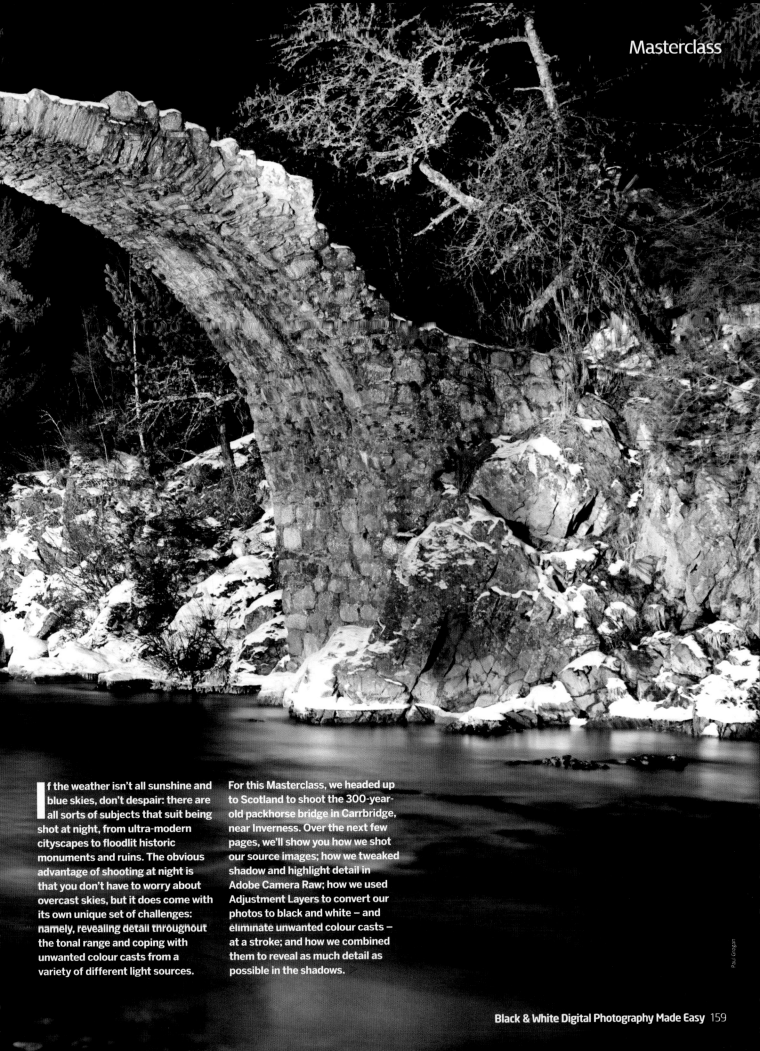

If the weather isn't all sunshine and blue skies, don't despair: there are all sorts of subjects that suit being shot at night, from ultra-modern cityscapes to floodlit historic monuments and ruins. The obvious advantage of shooting at night is that you don't have to worry about overcast skies, but it does come with its own unique set of challenges: namely, revealing detail throughout the tonal range and coping with unwanted colour casts from a variety of different light sources.

For this Masterclass, we headed up to Scotland to shoot the 300-year-old packhorse bridge in Carrbridge, near Inverness. Over the next few pages, we'll show you how we shot our source images; how we tweaked shadow and highlight detail in Adobe Camera Raw; how we used Adjustment Layers to convert our photos to black and white – and eliminate unwanted colour casts – at a stroke; and how we combined them to reveal as much detail as possible in the shadows.

Paul Grogan

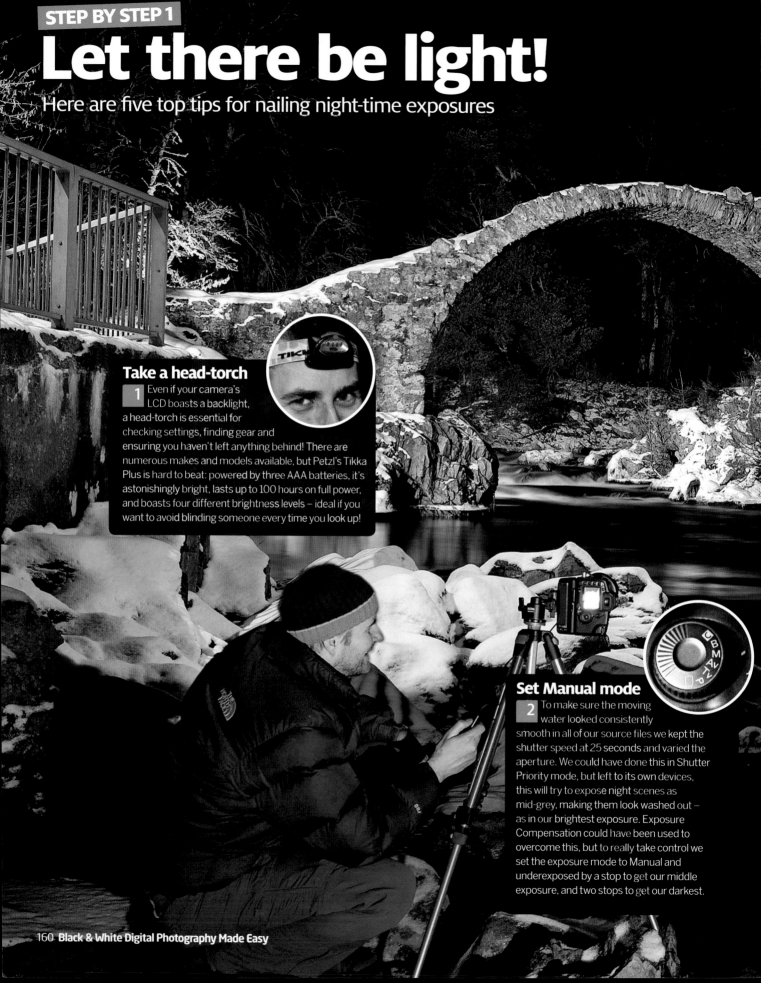

Let there be light!

Here are five top tips for nailing night-time exposures

Take a head-torch

1 Even if your camera's LCD boasts a backlight, a head-torch is essential for checking settings, finding gear and ensuring you haven't left anything behind! There are numerous makes and models available, but Petzl's Tikka Plus is hard to beat: powered by three AAA batteries, it's astonishingly bright, lasts up to 100 hours on full power, and boasts four different brightness levels – ideal if you want to avoid blinding someone every time you look up!

Set Manual mode

2 To make sure the moving water looked consistently smooth in all of our source files we kept the shutter speed at 25 seconds and varied the aperture. We could have done this in Shutter Priority mode, but left to its own devices, this will try to expose night scenes as mid-grey, making them look washed out – as in our brightest exposure. Exposure Compensation could have been used to overcome this, but to really take control we set the exposure mode to Manual and underexposed by a stop to get our middle exposure, and two stops to get our darkest.

Compose with care

4 It can be difficult to see what's in frame at night, so it's worth checking your time, when you're composing your finished shot. Before you even get set up, set your ISO to 1600 or 3200 and fire off a few hand-held shots, just to see which compositions might work best. Do the same once you've got everything set up on your tripod, too – that way, you won't have to wait 30 seconds to find out your horizon is wonky. But remember to set it back to ISO100 or 200 for the actual shot to avoid noisy results!

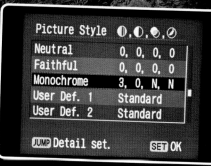

Set Monochrome Picture Style

5 If you're shooting in RAW, your camera's Picture Styles (if supported) won't even be recognised by Adobe's Camera Raw editor when it comes to editing your shots. But if you are thinking of converting your images to black and white, it's worth setting the Monochrome Picture Style in camera, as it will give you some idea of how your finished image might look when converted. Plus, it will also strip out any unwanted colour casts, so that you can concentrate on tonal information alone.

Pre-focus your lens

3 Once you've perfected your composition, the last thing you want to do is have to move your camera so that one of your AF points is over the object you want to focus on. In our shot, we wanted to focus on the bridge, but none of our AF points were in the right place. The way round this was to focus on the bridge first, then set the lens to MF (manual focus) to lock the focus. We then recomposed to our heart's content, safe in the knowledge that our lens wouldn't try to hunt for a new focal point when we pressed the shutter release.

STEP BY STEP 2 Merge multiple exposures

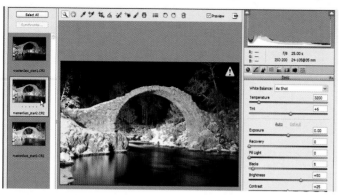

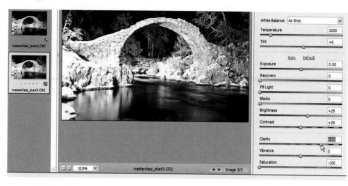

Open 'em up

1 Download masterclassfloodlit_start.zip from the *Black & White Digital Photography Made Easy* Video Disc and launch your copy of Photoshop CS. Go to File>Open to navigate to the folder, then click-and-drag to select all of the start files. Hit OK to open them all up in the Adobe Camera Raw editor.

Tweak the tones

4 Now to reveal detail but retain the shadows. Looking at just the bridge and its reflection on the left, drag Fill Light to 10, Blacks to 10 and Clarity to 40. Next, select 'start2', and this time looking at the river, drag Blacks to 10 and Brightness to +60. Lastly, select 'start3' and, keeping an eye on the trees, drag Blacks to 0, Brightness to +25 and Clarity to +50.

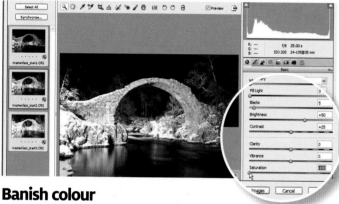

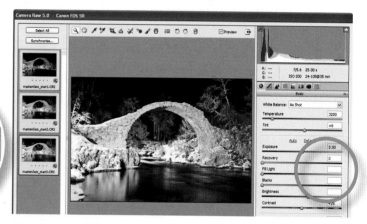

Banish colour

2 The yellow glow from the street lights is a bit distracting when viewing these shots. Because we'll be converting the final image to mono, to get an idea of how our RAW adjustments will affect our final image, click Select All and drag Saturation down to -100 to convert all the source files to black and white.

Restore colour

5 Once you've finished your adjustments, click Select All again and drag the saturation slider back to 0. We could leave it at -100 and open our start files as desaturated images in Photoshop but, as we'll see, there's a better way of converting to black and white that will give us much more control over how each of our exposures are converted. Hit Open Images.

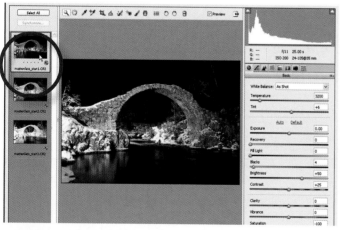

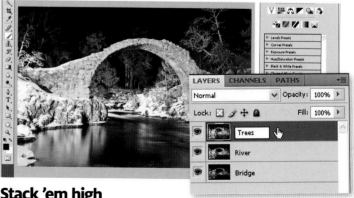

Evaluate the exposures

3 Click on each of the thumbnails in turn to decide which areas of each image will contribute to our final composite. From looking at each image, you can see that 'start1' offers to best exposure for the bridge and its reflection, 'start2' for the river and rapids, and 'start3' for the trees. Select 'start1' to start tweaking.

Stack 'em high

6 Select 'start2' and go to Select>All, then Edit>Copy. Select 'start1' and go to Edit>Paste to paste 'start2' into a new layer on top of 'start1'. Do the same with 'start3', then double-click on the label 'Background' to rename it 'Bridge', 'Layer 1' to rename it 'River' and 'Layer 2' to rename it 'Trees'. You should now have a layer stack containing all three source images.

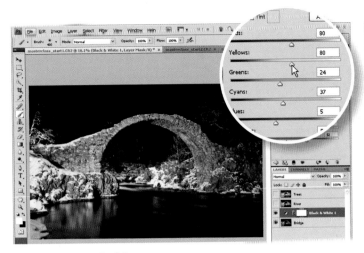

Convert the bridge...

7 Click the visibility icons of the top two layers to make them invisible then select the 'Bridge' layer. Click on the Create New Adjustment Layer icon and select Black&White from the drop-down menu. By adjusting the sliders, you'll see that all of the tonal information is in the red and yellow channels. Click Auto and drag Reds to 100 and Yellows to about 80.

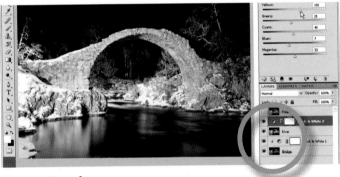

...and the river...

8 Holding down the Alt key, hover between the 'Bridge' and Black&White layers and click to group them together. Next, select the 'River' layer and click the box to the left of the thumbnail to make it visible. Repeat Step 7, this time leaving Reds alone and dragging yellows to 100, to lighten the river's swirls. Group this layer with the 'River' layer by Alt-clicking.

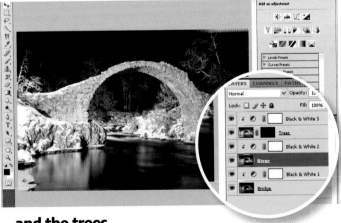

...and the trees

9 Finally, repeat Step 7 for the 'Trees' layer, again leaving Reds alone and dragging Yellows up to 100 – not forgetting to Alt-click to group the 'Trees' layer with its Adjustment Layer. Next, select the 'Trees' layer and, holding down Alt, click on the Add Layer Mask icon to mask out the 'Trees' layer. Do the same for the 'River' Layer, so that all you see is the 'Bridge' layer.

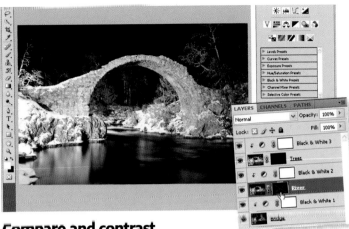

Compare and contrast

10 Select the 'River' layer, hover over its mask and Shift-click to turn it on and off. By comparing the 'Bridge' and 'Tree' layers like this, you'll get a good idea of which areas of the 'River' layer to reveal: in this case, the rapids in the middle, the river area to the right, and the rocks on the far right.

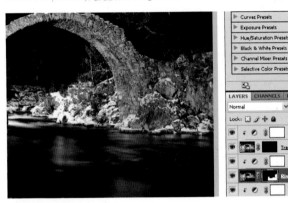

Reveal the river

11 Making sure that this mask is restored and selected, grab the Brush tool and set Size to 500 pixels and Hardness to 0. Press to D to default your foreground colour to white and gently spray over the dark part of the river, the rapids and the rocks on the right to create a hole in the mask and reveal the lighter areas of the 'River' layer below. If you make a mistake, press X to toggle the foreground colour to black and paint the mask back in.

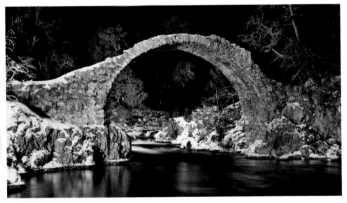

Lighten the trees

12 Repeat Step 10 for the 'Trees' to determine which areas from this exposure need to be included (in this case the background trees). Finally, repeat Step 11 to create a hole in the 'Trees' mask to reveal the lighter trees below, using the [and] brackets to adjust the brush size around the bridge. To save your finished image as an editable PSD or TIFF, go to File>SaveAs. ■

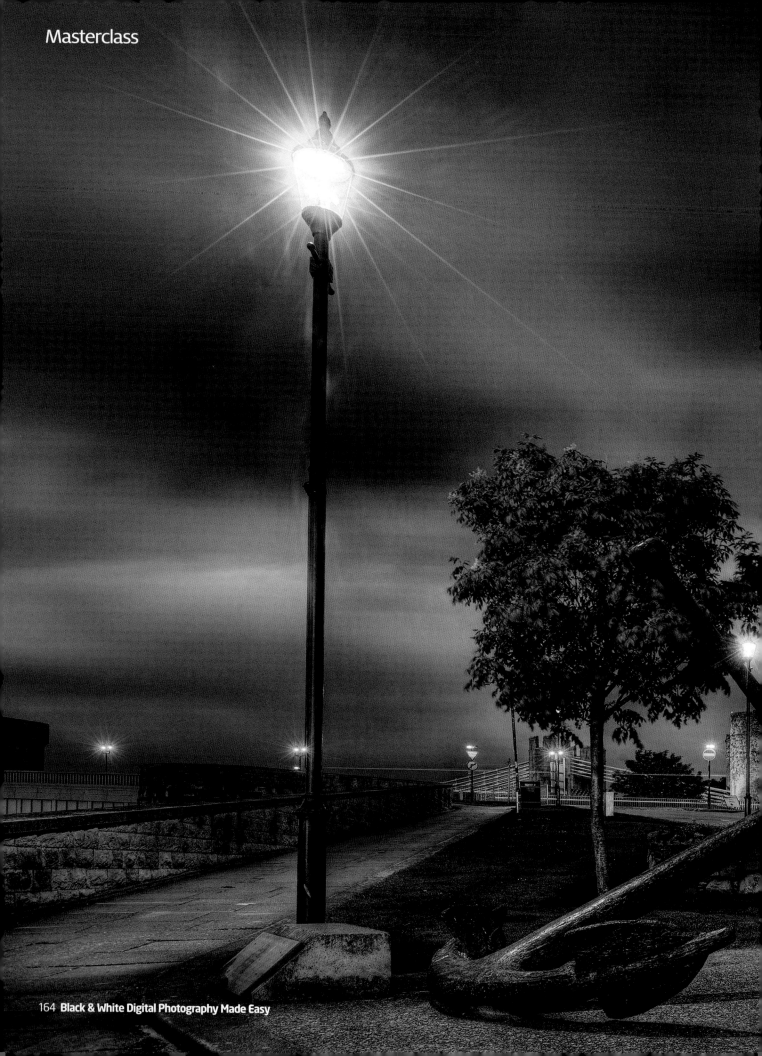

Shoot for the moon

On the disc
Start image and video on your free DVD

Learn how to photograph the moon, then combine your shot with a night scene for a cool composite image...

The moon can add a tremendous amount of impact and drama to an otherwise-ordinary night scene. A big full moon in a landscape shot can also evoke powerful emotions and moods.

Photographing the moon can be challenging, however, and there are several advantages to creating a composite of the moon and your chosen landscape. Normally the moon is so bright and the landscape so dark that it's difficult to have detail in the landscape without burning out the moon. You can make the moon as large as you like, and you can place it in just the right spot within your scene. Plus you have more creative latitude to adjust the moon's colour temperature and brightness. And you avoid the disappointment of clouds obscuring your view of the moon on the few days a year that it rises in the best location within the scene.

The winter months are an ideal time to shoot the moon, and it's also a great time to photograph moody landscapes and cityscapes at night to go with it. Because cold air holds far less moisture than warm air, it's easy to get sharper telephoto images – plus, as night falls earlier, you won't have to stay up too late to get your shot!

With this in mind, in this Masterclass we consult the timetables for moonrise, check the weather forecast for a clear night, then head out to the countryside, away from bright city lights, in search of a good spot. We then combine our moon with a nightscape shot. Here's how it's done...

Jeff Morgan

STEP BY STEP 1
Over the moon!
Shoot a great source image of earth's satellite

Plan ahead
1 Decide on the moon phase – crescent or full – you would like to shoot. You can check moonrise times on websites such as www.timeanddate.com/worldclock/moonrise.html. Head out into the countryside, away from bright city lights to avoid light pollution. It can be quite cold waiting in a field, so wrap up warm and don't forget your fingerless gloves and a headlight or torch.

Use a long lens
2 You need a long telephoto lens to capture a good-sized moon for your composite images – ideally 400mm or more. The moon appears larger nearer the horizon, but air quality is poorer and atmospheric distortions are much greater here, so the best place to capture it is halfway between the horizon and its highest point. The 1.5x or 1.6x crop factor on APS-C-sensor D-SLRs brings you closer still, giving a 400mm lens an effective focal length (EFL) of 600-640mm, and used in conjunction with a 2x extender, gives an EFL up to a huge 1280mm!

1280mm EFL

Banish the shakes
3 Using a long lens with a slow exposure can be challenging. Use a sturdy tripod, remote shutter release and Mirror Lockup custom function to minimise the chances of camera shake. Mounting the lens collar on the tripod, rather than the camera, also helps. You can dampen vibration using small sandbags or weights, with one laid on the camera and the other on the lens. Professionals choose a gimbal head, like the Wimberley Sidekick, but any decent quality tripod-and-head combination will yield acceptable results.

Focus carefully

4 Shooting at over long distances, the infinity setting of a lens isn't accurate enough to get a sharp image; there just isn't enough depth of field to fix focusing errors with a long lens, especially at the f/8 aperture you'll be using. The best option is to switch to Live View mode, if your D-SLR supports it. Use Manual Focus on your lens, zoom to maximum magnification, and focus carefully on one of the moon's craters. Atmospheric haze or scattered clouds can make it difficult to get a sharp image as these have a softening effect. A cold night with low humidity and no pollution or dust is best.

Check the histogram!

5 Shooting in RAW gives you image quality advantages when compositing the image in Photoshop as you'll be able to tweak white balance (we found the Daylight WB setting to be a good starting point) and adjust the colours without degrading image quality. Achieving the correct exposure in-camera will involve some trial and error. Carefully view the histogram to ensure the highlight warning isn't flashing. If the moon is too small in the frame, it won't be easy to see those overexposed pixels blinking!

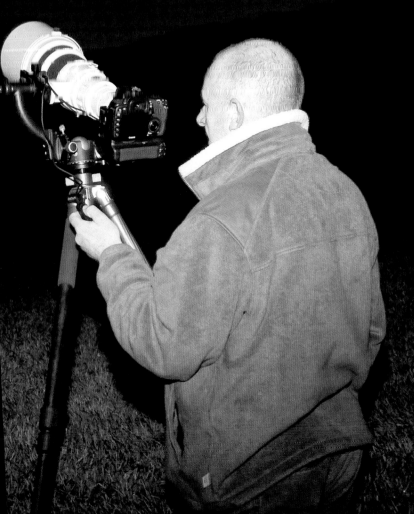

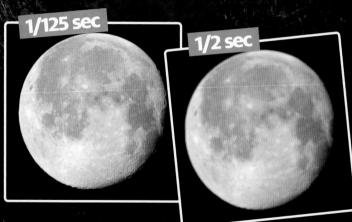

1/125 sec

1/2 sec

Switch to Manual

6 The moon is surprisingly sprightly, so you'll need a fast shutter speed to counter its motion or you'll end up with a blurred shot. As it's a very bright object surrounded by lots of dark space, your camera's metering system will be easily fooled, so switch to Manual shooting mode. We settled on 1/125 sec at f/8, ISO100, and that's your best starting point. An aperture of f/8 is a good choice as it gives a generous depth of field and will be close to the sharpest image quality available on many lenses.

Masterclass

STEP BY STEP 2 — Fly me to the moon!

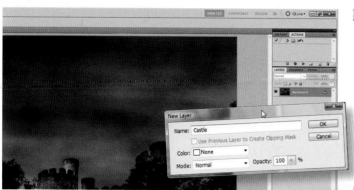

Open source images

1 Browse to the folder masterclassfloodlit_start.zip on the Video Disc. Open the castle image, named shootmoon_start1.jpg. Ensure the Layers palette is visible (If not, press F7 or go to Window>Layers). Then double-click on the layer name 'Background' and rename it 'Castle'.

Feather and smooth

4 Complete your selection around the tower by double-clicking on the original anchor point. Go to Select>RefineEdge. Set Feather and Smooth amounts to 1 pixel each; everything else should be set to zero. This will smooth out the edge nicely while providing a crisp silhouette for the moon image. Click OK.

Tidy up the castle

2 Overlapping the moon with one of the castle's towers will be easier if we tidy the edges first. Zoom in to 200% (with Ctrl and +). Select the Clone tool with the following settings: Size 10 pixels, Hardness 0%, Mode Normal, Opacity 100%, Flow 100% and uncheck Aligned. The key to cloning is picking a good source point. Clone out the leaves and branches that protrude into the sky, leaving a clean stone edge.

Copy to a new layer

5 Copy the selected area of the castle to a new layer (Edit>Copy followed by Edit>Paste, or use the keyboard shortcut Ctrl+J). Double-click on this new layer, and change its name to 'Tower'. This is the layer that we will slip the moon behind, so that it appears to be rising from behind the castle tower.

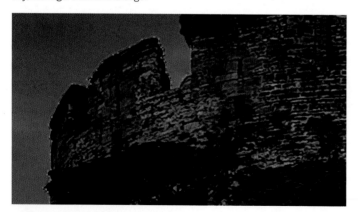

Select the castle tower

3 Now grab the Magnetic Lasso tool and use these settings: Feather 0, Anti-alias, Width 10, Contrast 10% and Frequency 57. View at 200% and click on the tower to place an anchor point. Follow the edge around the whole tower, placing a click at corners and every half-inch or so, and then take a path back through the trees, following the edge of the darker area.

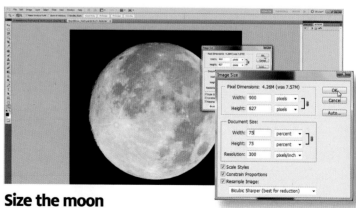

Size the moon

6 Now open the image of the moon, shootmoon_start2.jpg. Go to Image>Size. Check to see that Resample Image and Constrain Proportions are both selected, then change the drop-down menu from 'cm' to 'percent'. With your own images this will involve trial and error, but with ours enter 75% and click OK.

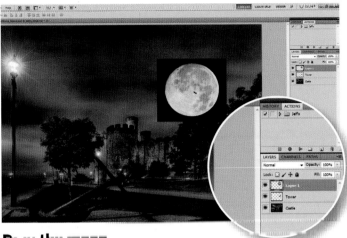

Drag the moon

7 Make sure you have the Move tool selected (press V). Click on the moon image and drag it up to the castle image tab, but don't let go of the mouse button yet. When the castle image opens, drag the moon into position, near the second tower, then let go of the mouse button. It will appear in a new layer. Double-click on the name of the moon's layer and call it 'Moon'.

Move behind the castle

9 Highlight the 'Moon' layer in the Layers palette and drag it down the layer stack until it is right over the line between the 'Castle' and 'Tower' layers. As the line splits in two, drop it there; the 'Moon' layer now sits between the 'Castle' and 'Tower' layers.

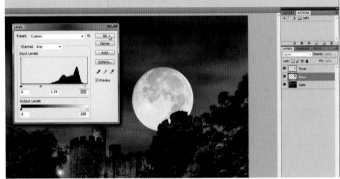

Blend it in

8 The moon is in place but doesn't look too good, surrounded by the black square. This is easily fixed by changing the Blending Mode. Make sure the 'Moon' layer is selected, then change the Blending Mode in the Layers palette drop-down menu from Normal to Lighten. This quickly gets rid of the black square, enabling the moon to really shine.

Lighten up a little

10 Make fine position adjustments to the moon with the Move tool. Go to Image>Adjustment>Levels and lighten the moon slightly with the following settings: Black Point 0, Midpoint 1.74, and White Point 245. Go to File>Save. By saving this image as a PSD file, the layers and adjustability are retained. Or you can simply flatten the image (Layer>FlattenImage) and save it as a JPEG file. ■

The whole of the moon
Other creative ways to use your moon image

A great moon image is not just limited to compositing into landscapes. It can also be used as a background image for many other creative double-exposure techniques. It can be easily combined with birds, buildings, people and aeroplanes – in fact nearly any silhouette can be enhanced with a good lunar backdrop. You can also create a totally other-worldly dreamscape. Just let your imagination run wild!

Photoshop essentials

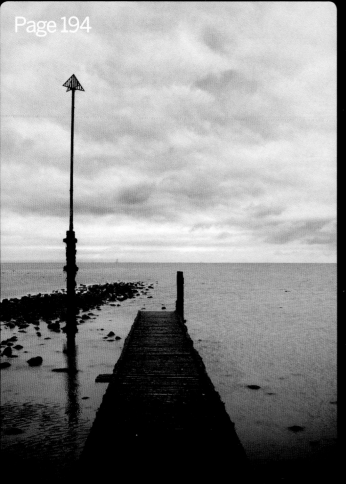

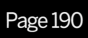

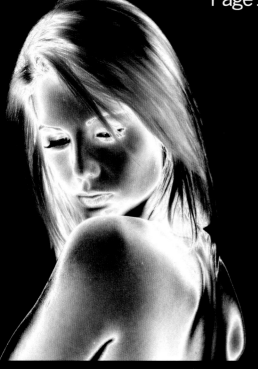

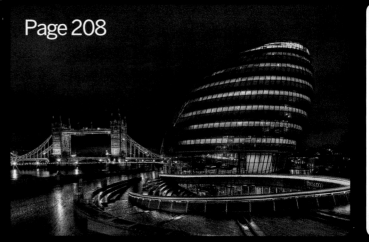

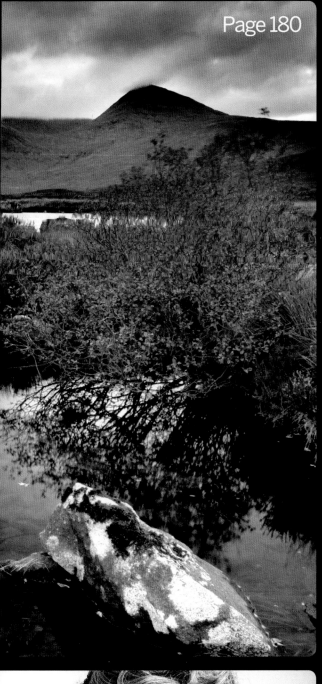

Page 180

Photoshop essentials 5

Page 198

Ali Jennings

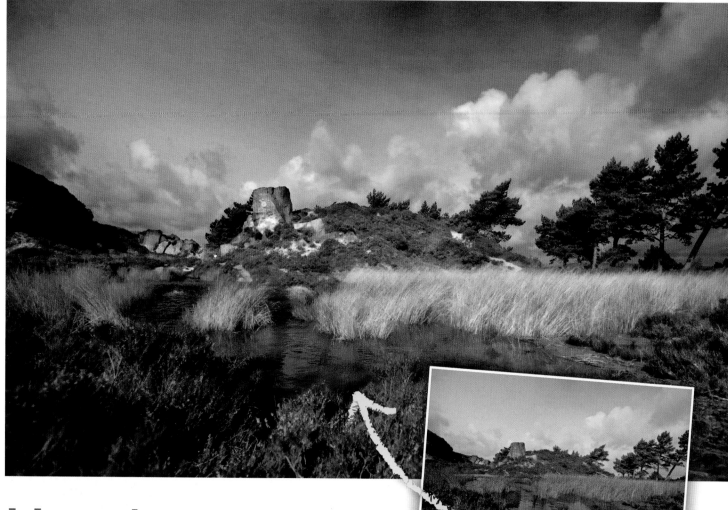

How to...
Add atmospheric motion to a scenic

On the disc Start image and video on your free DVD

Bring a so-so landscape shot to life by adding neutral density filter effects to mimic motion blur, then give it a moody mono makeover

WHAT YOU'LL NEED *Photoshop Elements/CS*
WHAT YOU'LL LEARN *How to apply the effect of a neutral density filter and convert your image to monochrome*
IT ONLY TAKES *30 minutes*

Neutral density (ND) filters are an essential tool for landscape photographers, but due to the many possible combinations of strength and graduation, choosing the right one to use can be confusing. Essentially, solid ND filters enable you to slow down the exposure. For instance, if you want to capture movement within a landscape but the lighting conditions are too bright to do so without

resulting in overexposure, fit an ND filter. Graduated neutral density filters are more common and enable you to balance the difference in exposure values in a scene, such as between a bright sky and dark land.

In this tutorial, we're going to start off by showing you how to apply the characteristics of both types of ND filter to the image, drawing out the detail of the rain clouds and reproducing the movement of wind through the grass with a selective application of Motion Blur. We'll then be looking at how to quickly convert your image to monochrome using Elements' fantastic Convert To Black And White feature. However, rather than relying on the presets, we're going to use the Custom sliders to perfect the conversion based on the colour content of the image.

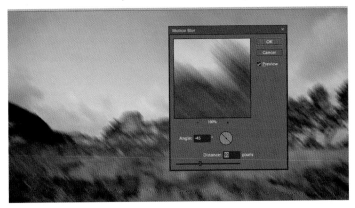

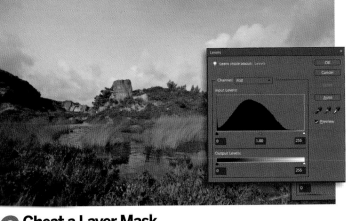

1 Apply motion blur

Open the image nd_start.jpg from the Video Disc and duplicate the 'Background' layer three times. Click on the top layer and apply a Motion Blur with an Angle of 45° and a Distance of 100, then turn the visibility of the layer off. Click on the next layer down and apply an angle of -45° and a distance of 90 pixels. Turn the visibility off.

2 Cheat a Layer Mask

Turn on the visibility of the top layer. Create a Levels Adjustment Layer and drag this below the top layer. Hold Alt and click between the layers to create a Clipping Mask. Use a black brush to hide the blurred sky and static areas of the blurred layer. Reduce the Opacity to 30%.

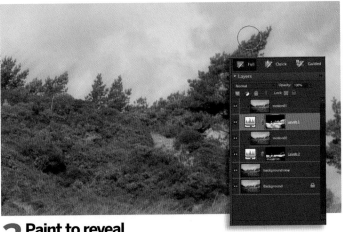

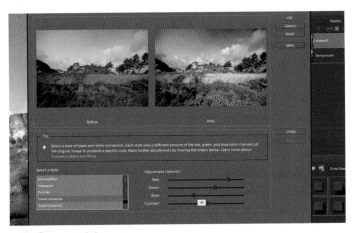

3 Paint to reveal

Repeat Step 2 for the next blur layer. Use the white brush in each of the Layer Masks, with an Opacity of 30%, to add subtle blur around the trees and horizon. The aim is to blur the grassy areas and the edges of the leaves to mimic the movement created by the wind.

4 Convert to mono

Flatten the image, then create a new Black and White Adjustment Layer. Adjust the settings for Red to 120%, Green to 50% and Blue to 60% (hover over the slider to show the numeric value). This should result in a darker sky, lighter grass and enhancement of the water.

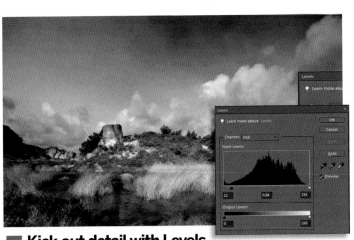

5 Kick out detail with Levels

Create a new Levels Adjustment Layer and increase the Shadows to 22, Midtones to 0.84 and Highlights to 255. Here, we're clipping into the histogram and enlarging the shadows area to increase the contrast. Finally, sharpen the 'Background' layer and flatten the image. ■

Expert tip
Draw out the highlights

As a final touch, use the Dodge and Burn tools, with an exposure of 4-5%, to increase the highlight areas and burn some of the shadows. This will increase the image contrast. Careful application of the two tools can really help to enhance the rocks and draw out the water area within the picture.

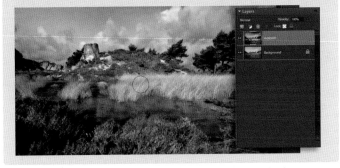

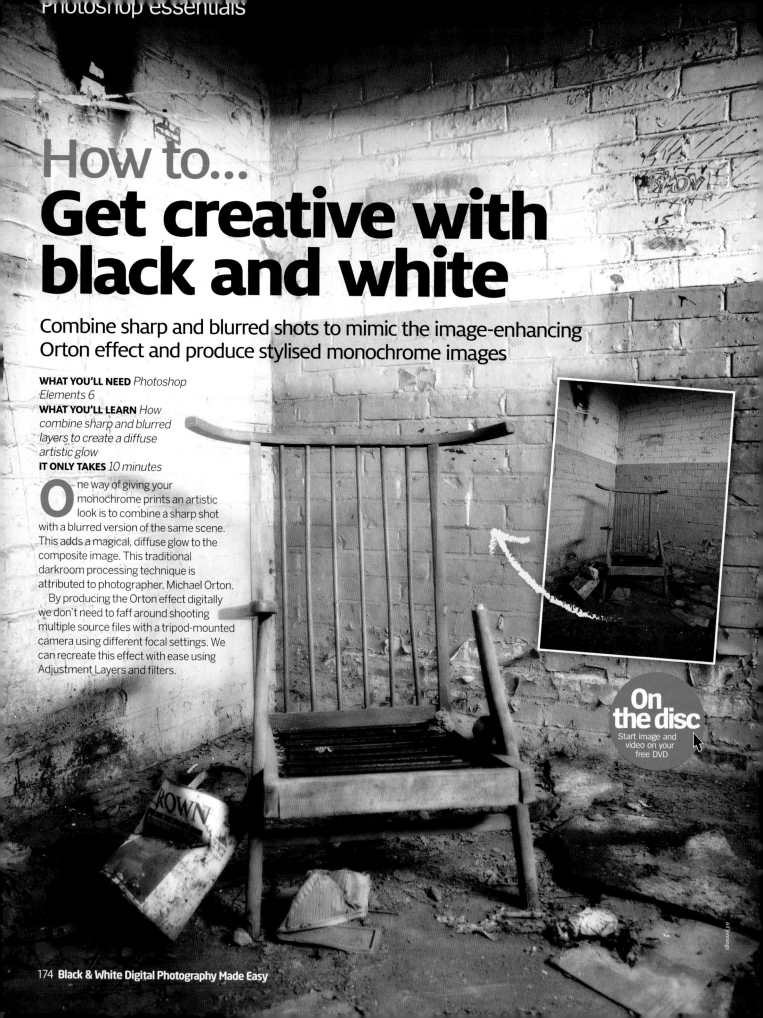

How to...
Get creative with black and white

Combine sharp and blurred shots to mimic the image-enhancing Orton effect and produce stylised monochrome images

WHAT YOU'LL NEED *Photoshop Elements 6*

WHAT YOU'LL LEARN *How combine sharp and blurred layers to create a diffuse artistic glow*

IT ONLY TAKES *10 minutes*

One way of giving your monochrome prints an artistic look is to combine a sharp shot with a blurred version of the same scene. This adds a magical, diffuse glow to the composite image. This traditional darkroom processing technique is attributed to photographer, Michael Orton.

By producing the Orton effect digitally we don't need to faff around shooting multiple source files with a tripod-mounted camera using different focal settings. We can recreate this effect with ease using Adjustment Layers and filters.

On the disc
Start image and video on your free DVD

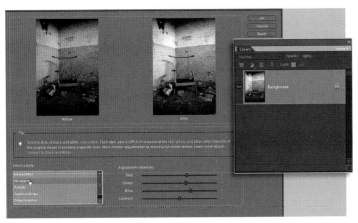

1 Convert to mono

Open creativebw_start.jpg. To create a high-contrast mono version of the image, go to Enhance>Convert ToBlackAndWhite, and select a Style and choose the Newspaper preset. This brightens up the washed-out blues on the background wall, creating brighter highlights.

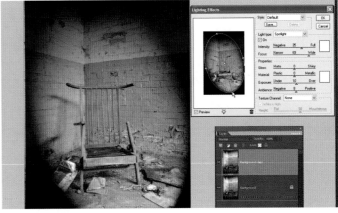

2 In the spotlight

In the Layers Palette, drag the 'Background' layer onto the Create New Layer icon to duplicate it. Go to Filter>Render>LightingEffects. Set Light type to Spotlight, the Material slider to 0, and Over to 10. Drag the Spotlight handles to make it cover the centre of the shot and click OK.

3 Add blur

The Duplicated Layer now has a spotlight illuminating the scene. The rendered spotlight has added a soft-edged vignette around the edge of the image. Go to Filter>Blur>GaussianBlur. Set Radius to 10.0 pixels and click OK to apply the blur settings to the 'Background Copy' layer.

4 Layer blends

Go to the Layers palette and set the 'Background Copy' layer's Blending Mode to Overlay. This breaks up the edge of the spotlight-produced vignette. It also adds a stylised, diffuse glow to the shot's highlights and creates a more artistic-looking, monochrome effect.

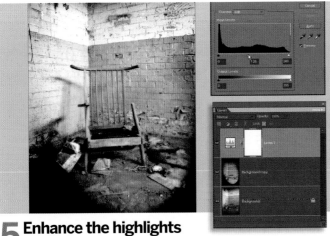

5 Enhance the highlights

In the Layers palette, create a Levels Adjustment Layer. Boost the shot's blurred highlights by dragging the white input level highlight slider left to 249. Brighten the midtones a little by dragging the grey midtone input level slider left to 1.28. Click OK.

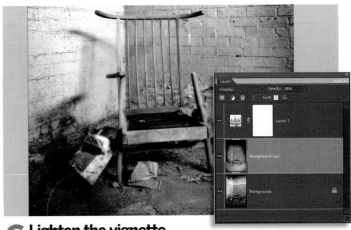

6 Lighten the vignette

To reduce the strength of the spotlight-created vignette and dodge in some hidden shadow detail from the Layer below grab the Eraser tool (press E). In the Options bar, set Opacity to 25%. Spray the Eraser over the vignette at the bottom of the shot to make it more transparent. ∎

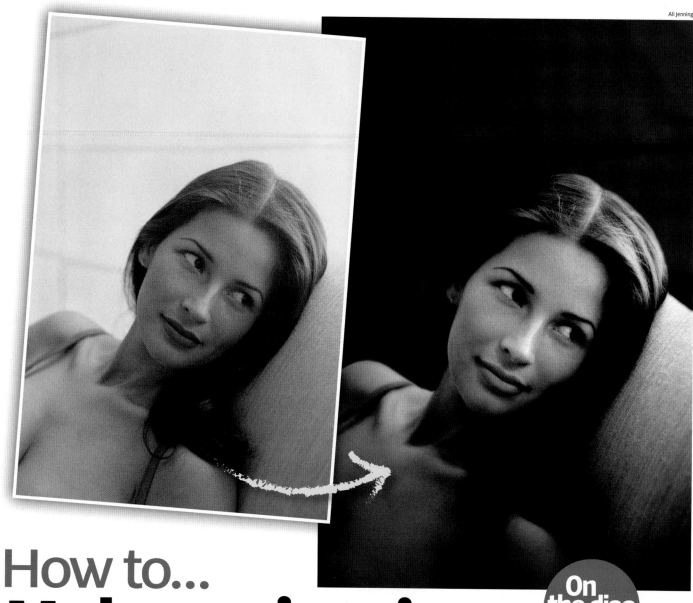

Ali Jennings

How to...
Make an iconic Hollywood press shot

See how a little Photoshop Layers work, plus some clever use of blending and lighting effects, can help you produce a 1930s-style portrait...

WHAT YOU'LL NEED *Photoshop Elements/CS*
WHAT YOU'LL LEARN *How to get creative with layers, blending and lighting effects to enhance a portrait*
IT ONLY TAKES *30 minutes*

The 1930s lifestyle set the precedent for the big Hollywood players of today, and during that short period of peace between wars, much of the western world was letting its hair down with fashion, style and an exploding art scene. Photography had also relaxed from the

formal shots at the turn of the century and photographers were working their subjects to radiate the cool beauty of the time. The cameramen also began experimenting with lighting, emulating the studios and started portraying the actors with immaculate hair, skin and features to promote them as living the perfect life. Images of actresses Greta Garbo and Vivian Leigh still stand out for their subtle facial expressions and relaxed posses.

To replicate the style and effect of the '30s we'll build the image out of a series of layers using blending, cloning, Levels and filters to produce stunning black-and-white '30s-style portraits.

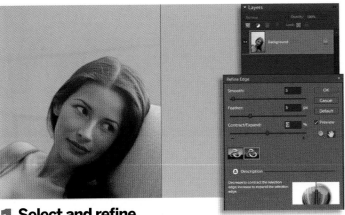

1 Select and refine

Open hollywood_start.jpg and select the Polygonal Lasso tool to trace carefully around the outline of the subject, click to finish the selection when the two ends meet. Click Refine and adjust the values to Smooth: 5 Feather: 5 and Contract: 2, click OK and save as 'Portrait'. Select>Save selection.

2 Split the image

Copy and Paste the selection into a new layer, then click back on the 'Background' layer and reload the 'Portrait' selection, making sure you have clicked the Invert button. Copy and Paste the selection into a new layer. Name one layer 'Portrait' and the other 'Background'.

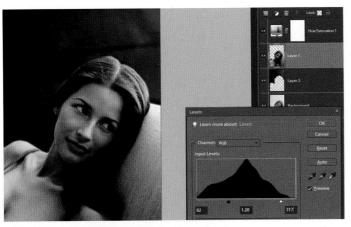

3 De-saturate and enhance

Create a new Hue/Saturation Adjustment Layer for the top layer and move the Saturation slider to -100. Click on the 'Background' layer and use Levels (Ctrl+L) with values of 228, 1.00 and 255 to darken the background. Now apply a Gaussian Blur of 20 to smooth the detail.

4 Smoothing detail

Click on the Portrait Layer and apply a Levels adjustment of 82, 1.20 and 217. Now duplicate the 'Portrait' layer and apply a Gaussian Blur of 20. Change the Opacity to 50% and Blending Mode to Overlay and merge with the first 'Portrait' layer.

5 Clone out halos

Select the Clone tool and a relatively small brush with an Opacity of 50%. Select the 'Background' layer and carefully use the Clone Stamp tool to remove the dark halo that surrounds the subject. Apply a Levels adjustment to get the background and hair tone to match.

6 Dodge and Burn

Create a new Levels adjustment as the top layer with values of 21, 1.36 and 239 and then, from the Layer menu, select Flatten Image. Select the Dodge tool with an Exposure value of 5%; use the brush carefully to draw out detail in the hair, eyes and mouth. ■

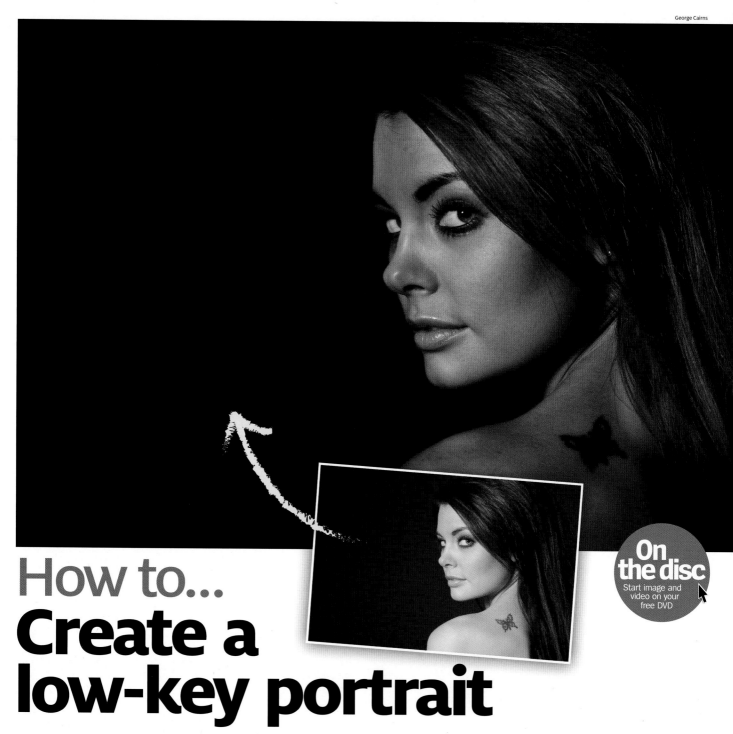

George Cairns

How to...
Create a
low-key portrait

Create a moody, monochrome, low-key portrait from
a bright, flat-lit colour photo by boosting contrast...

WHAT YOU'LL NEED *Photoshop Elements*
WHAT YOU'LL LEARN *Use Adjust Colour Curves to increase the
contrast in a flat-lit portrait and then add Adjustment Layers to
mimic a low-key effect*
IT ONLY TAKES *15 minutes*

Pictures that have low-key lighting consist predominantly of
midtones and shadows, although you do need a few highlights to
bring out details in areas like the subject's eyes. Our colour source

file has been lit from the front using a strong key light. This produces a
flat-lit portrait that lacks contrast between the midtones and highlights.

We'll show you how to increase the shot's contrast to help emphasise
the contours of the subject's face and create a low-key lighting portrait.
Low-key lighting changes the mood of our bright, flat-lit studio shot,
producing a dramatic version of the same subject. We'll also show how to
use Adjustment Layers, give it a monochrome makeover and combine
multiple Adjustment Layers with the Adjust Colour Curves command to
complete the low-key lighting effect.

1 Open source file

Open lowkey_start.jpg from the DVD. Go to Window>Layers and duplicate the 'Background' layer by dragging it onto the Create New Layer icon at the top of the Layers palette. Click on the 'Background Copy' layer. Go to Enhance>AdjustColour>AdjustColourCurves.

2 Super styles

Click the Increase Contrast style (or click the Increase Contrast thumbnail in version Elements 5.0 or above). This reveals more of the subject's bone structure. If using Elements 5.0 or above, open the Advanced Options tab before moving onto Step 3.

3 More contrast

To increase the contrast even more between the skin's midtones and highlights, drag the Midtone Brightness slider to the left. Don't worry about the colours looking too saturated, as you'll be making a mono version of the shot. Click OK to apply the image adjustments.

4 Marvellous mono

Click the Create Adjustment Layer icon at the top of the Layers palette. Choose Hue/Saturation. Drag the Saturation slider to the left to lose all colour info. Click OK. Add a Levels Adjustment Layer. Drag the Midtone slider to the right to darken the midtones for a low-key look.

5 Adjust brush tip

The mono midtones look darker and have more definition than the bright, flat-lit skin of the source file, but the darker hair has lost all detail. Press B to grab the Brush tool. Choose a soft brush tip from the Preset picker. Set Size to 900. Target the Levels Adjustment Layer's Mask icon.

6 Mask it

Set the toolbox's Foreground Colour to black. Spray the brush over the subject's hair and eyes to mask the Levels Adjustment Layer. Now only the midtone skin pixels are darkened. Use a Brightness/Contrast Adjustment Layer to darken the skin to complete the low-key effect. ■

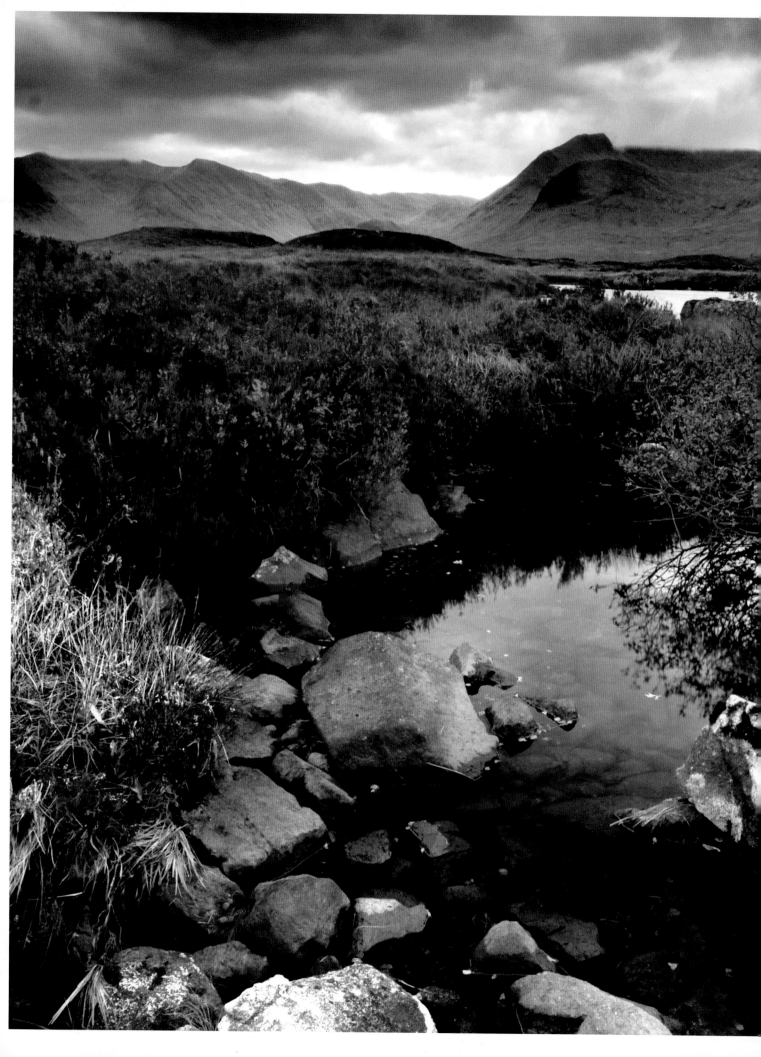

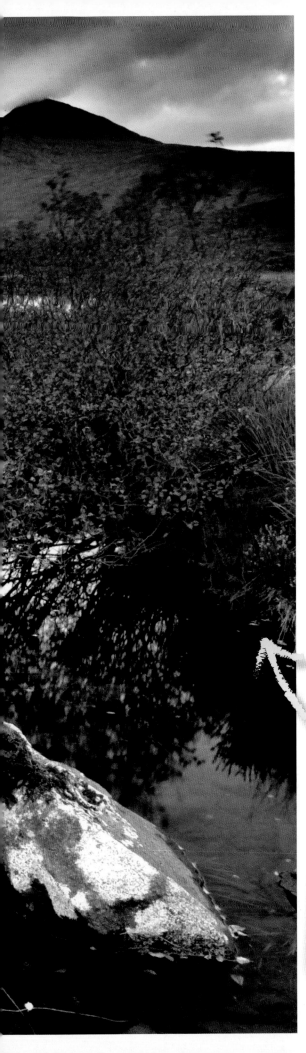

On the disc
Start image and video on your free DVD

How to...
Get a classic mono look

Ever wanted to turn a plain colour landscape into a mono masterpiece? Here's how...

WHAT YOU'LL NEED *Photoshop Elements/CS*
WHAT YOU'LL LEARN *How to create and apply that classic Ansel Adams black and white look to all your landscapes*
IT ONLY TAKES *20 minutes*

Undoubtedly the greatest 20th century master of black-and-white landscape photography was the legendary Ansel Adams. His classic style of beautifully exposed mono prints with a rich tonal range has been a source of inspiration for decades and become a benchmark for great landscape photography. Now you can apply Adams' style to all your landscapes. To truly get the Ansel Adams look and recreate his 'zone' system (see Expert Tip, page 189) you'd need to shoot large-format sheet film and process it using nasty, harmful chemicals. Fortunately, you can get very close by shooting digitally and using computer editing software as you'll see later. In the field, however, make sure you expose to retain the highlights in the scene – pay close attention to the sky – so that you'll have plenty of detail and pixel information to manipulate. Shoot bracketed RAW exposures.

Of course, Ansel Adams' other trademark was taking pin-sharp images front-to-back so remember to shoot using the smallest aperture possible, such as f/22, and who knows, you could become a 21st century master of landscapes. ▶

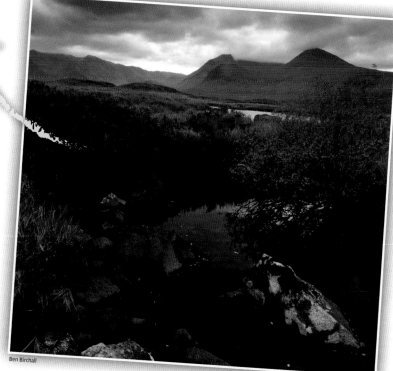

Ben Birchall

Photoshop essentials

Expert tip
Get the best from RAW

Before you can begin working your image in Photoshop you'll need to convert the RAW file using Adobe Camera Raw (ACR) software. But, rather than tweaking it to death using all ACR has to offer, simply adjust the Exposure, Fill Light or Recovery sliders to get the best Histogram possible – by this, we mean a Histogram where all the pixel information is contained within the Histogram box and doesn't butt up against either the left or right edges. If it does go into the edges, the image information will become 'clipped' and no longer available to work within Photoshop. It's okay to apply some sharpening, but avoid altering the colour values and remember to leave the mono process until the full image-editing stage.

1 Layer up
Open classicmono_start.CR2 from the Video Disc in ACR, follow advice above then click Open Image. Duplicate the 'Background' layer to enable editing of separate Adjustment Layers. Open the Layers palette and right-click the 'Background' layer, then select Duplicate Layer from the menu. Always work on the 'Background Copy' layer.

2 Lose the colour
Desaturate the image using an Adjustment Layer by clicking Layer>NewAdjustmentLayer>Hue/Saturation – set Saturation to -100. This will retain the colour pixel information and enable you to work on the colour data layers with more precision.

3 Find the zones
To work individually on each zone (see Expert Tip, above right), you'll need to split the image into imaginary areas of similar tones. Here we've decided that the photo has five areas that need to be worked on separately – the sky, distant mountains, water, bushes and rocks.

4 Adjust the zones
To work on the sky zone, create an Adjustment Layer by clicking on Layer>NewAdjustmentLayer>Levels and drag the Shadow and Highlight sliders towards the centre, until the sky looks dramatic. Ignore the rest of the image for the time being.

Expert tip
Adams' Zone system

Adams applied his Zone system to every aspect of his work, from exposure in the field right through to developing and printing. It's based on a scale of 11 tones ranging from pure black to pure white. We can transfer his system to Photoshop fairly easily. Open up Curves in Photoshop CS3 or above and click the Curves Display Options. Select the option to display the grid with 10% increments. Each point where the curve line meets the grid intersections, as we've illustrated by placing edit points, refers to a Zone. The bottom left hand point is Zone 0, second left is Zone 1 and so on until the top right hand point, which is Zone 10. Adjusting the curve between the Zone points, rather than the whole Curve line, alters the brightness of that Zone only, enabling finer tuning.

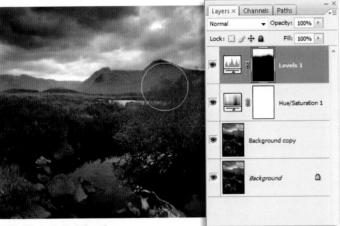

5 Paint it black
To restore the rest of the image to normal while retaining the dramatic quality of the sky, choose a large, feathery brush from the Tools palette and paint black on the Levels Layer Mask over the whole land area to return the detail.

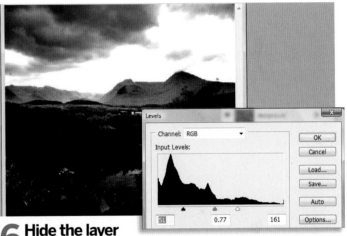

6 Hide the layer
It's a good idea to hide the last Adjustment Layer so you can see the overall effects on the zone you're adjusting, so click the 'eye' icon next to the last layer. Select another Levels Adjustment Layer then adjust the Levels for the mountains.

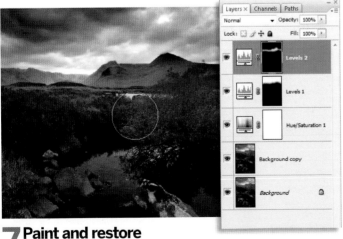

7 Paint and restore
Using the large, feathery brush from the Tools palette, paint black over the lost detail around the rocks, water, bushes and sky area carefully excluding the mountains. At this point, restore the Layer visibility of the sky Layer by clicking the icon.

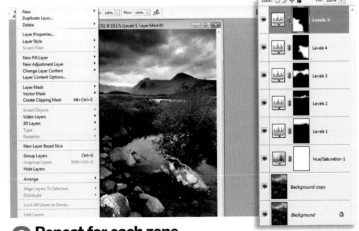

8 Repeat for each zone
Repeat the process by hiding the visibility of each previous Levels Adjustment Layer and making a new Layer for the zone you want to work on. At the end of this process, flatten the image together by clicking Layer>FlattenImage. ▶

How to...
Get a classic mono look (continued)

9 Brush and burn
Select the Burn tool from the Tools palette. Choose Shadows from the Range menu and choose an exposure around 7%. Make sure the brush is large and feathery then begin to burn the sky on the right.

10 Deepen the shadows
To deepen the shadows in the water in the foreground, increase the brush diameter size to around 1,000 pixels. Make a few, short, swift strokes over the water to increase contrast.

11 Dodge the midtones
To pull back and even the heavy tone around the bushes in the centre of the frame, dodge the midtones. Select the Dodge tool by clicking and holding the Burn tool in the Tools palette.

12 Dodge the highlights
Finally, dodge a few highlights to increase contrast. Select Highlights from the drop-down in the Range and keep Exposure at 7%. Reduce brush size to 250 pixels and stroke the naturally bright areas. ■

Expert tip
The golden rule
Dodging and burning is a simple process. The results can be stunning and even fantastical when applied creatively. However, there's one golden rule to observe. Never dodge the shadows and never burn the highlights. Why's that you ask? Well, technically, because pure shadow and highlight contain no detail there's nothing to pull back or reveal. Creatively it will look terrible, as highlights become muddy, grey, washed-out areas and shadows will become the same, with horrible grey streaks. It's fine to dodge or burn midtones in an image, but the effects won't be as bold. Just burning shadows and dodging highlights will greatly improve contrast.

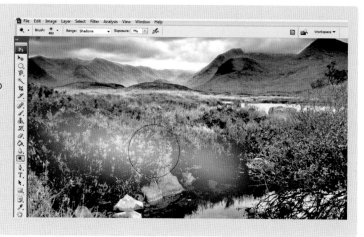

How to...
Add grain
to digital photos

Transform your mono shots with a sepia tint, then get creative with noise

WHAT YOU'LL NEED *Photoshop Elements 5.0 or above*
WHAT YOU'LL LEARN *How to give a black-and-white image a sepia colour tint, how to add noise to create a grainy film effect*
IT ONLY TAKES *5 minutes*

Back in the days of traditional film photography, specialist films and printing techniques could be used to create photographs with sepia tints and a grainy appearance. It could be a long an arduous process to get the best results, but today il's much easier to add these effects to your digital images in Photoshop.

A sepia effect can give a mono print an artistic, classic quality. This treatment won't work with all subject matter, so il's best reserved for traditional scenes, such as our shot of a lone tree. By adding noise you can recreate the grainy look of images shot on film at a high ISO. Normally noise is something to be avoided, but when working with sepia-toned images, grain can be used to give your images a creative finish...

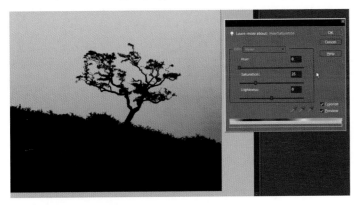

1 Create a tint
Open the image noise_start.jpg and go to Image>Mode>RGBColour. Now go to Enhance>AdjustColour>AdjustHue/Saturation. You can use the Hue/Saturation sliders to give this mono image a sepia tint. Click Colorize and your image will be converted to mono with a solid tint.

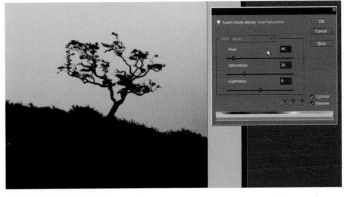

2 Make it sepia
The Hue slider now controls the colour (hue) of the tint you have just created. Drag it along until the tint becomes a subtle, washed out brown, rather than a strong overall colour cast (we used a value of 40). Use the Saturation slider to alter the intensity of the sepia tint. Hit OK.

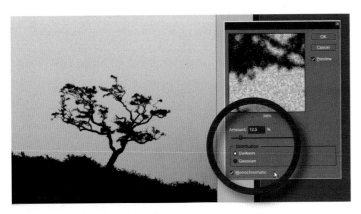

3 Open the Noise filter
Next, go to Filter>Noise and select Add Noise. This will open the Noise filter, which adds random speckled pixels to your image. Because you want the noise to replicate the look of grain on black-and-white film, select the Monochromatic option to remove the coloured specks.

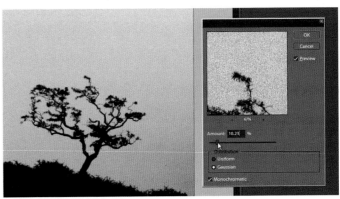

4 Fine-tune the grain
There are two types of noise textures to choose from: Uniform and Gaussian. Select Gaussian (which provides a more uneven effect that looks more like film grain) and then use the Amount slider to control the strength of the noise. Aim for somewhere around 10%. ■

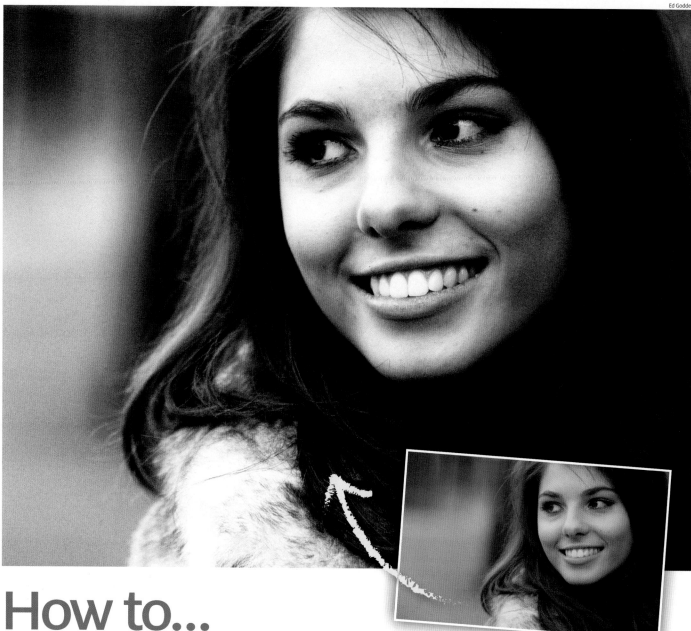

How to...
Get striking results in black and white

On the disc
Start image and video on your free DVD

Tired of muddy mono portraits? The art of the perfect black and white conversion is just a few clicks away...

WHAT YOU'LL NEED *Photoshop Elements/CS/Lightroom*
WHAT YOU'LL LEARN *How to use the Convert To Black And White command, add realistic grain and use Colour Curves*
IT ONLY TAKES *10 minutes*

Creating an effective black-and-white image digitally used to be quite a tricky business – and a task that the Photoshop novice could easily get wrong. Now it's much easier, thanks both to the Convert To Black And White feature in Photoshop Elements and also to the HSL/Greyscale facility in Adobe Camera Raw, for those who prefer to work with RAW images. Essentially, in both cases, the black-and-white conversion consists of tweaking the greyscale tones of particular channels and colours in the original image, so they're to your liking in terms of greyscale tones. In Photoshop Elements, Convert To Black And White gives you access to all three colour channels, and you can tweak the predominance of each to control the tone of specific areas in your image. In ACR's HSL/Greyscale dialog, you can target the output tones of specific colour ranges more directly.

By using either method, your route to striking black-and-white portraits is assured. Here's how it's done...

1 Choose a Preset

Open bwportrait_start.NEF from the Video Disc in ACR, then click Open Image to go into the main Photoshop Elements window. Go to Enhance>ConvertToBlackAndWhite. It's best to start the conversion process by choosing one of the Style Presets from the left-hand side of the dialog. Review each preset and choose the one that's closest to the effect you want. Here, we've chosen Portraits.

2 Channel sliders

The three Adjustment Intensity sliders relate directly to the original Red, Green and Blue channels in the colour image. Dragging the slider to the right adds more data from that colour channel, and dragging it to the left reduces the amount of that channel visible in the final image.

3 Avoid blow-out

It's important not to push any of the sliders too far to the right, as this will blow out the highlights in the image. Bear in mind that the sliders relate directly to the colours in the original shot. Our bluish background can be darkened by dragging the Blue slider to the left.

4 The perfect mix

Moving the Green slider to the right introduces much-needed contrast to the image. You can now juggle the sliders together to cook up your optimum mix. View the effect on the image itself by dragging the dialog box out of the way.

5 Careful with the contrast

The Contrast slider can be a little fierce so, if you do use it, make only very small adjustments, as you'll have more control over the contrast back in the main Elements workspace. When you're happy with the overall tonality, click OK to apply the changes to your image.

6 Curves adjustment

Finally, tweak the contrast via Enhance>AdjustColour>Adjust Colour Curves. Here, we've darkened the shadows and punched up the highlights a little. Dragging the Midtone Contrast slider a touch to the right adds some weight to the midtones. ▶

How to...
Create striking mono with RAW

For more control over your black-and-white mix, choose the HSL/Greyscale facility in Adobe Camera Raw

For the ultimate control over how colours convert to greyscale, the HSL/Greyscale tab in ACR should be your tool of choice. Here, you can tweak the tone of virtually every single range of colours within the image. You can darken a range of tonal conversions by dragging the appropriate colour slider to the left, or lighten them by dragging to the right. You can further tweak the final monochrome via a simple curve.

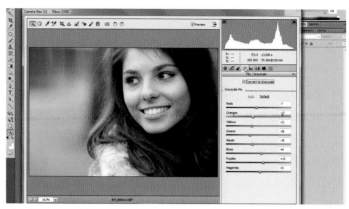

1 Automatic start
Open bwportrait_start.NEF from the Video Disc in Adobe Camera Raw. Correct the exposure as usual in ACR and then click on the tab for HSL/Greyscale. Check the box for Convert To Greyscale. Although you can start adjusting the sliders straight away, it's often useful to hit the Auto button for a good starting point.

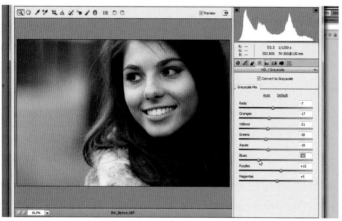

2 Target specific colours
Each of the sliders control the greyscale tone of specific colour ranges within the original colour image. Darken the tone of a particular colour range by dragging the appropriate slider to the left, or lighten it by dragging the slider to the right.

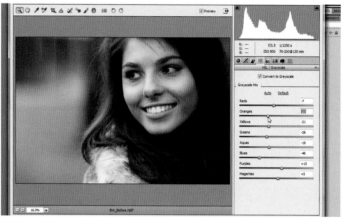

3 Watch the noise
In this image, dragging the Oranges slider to the left darkens the midtones and shadows of the face. It's important not to drag the sliders too far to the left as you'll start to introduce unwanted noise and posterisation into the targeted areas.

4 Tone Curve
At any time, to adjust contrast you can click on the Tone Curve button. Choose the Point tab. Now, select a preset from the drop-down Curve: Option or manipulate the curve itself. We've created a simple contrast curve, brightening the highlights and intensifying the shadows.

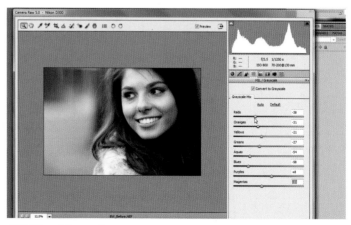

5 Final tweaks
You can still return to the HSL/Greyscale tab and tweak the tone of the particular colour ranges further. Keep an eye on the histogram as you make adjustments to avoid any clipping. You can save your mix by clicking the palette menu arrow and choosing Save Settings. ■

Jade Lord (Future)

How to...
Enhance fine details

Use the Burn tool to give your monochrome images added depth

WHAT YOU'LL NEED *Photoshop Elements 5.0 or Photoshop CS and above*
WHAT YOU'LL LEARN *How to use the Burn tool to 'paint' in detail, how to enhance specific areas of an image to create a striking mono print*
IT ONLY TAKES *5 minutes*

Traditionally, the Dodge and Burn tools are used to lighten and darken areas of a photo to improve tone and contrast. However, the Burn tool can also be used like a paintbrush to emphasise fine areas of shadow and detail. This works particularly well with still-life arrangements.

Our rose image is bursting with texture, and the black and white conversion has boosted this, but each petal edge can be accentuated further by subtly darkening the area with the Burn tool. By using a very small brush you can 'paint' detail into the tiniest of areas to create a striking image that really catches the eye.

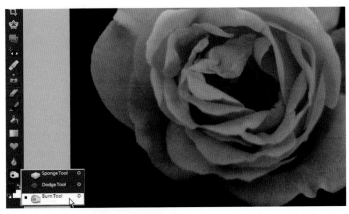

1 Select the Burn tool
Open the image fine_start.jpg from the *Black & White Digital Photography Made Easy* Video Disc and select the Burn tool from the Tools palette. You'll notice that in the Options bar, at the top of the screen, there are a number of options that allow you to fine-tune the way

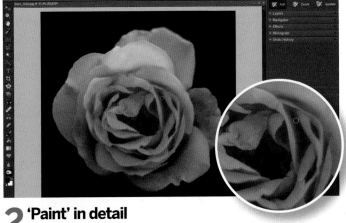

2 'Paint' in detail
Select Midtones for an overall even adjustment. Set the Exposure to 5% for a subtle darkening effect and make your brush quite small. Carefully 'paint' over the shadows and edges of the petals, building up this painted effect to accentuate the rose's texture and shape.

3 Set your brush size
In the Brush drop-down menu, you can alter the Burn tool's Brush Size and Hardness. You'll need a very small soft-edged brush, so set the Size to 50px. You can use the '[' and ']' keys to alter its size, and as you do you can see the brush increase or decrease over your image.

4 Dodge areas to finish
Other areas can be lightened and highlighted using the Dodge tool. Select it from Tools palette and set the Range to Midtones and Exposure to 5%. Finally, increase the brush size so it covers a fair amount of a petal, and then sweep over areas to lighten them. ■

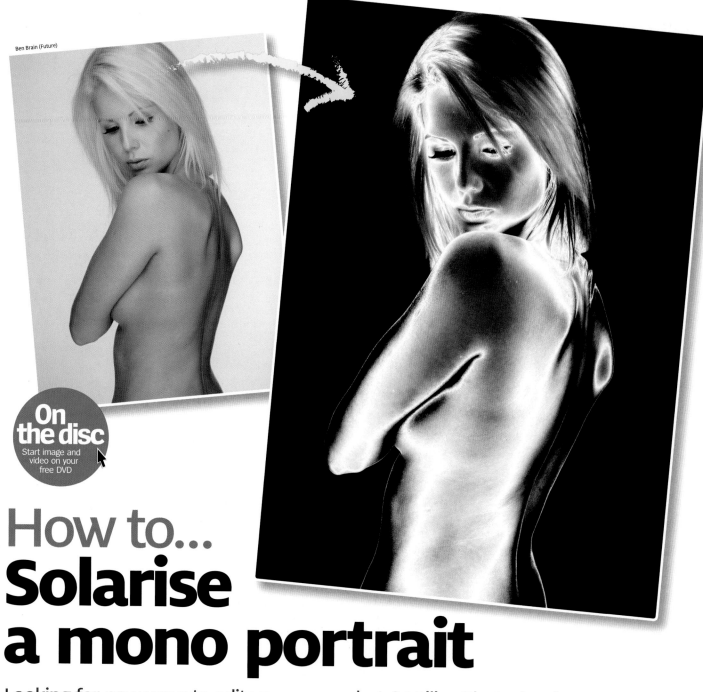

Ben Brain (Future)

On the disc
Start image and video on your free DVD

How to...
Solarise
a mono portrait

Looking for new ways to edit your mono shots? Utilise Photoshop's powerful Curves command to recreate a traditional darkroom technique

WHAT YOU'LL NEED *Photoshop CS or above*
WHAT YOU'LL LEARN *How to alter tone using Curves, how to invert specific tones, how to lighten dark tones using Layer Masks*
IT ONLY TAKES *10 minutes*

At first glance a solarised photograph may look like a negative version of the mono image. However, in a negative all the shadows and highlights are reversed so that blacks become white and vice versa. Solarised images, on the other hand, feature a wide range of contrasting tones – only some of which are reversed. Another distinctive property of a solarised photo is the sharp white line that appears around

high-contrast areas. This makes the textures in the photo look shiny, which, as in the image above, enhances and emphasises the soft contours of our subject's skin.

The solarisation effect was discovered by accident and is tricky to produce in a traditional darkroom, but thanks to the tools packed into Photoshop's digital darkroom you can create a solarised image with ease. On the opposite page we'll show you how to discard a shot's colour information and use the Curves command to create a classic solarised effect. You'll also use Curves in a more traditional way to boost the contrast between the highlights and shadows, and fine-tune the results with a bit of old-school dodging and burning.

1 Desaturate the colour shot

Kick off by opening the image named solarise_start.jpg from the Video Disc in Photoshop CS. To quickly convert this colour image to monochrome, go to Image>Adjustments>Desaturate. At this stage you'll see that the desaturated greyscale image looks a little washed out, which reduces the impact of the colour photo.

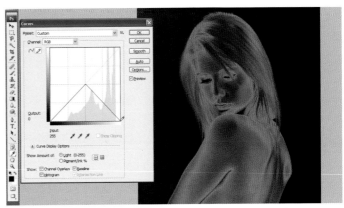

2 Draw an inverted 'V'

Go to Image>Adjustments>Curves. Click on the pencil-shaped Draw To Modify The Curve icon. Hold down the Shift key and click in the bottom left-hand corner (where Output and Input both read 0). Place a second point in the middle of the curve (at Output 128, Input 128). Place a third point at the bottom right (Output 0, Input 255) and click on OK.

3 Create an Adjustment Layer

In Step 2 you inverted the highlights but left the midtones and shadows untouched, so the subject's eyelashes, for example, are still black. The shot still looks washed out, so go to Layer>NewAdjustment Layer>Curves. Click OK in the New Layer window to create a new Curves Adjustment layer.

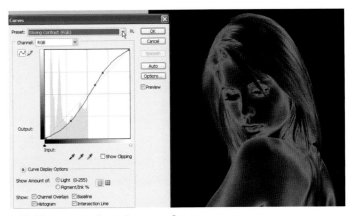

4 Try a contrast preset

You could try to boost the image's contrast by going to the Preset menu and choosing the Strong Contrast (RGB) curve. This automatically places points on the curve, darkening shadows and midtones and brightening highlights. There's still not enough contrast, though, because there are no pure whites in the image.

5 Try a manual adjustment

Select the left-hand Eyedropper tool (Sample In Image To Select Black Point). Click on an area that should be jet black. This will darken the shadows. Now select the right-hand Eyedropper tool (Sample In Image To Select White Point) and click on one of the brightest points on the girl's skin to brighten the highlights. Click OK when you're finished.

6 'Dodge' the shadows

Finally, grab the Brush tool from the Tools palette and choose a soft brush tip from the Preset picker in the Options bar. Set its Radius to 600, Opacity to 21% and Flow to 25%. Now click on the 'Curves 1' Adjustment Layer's mask (the white rectangle). Spray over the dark shadows on the face and shoulder and 'dodge' (lighten) those areas. ∎

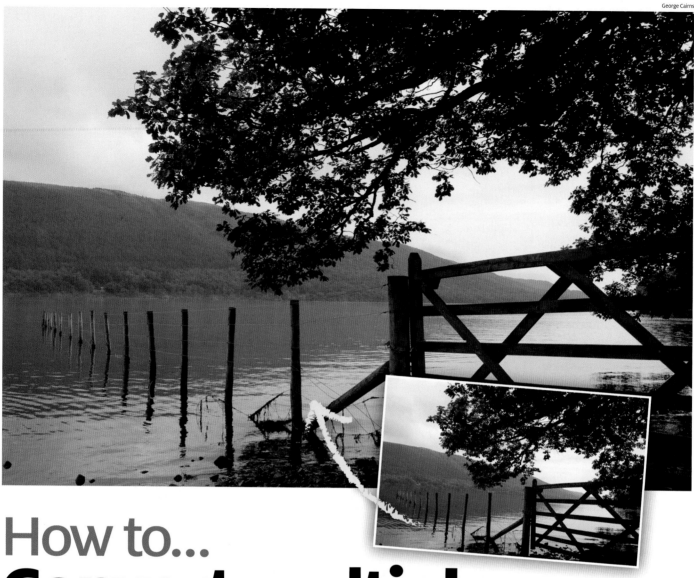

George Cairns

How to...
Convert multiple images in Lightroom

If you have a number of colour images to convert to black and white, you can do them all at once using Lightroom's batch-processing tools

WHAT YOU'LL NEED *Photoshop Lightroom 2 or above*
WHAT YOU'LL LEARN *How to batch-convert photos, how to make selective tonal adjustments, how to create slideshows and web galleries from your shots*
IT ONLY TAKES *25 minutes*

One of the best things about Photoshop Lightroom is that it's a one-stop shop. You can use it to import, organise and edit your photographs. But there's no point in sprucing up your pictures' pixels if they'll just gather digital dust on your PC, so Lightroom is well equipped to help you share your shots, too.

We'll show you how to use Lightroom to batch-process a series of colour photographs, creating a mono version of each as you import them. We'll then use the Develop module to tweak their tones using Lightroom's global image adjustment tools before fine-tuning specific areas using the Adjustment Brush. You'll then discover how to take the processed mono pictures and create a stylish interactive Flash web gallery, or produce a slick slideshow that you can mail to friends and family.

The image above was shot on an overcast day, so the colours lacked saturation. But by converting it to black and white, we created a shot with a wider range of shadows, midtones and highlights that emphasise the shape and form of objects in the scene in a more effective way.

1 Process multiple files

First download and unzip the lightroom_start.zip file from the DVD. Go to File>Import and choose Import Photos From Disk. Browse to the Lightroom_start folder and click on Import All Photos In Selected Folder. Set the File Handling option to Copy Photos To A New Location And Add To Catalog, then set the Develop Settings menu to General – Greyscale. Click Import and Lightroom will desaturate the shots as it imports them.

2 Tweak the tones

Click on Lightroom_start.CR2, then click on the Develop tab. Increase the contrast by pushing Exposure up to +0.57. This brightens the highlights and midtones. Boost the strength of the shadows by dragging Blacks to 12. Some of the dark branches will become clipped, however the extra contrast emphasises their complex shapes.

3 Make selective adjustments

You can darken the washed-out mountains a little to differentiate them from the water. Select the Adjustment Brush from beneath the histogram. Set Effect to Exposure, reduce Amount to -50, set Brush Size to 25 and give it a Feather of 47 to gently blend the adjusted pixels with their neighbours. Carefully spray the brush tip over the mountains.

4 Share and enjoy

Click on the Slideshow tab (top right). Now tick Stroke Border and use a Width of 10 pixels to add a white border to your photos. Tick Cast Shadow to create a drop shadow that makes the shots stand out from their backdrop. Next, choose Slideshow>Export PDFSlideshow to create a self-contained file that showcases your monochrome conversions.

5 Perfect your prints

By clicking on the Print module you can use the Layout Engine to create a Picture Package. This enables you to print multiple copies onto one sheet. To print images at a specific size, click on the relevant size option (5x7 inches, for example) in the Cells pane. Click Print when you're happy with your layout.

6 Create a web gallery

You don't need to be a web designer to produce an attractive online gallery that can be used to showcase your black-and-white images. Click on the Web menu and choose a template from the Template Browser on the left. This creates an interactive slideshow of your shots, as well as placing them in a scrolling frame. Choose Web>ExportWebPhotoGallery to produce HTML or Flash files that you can upload to your website. ■

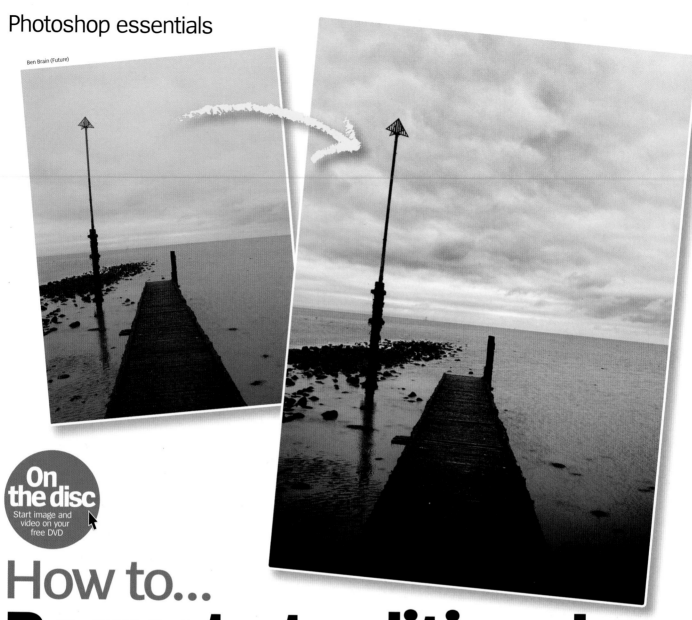

Ben Brain (Future)

On the disc
Start image and video on your free DVD

How to...
Recreate traditional film effects

Do you miss the rough-and-ready look of black and white film? Then try using the sophisticated Silver Efex Pro plug-in to transform your mono landscapes

WHAT YOU'LL NEED *Photoshop CS3, Silver Efex Pro (plug-in)*
WHAT YOU'LL LEARN *How to recreate realistic film grain, how to make selective tonal adjustments, how to add a vignette effect*
IT ONLY TAKES *25 minutes*

P hotoshop offers a variety of ways to create black-and-white prints. You can quickly desaturate a shot to create a greyscale image and then use the Levels command to tweak the shot's tones, for example. The Black and White adjustment also allows you to mimic the traditional trick of using coloured filters over the lens to lighten or darken specific tones in your mono shot, so you can emphasise specific areas. Photoshop makes basic colour-to-black-and-white conversions easy,

especially if you are new to image editing. However, if you come from a traditional photography background you'll have experience of producing black and white prints using different types of film. The Photoshop plug-in Silver Efex Pro enables you to mimic the wide range of effects produced by different black and white film stocks, so you can recreate your favourite monochrome look (the distinctive high grain effect produced by fast ISO speed film, such as Ilford Delta3200 Pro, for example).

Silver Efex Pro presents all the mono conversion tools you'll need in a single easy-to-access interface. As well as making adjustments to the image as a whole, you can make localised tonal changes using the plug-in's powerful Control Point feature. So download the 15-day trial from www.niksoftware.com and let's put the plug-in through its paces...

1 Install the plug-in

Follow the installer's instructions to place the plug-in into Photoshop's Plug-Ins folder. Now launch Photoshop CS3 and open the nik_start.jpg source image from the Video Disc. Navigate to the Filters menu and choose NikSoftware>SilverEfexPro. A monochrome version of the colour source file will now open in the Silver Efex Pro interface.

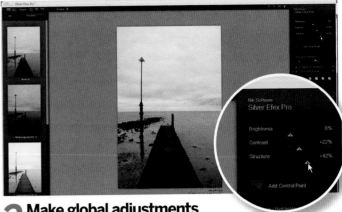

2 Make global adjustments

You can emphasise the shapes in the shot by pushing Contrast up to +22%. This makes the dark black pier and post stand out more prominently against the white-and-grey backdrop. Push Structure up to +42% to increase the localised Contrast. This will help to restore some of the overexposed cloud detail.

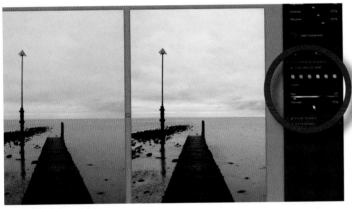

3 Filter effects

Click the Side-by-Side Preview icon to compare the original image with your monochrome version. You can now see how brown the water is in the original shot. You can lighten that colour to increase the contrast between the grey water and the dark pier in the mono conversion: go to the orange filter in the right-hand toolbar and increase Strength to 97%.

4 Clever control points

The sky is still too overexposed. To restore missing detail in this area without tinkering with the carefully edited tones in the lower half of the shot, click Add Control Point. Cick-and-drag the Control Point's top slider to increase the selection marquee size. To darken the clouds, set Brightness (B) to -24, Contrast (C) to 47 and Slide Structure (S) to 52.

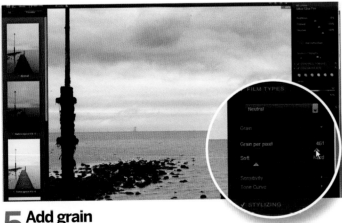

5 Add grain

Select the Zoom tool in the top-right of the interface and click on the image to zoom in to 100%. To make the shot look as if it was taken using high-ISO film, go to Film Types and click on Grain. Set Grain Per Pixel to 460 for tighter clumps of noise, then drag the Soft/Hard slider towards the Soft end for a more blurred and natural-looking grain effect.

6 Create a vignette

Zoom out, then click on the Stylizing panel in the right-hand toolbar and choose Vignette. Activate the Place Center icon and click the middle of the sky section. Drag Amount to -46% and Size to 50%. This darkens the bottom corners of the image. To warm the cool shot up a little, go to Toning and choose the Sepia 17 preset. Click OK and you're done. ∎

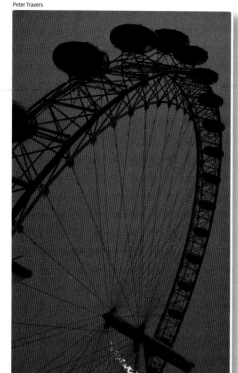

Peter Travers

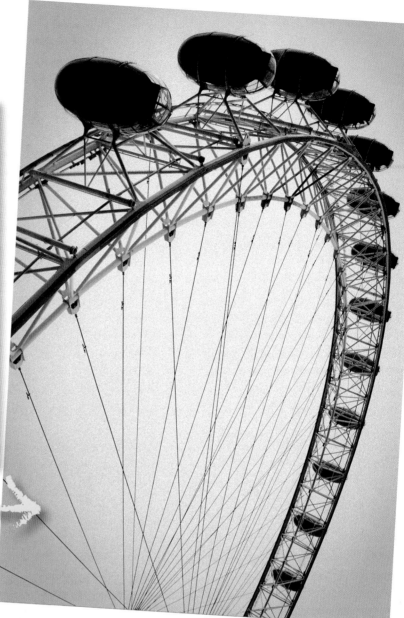

How to...
Use ACR for cool mono conversions

As well as editing RAW files, Photoshop's Adobe Camera Raw
is also great for converting images to black and white

On the disc
Start image and
video on your
free DVD

WHAT YOU'LL NEED *Photoshop CS5*
WHAT YOU'LL LEARN *How to use Adobe Camera Raw, how to create a
pro-look mono image with the Grayscale tab, how to add grain and
vignetting creatively, how to add a Photo Filter Adjustment Layer*
IT ONLY TAKES *10 minutes*

To create a black-and-white image you have two choices. You can
use the Monochrome Picture Style on your camera, or shoot in
colour and then use editing software to convert your images to
mono. We always recommend shooting in colour and then converting
your shots to mono, as you have more control and can boost individual

tones to get the best results. This would normally mean using
Photoshop's Black & White command. There is a third option, however:
use Adobe Camera Raw. In this tutorial we show you how to use lots of
ACR's tabs. You'll start off with the Basic tab, then use the Tone Curve tab
to plot points to boost contrast, and finally the HSL/Grayscale tab for
your mono conversion.

We're using Photoshop CS5 and the Adobe Camera Raw 6.0 plug-in,
which also has an improved vignetting option that applies the effects to
your cropped image – found under the fx/Effects tab. After adding grain
and cropping, you'll open the converted shot in Photoshop and add a
Deep Blue Photo Filter Adjustment Layer to spice up your mono image.

1 Start off the basics

From the Video Disc, first open acr_start.CR2 in Photoshop CS5, it will open in the Adobe Camera Raw workspace. Under the Basic tab, brighten up the shot by boosting Exposure to +2.00, and to reduce any burnt out highlights, set Recovery to 35. Leave the following on their default settings: Blacks on 5, Brightness at +50, and Contrast at +25.

2 Adjust the contrast

Under the Tone Curve tab, click the smaller Point tab and plot three points: one bang in the centre, and one top and bottom, to create a nice S-curve to boost the overall contrast. On the Detail tab, under Noise Reduction set Luminance and Colour both to 20.

3 Convert to black and white

Under the HSL/Grayscale tab, simply click Convert To Grayscale to create a mono image. We found the Auto settings worked just fine for our shot, but you have lots of control over your conversion with the eight different colour channel sliders. Experiment, as different settings on each slider will suit the respective colours in your own images.

4 Workflow options

To add a Photo Filter Adjustment Layer (Step 6) you need an RGB image, not Grayscale. If your Workflow Options aren't set correctly, click the data line (eg 'sRGB; 8 bit; 2186 by 3110; 300dpi') below your image. In the Space drop-down menu, pick sRGB. Or, later on in Photoshop's main editing workspace, go to Image>Mode and choose RGB Colour.

5 Post-crop vignette

Pick the Crop tool and select Normal from the drop-down menu, then crop and tilt (hover the mouse arrow outside the corner of the crop box) for a neater composition. Click the fx/Effects tab under Grain and set Amount to 40, Size to 40 and Roughness to 50. Under Post Crop Vignetting, keep Style on Highlight Priority, set Amount to -25, Midpoint to 65, Roundness to 0, Feather to 50, and keep Highlight at 0.

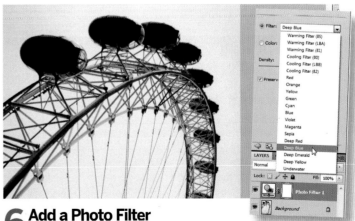

6 Add a Photo Filter

Click Open Image to open the main Photoshop CS5 workspace. Then go to Layer>NewAdjustmentLayer>PhotoFilter. In the Adjustment Layer window, choose Deep Blue from the drop-down menu. Set Density to 60% and keep the Preserve Luminosity box checked. Go to Layer>FlattenImage, then File>Save (as JPEG or TIFF) ■

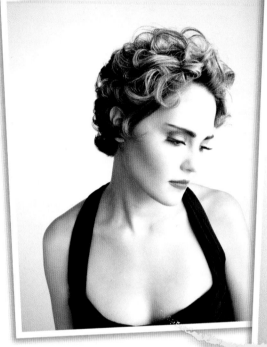

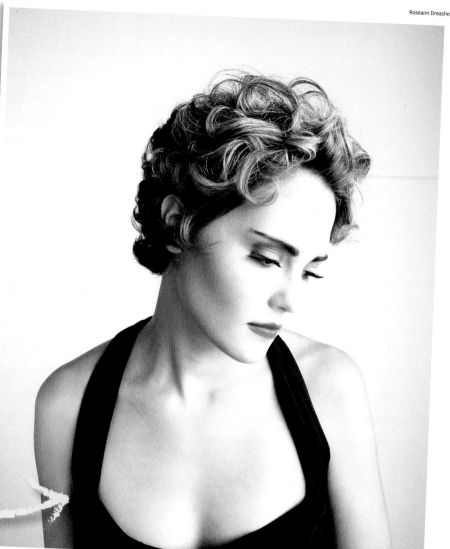

Roseann Dreasher

How to...
Sharpen selectively for professional results

Looking for a way to polish your portraits? Use Photoshop Elements to restore detail in soft-looking areas without adding unwanted artefacts

WHAT YOU'LL NEED *Photoshop Elements 6 or above*
WHAT YOU'LL LEARN *How to selectively sharpen blurred pixels, how to leave focused areas unsharpened and avoid artefacts*
IT ONLY TAKES *10 minutes*

For close-up portraits, the usual rules of image sharpening do not apply. While practically every shot that you take with a high-end camera will need to have some digital sharpening applied, the standard approach using the Unsharp Mask filter will not work if you want to flatter your subject.

The normal method is to set the three Unsharp Mask sliders to give a sharpening effect that works across the whole image. But do this with a picture of someone's face, and the amount of sharpening needed to give impact to the eyes and the lips will accentuate even the smallest laughter lines and skin pores.

The solution is to sharpen just the parts of the face that need the Unsharp Mask treatment – and to leave those wrinkles and spots unsharpened. You can use the High Pass sharpening method for this selective sharpening approach, but the trusty Unsharp Mask can also be used. The secret is to copy the image into a new layer and then apply the right amount of Unsharp Mask needed to bring out the eyes in this copy layer. You then use the Eraser tool to delete the areas from this layer that didn't need sharpening to reveal the unsharpened version of these areas in the layer below. Here's how it's done...

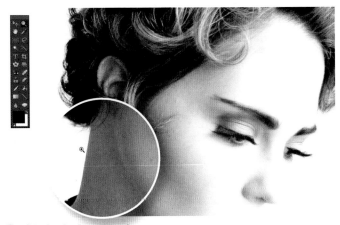

1 Zoom in

Open the file named sharpen_start.jpg from your Video Disc. Grab the Zoom tool and zoom in to 100% magnification to see the shot at full size (or click the 1:1 option in the Options bar). You'll see that the more distant hair at the back of the model's head looks sharp, but her eyes and lips are too soft and need accentuating.

2 Global sharpening

Try selecting Enhance>AutoSharpen to sharpen the whole image. By doing this you will instantly reveal more detail in the model's eyes and lips, but also add ugly artefacts to other areas, such as the dark line (or halo) you can see clinging to the model's neck. Press Ctrl+Z to undo this.

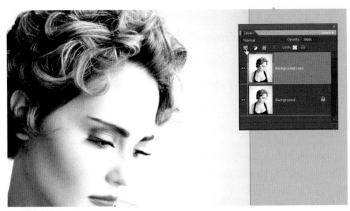

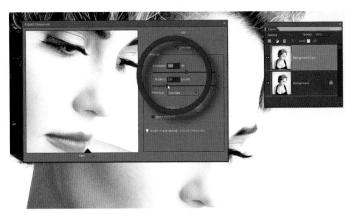

3 Duplicate the Background layer

To selectively sharpen just the eyes and lips while leaving the sharp areas untouched, first ensure the Layers palette is open by going to Window>Layers. Now drag the 'Background' layer onto the Create A New Layer icon at the top of the Layers palette to create a copy. This way you can return to your original image at any time, should you wish.

4 Adjust the sharpness

Next, click on the 'Background copy' layer in the Layers palette to select it, then go to Enhance>UnsharpMask. Click on the + sign in the window that appears to zoom in to 100% and position the subject's face in the preview window. Set Amount to 100%, Radius to 2 and leave Threshold on 0.

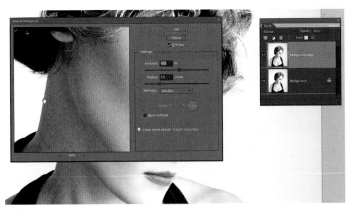

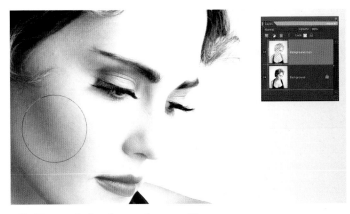

5 Analyse artefacts

Click-and-drag inside the Unsharp Mask's preview window to look for artefacts. The sharpening process has also emphasised picture noise, and revealed unwanted texture in the skin. The hair is now over-sharpened. Click OK to sharpen the image. We'll minimise the artefacts in the next step.

6 Reveal the layer beneath

There are now two versions of the photo – the sharpened image and the original shot on the layer below. Target the top layer by clicking on it and then select the Eraser tool. Set Size to 150 and Opacity to 55%. Use the Eraser tool on the hair, body and skin to reduce the sharpening, leaving the eyes, nose and lips to remain good and sharp. ∎

George Cairns

How to...
Master Layer Masks in minutes

Layer Masks may sound daunting, but they're surprisingly intuitive, and can help you declutter an image with ease

WHAT YOU'LL NEED *Photoshop CS or above*
WHAT YOU'LL LEARN *How to align several shots of the same scene, how to hide unwanted people using Layer Masks, how to transform layers to fix converging verticals, how to use an Adjustment Layer to convert to mono*
IT ONLY TAKES *15 minutes*

O nce you get your head around working with multiple layers, you can go one step further and use masks to help you pick and mix the best bits from each layer. Take our finished architectural scene for example: we could have hung around until all the tourists had left, but this

would have taken too much time. By shooting multiple exposures as people wandered by, we were able to capture every architectural detail in three different shots.

In this tutorial, we'll teach you how to place the three source files onto separate layers and align them so that the buildings are in the same position on each of the layers.

You'll then add a see-through mask to every layer. By painting black on a layer's mask, you can effectively mask out the unwanted people on that layer, revealing a clear area of architecture from the layer below. We'll finish off by straightening up the converging verticals, and using an Adjustment Layer to create a striking monochrome scene.

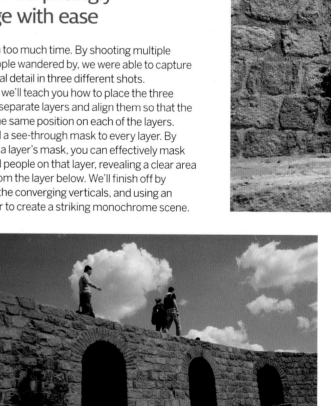

1 Align your shots
You could copy each photo into a single file on separate layers, but there's a quicker way that also aligns your images. In Photoshop CS, go to File>Automate>Photomerge. Click Browse and find masks_start.zip on your Video Disc, unzip the file, then click and drag the three masks_start images inside the folder. Click Open. Tick Auto, untick Blend Images Together, then click OK.

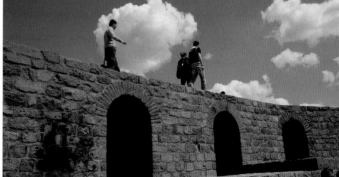

2 Check the layer order
Photomerge will place the shots in a single document on separate layers, and then – because they were shot by hand – reposition each layer to make sure the buildings overlap as accurately as possible. Next go to Window>Layers and drag the layer thumbnails so that 'masks_start1' is at the bottom of the stack, and 'masks_start3' is at the top.

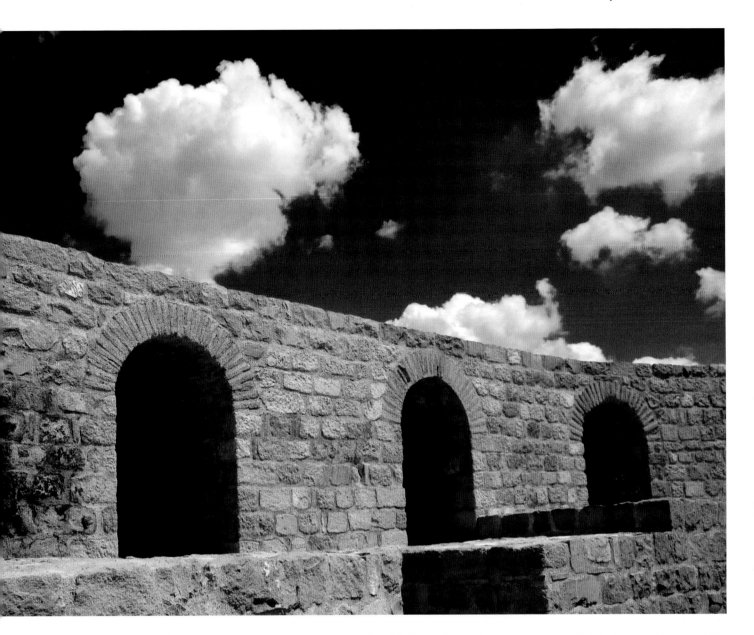

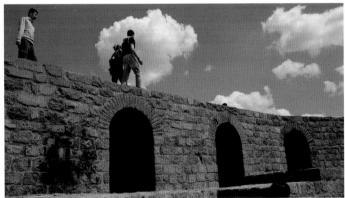

3 Alter the opacity

Click on the 'masks_start3' layer, then change the Opacity slider at the top of the Layers palette to 20%, to compare the content of this layer with 'masks_start2' below. The man on the left and the couple at the bottom almost vanish, showing there are some clear patches of building and sky below, on 'masks_start2'. Restore Opacity to 100%.

4 Add a mask

Click the Add Layer Mask icon at the bottom of the Layers palette. A white mask attaches itself to the 'masks_start3' layer. Think of this mask as sitting on top of the layer it's attached to: a white mask doesn't mask out any of this layer, making the whole layer visible, but painting black on the mask effectively hides pixels, revealing the layer below. ▶

5 Let us spray

Select the Brush tool. In the Options bar presets, choose a soft brush with a diameter of 300 pixels and set Opacity and Flow to 100%. Click on 'masks_start3's Layer Mask thumbnail. Ensuring the foreground colour in the Tools palette is set to black, begin to spray the brush over the unwanted man at the top left.

6 Hide the layers

Do the same with the couple on the top of the wall. This will reveal a man on the layer below, but we'll mask him out later. Finally, mask out the couple at the bottom. To get a better idea of what your mask is doing, click the two lower layers' eye-shaped icons to make them invisible. You'll see the holes the mask has made in the top layer. Click the eye icons again.

7 Vanishing act

Select the 'masks_start2' layer and create a Layer Mask, as in Step 4. Click the mask and spray the black brush over the remaining man. As an experiment, press X to swap the foreground colour to white: when you spray, you erase the black mask to reveal the hidden man. Press X to return to a black brush and hide him again.

8 Send in the Cone Stamp

The top of a head remains visible, because it's in exactly the same position in each different layer. Select 'masks_start3' and click on the Create New Layer icon in the Layers palette. Grab the Clone Stamp tool and select Sample All Layers. Alt-click to sample a nearby patch of wall and sky, then clone out the head.

9 Transform your image

Press Shift+Ctrl+Alt+E to combine all the layers into a new one on top. To straighten the converging verticals, go to Edit>Transform>Perspective. Drag the top corner handles out a bit to straighten the verticals, then click the tick. Next go to Edit>Transform>Scale to enlarge the shot a little to hide any overlapping edges. Click the tick again.

10 Convert to mono

To make those fluffy clouds pop out more, click the Create New Adjustment Layer icon and choose Black&White from the drop-down menu, then choose Infrared from the next drop-down menu. Darken the sky by dragging Blues to -56, and lighten the architecture by popping Yellows to 274 and Reds to 70. These contrasting tones make the building's shapes and textures stand out better. ■

How to...
Dodge and burn with the Brush tool

Use a grey overlay to darken shadows and brighten highlights for dramatic effect

WHAT YOU'LL NEED *Photoshop Elements 6 or above*
WHAT YOU'LL LEARN *How to add a 50% neutral grey overlay layer to your image, how to use the Brush tool to lighten and darken specific areas of an image selectively*
IT ONLY TAKES *10 minutes*

The Dodge and Burn tools aren't the only way you can transform dull, uninspiring photographs by darkening their shadows and brightening lighter tones. By creating a neutral grey overlay layer, you can use the Brush tool with a black or white foreground colour to selectively darken and lighten areas.

The advantage over the Dodge and Burn tools is that it's much easier to edit the adjustment, and the end result looks much more dramatic.

We'll begin by converting our image to black and white, but this technique will also work with colour landscapes to boost detail in cloudy skies and increase contrast in foregrounds.

1 Create an Overlay layer
Open your image in Photoshop Elements and go to Enhance> ConvertToBlackAndWhite. Choose the Scenic Landscape preset and click OK. Go to Layer>New>Layer and choose Overlay from the Mode menu. Tick Fill With Overlay-Neutral Colour (50% Grey).

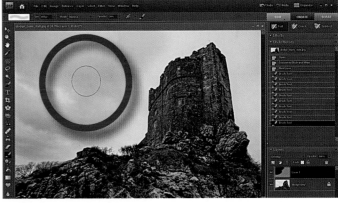

2 Darken the skies
Select the Brush tool and pick a soft brush of around 600 pixels. Set Mode to Normal and Opacity to 20%. Press D to set the foreground colour to black, then paint the sky to enhance the detail, being careful not to paint over the foreground. It's best to build up the effect slowly.

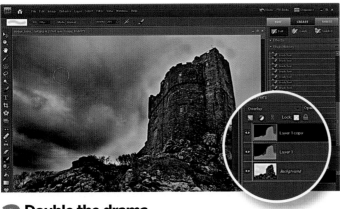

3 Double the drama
To double the strength of your sky, copy Layer 1 (Layer>Duplicate Layer). If you notice that the castle starts to look like it's 'glowing' around the edges, zoom in to 50-75%, drop the brush size to 100-175 pixels and paint over any bright sky around the edges of the foreground.

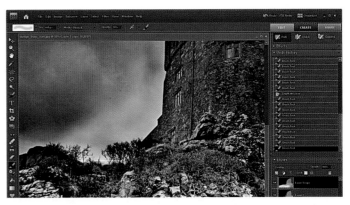

4 Brighten the foreground
Change the brush size to 500 pixels and press X to set the colour to white, then paint over the rocks and castle to brighten them up. Zoom in to 100%, decrease the brush size to 70 pixels and clean up any overly dark edges. Go to Layer>FlattenImage and you're done. ■

George Cairns

How to...
Get moody with monochrome!

Add brooding atmosphere to your black-and-white conversions by instantly adding a subtle wash of colour and faking film grain

On the disc
Start image and video on your free DVD

WHAT YOU'LL NEED *Photoshop Elements 7 or above*
WHAT YOU'LL LEARN *How to desaturate a shot and add a colour tint, how to add a dramatic vignette, how to create film grain effects*
IT ONLY TAKES *15 minutes*

There are many ways to create a striking black-and-white shot. The Convert To Black & White command in Photoshop Elements enables you to lighten or darken existing colours to draw attention to specific subjects in the monochrome version. However, this technique doesn't suit every image; it won't be that effective on photos that don't have much colour variation. Our start image is mostly a wash of florescent orange, so there isn't much for the Convert To Black & White

command to work with. We could try desaturating the shot with Remove Colour, but this will produce a wash of greyscale tones that lack contrast.

In this tutorial we show you how the Hue/Saturation command enables you to kill two birds with one stone by removing the shot's original colour, then adding a tint to change the desaturated image's mood. Adding a hint of cold blue to the mono image evokes a more menacing atmosphere, and you can then lighten or darken specific tones using the Dodge and Burn tools to emphasise certain features (like the sinister figure in the distance). By painting in a vignette to darken the shot's edges, you can place the subject in a more threatening environment. We'll finish off by adding a dash of gritty film grain to enhance the scene's grungy urban atmosphere.

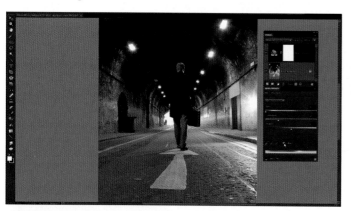

1 Desaturate the shot
Open mono_start.jpg from the Video Disc. Go to Windows>Layers to open the Layers palette. Click on the Create New Adjustment Layer icon at the bottom of the Layers palette and choose Hue/Saturation. Tick the Colourise button. This instantly desaturates the shot and enables you to change its mood with a wash of colour.

2 Change the hue
The great thing about the Colourise option is that it preserves luminosity. A wash of colour is added to the shadows and midtones, but the brightest highlights remain white. The colourised shot still looks too warm though, so cool the shadows and midtones by dragging the Hue slider to a chillier 217 and changing Saturation to a more subtle 15. ▶

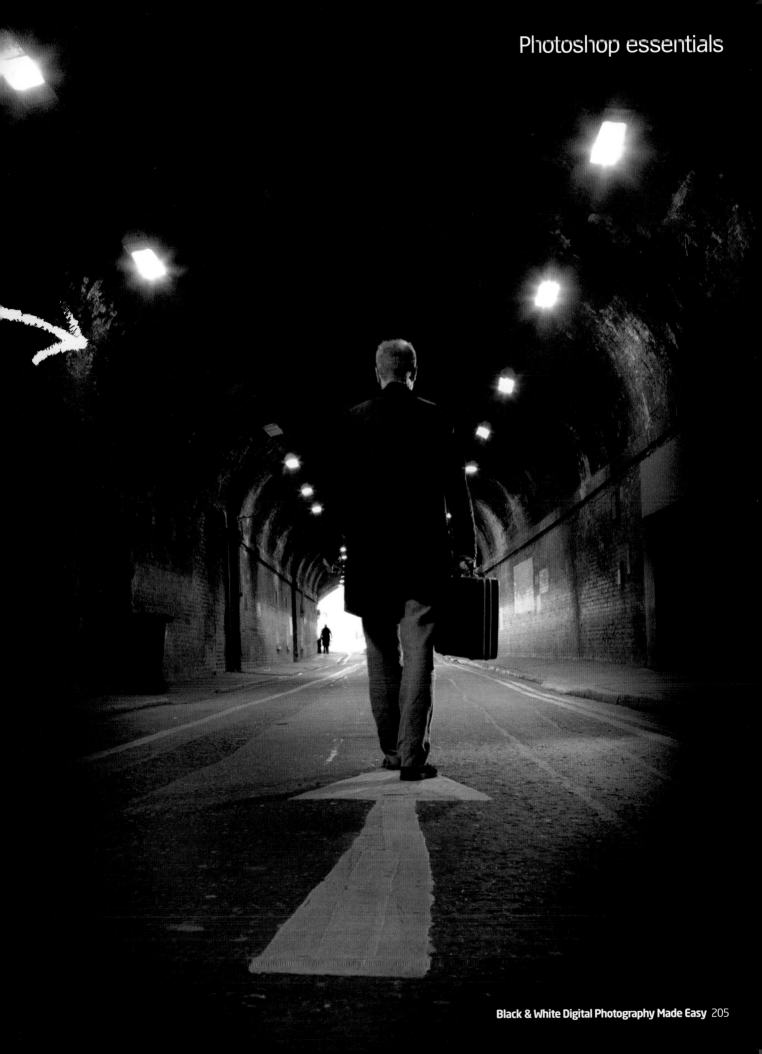

Photoshop essentials

3 Darken the shadows
Click the Add New Adjustment Layer icon and choose Levels. Drag the black shadow input level control point to 42 to dramatically darken the shot's shadows. This plunges the darkest areas into detail-free shadow, creating a menacing location for our subject to walk through. The brightest highlights and most of the midtones remain unaltered.

4 Selective adjustments
At this stage the main figure is a little lost in the shadows. Grab the Brush tool from the Tools palette. Choose a soft round brush from the Brush Preset picker and set its size to 400 pixels. Set its Opacity to 17%. Set the Tool palette's Foreground Colour to black. Click on the 'Levels 1' Adjustment Layer's mask. Spray over the main figure's coat to lighten it.

5 Dodge the highlights
To help the main figure stand out even more, click on the 'Background' layer in the Layers palette to target it. Grab the Dodge tool from the Tools palette. In the Options bar at the top, set the Size to 45 pixels, Range to Highlights and Exposure to 20%. Spray on the highlights around the edge of the figure to lighten them a little.

6 Burn the shadows
Select the Burn tool; it shares a compartment with the Dodge tool from the Tools palette. In the Options bar, set Size to 175 pixels, Range to Shadows and Exposure to 50%. Click and spray over the distant figure to darken him, creating a more striking silhouette. Burn the midtones in the right-hand doorway to add more menacing shadows to the scene.

7 Add a vignette effect
Click the Create New Layer icon. Go to Edit>FillLayer. Set Contents to Black and click OK. In the Layers palette, pop this layer above the 'Background' layer but below the two Adjustment Layers. Use a soft-edged Eraser tool to remove part of the layer to reveal the man and the tunnel lights. Leave the edges of the frame hidden in shadow.

8 Fake film grain
Click the Create New Layer icon. Again, go to Edit>Fill Layer, but this time choose 50% Grey from the Contents options. Click OK. Go to Filter>Noise>AddNoise. Set Amount to 20%, Distribution to Gaussian, tick Monochromatic and Click OK. For a softer grain, go to Filter>Blur>GaussianBlur. Set Radius to 0.5 pixels and click OK. Set the Blending Mode to Soft Light and reduce Opacity to 72%. ∎

How to...
Colour
by hand

Paul Grogan (Future)

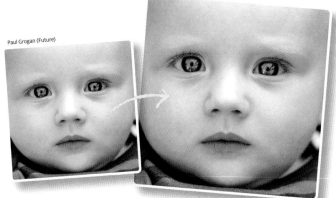

Add subtle colouring to mono portraits to make them really eye-catching

WHAT YOU'LL NEED *Photoshop Elements 6 or above*
WHAT YOU'LL LEARN *How to use brushes and Blending Modes to hand-paint your mono shots, how to use layers to colour parts of your images non-destructively*
IT ONLY TAKES *5 minutes*

Back in the days before colour film was invented, photographers used to hand-colour their black-and-white prints using little more than a paintbrush and paints. Getting it right took patience and a steady hand, and involved watering down the paint or dye until it was the right shade before painting it on

slowly. It was easy to get it wrong, and just one small mistake could be enough to ruin a print.

These days, it's much simpler and, thanks to Photoshop Elements, you can correct mistakes as you go along. In this tutorial, we'll show you how to add impact to any mono image with the help of some subtle hand colouring.

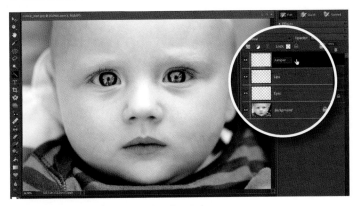

1 Create a Background copy
Copy the file named colour_start.jpg from your Video Disc onto your PC. Open it up in Elements, go to Window>Layers to open up the Layers palette and then click on the Create New Layer icon. Double-click on the words 'Layer 1' and rename the layer 'Eyes'. Create a third layer and rename it 'Lips', then make a fourth layer and rename it 'Jumper.'

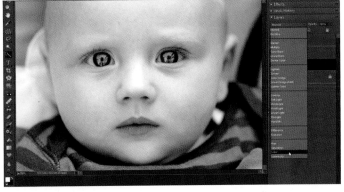

2 Grab a brush
Click on the 'Eyes' layer, zoom in on the eyes and choose Colour from the Blending Mode menu at the top of the Layers palette. Grab the Brush tool and select a soft-edged brush with a Diameter of 100. Set Hardness to 10% and Brush Mode to Normal. Drag the Opacity slider to 80% and go to Window>ColourSwatches. Select Pastel Cyan Blue.

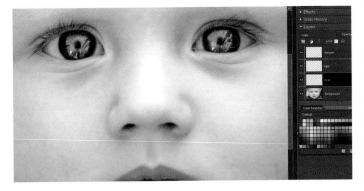

3 Start painting
Paint over the irises, taking care not to stray into the whites of the eyes. At this stage they'll look a bit startling, so drag the Opacity slider at the top of the Layers palette to 50% to tone things down. Select the 'Lips' layer and repeat Step 2, this time using Pastel Magenta to paint in the lips. To tone them down, drag the Opacity slider to 10%.

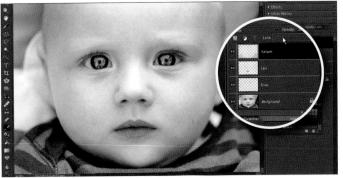

4 Go green
Zoom back out, select the Jumper layer and set the Blending Mode to Colour. Increase your brush size to 400, select Pastel Yellow Green from the swatches and paint over the jumper, reducing the brush size using the [key on your keyboard to avoid painting the baby's chin green. When you're finished, move the Opacity slider to 20%. ∎

Jeff Morgan

How to...
Boost shots with a B&W conversion

Learn how to turn a colour photo into stunning black and white, then add a vignette and noise for a gritty urban feel to your image

WHAT YOU'LL NEED *Photoshop CS3 or above*
WHAT YOU'LL LEARN *How to control detail and contrast in B&W conversions, how to tone or tint a monochrome image, how to darken corners with Lens Correction, how to add a grain-like effect*
IT ONLY TAKES *15 minutes*

Classic black-and-white photography has always been the serious photographer's tool of choice. But in this digital age, conventional wisdom has it that a simple greyscale conversion won't give the best results, and that for truly amazing mono images you'll have to use Photoshop's

Channel Mixer, which has its own complexities. However, its Black & White adjustment window does a great job quickly and simply! The secret is tones and texture; the key is to separate the colours of your image to help subjects stand out from their surroundings and have good tonal range.

Another advantage of converting to black and white is that images with colour problems, such as mixed lighting or bright, garish colours in the background, can be tamed in monochrome. Our shot of the London skyline provides the perfect example, suffering from low cloud and tungsten lighting which, in colour, results in a displeasing dirty orange-brown sky!

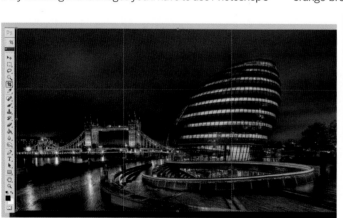

1 Adjust saturation
Open film_start.jpg from the Video Disc. Press C for the Crop tool and draw a box from the top-right of the image down and across to exclude the purple barrier and the lit box on the lower left. Press Enter. Since your conversion is based on the image colours, use Ctrl+U to open the Hue/Saturation window. Now increase Saturation to +15 and hit OK.

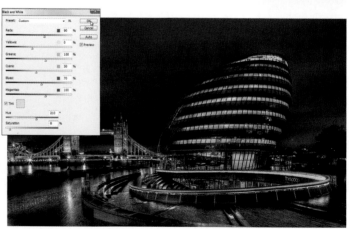

2 B&W and tone
Go to Image>Adjustments>Black&White, and set Reds to 90%, Yellows to 0%, Greens to 100%, Cyans to 30%, Blues to 70%, and Magentas to 10%. Next select a nice cool blue tone by ticking the tint box, set Hue to 210° and Saturation to 8%, then click OK.

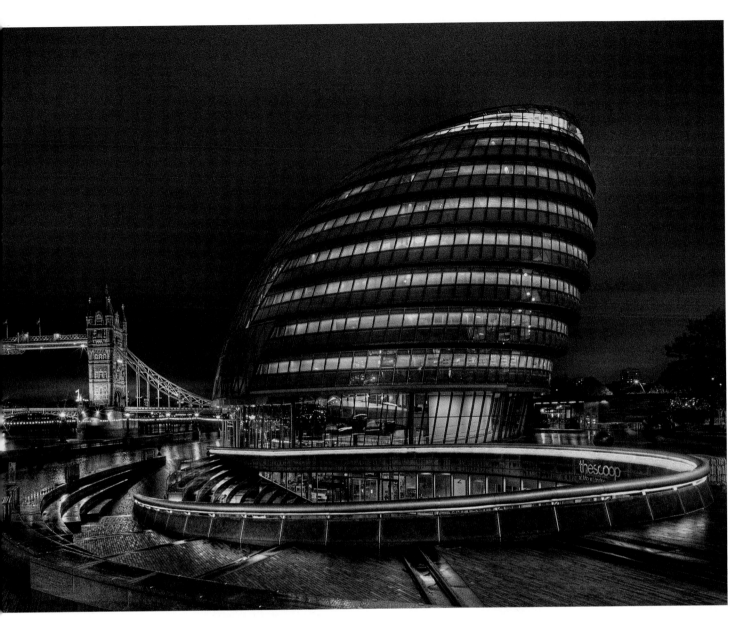

3 Darken the corners and edges

Go to Filter>LensCorrection (Filter>Distort>LensCorrection in earlier versions) and select the Custom tab. Under Vignette, push the Amount slider left, towards Darken; -20 is a good value, and then hit OK. Next select the Burn tool and set Size to 150, Hardness to 0%, Range to Midtones and Exposure at 6%. A wipe along the top of the sky, one on the bottom and brushing a couple on the brighter steps will help keep your eyes nicely on the building and bridge.

4 Gritty urban noise

For the final step we will add some noise, go to Filter>Noise>Add Noise. Make sure Gaussian is selected and monochromatic is ticked. This adjustment is very dependent upon image size and personal taste, so it pays to experiment with the value setting for other images. For this image, 3% gives a nice and grainy ISO800-feel to the scene. ■

How to...
Create a modern family portrait

It's surprisingly easy to give portraits a contemporary makeover. Follow our easy guide to transform colour shots into mono masterpieces

WHAT YOU'LL NEED *Photoshop Elements 6 or above*
WHAT YOU'LL LEARN *How to make a Levels adjustment, how to use the Dodge and Burn tools*
IT ONLY TAKES *15 minutes*

The popularity of a distinct style of commercial family portraiture has rapidly increased in recent years – portraits shot against a pure white backdrop and processed in striking high-contrast monochrome. In this guide we'll demonstrate that there's no need to pay through the nose for studio portrait photography. With Photoshop Elements, you can recreate the same stunning effect with a little judicious image editing.

We'll start with a typical family portrait shot, desaturate the colour, and then perform a little Levels magic to generate the super-high-contrast tonality. By using Levels, you can compress the tonal range of your desaturated image and shift the distribution of the highlights, midtones and shadows.

Of course, as with any really effective graphic image, you'll need to do a little bit extra; tweaking the final image with some manual dodging and burning. The Dodge and Burn tools enable you to selectively lighten and darken particular tonal ranges – in effect you're able to paint with light. The Exposure setting controls how much the tools lighten or darken your chosen range of tones. Learn how to get brilliant results, and save a fortune!

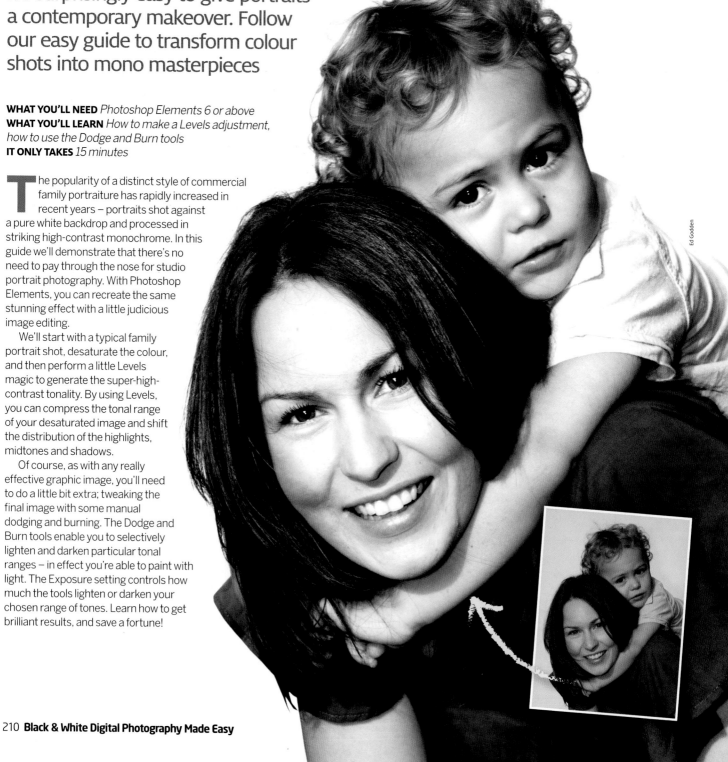

Ed Godden

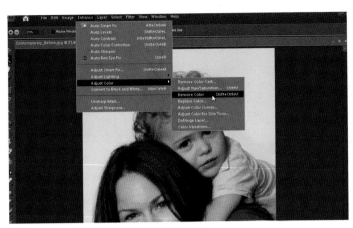

1 Desaturate your image

Open contemporary_start.jpg, then go to Enhance>AdjustColour>RemoveColour. This results in a fairly flat monochrome image, but it serves as a good basis for further tweaking. We'll do this using a Levels Adjustment Layer, so go to Layer>NewAdjustmentLayer>Levels.

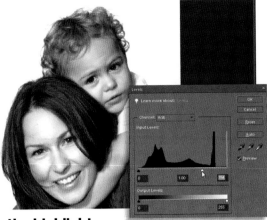

2 Brighten the highlights

First, we want to boost the image's highlights. In the Levels window, grab the white Highlights slider and drag it to the left. Focusing on the image itself, adjust the slider's position until the highlights are bright, but not completely blown out. You can make further adjustments later.

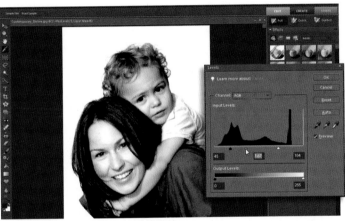

3 Increase the contrast

Grab the black Shadows slider and drag it to the right to compress the shadows. Control the midtone contrast by repositioning the central grey slider; we've dragged it to the left to lighten the midtones. Re-adjust both the black and white sliders to avoid blown-out or posterised areas.

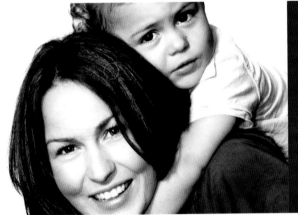

4 Lighten selectively

Once you're happy with the effect, hit OK to apply it, then go to Layer>FlattenImage. Select the Dodge tool. In the Options bar, set Range to Midtones and Exposure to around 10%. Now you can use the tool to lighten areas, such as bringing out the midtone detail in the hair.

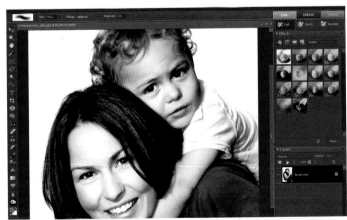

5 Dodge the highlights

Use the Dodge tool set to Highlights to brighten the highlights in the image, especially the catch-lights in the eyes. You can also Dodge the background to ensure it's pure white. The Burn tool can be used with Range set to Midtones to darken shadow areas in the faces. ■

Expert tip
Dodge and Burn effectively

The Dodge tool lightens tones and the Burn tool darkens them. With both of these tools you can target a specific tonal range – Highlights, Midtones or Shadows. Selecting a specific Range protects other tones from being affected by each of the tools.

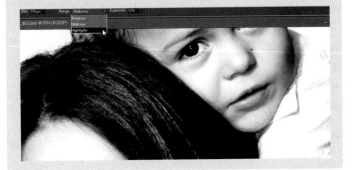

Chris George

How to...
Control tones the advanced way

Photoshop Elements users can take full control of the black-and-white conversion process in a clever way. Here's how...

WHAT YOU'LL NEED *Photoshop Elements 5.0 or above*
WHAT YOU'LL LEARN *How to control the shade of grey each colour becomes when you convert images into black and white, how to use some of the advanced features offered by Adjustment Layers, how to add a toned effect to your monochrome image*
IT ONLY TAKES *15 minutes*

There are lots of ways to convert colour pictures to black and white, but the number of choices depends on the software you're using. Photoshop Elements offers fewer options than Photoshop CS. With Photoshop

CS, you get extra settings during the RAW conversion, as well as two Adjustment Layer choices: Black and White and Channel Mixer. The beauty of these extra options is that they enable you to control the shade of grey that each colour in your image becomes. Typically, you can use these tools to make blue skies appear darker and to ensure that faces become the precise shade of grey that you desire. All is not lost, however: Elements users can get this degree of control using a cunning trick with a pair of Hue/Saturation Layers...

On the disc
Start image and video on your free DVD

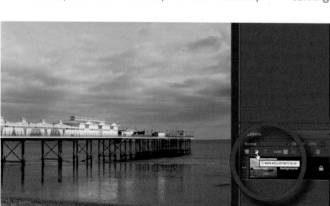

1 Add a new layer
Open the image huesat_start.jpg in Photoshop Elements' Full Edit mode. Ensure the Layers palette is visible by clicking Window>Layers. Click on the half-moon Create Adjustment Layer icon in the Layers palette and choose Hue/Saturation from the drop-down menu. Don't move any of the sliders on the window at this point, click OK if necessary.

2 Second Adjustment Layer
Now create a second Hue/Saturation Adjustment Layer. This will be used to turn the colour shot to black and white, while the first will be used to change the brightness of particular tones in the image. Click the half-moon icon once more, choose Hue/Saturation from the drop-down menu and click OK if using Elements 7 or earlier.

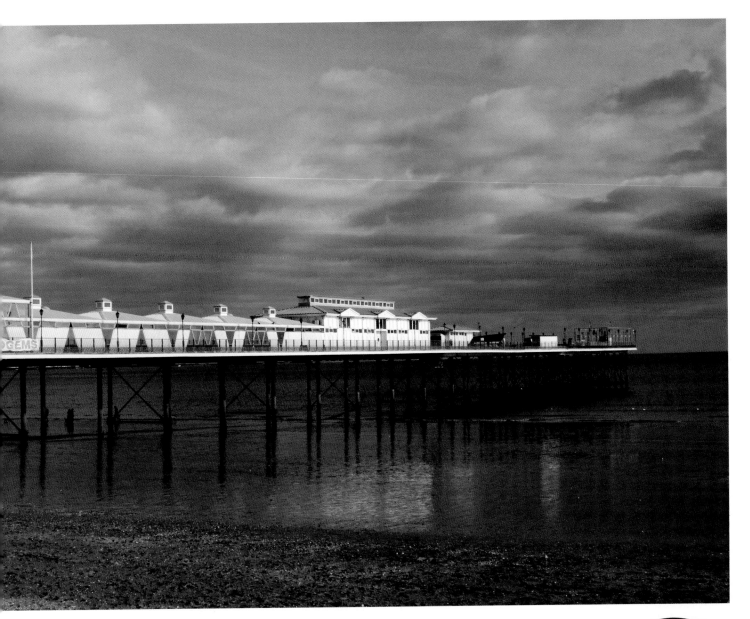

3 Change the Blending Mode

In the Layers palette, ensure that the 'Hue/Saturation 2' layer is highlighted. Click on the word 'Normal' at the top left of the palette, which brings down a menu of all the available Blending Modes. Choose the Colour option from the list. This simple change will mean that you can use both the Lightness and Saturation sliders in Steps 5 to 8.

4 Convert to black and white

In the Layers palette, double-click the left-hand icon on the 'Hue/Saturation 2' layer. This brings up the Hue/Saturation controls. Leave the Edit mode set to Master, but move the Saturation slider to the far left, a setting of -100. This turns your main visible image of the pier from colour into black and white. Next, we'll tweak this image. ▶

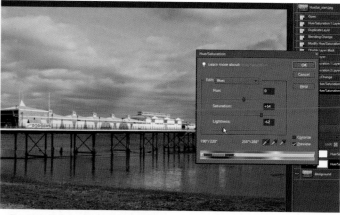

5 Shades of grey

We now need to adjust the black-and-white conversion so that the shades of grey are the desired density. Double-click on the left-hand icon on the 'Hue/Saturation 1' layer. We'll start off by working on the sky area. Click on the Edit mode (where it says Master) and choose Blues from the drop-down menu.

6 Darken the sky blues

The range of blues affected is preset, but we can tweak the exact selection using the Eyedropper tools. Pick the Eyedropper with the + symbol next to it and then click on two or three points in the sky in the image (this adds to the colour range affected). Move the Saturation slider to +54 and the Lightness slider to -62 to darken the sky.

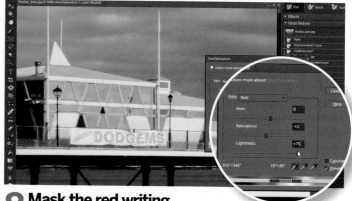

7 Lighten the yellow sand

Click on the Edit options again (it currently says Blues) and now choose Yellows from the drop-down menu. This will enable you to adjust the tone of the beach area in the foreground of our seaside image. Move the Lightness slider to +35 to turn the sand into a lighter shade of grey.

8 Mask the red writing

The process of altering the grey shade that each colour becomes can be used to hide unwanted details. Here, the dodgems banner is distracting. Pick Reds from the Edit drop-down menu. Move Saturation to -12 and lightness to +75. The wording blends into the background, so is less noticeable. (Click OK, if using Elements 7 or earlier.)

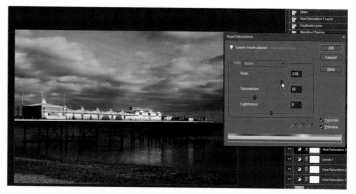

9 Boost contrast in Levels

As is usual with mono conversions, the image lacks contrast. In the Layers palette, click on the 'Hue/Saturation 2' layer, so that the top layer is selected. Click on the half-moon Create Adjustment Layer icon and choose Levels. Move the Black input slider to 19, the central Grey input slider to 0.92, and the White input slider to 241 (click OK).

10 Add a blue rinse

As a final touch, you can add a toned effect to the image. Click on the half-moon Create Adjustment Layer icon again. Choose Hue/ Saturation. Click to check the Colourise option. Choose the colour tint by moving the Hue slider – we set a value of 238 to add a blue tone. Use the Saturation slider to adjust the intensity of the tint; we chose a setting of 14. Click OK if necessary when you're done. ■

On the disc Check out the video on your free DVD

How to...
Create a photobook

Produce and order a stylish photobook using the Projects section of Photoshop Elements and have it shipped straight to your door

WHAT YOU'LL NEED *Photoshop Elements 5.0 or above*
WHAT YOU'LL LEARN *How to put together a photobook in the Elements editor, how to order the book from the Kodak online store without leaving the Elements interface*
IT ONLY TAKES *20 minutes*

Photobooks have become increasingly popular. They are a great way to commemorate events like weddings, and be accessed directly through Photoshop Elements using the Kodak EasyShare Gallery. As long as you're happy to use this service, there's no need to leave the Elements interface.

To enable the Photobook option, you need to change the Country Settings (the service isn't directly available in the UK, so your book will be shipped from the US). Go to Edit>Preferences> AdobePartnerServices, click on the Location button and select US & Canada. You're now ready to create and order your photobook.

1 Start Choose your images
In Photoshop Elements, open the Project Bin, then navigate to the images you want to use and click on Open. Under the Create tab, click Projects then Photo Book. Whichever photo is at the front of your Project Bin will appear as the image on the title page of your book, but you can change this by moving another image to the front. Click Next.

2 Configure layout and appearance
You can either lay out the pages randomly or, for more flexibility, click Choose to decide the right- and left-hand page layout. Click Next and you'll be asked to choose a theme. Think about the subject matter when choosing a theme – you won't want a 'holiday' theme for a wedding album, for example.

Sarah and Mark's Wedding
15 August 2009

3 Create your photobook
Click Auto-Fill to automatically place the Project Bin images within the book. Untick Auto-Fill for more flexibility. You can choose the number of pages in your book (we chose 20, but extra pages can be added for 99¢ about 65p – each). Click Create. Add titles and captions with the Text tool, and when you're done, save and click Order in the bar just below the images.

4 Finish Make your order
If you don't have a Kodak account, you'll need to create one here (follow the on-screen instructions). Next, choose the material you want for your book cover – some options cost extra. Enter the delivery address, payment details and confirm. Your book should arrive by airmail within one week. ∎

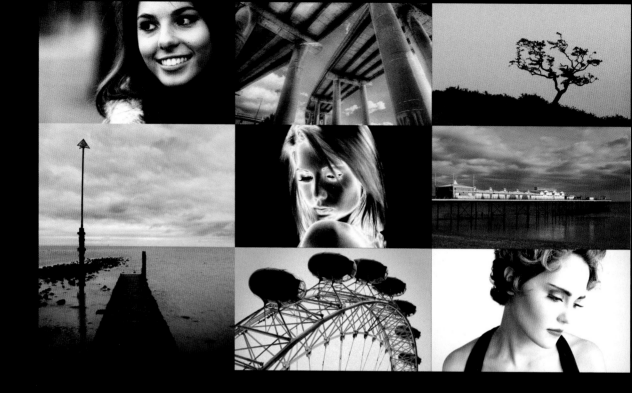

Important
About copyright

Please note that all the images on your DVD are copyright. ***They are not 'royalty-free' or 'library' images.*** They are supplied solely for your own private use, so you can work along with our tutorials. They must not be sold on, redistributed in any form (whether as-supplied or edited), made available on any server or website, or used for any commercial purpose.

How to... Use the disc interface

1 Welcome to the disc

After the disc interface launches and you've accepted the terms of use, you'll see this Welcome screen. To access the tutorials on the disc, simply click the Videos tab in the bar below the title. You will also notice a tab for PhotoRadar.com – our website that features image galleries, blogs, news, reviews, videos and lively magazine forums (note that this button will work only if you have an active internet connection).

2 Viewing the videos

After clicking the Videos option, you'll be presented with a pictorial list of tutorials in the same order in which they appear in the printed magazine. Click on the tutorial of your choice and the video will launch in the main interface. Click the play icon to start the video and pause to stop it. You can also skip back and forward through the video by moving the slider. Once you've finished viewing the video, simply click the Back button to go to the main Videos tab.

3 Accessing the images

All tutorial images are stored alongside their corresponding video. To the right of the video you will see an option called 'Click here to download the start image for this tutorial'. Select this link and you'll be asked to choose where to save the images to – we recommend the Desktop, for easy access. Once the files have downloaded, you can then open them in Photoshop Elements/CS, or any other software specified in the associated video/printed tutorial.

Your free DVD includes step-by-step videos that will take you through practically every Photoshop tutorial in this book. You can listen and watch to see exactly how each image is edited and transformed – and you can read along on the accompanying pages in the book too, should you want. Furthermore, we provide you with all the 'start' images you'll need to complete the step-by-step projects in this book. You'll find our little 'On the disc' sticker on the page to remind you. Note that not all the tutorials in this book will be accompanied by source images: some don't require our images to follow a project.

To access the files on this disc, first insert the DVD into your drive of your computer. Whether you're using a Mac or a Windows PC, the disc should work equally well.

Getting going

The first item that should appear on your screen is the disclaimer window; here you'll need to click on 'I agree'. Please remember that this disc has been scanned and tested at all stages of production, but – as with all new software – we recommend that you run a virus checker before use. We also recommend that you have an up-to-date backup of your hard disk before using this Video Disc. Future Publishing does not accept responsibility for any disruption, damage and/or loss to your data or computer system that may occur while using this disc, or the data and programs on

it. Consult your network administrator before installing software on a networked PC.

There are 28 video lessons along with their source files on this DVD, arranged in the order they appear in the bookazine. For your convenience, we have stored the videos and corresponding images together on the interface so you can access them as-and-when you need them. See above for a guide to finding your way around the disc.

Our video tutorials are in Flash format and we recommend that you install the latest version of Adobe's Flash Player, available free at **www.adobe.com/flashplayer**.

Questions and queries

If you have a query about using your disc's interface or its content, please visit our reader support website at **www.futurenet.com/support**, where you can find solutions to many common problems. In the unlikely event of your disc being defective, please e-mail our support team at **support@futurenet.com** for assistance. Please note that we can only provide basic advice on using the interface and disc content. We cannot give in-depth help on your applications, hardware or operating system.

Expert tip
Starting the disc interface manually

If the disc interface doesn't load automatically when you insert the disc, here's what to do.

PC users: Click on the Windows Start button and click Run. Now click Browse and go to the CD directory in My Computer. Look for a file called CBZ.exe and double-click on it. Click OK in the Run dialog, and the interface should open.

Mac users: Double-click the disc icon to view its contents, then double-click 'CBZ.app' to launch the interface.

Index

More Great Books from Fox Chapel Publishing

The Complete Digital SLR Handbook
Mastering Your Camera to Take Pictures Like a Pro
By Editors of PhotoPlus Magazine

Everyone wants to take great photographs, and this book shows how to make every shot a winner with expert advice on settings, sharpness, and exposure. Includes CD.

ISBN: 978-1-56523-717-9
$27.95 • 192 Pages

Photoshop For Photographers
Everything You Need to Know to Make Perfect Pictures from The Digital Darkroom
By Editors of PhotoPlus Magazine

This expert guide shows you how to get even better results from your digital SLR photography using Photoshop's photo-editing tools. In-depth workshops include tricks and techniques to create perfect photos. Includes CD.

ISBN: 978-1-56523-721-6
$27.95 • 216 Pages

How to Draw and Paint Anatomy
Professional Artists Teach You Practical Drawing Techniques
By Editors of ImagineFX Magazine

Art students, professional illustrators, and amateurs alike will find inspiration and encouragement to develop their core skills and embrace innovative digital techniques. Includes CD.

ISBN: 978-1-56523-716-2
$27.95 • 112 Pages

The Official Vampire Artist's Handbook
How to Create Your Own Patterns and Illustrations of the Undead
By Lora S. Irish

Learn how to draw vampire art in simple, easy steps. Instructions could be used to create patterns for various crafts and for drawing.

ISBN: 978-1-56523-678-3
$27.95 • 112 Pages

Cigar Box Guitars
The Ultimate DIY Guide for the Makers and Players of the Handmade Music Revolution
By David Sutton

Part DIY guide, part scrapbook - this book takes you behind the music to get a glimpse into the faces, places and workshops of the cigar box revolution.

ISBN: 978-1-56523-547-2
$29.95 • 224 Pages

Learn to Play the Ukulele
A Simple and Fun Guide for Complete Beginners (CD Included)
By Bill Plant and Trisha Scott

With the help of this book and companion CD, anyone can learn to play the ukulele overnight.

ISBN: 978-1-56523-687-5
$14.95 • 64 Pages

The Art of Steampunk
Extraordinary Devices and Ingenious Contraptions from the Leading Artists of the Steampunk Movement
By Art Donovan

Dive into the world of Steampunk where machines are functional pieces of art and the design is only as limited as the artist's imagination.

ISBN: 978-1-56523-573-1
$19.95 • 128 Pages

How to Make Picture Frames
12 Simple to Stylish Projects from the Experts at American Woodworker
Edited by Randy Johnson

Add a special touch to cherished photos or artwork with hand-made picture frames. The experts at American Woodworker give step-by-step instructions using a variety of woods and styles.

ISBN: 978-1-56523-459-8
$19.95 • 120 Pages